Barry Segui

20.11.98

W9-DFD-078

LOVIS CORINTH

CALIFORNIA STUDIES IN THE HISTORY OF ART

Walter Horn, Founding Editor
James Marrow, General Editor

Discovery Series

LOVIS

CORINTH

Horst Uhr

UNIVERSITY OF CALIFORNIA PRESS :: BERKELEY LOS ANGELES OXFORD

University of California Press
Berkeley and Los Angeles, California
University of California Press, Ltd.
Oxford, England
© 1990 by The Regents of
the University of California
The works of Lovis Corinth are
© by Wilhelmine Corinth Klopfer,
New York

Library of Congress Cataloging-in-
Publication Data

Uhr, Horst, 1934–
Lovis Corinth / Horst Uhr.
p. cm.—(California studies in the
history of art ; 27)
Includes bibliographical references.
ISBN 0-520-06776-2 (alk. paper)
1. Corinth, Lovis,
1858–1925. 2. Artists—
Germany—Biography.
I. Title. II. Series.
N6888.C67U37 1990
759.3—dc20
[B] 89–20317

Printed in Japan

9 8 7 6 5 4 3 2 1

The paper used in this publication
meets the minimum requirements
of American National Standard for
Information Sciences—Permanence
of Paper for Printed Library
Materials, ANSI Z39.48-1984. ∞

To the memory of Auguste and Wilhelm Uhr

CONTENTS

ILLUSTRATIONS

FAMILY PHOTOGRAPHS

Following page 127

PLATES

Following page 178

FIGURES

PREFACE AND ACKNOWLEDGMENTS

My interest in Lovis Corinth began in the autumn of 1970 when I saw six of his works in the exhibition of nineteenth-century German painting at the Yale University Art Gallery. All were from the early stages of his development, but they displayed a versatility, both conceptually and iconographically, that I found compelling. As I learned more about the artist, I was struck, after even a cursory survey of his work, by the extent to which Corinth was indebted to the past. Many of the great themes of Western art were represented, and his style was often reminiscent of the great Dutch and Flemish masters of the seventeenth century. At the same time, Corinth reinterpreted his sources in an entirely original and unconventional way. I have come to believe that this juxtaposition of tradition and modernity constitutes the most characteristic feature of his work. Only Max Beckmann is in this respect comparable to Corinth. It also became quickly evident to me that Corinth's personal life was a life in pictures, among them an astonishingly large number of self-portraits, both real and metaphoric. Because of this a comprehensive study of Corinth is best conducted from a biographical point of view, as I have done in this book. Fortunately, Corinth was an avid writer and left two autobiographical accounts that inform us of some of his innermost thoughts. He also commented on the politics and the artistic milieu of his time and on the people he knew, and he summarized his approach to painting in a teaching manual. Our understanding of Corinth is further augmented by the two memoirs published by his widow, the painter Charlotte Berend, and a compilation of personal papers and letters edited by his son, Thomas.

This book, however, would have been easier to write had Corinth's work been less varied. But instead, for nearly half a century he painted landscapes, portraits, still lifes, and genre scenes as well as subjects taken from history, literature, mythology, and the Bible, selecting at different times and for different reasons one category or another. At certain times in his development Corinth devoted his most creative energy to his drawings. In these he often achieved a freedom of expression that his paintings were to manifest only

years later. Consequently, while adhering to a chronological approach, I found it necessary to emphasize one subject or one medium over others as the circumstances required.

It should be stressed at the outset that Corinth was also an unusually productive artist. His catalogued oeuvre comprises close to a thousand paintings and nearly the same number of prints, while the drawings and watercolors exceed the combined output of the painter and printmaker. As with any legacy so prodigious, the quality of the individual works varies. While it has been common, especially in exhibitions of Corinth's work, to concentrate only on the great masterpieces, I have tried to avoid this approach. The problem is intensified by Corinth's remarkable late style, which on account of its alternately spectacular and moving qualities appeals to modern sensibilities. It would have been easy to emphasize Corinth's late works at the expense of his more tentative and—from a late twentieth-century point of view—perhaps old-fashioned early works. Without prejudice to the much greater importance of Corinth's late paintings and graphics, I have tried to resist that temptation, because as a historian I find the genesis of achievement at least as fascinating as the final result. I also believe that only a thorough discussion of Corinth's earlier development allows us to assess the real accomplishment of his later years. Corinth was a learner by nature, and his entire life was a continuous process of relearning and reevaluating what he had been formally taught. And only against the background of his efforts to make himself into the painter he turned out to be is it possible to understand the inner turmoil accompanying his efforts to master anew his technical facility when a severe stroke in 1911 threatened to end his career.

The abbreviations B.-C., Schw., and M. refer to the oeuvre catalogues by Charlotte Berend-Corinth, Karl Schwarz, and Heinrich Müller, listed in the bibliography. The sources for illustrations are given in the captions. The photographs credited to Bruckmann were made from originals supplied by Verlag F. Bruckmann, the publisher of the Berend-Corinth oeuvre catalogue; those "after Bruckmann" were photographed from the catalogue itself. Dates for artists' lives have been given only for individuals closely associated with Corinth. These dates are introduced not necessarily where the artists are first mentioned but rather when their work and relationship to Corinth are discussed. The titles of literary works are given in the original form, since many have never been translated into English. In the case of dramatic works, titles are in the language in which the plays were performed in the context of the discussion, except in the case of Shakespeare, where this would have been unnecessarily pedantic. Except for quotations from English-language sources, all translations in the text are my own.

My research was aided by the recollections of the late Thomas Corinth, who kindly granted me a number of interviews and supplied me with useful bibliographical material. I also owe a very special debt of gratitude to the painter's daughter, Wilhelmine Corinth Klopfer, who shared with me her memories of her parents and provided me with photographs of her father's works and of the Corinth family. The late Heinrich Müller and his wife received me most graciously on several visits to their home in Hamburg and permitted me to photograph their extensive collection. Dr. Peter Schäfer in Schweinfurt did everything possible to make my excursion to Schloss Obbach a rewarding experience. Allan Frumkin encouraged my visits to his gallery in New York to study and photograph drawings by Corinth. I gratefully acknowledge the assistance of Dr. Thomas Deecke, who generously allowed me to make use of photographic negatives in his possession.

Throughout my research and writing I have counted on the goodwill and help of colleagues, collectors, and museums in locating or obtaining photographic material and clarifying information. I want to thank in particular Jan A. Ahlers, H. L. Alexander von Berswordt-Wallrabe, Dr. Andreas Blühm, Cécile Brunner, Orlando Cedrino, Dr. Dorothea Eimert, Dr. Zdenek Felix, Dr. Dieter Gleisberg, Dr. Rosel Gollek, Professor Julius S. Held, Becky Hoort, Kitty Kemr, Dr. Helmut Knirim, Madeleine Koch, Pastor Klaus Krug, Dr. Christian Lenz, Bruce Livie, Dolores Mellenthin, Hans Paffrath, Renate Pohlhammer, Dr. Anne Röver, Dr. Eberhard Ruhmer, Bernd Schultz, Judith Schwarz, Mary Stephenson, Dr. Wolfgang Stolte, and Dr. Werner Timm.

I have also benefited greatly from the advice and encouragement of Alessandra Comini. Hans-Jürgen Imiela has shared my interest in Corinth from the very beginning of my studies. In addition to good counsel, he provided catalogues, out-of-print books, and photographs with exemplary generosity. His own work on Corinth and on Corinth's contemporaries has aided me far more than my footnote references can convey.

I thank Deborah Kirshman and Lisa Banner of the University of California Press at Berkeley for having attended in such a cordial and efficient manner to the numerous details involved in the publication of this book. And I am extremely grateful for the care and skill with which Stephanie Fay edited the manuscript.

For his thoughtful criticism and unwavering intellectual and moral support my greatest debt is to Edwin Hall.

Horst Uhr
Grosse Pointe, 1989

INTRODUCTION

Lovis Corinth is one of the great individualists in the history of art—a painter whose works, like those of Rodin, Degas, van Gogh, and Beckmann, transcend both his own time and conventional classifications. In the course of an astonishingly productive career he managed to link the nineteenth-century academic tradition, a German interpretation of Naturalism, and what has been called German Impressionism to the forceful style of the Expressionists. Efforts to define his contribution, however, owe more to each generation's need to rewrite art history than to an understanding of Corinth's own perception of his work or his individualism.

Corinth's productive years, which spanned nearly half a century—from 1876, when he entered the academy in Königsberg, to 1925, when he died—coincided with the major art movements from Impressionism to the rise of Surrealism. From his studies at the academies in Königsberg and Munich and at the Académie Julian in Paris, Corinth gained a profound respect for the nineteenth-century academic tradition; and he adhered to it in many ways throughout his career, both as a teacher and in his own work. But he also explored a variety of then current trends, experimenting briefly with the formal idiosyncracies of *Jugendstil* and pursuing the Naturalism of Wilhelm Leibl and other painters of the Leibl circle. His work, moreover, evolved at the time when the works of the French Impressionists were first exhibited in Germany. By the turn of the century Corinth had emerged as one of the most eminent German painters and a major force in the Berlin Secession, joining Max Liebermann and Max Slevogt in what came to be known as the "triumvirate of German Impressionism."[1]

At the height of his career, in December 1911, Corinth suffered a stroke, an experience that ultimately led him to a new freedom of expression. The personal imprint apparent in even his earlier works, which despite their varied roots have great individuality, becomes particularly strong in the paintings and graphics he produced from 1912 on. Their alternately introspective and

aggressively emotional tone, conveyed through evocative colors and pictorial structures, has assured him a place in the history of German Expressionism.

Art historical labels, however, fit only part of Corinth's output—sometimes only a minor part—at any given stage of his development. He painted outstanding naturalistic portraits, for example, as well as compelling slaughterhouse scenes and dusky interiors, and he painted still lifes and landscapes that link him to Impressionism; but at the same time he produced ambitious allegories and figure compositions illustrating biblical and mythological scenes—the works that made his reputation. And if some of Corinth's work seems to place him among the Expressionists, he was, at best, an Expressionist *malgré lui,* rejecting Expressionism on both aesthetic and philosophical grounds. His work thus defies easy categorization, yet it has remained "modern" according to his own definition of the term, which he applied to all pictures "that on account of their high artistic value continue to affect people throughout time regardless of art movements."[2] For Corinth the work of art has "no . . . practical and profitable properties" but "is an end in itself. It is egotistic like a god, stands there in all its beauty, and allows itself to be worshipped by its true priests."[3]

Serious critical discussion of Corinth's work began at the turn of the century, when he moved to Berlin. Although from the beginning both his subjects and his formal solutions elicited conflicting responses, with critics generally evaluating his work according to personal biases and ideological considerations as well as aesthetic criteria,[4] by the end of his life Corinth was held in high esteem. Memorial exhibitions of his work throughout Germany followed his death. In January 1926 Ludwig Justi organized the first of these, at the National Gallery in Berlin, featuring more than five hundred paintings and watercolors. The gallery building was swathed in flags; on the roof flames rose from granite bowls. Concurrently, the Berlin Secession exhibited Corinth's drawings and the Berlin Academy his prints. Virtually every major German city held its own memorial exhibition.

Ten years later, in 1937, Corinth was featured in a still larger show, the Munich exhibition Entartete Kunst, the most infamous of several exhibitions of "degenerate art" organized by the Nazis to incite the public against modern art. Nearly seventeen thousand sculptures, paintings, drawings, and prints were confiscated from German museums for this exhibition, among them almost three hundred of Corinth's late works, including some of his greatest masterpieces. These, ironically, shared the fate of works by artists he had despised; seven of them were selected for special ridicule under the classification "inadequate craftsmanship and artistry." To obtain much-needed

currency, the Nazis in 1939 sold several of Corinth's confiscated works at auction in Lucerne; still others were exported by specially selected dealers.

Although Corinth's work had thus become known throughout Europe, the American public for many years remained largely unaware of it. One American—his experience is typical—describes his discovery of Corinth in 1930 during a visit to the Kronprinzenpalais in Berlin, where he was attracted by a large still life with flowers:

> It was by an artist of whom I hadn't even heard. His name was Lovis Corinth. I soon came upon another canvas and, on the strength of the initial experience, recognized the style immediately. . . . But who was this Lovis Corinth? And why hadn't I known him all along? Apparently he was a German artist esteemed to be of some importance, since I had found two pictures—no, here was a third—in the collection of an important museum. Then all at once I walked into a whole gorgeous roomful of Lovis Corinths, which took my breath and stirred the sort of elation that accompanies a sense of discovery.[5]

Corinth's son, Thomas, who had settled in New York in 1931, helped to organize the first exhibitions of his father's work in the United States: at the Westermann Gallery in New York in 1937 and 1939 and at the Galerie St. Etienne in 1943 and 1947. Reactions to these shows were overwhelmingly positive, although the reviewers were hard-pressed to classify Corinth's highly individual mature works, comparing them with those of Cézanne and van Gogh. But these comparisons, however flattering their intent, were less to the point than the assessment of the critic who noted Corinth's "power and range. . . . the variety and passion of his styles" and characterized him as "a kind of Wagner in painting."[6]

In 1950, to commemorate the twenty-fifth anniversary of the painter's death, Curt Valentin organized a traveling exhibition of nearly eighty works that was seen on both coasts and in the Midwest as well as in eastern Canada. In his preface to the catalogue, Julius Held spoke of the tardiness of Corinth's American reception:

> Corinth is still practically unknown in this country even though some of his finest works are in American private collections and some museums are beginning to become aware of his stature as a graphic artist. May this exhibition help to gain for Corinth his rightful place in our picture of European art. He will most surely appeal to our younger artists, and the larger public, too, will be fascinated by his vigorous and uncompromising art. Indeed, I am convinced that before long Corinth's name will be as familiar and as meaningful to all as the names of other great European artists of his generation.[7]

Yet in the American cultural milieu, long accustomed to the formal solutions of the French avant-garde as the preeminent expression of modernism, German art, with its heightened emotional tone, met with little understanding. Moreover, Americans, acutely aware that Germany had twice in this century plunged the world into devastating conflict, found it difficult to regard German cultural contributions dispassionately. The knowledge that such artists as Corinth and the German Expressionists had themselves been victims of the misguided policies of the Third Reich had little effect. Hilton Kramer, writing more than a quarter century ago, recognized that Corinth's work "belongs at once to the past and to the present" and believed that the time had come "for his great work to enter into its rightful position in our histories, in our museums, and above all, in that part of our lives where art—rather than the vagaries of artistic fashion—really counts."[8] In the context of Abstract Expressionism and other abstractions such as Minimalism, ABC Art, or Primary Structures, however, this expectation was not fulfilled.

Although German museums and galleries have always accorded Corinth a special place of honor, even in postwar Germany his art remained on the periphery of the collective aesthetic consciousness because it was so obviously out of tune with the pervasive trends of abstraction. Large exhibitions in Germany and in London in 1958 and 1959 to mark the hundredth anniversary of Corinth's birth did little more than reaffirm the esteem in which his work had been held before its degradation by the Third Reich.

More recently, however, greater tolerance toward the nineteenth-century academic tradition and a revived interest in content in a work of art, a "hunger for pictures," as it has been called,[9] have paved the way for a new and sympathetic look at Corinth's work. Specifically in the context of Neo-Expressionism and a concomitant concern for subjective and autobiographical expressions, Corinth has finally achieved the recognition he deserves. Major German exhibitions in 1985 and 1986 in Essen, Munich, Regensburg, and Bremen, ostensibly linked with the sixtieth anniversary of the painter's death, also testify to his new popularity. Indeed, the visible record of his emotional life, manifested in his unusual colorism and in the stabbing, furious strokes of the broad brush, have struck a sympathetic chord in the avant-garde. Contemporary painters like Willi Sitte and Manfred Bluth have begun to pay specific homage to Corinth in their own work, and in the most recent survey of developments in German art from 1905 to 1985 he is featured prominently alongside Nolde and Beckmann as one of the great German painters of the twentieth century.[10]

ONE :: YOUTH
AND
STUDENT
YEARS

THE TANNER'S SON FROM TAPIAU

Lovis Corinth once remarked that nature has a way of placing a budding artist in the environment most likely to nurture his creative instincts.[1] He made this statement while reflecting nostalgically on his own childhood, although he was fully aware that the real circumstances of his early years had provided him with little opportunity for artistic growth. Indeed, in a diary entry for May 8, 1925, about two months before his death, he confessed with undisguised regret, "I did not have a good upbringing. In fact, it was one of the worst possible. Those who are brought up better have no idea what effect this has on a child. . . . Not that I want to blame my parents. They did not know any better."[2] There is no question that Corinth's brusque demeanor—frequently offensive to those who did not know him—as well as his continuing self-doubt and his determination to succeed resulted from a childhood that had made him deeply insecure.

Corinth's ancestors, originally perhaps native to the Salzburg region, had settled in East Prussia in the early eighteenth century. They were peasants and artisans in the villages of Lindenau, Moterau, and Neuendorf and in the small town of Tapiau, about twenty miles east of Königsberg. Most of them tilled their own land or operated family workshops. The painter's father, Franz Heinrich Corinth, had grown up to be a farmer. But as the youngest of four sons he had no claim to his parents' property, which, in keeping with local tradition, was to be passed on to his oldest brother. He might have continued working on the family farm had not frictions between the brothers forced him to seek his fortune elsewhere. At eighteen he volunteered for military service and later found employment as secretary to the mayor of Tapiau. Eventually he acquired an estate of his own by marrying a widow. He was twenty-eight years old when he and his cousin Amalie Wilhelmine Opitz exchanged wedding vows on October 2, 1857. The bride was forty-one and the mother of five teenage children. In addition to a sizeable portion of land, she

owned a tannery, much neglected by her first husband but potentially profit-able and suitable for expansion. Franz Heinrich soon developed such shrewd insights into the technical and managerial needs of the tanning business that he quickly transformed the shop into a lucrative enterprise.

Amalie Wilhelmine Opitz was the daughter of a prosperous shoemaker from Tapiau. Her first husband, thirty-seven years her senior, had treated her cruelly during eighteen years of marriage, leaving her disillusioned and emotionally withdrawn. After his death the task of raising her children and looking after her property had taught her to be self-reliant. Even in her new marriage she retained absolute control of household affairs and demanded strict obedience from everyone. Franz Heinrich, occupied with supervising the farm and managing the tannery, did not interfere with her domestic re-gime. Although the relationship between husband and wife was fairly conge-nial, it too was overshadowed by a conflict that caused Amalie Wilhelmine unending misery and led her to suppress her feelings still further. The sons of her first husband saw Franz Heinrich as an intruder on their property rights and greeted him with malice and hatred. They attacked him physically and even threatened the life of their little stepbrother. "There was no harmony in our house," Corinth wrote in his memoirs. "Besides, everyone was older than I! They were barbarians in the true sense of the word."[3]

Corinth, the only child of Franz Heinrich and Amalie Wilhelmine, was born in Tapiau on July 21, 1858. At his baptism on August 8 in the Protestant church there he was given the names Franz Heinrich Louis, the third name in honor of his paternal grandmother Louise Stiemer; relatives and friends of the family usually called the boy Luke or Lue. Given the tense, awkward relationship between Franz Heinrich and his stepchildren, the development of a close bond between the young father and his own son was inevitable. The father comforted the boy when he was frightened and ill and eagerly or-dered a flute from a Königsberg shop when Louis wanted to learn to play a musical instrument. Franz Heinrich hoped that his son would have the uni-versity education he himself had been denied. Corinth's mother, in contrast, cared little about the boy's schooling. She was satisfied if he knew how to distinguish the good from the bad and, when necessary, taught him the dif-ference with the aid of a whip. Her hopes for his future centered on the pur-chase of a small farm, where he could carry on the family tradition without interference from his bickering stepbrothers. Louis often watched his mother as she sat for hours silently spinning or working the loom. There seems to have been little spontaneous communication between the two; only many years later did Corinth understand that when his mother occasionally "forced"

him to hug her, it was because she needed affection.[4] "Deep inside we all felt a great yearning to love," he recalled. "But this love was never allowed to be expressed. Rather, it was hidden out of fear of revealing too much tenderness."[5] Late in his life he acknowledged the pernicious effect on him of such a childhood:

> I have been unhappy throughout my life. From the beginning there was the secret war of my stepbrothers against me, a continuous strife and quarrel over the fact that they had received no education. Secretly they even threatened to kill me. The memory of this situation from my childhood has remained with me to this day. I have always felt a certain respect toward the more privileged classes. Yet my disposition did not allow me to love anyone. On the contrary, everyone considered me rather repulsive and crude on account of my ill-bred barbarity. I envied those who possessed a cheerful temperament or greater ability than I. A burning ambition has always tormented me. There has not been a day when I did not curse my life and did not want to terminate it.[6]

Corinth wrote repeatedly about his childhood. His autobiography includes diary entries written when advancing age and political turmoil often gave rise to despair, as indicated by the passage just quoted, as well as recollections of a more lighthearted nature. In addition, he wrote an amusing, partly fictionalized, autobiographical account, *Legenden aus dem Künstlerleben*. These "legends," first published in 1908, feature one Heinrich Stiemer, a pseudonym for Lovis Corinth. The opening pages of Corinth's *Gesammelte Schriften* (a compilation of articles, some originally published in *Kunst und Künstler, Pan,* and several Berlin newspapers), moreover, contain brief recollections of his boyhood in Tapiau. But the *Selbstbiographie* remains by far the most important source of information on Corinth's family and childhood. The first three chapters deal at length with the painter's youth and years of study. Written between 1912 and 1917, they were apparently planned from the outset for publication. In their careful exposition and stylistic unity they contrast with the later chapters, which retain the form of the diary found in Corinth's desk after his death. Written between November 1918 and May 8, 1925—a time when Corinth, increasingly subject to despondency, questioned the meaning of his life and work—these entries offer an invaluable key to his complex personality.[7]

Corinth's recollections of his childhood are rich in anecdotes and lively descriptions of his parents' home, the barns, the stables, and the tanning pits where bloodstained hides were prepared for processing into leather. We read of animals being slaughtered, their carcasses skinned and broken open, dis-

charging litters of opalescent, steaming entrails. Greedy chickens drink voraciously from pools of blood in the yard adjoining the stables and the tannery. Even when the boy was still too frightened to watch the actual killing, a dead animal held no particular terror for him. Rather it fascinated him like a strange and bizarre toy, as when he once occupied himself by poking the eyes out of the head of a freshly slaughtered pig. Written with the painter's sensitivity for evocative details, these recollections frequently speak of Corinth's intoxication with physical force. Years later, slaughterhouses and butchers' stores continued to interest him. They form part of an iconography of aggression and violence found throughout his oeuvre.

Beyond the stables and workshops as well as in them Louis found much to marvel at. The Corinth home stood near the divergence of the river Deime from the mightier Pregel, where the latter continues its separate course to the Baltic Sea. There Louis watched steamers carrying travelers to and from the seashore and slow-moving Lithuanian onion barges on their way to the Königsberg market. Yet nothing pleased him more than to spend his time cutting silhouettes from paper and making caricatures. Friedrich Wilhelm Bekmann, an elderly carpenter who frequently helped Corinth's father with chores, had taught him how to draw all sorts of animals and human figures, and Corinth fondly remembered the old man many years later as his "first teacher in art."[8] Another friend, Emilie, the one-eyed daughter of one of the women supervisors employed in the state prison located in the remains of an old castle across the river, lived with her mother upstairs in the Corinth home. Emilie sometimes unrolled for Louis a carefully guarded family treasure, a reproduction of the equestrian statue of King Friedrich Wilhelm III of Prussia, and told him of the monument that stood on the parade grounds in Königsberg. Emilie, according to Corinth, first aroused in him a love for pictures, and he began to examine the crudely painted allegories on the target disks that some of his parents' friends and relatives had won at shooting matches in the nearby village of Wehlau and displayed proudly in their homes. He also admired the frescoes on the vaulted ceiling of the Tapiau church, which filled him with awe. Once he even had the good fortune to watch a painter at work on a landscape study by the river.

When Louis was not yet six, in the spring of 1864, he went to school in the one-room schoolhouse in Tapiau. He quickly learned to read and write, but arithmetic never ceased to confound him. Despite supplementary lessons, he had to repeat one class. Corinth's father remained nonetheless determined that his son receive the training required for university study and at Easter

1867 took the nine-year-old to Königsberg and enrolled him at the Kneiphö-fisches Gymnasium.

Except for summer vacations, which he spent in Tapiau, Corinth lived for the next seven years with his mother's sister. His aunt, the widow of a shoe-maker, was avaricious, aggressive, and crude. Although Corinth learned to appreciate her sarcastic humor, he despised her character. Since she was more interested in having Louis chop wood and attend to other menial chores than in having him memorize Greek and Latin, his scholastic performance left much to be desired. Although the school authorities suggested repeatedly to Corinth's father that he change the boy's environment, the advice, strangely enough, went unheeded. The dichotomy between Louis's home life and his life in school set him apart from his refined and well-groomed fellow stu-dents, who from the very beginning laughed at his pronounced East Prussian dialect. Although he soon forced himself to speak only High German, he re-mained an outsider, masking his insecurity with sullen and aggressive behav-ior. Without the companionship of friends and caring relatives, he devoted most of his free time to drawing. This was also the only subject in which he excelled at school.

Some of his earliest drawings still survive. They include a caricature of one of his teachers supervising the boys in the rainy schoolyard and other drawings inspired by lessons in ancient history and illustrations in his school-books. Awkward and crude, these drawings hardly indicate a precocious tal-ent. As an adult, however, Corinth cherished these juvenilia. They largely escaped his self-critical destruction of many of his student works and other early paintings. Evidently wishing to document the genesis of his creative activity, he preserved many and as late as 1915, at the height of his career, gave one of them, a drawing illustrating the death of Alexander the Great, to his then eleven-year-old son Thomas as a Christmas gift.[9] One early drawing stands out for its superior conception and execution. This is a self-portrait (Fig. 1) done sometime in 1873, when Corinth was either fourteen or fifteen.[10] Relying primarily on contours and a few skillfully placed accents to define such details as the nose and eyes, Corinth seems to have captured his like-ness with deceptive ease. The features are close to the picture surface and dominated by the apprehensive yet challenging gaze. The look is that of a youth who knows doubts but is sustained by stubborn resolution. Perhaps the death of Corinth's mother on April 6, 1873, helps to account for the se-rious expression. At any rate, this self-portrait marks the beginning of a fas-cination with his own image that was to persist throughout Corinth's career,

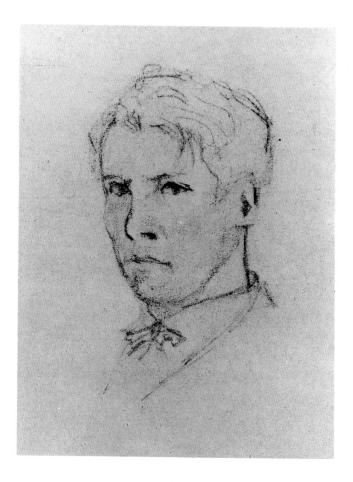

FIGURE 1.
Lovis Corinth, *Self-Portrait*, 1873. Pencil,
8.9 × 7.6 cm. Private collection.

frequently prompted by an event of some autobiographical importance. With
the possible exception of Rembrandt, Max Beckmann, and Egon Schiele, no
other artist has been so fascinated with his own image.[11]

In the spring of 1876, having taken eight years to complete six grades at the
Kneiphöfisches Gymnasium, Corinth asked his father's permission to leave
school three years prior to his expected graduation and enroll in the Königs-
berg Academy instead. Franz Heinrich was disappointed, but his kindness
did not permit him to interfere with his son's own plans for the future.

By the time Corinth was admitted to the Königsberg Academy, at Easter
1876, the circumstances of his life had changed markedly. Following the death

of his wife, Franz Heinrich Corinth sold the property in Tapiau, paid his step-children their share of their mother's estate, and invested the remaining, still substantial, capital in a number of houses in Königsberg. He himself moved to the city in 1876, sharing with Louis a spacious and pleasantly furnished apartment at Tragheimer Pulverstrasse 25. Henceforth he was to take an avid interest in his son's career, supporting him generously and encouraging him in every way possible.

AT THE KÖNIGSBERG ACADEMY

As might be expected in a provincial capital as remote as Königsberg, the artistic milieu was undistinguished. The municipal painting gallery featured copies after Italian and Netherlandish masters from the fourteenth through the seventeenth century, on loan from the royal painting gallery in Berlin, and a small group of German, Flemish, and Dutch works—including paintings attributed to Holbein, Brouwer, and Frans Hals—that had been left to the city by a former mayor, Theodor Gottlieb von Hippel.[12] The gallery's contemporary art reflected the taste and discretion of members of the Königsberg Artists' Association. Since 1833 this organization had sponsored the biennial exhibitions at the Königsberg Castle and was responsible for acquiring modern paintings for the gallery's permanent collection. The works purchased over the years were mostly history and genre paintings, including pictures by Paul Delaroche, Ary Scheffer, Karl von Piloty, and Franz von Defregger. Since the 1870s the municipal gallery had been housed in the art academy, and the collection served as a convenient supplement to studio instruction.

The academy itself was founded in 1842 by order of King Friedrich Wilhelm IV of Prussia, replacing a drawing school that had been in operation since 1790, superintended by the academy in Berlin.[13] The teaching program of this drawing school was based on that of the private Parisian ateliers: students began by copying engravings and reproductions of drawings and then proceeded to drawing, first from plaster casts and, finally, from the live model. Anatomy, geometry, and perspective were also taught. This was still the curriculum (augmented only by instruction in painting) when Corinth attended.

Unfortunately, the full extent of Corinth's activity during his years at the Königsberg Academy cannot be known because he destroyed so many of his early works. "Nobody thinks of buying these crazy products of a young man, or . . . of accepting them as gifts," he wrote in 1917 in a letter to Alexander Koch, the editor of *Deutsche Kunst und Dekoration*.[14] Thus no drawings or paintings of the nude model from this time have come to light. And there is little

additional evidence of what may be called student work in the strict sense of the term, since all of Corinth's paintings and most of the drawings that have survived from this time originated outside the classroom. They indicate at best that Corinth was a serious student who applied himself diligently and soon developed a keen power of observation.

Corinth's memoirs, similarly dominated by accounts of extracurricular activities, reveal nothing of his attitude toward the teaching program at the academy. He later remembered his years there as the happiest of his youth, largely because he discovered then the joys of a harmonious home life and found friends who knew how to surmount his habitual reserve. "No student was considered competent," he wrote, "unless he was also a notorious drinker. We soon developed great mastery in the consumption of alcohol. . . . All my new friends drank . . . until we could no longer tell which one of us could hold the most." [15] While at the academy Corinth set a pattern of social behavior he would follow in his early adult life.

Relations among the teachers at the academy were less congenial than those among the students. Because the school lacked effective leadership, petty rivalries among the faculty developed into bitter intrigues. The academy's first director, the history painter Ludwig Rosenfelder, had retired in 1874 after more than thirty years of service, and Max Schmidt, a landscape painter who had previously taught at the Weimar Academy, was temporarily entrusted with administering the school. For six long years, however, the Prussian Ministry of Education was unable to decide on a permanent successor to Rosenfelder. Meanwhile, the various faculty members hoping to be appointed to the vacant post regarded one another with suspicion.

Corinth's first teacher at the academy was Robert Trossin (1820–1896), a pedantic copper engraver well known for meticulously reproducing paintings by Van Dyck, Guido Reni, and Murillo as well as several contemporary masters. He taught the antiquated method of drawing after model books by Bernard Romain-Julien, the French painter and lithographer, and lithographs by Josef Kriehuber, the Viennese portraitist. Corinth remembered Trossin as patient and tenacious:

> "Not too pitchy!" That was his favorite expression whenever a student had used too much black chalk. Trossin was a member of the old guard, . . . it was said that he could even boast of having been awarded a Russian medal. He had engraved Guido Reni's *Mater dolorosa,* and legend had it that copying the figure's neck alone had taken many months of hard work. [16]

FIGURE 2.
Lovis Corinth, *Carousing Lansquenets,*
1876. Pen, 18.4 × 24.1 cm. Hamburger
Kunsthalle, Hamburg (1957/224).

Johannes Heydeck (1835–1910), one of Rosenfelder's former students,
taught drawing after plaster casts and the live model as well as painting. Like
his teacher, Heydeck specialized in history paintings in the manner of Louis
Gallait and Edouard de Bièfve, Antwerp painters whose works were first
shown in Germany in 1842 to unprecedented acclaim. Corinth was enthralled
by the extravagant staging and rhetoric of such compositions and by the care
lavished on the smallest detail. He particularly admired Rosenfelder's chef
d'oeuvre in the Königsberg municipal painting gallery, *The Surrender of Marien-
burg Castle to the Mercenary Captains of the Teutonic Order in 1457* (1857; present
whereabouts unknown): "Suits of armor, flowing robes, velvet draperies, and
the way the Grand Master holds the key to the fortress in his veined hand. . . .
these were my motifs around 1876." [17]

Carousing Lansquenets (Fig. 2), a pen-and-ink drawing, testifies to Corinth's
early enthusiasm for historical subjects. Although the date and signature
were added much later, the drawing was apparently done soon after Corinth
began his studies at the academy. The faulty anatomy of the figures indicates

FIGURE 3.
Otto Edmund Günther, *The Gambler*,
1872. Oil on canvas, 40.8 × 48.0 cm.
Kunstsammlungen zu Weimar.

a lack of experience in life drawing; the hatchings and crosshatchings, pains-
takingly applied, are a legacy, no doubt, of Trossin's copying method.

Corinth's plans to become a history painter in the tradition of Rosenfelder
were short-lived, however, for his interest was soon given a new direction by
Otto Edmund Günther (1838–1884), a graduate of the academies of Düsseldorf
and Weimar who joined the Königsberg faculty in 1876. Günther's early works
include a number of historical compositions, but he had long since turned to
genre painting, deriving his subject matter almost exclusively from the every-
day life of Thuringian peasants. He was especially fond of themes that allowed
him to explore anecdotal byplay and frequently applied the melodramatic
rhetoric of history painting to such situations as the one he depicted in *The
Gambler* (Fig. 3). In this painting a young peasant woman has come with her
infant to the inn to fetch her husband, who has just lost at cards. The concep-
tion and general composition of the painting recall works by Ludwig Knaus
and Benjamin Vautier, Düsseldorf artists who practiced a similar ethnographic
genre. Although Günther's tonal palette differs from the lively colorism of
Knaus and Vautier, the meticulous still-life elements in the picture are yet
another legacy of the Düsseldorf school.

In Königsberg, Günther was originally appointed to teach painting, but he soon assumed responsibility for some of the advanced drawing classes as well. He was the youngest member of the faculty, and his approach differed markedly from that of his colleagues. Seeking to expand the experience of his students beyond the confines of the academy's curriculum, he founded a junior artists' association, where they could work independently, exchange ideas, and engage in mutual criticism. He also encouraged them to work as much as possible out-of-doors and to heighten their visual perception in a familiar milieu by choosing subjects in the Königsberg market and the harbor. Corinth's memoirs include a vivid account of the mornings he spent in the slaughterhouse by the river Pregel. There he sketched and painted, oblivious to the pushing and shoving of the butchers and the sounds of the animals collapsing beneath cracking axes, his eyes fixed firmly on the movements of the men and on the colors: the reds and fatty whites of raw meat and the purple, shot through with glistening mother-of-pearl, of the entrails hanging in clusters from iron posts.[18] Günther's informal teaching method and easygoing manner appealed to Corinth: "For me Günther was an excellent teacher. Even more important, he was like a fatherly friend. Clever and sparkling with wit, he drew me, the awkward and suspicious youth, close to him."[19]

Not surprisingly, Günther had a profound effect on Corinth's early development, both directly and indirectly. In the summer of 1876 he persuaded Corinth and several other students to travel to Thuringia, where he introduced them to some of the leading painters of the Weimar school, including the aged Friedrich Preller, who in his youth had enjoyed the support of Goethe. A visit to the studio of the landscape painter Karl Buchholz, a quiet, introspective man, impressed Corinth, who called him "the genius of that Weimar period." Corinth remembered seeing in Buchholz's studio many of the small pictures contemporary critics had praised as depictions of nature "in her morning gown."[20] Buchholz's landscapes of the 1870s are indeed poetic, though faithful, descriptions of the Thuringian countryside, their basic structure unvarying. The artist rarely, and then only sparingly, introduced human figures into his landscapes, although he usually implied human presence with a pictorial space that seems to adjoin the viewer's own. One of the landscape drawings Corinth made during his journey through Thuringia (Fig. 4) is similar in conception and evidently bears more than an accidental resemblance to Buchholz's quiet pictures. Technically the drawing is superior to the contemporary figure composition in Hamburg (see Fig. 2). Corinth's attention to the details of the half-timbered houses is matched by his care in observing the boulders in the foreground and the masonry of the bridge. The bridge leads

FIGURE 4.
Top of page: Lovis Corinth, *In Thuringia,*
1876. Pencil, 26 × 36 cm. Private
Collection. Photo courtesy Bernd
Schultz.

FIGURE 5.
Above: Lovis Corinth, *The Barn,* 1879.
Pencil, 19.5 × 27.3 cm. National Gallery
of Art, Washington, D.C., Rosenwald
Collection (B-19562).

FIGURE 6.
Opposite: Lovis Corinth, *Kitchen Interior,*
1880. Pencil, 27.0 × 31.7 cm. National
Gallery of Art, Washington, D.C.,
Rosenwald Collection (B-19567).

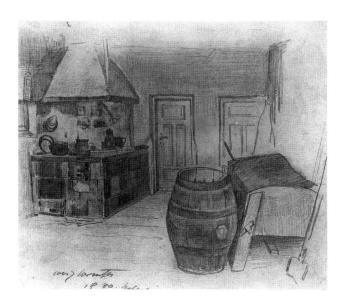

toward a compositional center that is reinforced by the shadow under the roof at the left and the repeated diagonal roof lines on the right. The careful execution suggests that the drawing may have been intended for one of the academy-sponsored competitions usually held at Christmas time, when outstanding portrait and figure studies and landscape drawings were selected for special awards.

Other works from Corinth's early student years are more specifically indebted to Günther's example. It did not take much persuasion to make the budding artist seek his inspiration in the East Prussian countryside, familiar as he was with the life and customs of the local peasants. He drew two barn interiors (Fig. 5), one occupied by horses, the other by cows, during a visit to his aunt and uncle's farm in Moterau in 1879. The signature and the incorrect date of 1883 are later additions; the lower half of the drawing was in fact a study for a small painting of a cow barn (B.-C. 2) dated 1879. *Kitchen Interior* (Fig. 6), drawn the following year when Corinth was back in Moterau painting portraits of his uncle and aunt (B.-C. 5, 6), like *The Barn*, lacks spontaneity. The awkwardly diffident style of both drawings typifies this stage in Corinth's development. The individual objects and forms are cautiously circumscribed by reinforced contours; hatching and crosshatching indicate modeling. Delicate modulations, partly exploring the grainy texture of the paper, unify the composition, whose pervasive tonality resembles that of Günther's

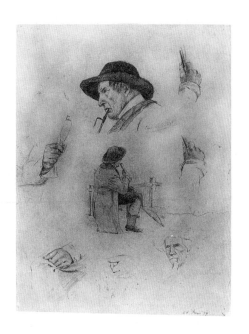

FIGURE 7.
Right: Lovis Corinth, *Seated Peasant and Other Sketches*, 1877. Pencil, 26.1 × 20.0 cm. National Gallery of Art, Washington, D.C., Rosenwald Collection (B-19571).

FIGURE 8.
Opposite: Lovis Corinth, *Portrait of a Man*, 1879. Oil on canvas on panel, 39.5 × 31.0 cm, B.-C. 3. Hamburger Kunsthalle, Hamburg (2630). Photo: Ralph Kleinhempel.

dusky interiors. The drawing of a seated peasant (Fig. 7), dated June 26, 1877, more specifically suggests the figures that inhabit Günther's genre paintings. Here the fastidious drawing method is evident in the repeated sketches of the hands and in the portrait sketch in the upper center of the sheet, where the textures of hat, face, and shirt collar are all carefully distinguished.

The same attention to detail is found in the few paintings that survive from Corinth's years at the Königsberg Academy. They consist of a forest interior (B.-C. 1) conceived in the manner of Buchholz, the *Cow Barn* (B.-C. 2) already mentioned, and four portraits, including the ones he painted of his uncle and aunt in Moterau—all from the last two years at the academy. The small painting in Hamburg of an unidentified man (Fig. 8) exemplifies these early studies in oil. The averted gaze and inanimate expression indicate that Corinth grasped the sitter's image primarily in its characteristic form and appearance; the extreme close-up view allowed him to explore physiognomic details fully. The modeling is smooth and reveals a thorough understanding of the interaction of facial muscles and bone structure.

Corinth's studies in Königsberg ended abruptly in the spring of 1880 when Günther resigned from the academy. From the beginning Günther's popularity had irritated his colleagues, and as his following continued to grow, they accused him of catering to the school's best students to gain the coveted position of academy director. Rather than endure such strife, he decided to return to the Weimar Academy, but not without assuring his devoted students of the best possible further training. Some followed him to Weimar; others went to Berlin. Corinth, on Günther's recommendation, was admitted to the studio of the celebrated Franz von Defregger at the academy in Munich.

> The walls of Munich are covered with frescoes as with wallpaper upon which are painted red, blue, green, yellow, and rose-colored robes, . . . silk stockings, riding boots, and doublets. Here is a king who takes an oath, there is a king who abdicates, and still another who signs a treaty, . . . this one gets married, that one dies. . . . And sculpture! It is unbelievable! One can easily count three thousand statues in the city. They all look alike. . . . [But] the young people of Munich amount to something. This is why I stayed so long. They are firmly determined to let go of the old bric-a-brac, and I have seen young painters spit when the conversation turned to the so-called princes of German art.[21]

Thus Gustave Courbet, in a letter to his friend Castagnary dated November 20, 1869, summed up his impressions of the Bavarian capital. The French painter had just returned from the city's first major international exhibition, which included some of his paintings along with those of Manet, Corot, and several leading exponents of the Barbizon school. Despite the widespread criticism of the "social" implications of his picture *The Stonebreakers* (1849; formerly Staatliche Gemäldesammlungen, Dresden), he was awarded Munich's highest distinction, the Order of Saint Michael First Class. Considering that the exhibition included nearly 4,500 works from all parts of Europe, Courbet's success was no mean feat and remains a credit to the perceptive jury. That he could both mock Munich as a stronghold of history painting and gain recognition there for his achievement indicates how the 1869 exhibition pitted opposing tendencies against each other: the dazzling historical reconstructions typical of Piloty and his followers and the visual immediacy that distinguishes not only Courbet's work but also the candid pictures of Wilhelm Leibl, whose sensitive *Portrait of Frau Gedon* (1868–1869; Staatliche Gemäldesammlungen, Neue Pinakothek, Munich) was included in the show. In its execution Leibl's picture resembles contemporary paintings by Manet. Yet Courbet, who considered this portrait the best German work in the entire exhibition, was no doubt thinking of Leibl when he wrote to his parents, "The young people [of Munich] paint exactly the way I do."[22]

The development of German and specifically Munich painting might have been radically altered had there been an immediate sequel to the exhibition. For there is no question that by 1869 Paris and Barbizon had seriously challenged Rome as the mecca for German painters. Between 1760 and 1840 more than three hundred German artists had studied in the French capital.[23] Although most were from Berlin, the Bavarian contingent had increased stead-

ily since about 1815. Just prior to 1869 the Munich landscape painter Adolf
Lier worked with Jules Dupré, and in 1868 Hans Thoma and Otto Scholderer
were in touch with the Barbizon painters and Courbet. Henri Fantin-Latour
paid special homage to Scholderer when he included him among Manet's
friends in the historic group portrait *A Studio in the Batignolles Quarter* (1870;
Musée d'Orsay [Galeries du Jeu de Paume], Paris). Leibl, who formed a close
friendship with Courbet during the 1869 exhibition, also accepted an invita-
tion from the painter Henriette Browne (Sophie de Saux) to visit Paris in No-
vember of the same year. Unfortunately, the outbreak of the Franco-Prussian
War forced him to return home after only nine months. Many years were to
pass before a similarly congenial exchange between artists of the two coun-
tries could be resumed.

The art-loving public, even after the 1869 exhibition, continued to prefer
historical concoctions to works based on direct experience. Purely pictorial
problems like those emphasized by Leibl elicited little interest during the
"Gründerzeit," or boom period, of the 1870s and 1880s. Far more popular
were the spectacular works by Piloty and the Austrian Hans Makart, whose
name has become especially associated with these vainglorious years. He and
his friends Franz von Lenbach and Friedrich August von Kaulbach enjoyed
unprecedented financial success while Leibl and the painters of his circle had
little following. Indeed, Leibl left Munich in 1873 and spent the rest of his life
in the small villages of Upper Bavaria.

When Corinth arrived in Munich, painting there was dominated by two
trends. The retrospective tendencies of the Piloty school were vigorously
championed by Lenbach while many younger artists followed the painters in
Wilhelm von Diez's circle. Lenbach's worship of gallery tones and his stereo-
typing of chiaroscuro effects borrowed from Titian, Rembrandt, Velázquez,
and Van Dyck made him the natural spokesman for reaction. Diez, though
not especially innovative himself, encouraged his students to become inde-
pendent. Largely self-taught, he was an outstanding draftsman and illustrator
in the tradition of Adolph von Menzel and a fervent admirer of the Dutch
genre painters of the seventeenth century, whose works he had studied in the
Alte Pinakothek. The narrative talent that made him a fine illustrator also
determined his choice of motifs as a painter. Diez is still best known for his
scenes from the time of the Thirty Years' War and the wars of the French
Revolution. But his paintings, unlike Piloty's elaborate historical reconstruc-
tions, celebrate the unsung heroes on the periphery of the action, boisterous
freebooters, camp followers, and peasants. Diez's studio, the most popular at
the Munich Academy, attracted men as dissimilar in talent and temperament

as Leibl's friend Wilhelm Trübner; Max Slevogt; Fritz Mackensen, who later helped to found the Worpswede painters' colony; and the future theorist of the Dachau school, Adolf Hölzel, who eventually became one of the most important teachers of twentieth-century German art.

Franz von Defregger (1835–1921), whom Günther had suggested as Corinth's next teacher, had been Piloty's student and continued to work in the spirit of the aging but still influential master. He was especially famous for a type of "historical" genre painting he himself had invented. His earliest work in that genre—the one that originally established his reputation—is *Speckbacher and His Son Anderl* (Museum Ferdinandeum, Innsbruck), painted in 1869, the first in a series of pictures illustrating episodes from the Tyrolean Peasant Wars of Liberation of 1808–1810. When Corinth came to study with him in the summer of 1880, Defregger was hard at work on *The Storming of the Red Tower* (1881; Staatliche Gemäldesammlungen, Neue Pinakothek, Munich), a lively multifigure composition depicting an event from the War of the Spanish Succession of 1701–1714. Besides these historical subjects Defregger also painted a great deal of peasant genre, idealized pictures of life in the villages of his native Tyrol that have much charm and a folksy wholesomeness that suggests none of the drudgery and hardship of everyday rural existence. His romanticized conceptions, with their lively characterizations and authentic milieus, made him the most popular peasant painter in Munich in the 1880s and 1890s.

Corinth had become familiar with the range of Defregger's work in Königsberg, where the municipal gallery owned one of Defregger's pictures of Tyrolean poachers and, in 1879, had acquired a major painting from the Tyrolean Peasant Wars cycle, *Andreas Hofer on the Way to His Execution* (1878). Defregger was clearly well suited to rekindle Corinth's love for history painting without disturbing the reverence for nature that Günther had fostered in his students, and Günther's suggestion that Corinth continue his studies with the Munich painter must have seemed logical.

As it turned out, however, Defregger thought Corinth needed more experience in painting and suggested he make up the deficiency elsewhere. Thus Corinth remained in Defregger's studio for less than six months, entering the atelier of Ludwig von Löfftz (1845–1910), another much-sought-after teacher at the Munich Academy and one of Wilhelm von Diez's former students, in October 1880. For his own pleasure Löfftz painted fresh and spontaneous landscapes and interiors. In public showpieces like *Christ Lamented by the Magdalene* (Fig. 9), on which he labored for five years, however, he concentrated on meticulous modeling. In his teaching, too, he emphasized the accurate repro-

duction of each nuance of light and shade, usually to the detriment of color. According to Corinth, the models in Löfftz's studio were expected to pose for months on end:

> Especially favored were old models or those who no longer had any fresh skin tones. "Ruins of mankind," we used to call them. We scrutinized their faces and tried to render them in shades of grayish green. We called such works "good in tone." Löfftz came and gave his approval whenever a student had worked in his beloved manner. "Very good in tone," he would say, or "two more years with me, and you will be an artist."[24]

Corinth painted two portrait studies of old women (B.-C. 7, 8) in this context in 1882. His recollections are corroborated by Karl Stauffer-Bern, a Swiss who studied with Löfftz in 1879 and 1880. Stauffer-Bern criticized Löfftz's excessive emphasis on modeling in a letter to his parents, March 20, 1880:

> One gets somewhat intimidated by this and does not dare to make a sponta-neous effort. . . . Surely, it also has an advantage, since one learns to pay very close attention to modeling, which otherwise is often neglected. Still, I believe that color should not be passed over lightly. In my study of that woman I was well on my way to losing the color altogether as I continually subdued the tone toward gray.[25]

Löfftz apparently demanded strict discipline and accepted only students who convinced him of their commitment to their work. Stauffer-Bern praised Löfftz as a dedicated teacher:

> Each time he corrects, one can tell that one has learned something. . . . He com-pletely sacrifices himself for his students, and I think his efforts are not wasted. We will hardly ever finish that nude, but I believe that we have learned a great deal by working on it and that once again we have made considerable progress.[26]

The nude that Stauffer-Bern referred to was a "crucified Christ" on which he and his fellow students worked "relentlessly."[27] Three drawings in an early sketchbook by Corinth, preserved in Kiel, suggest how common such an assignment was in Löfftz's studio: one is a nude Saint Sebastian, his up-raised hands fastened to a tree; the others are "crucified" male nudes, one a preliminary study for the 1883 painting *Crucified Thief* (Fig. 10). The drawing,

FIGURE 9.
Above: Ludwig von Löfftz, *Christ
Lamented by the Magdalene,* 1883. Oil on
canvas, 114.7 × 191.5 cm. Bayerische
Staatsgemäldesammlungen, Neue
Pinakothek, Munich (7723).

FIGURE 10.
Right: Lovis Corinth, *Crucified Thief,*
1883. Oil on canvas, 180 × 80 cm, B.-C.
10. Private collection, Bochum.

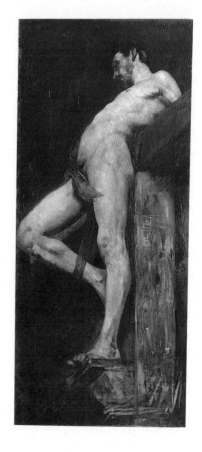

an example of the *mise en place* of French ateliers, typifies the clarifying life studies by nineteenth-century art students, who tried to unify human anatomy with a "line of action."[28] That Corinth's project originated in the classroom is even more evident in the painting than in the drawing. The complicated posture, particularly difficult to render in a foreshortened close-up seen from below, was clearly intended to present the student with pictorial problems to master in a life-size format; the theme itself was unimportant. The religious title was merely that suggested by the model's pose. Corinth painted the figure exactly as he saw it, including such awkward studio props as the footrest and the supporting strap around the right leg. Set off against the dark, opaque ground, the flesh parts are carefully modeled so as to register the slightest gradations of light and shade.

Löfftz's influence is also evident in the portrait Corinth painted of his father (see Plate 1) during a visit to Munich. Nearly life-size, it is the earliest large-scale portrait by Corinth that has survived. Touches of color, sparingly applied, enliven the pervasive grayish brown tonality of the picture. The modeling carefully explores the texture of the face and hands. There are technical flaws, such as the sitter's awkward position, which flattens him, and his unresolved relation to his surroundings. He sits not in a defined space but in front of an undifferentiated pictorial ground. Corinth's superior conception, however, more than compensates for these weaknesses, setting this painting apart from his earlier portrait studies. His attention to texture, here extended to the wineglass and rose on the corner of the table, speaks of efforts to render the characteristic material manifestation of each form. But it is also evident that the harmonious relationship between father and son and their mutual trust allowed the young painter to temper his fastidious technique with empathy. Franz Heinrich's physical proximity to the picture surface suggests a correspondingly close spiritual accord between father and son. His relaxed posture and patient expression testify to the love and confidence the two men shared.

That Corinth responded most empathetically to sitters he knew is confirmed by the eloquent self-portrait drawing of 1882 (Fig. 11). The drawing is surprising from a technical point of view, for it anticipates the forceful manipulation of the graphic medium that became typical of Corinth's more mature work; it is also his first self-portrait to emphasize keen characterization over physiognomic truth. The rugged features, for instance, belie Corinth's youth: he was no more than twenty-four years old when he made the drawing. The face rises darkly from a broad base of erratic lines that rapidly circumscribe the sketchbook, hand, and shoulders. The uneven hatchings ac-

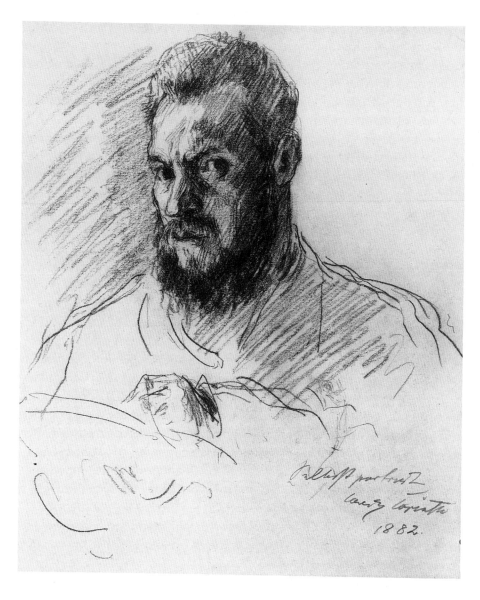

FIGURE 11.
Lovis Corinth, *Self-Portrait*, 1882.
Crayon, 30.9 × 25.9 cm. Staatliche
Museen, Berlin (DDR) (36/946).

centuate the forms revealed by the harsh light illuminating the face from the left. As in the self-portrait from 1873 (see Fig. 1), Corinth commands the viewer's attention by the sheer force of his gaze. Yet the glowering stare reveals an impassioned defiance only implied in the earlier drawing, in which the fastidiously groomed youth looks at us with vigilant apprehension. Corinth drew the later self-portrait as if in a state of barely contained agitation, with his hair and beard disheveled and unkempt. In none of his earlier works had he achieved a comparable unity of expressive content and form. Many years later Corinth would tell his own students that the artist's "passion to get to know himself . . . makes the self-portrait the favored means of study of any painter."[29] His own predilection for self-analysis explains why the 1882 self-portrait is one of his most independent and revealing works.

No other work from Corinth's student years in Munich shows the same freedom from academic conventions as this self-portrait. Indeed, Corinth remained largely untouched by trends outside the academy. For example, although he knew Wilhelm Trübner's paintings from the weekly exhibitions sponsored by the Munich Artists' Association in the Hofgarten arcades, Trübner's rich colorism and lively brushwork made no impression on him. If anything, as he later admitted, Trübner's work thoroughly bewildered him at this time.[30] He was certainly familiar with plein air paintings by Max Liebermann and Fritz von Uhde, for both artists were represented by major works at the international exhibition held at the Munich Glass Palace in 1883. The two outdoor scenes that Corinth painted the same year (B.-C. 15, 16), however, constitute no more than a minor effort to become engaged in similar pictorial problems. Instead, he admired Georges Rochegrosse's vividly depicted slaying of the Roman emperor Aulus Vitellius (1882; Musée Municipal, Sens), which was also included in the 1883 exhibition. And he borrowed outright the melancholy chiaroscuro of Jozef Israëls's *The Widower* (1880; Rijksmuseum H. W. Mesdag, The Hague) along with Löfftz's tonal manner when he painted *The Conspiracy* (Fig. 12) in 1884, emphasizing the descriptive and expressive function of the light that enters the dusky room through cracks in the shutter. The painting is highly ambitious not only in scale but also in Corinth's mastery of the pictorial space. Unlike the figures in Corinth's earlier portraits, the three men in the 1884 painting occupy a defined interior. Corinth's sense that one of his chief tasks in painting the picture was to articulate the interior space is evident from the calculated means he used to achieve this goal: reinforced by the *repoussoir* of the large dog in the foreground, the four chairs, standing at right angles to each other, serve as the primary space-defining

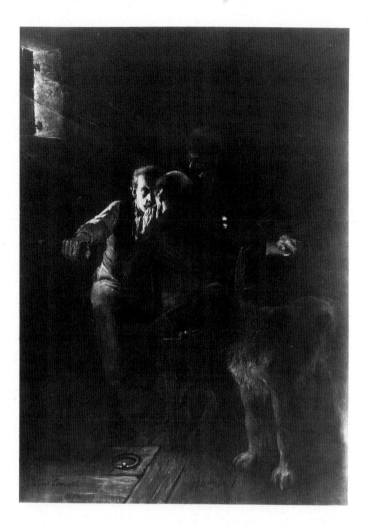

FIGURE 12.
Lovis Corinth, *The Conspiracy*, 1884.
Oil on canvas, 150 × 110 cm, B.-C. 17.
Present whereabouts unknown. Photo:
Bruckmann, Munich.

elements. Apparently Corinth invested the painting with a specific anecdotal content only after completing it. In short, like the *Crucified Thief* of the preceding year, *The Conspiracy,* originally entitled "The Black Plot," is still a typical student work. Nonetheless, Corinth was sufficiently satisfied with it to send it to London for exhibition.

Early in 1884 Corinth's relationship with Löfftz seems to have deteriorated, and Corinth hurried to leave Munich. Initially he thought of going to Paris, but he dreaded the French hostility toward German visitors that followed the Franco-Prussian War. Rumor had it that a German artist wishing to get ahead in Paris would do well to deny his nationality.[31] This rumor is confirmed by the somewhat earlier experience of Max Liebermann, who lived in Paris and Barbizon from 1873 to 1878. Liebermann had a studio in Montmartre in the building where Viscount Ludovic-Napoléon Lepic—perhaps best known from Edgar Degas's 1873 painting of him and his two daughters—also had an atelier. Lepic wanted to introduce Liebermann to several French painters, including Edouard Manet, but was forced to abandon his plans when these painters resisted even the suggestion that they might share a café table with the German. Liebermann had arrived in Paris with two letters of introduction, one addressed to the Belgian painter Alfred Stevens, the other to Léon Bonnat. Bonnat received him coolly and on a second visit, only slightly more gracious, advised him bluntly: "Make the small sacrifice of having yourself naturalized, and you will be one of us." Ignoring the suggestion, Liebermann nonetheless managed to exhibit regularly at the Salon from 1874 onward, though a critic that year commented angrily that in return for the privilege the painter should have relinquished his German citizenship. To this critic it seemed "a crime to perform Richard Wagner in France and to admit Prussians to our exhibitions." As late as 1882, Liebermann, having joined the Cercle des XV, avoided its meetings so as not to provoke hostile sentiments.[32]

Against this background it is perhaps not surprising that Corinth decided instead to go to Antwerp. Some of his friends in Munich had suggested that once there, he should get in touch with a young Belgian painter named Paul Eugène Gorge. Little is known about Corinth's sojourn in Antwerp, and it seems that in later years he did not even want to be reminded of the experience. He writes in his autobiography that he came to dislike the city after about three months and found the people he met through Gorge incompatible—probably because "they belonged to a different nation," and "the genuine East Prussian simply does not mix with strangers."[33] Only for Gorge did he reserve a special word of praise, calling him a man of "charm and pure character."[34]

Paul Eugène Gorge (1856–1941), a graduate of the Antwerp Academy, was affiliated with the artists' group Als Ik Kan, founded in October 1883 by a number of Antwerp painters, including the young Henry van de Velde. Con-

ceived as an artists' cooperative to further opportunities in the art market, Als Ik Kan was not avant-garde but conservative and traditional in outlook, as the group's name, taken from Jan van Eyck's famous motto, implies.[35] Gorge, for instance, about whom little else is known, painted landscapes and interiors in soft grayish tones. His work shows the influence of Charles Mertens's early paintings, which reflect the meticulous naturalism of Henri de Braekeleer. The artists Corinth met through Gorge were most likely associated with Als Ik Kan. He may also have been aware of the more adventurous efforts of Les Vingt, who held their first exhibition in Brussels in 1884, but in any event he was not impressed by what he saw of contemporary Belgian painting.

By 1884, Corinth later said, "the time of Rubens and Brouwer and the history painters Gallait, Verlat, and Leys was over."[36] He was not entirely correct. Charles Verlat still taught at the Antwerp Academy in 1884 and was not appointed director of that institution until 1887. His advocacy of a native tradition in painting in fact set the tone for the organization Als Ik Kan until the early years of the twentieth century.[37] Though colored by negative feelings, Corinth's comment reflects his own early admiration for nineteenth-century history painting. It also suggests that he engaged in more than a fleeting dialogue with the leading masters of the Flemish baroque. Although he knew paintings by Rubens and Jordaens from the collection in the Alte Pinakothek, only on Flemish soil did these masters begin to inspire him. The four paintings he completed in Antwerp all show a marked increase in colorism and a freer handling of the paint.

In the portrait of Paul Eugène Gorge (Fig. 13) Corinth juxtaposed the grayish blue of the background with the sitter's ruddy complexion and blond hair. The paint has been applied in fluid strokes, accentuating the contrasts of light and shade engendered by a strong source of illumination just outside the picture to the sitter's left. Gorge's posture is casual and relaxed. His gentle gaze gives credence to the purity of character Corinth admired in him, which helped to forge a lasting friendship between the two men.

Still more vigorous, in both execution and expression, is Corinth's painting of a black man (see Plate 2), poetically inscribed "Un Othello" in the upper right. The shirt, painted with a broad, loaded brush in stripes of red and white, stands out boldly against the grayish black ground. The subtle turn of the torso and the figure's close proximity to the picture frame reinforce the impression of immediacy conveyed by the energetic brushstrokes. Despite the literary allusion of the title, the portrait is no more than a character study, possibly of a sailor from the Antwerp harbor; it compares favorably with Rubens's similarly sympathetic studies of foreign sailors. Although it has been widely as-

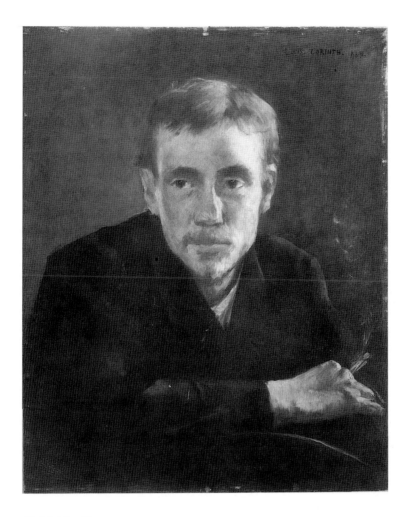

FIGURE 13.
Lovis Corinth, *Portrait of the Painter Paul
Eugène Gorge*, 1884. Oil on wood, 56 × 46
cm, B.-C. 22. Von der Heydt-Museum
der Stadt Wuppertal, Wuppertal-
Elberfeld. Photo: Studio van Santvoort.

sumed that Corinth was directly inspired by Rubens's and Jordaens's paintings of blacks,[38] it is unlikely that he knew these works at this time since they were not on public view. The sensitive conception that the painting shares in particular with Rubens's oil sketches must simply be accepted as a case of parallelism. Wilhelm Trübner's pictures of black men, painted in 1872 and 1873, might have served as iconographic precedents. Although Corinth did not mention seeing these until many years later,[39] they could have been among the works he had pondered at the weekly exhibitions of the Munich Artists' Association in the early 1880s. But even then Corinth's portrait remains highly original, differing markedly in its forthright naturalism from Trübner's predominantly anecdotal approach.

Although Corinth spent his last month in Antwerp in the congenial company of his father, his dislike for the city continued to grow. To make matters worse, when he submitted to an exhibition in Brussels a painting for which he had entertained great hopes, it was rejected by the jury. In 1917 he still remembered his disappointment acutely. "Out of revenge," as he put it, he eventually overpainted the picture with a kitchen still life (B.-C. 68) because it continued to remind him of the rejection.[40] Fortunately, news reached him at about this time that *The Conspiracy,* which he had sent to London, had been awarded a bronze medal. When he later referred to the painting as his "fledgling work,"[41] he was no doubt thinking of this, his first public recognition. The unexpected success apparently gave Corinth the confidence he needed to conquer his fear of the hostile French, for he quickly determined to leave Antwerp and to continue his studies in Paris after all.

AT THE ACADÉMIE JULIAN

Corinth arrived in Paris in early October 1884 and enrolled in the Académie Julian. Founded in 1868 by Rodolphe Julian, a minor painter who exhibited at the Salon des Refusés in 1863 and several times between 1865 and 1878 at the Salon proper, the Académie Julian was not an academy in the traditional sense but a place where students could draw and paint from the live model and profit, if they so desired, from an informal weekly critique. Although Julian had originally opened the school to prepare students for the prestigious Ecole des Beaux-Arts, by the early 1880s the two schools had become rivals. The Académie Julian was especially popular among students from abroad, even though they paid tuition there whereas study at the Ecole des Beaux-Arts was tuition free. Because the *école* was unable to admit all ap-

plicants—and because French taxpayers resented financing the training of foreigners—the Ministry of Fine Arts required foreign applicants to take a French language test so rigorous that only a few managed to pass it. Julian, by privately engaging teachers from the Ecole des Beaux-Arts, including such famous *pompiers* as Adolphe Bouguereau, Tony Robert-Fleury, Gustave Boulanger, and Jules Lefebvre, helped foreign artists to circumvent the language test: on payment of hard cash, they could study under the *école*'s leading masters without having to be admitted to the school itself. Moreover, because the "visiting professors" were usually also on the Salon juries, Julian's students stood to benefit substantially when they submitted their entries for acceptance to the annual Salon exhibitions.

Besides foreigners, the student body included young painters who rejected the *école* on principle and availed themselves of Julian's facilities because they could draw and paint there without much interference. Even at Julian's some of these students defiantly turned their paintings to the wall when the teachers came to offer their critiques. Many older artists kept returning to the Académie Julian because there they could count on having professional models to work from. According to one observer, only at Julian's did one find that "unique flesh, hearty and fair, with that particular touch of a supple glimmer."[42]

Julian's enterprise turned out to be highly successful. He eventually opened branch academies throughout Paris, including several studios for women. Over the years the foreigners at Julian's included the Russian Marie Bashkirtsev; the Englishman George Moore; the Swiss Félix Vallotton, Cuno Amiet, and Giovanni Giacometti; the Spaniard Ignacio Zuloaga; and the Finnish painter Aksel Gallén-Kallela. Among the Germans were Ludwig von Hofmann, Max Slevogt, Ernst Barlach, Georg Kolbe, Emil Nolde, Käthe Kollwitz, and Paula Modersohn-Becker. The better-known Frenchmen who attended the Académie Julian include Paul Sérusier, Pierre Bonnard, Edouard Vuillard, Maurice Denis, Paul Ranson, Henri Matisse, André Derain, and Fernand Léger.

Each of Julian's branch academies consisted of a group of hot, airless rooms crowded with noisy students whom a *massier*—a senior student responsible for sundry tasks in the atelier—was expected to restrain from the most flagrant disorder. The walls of some studios were covered with palette scrapings and caricatures; others, more decorous, were adorned with framed student drawings; still others displayed signs with such famous pronouncements by Ingres as "Le dessin est la probité de l'art," "Cherchez la caractère dans la nature," and "Le nombril est l'oeil du torse."[43]

Corinth attended the "little studios" at 48, Faubourg Saint-Denis, where his teachers were Adolphe Bouguereau (1825–1905) and Tony Robert-Fleury (1837–1911). On his arrival he was greeted with deafening noise, followed by caustic remarks intended to unnerve a newcomer. Troubled by the attention, Corinth thought it wise to keep his East Prussian origins a secret and responded to his fellow students' insistent questioning about his background and training by implying that, having studied in Munich, he was a "Bavarois." He was formally initiated into the group at an "altar" of atelier stools quickly set up for the occasion, a ceremony recorded in an old photograph.[44] A few days later he was sketched in caricature on the studio wall in the uniform of a Bavarian soldier against a red background and with bloody hands. The pithy inscription under it, "Quand même" (in spite of everything), indicated that for his French fellow students he was still a German.[45] As it turned out, however, Corinth got along well with everyone, partly, it seems, because his massive build and unmistakable physical strength commanded respect. Yet le gros Allemand, as he was called, never formed a real friendship with any of the French students. Nor did he ever mention Gallén-Kallela, who studied at Julian's at the same time. His closest acquaintances included another East Prussian, Franz Lilienthal; the Bavarian Ludwig von Zumbusch; and four young Swiss painters—Emil Beurmann, Louis Calame, Emil Dill, and a fellow from Zurich named Blaas. In his memoirs Corinth disguised the identity of his friends: Zumbusch is von Sambitsch, Lilienthal is Blumenthal, and Beurmann is probably the Swiss Mauerbrecher. Dill, Calame, and Blaas are not mentioned, although the latter two are commemorated in portrait drawings.[46]

Corinth made up his mind to remain in Paris for at least three years "to learn whatever there was to be learned";[47] even after eight years of study in Königsberg and Munich he apparently believed he could progress further only at still another academy. Moreover, he resolved to return to Germany only when he had distinguished himself at the Salon.

Although he was in Paris, Corinth remained unfamiliar with the works of the French Impressionists. He arrived too late for the memorial exhibition of Manet at the Ecole des Beaux-Arts, although he was in time for the next show, the large retrospective held in 1885 for Jules Bastien-Lepage, whose pseudo-impressionist brushwork and diluted colors may have embodied for Corinth the latest word in French modernism. On his frequent visits to the fashionable galleries of Georges Petit, a veritable sanctuary of academic art, Corinth admired the fabulous naturalism of Meissonier,[48] but since he spent the summer of 1885 vacationing in the Black Forest and that of 1886 on the Baltic seacoast near Kiel, he missed Monet's and Renoir's paintings at Petit's

fourth and fifth *expositions internationales.* Most likely Corinth encountered Impressionism only in the extreme form of Neo-Impressionism when in December 1884, seemingly by chance, he walked into the Salon des Indépendants,[49] where he saw works by Seurat, Signac, Guillaumin, Cross, and others, including a landscape sketch of the island of La Grande Jatte, a first study for Seurat's large painting.

Corinth's unfamiliarity with Impressionism is not really astounding, for French hostility toward German artists in Paris seems to have fostered a provincialism that did much to exclude them from the inner circles of the then developing avant-garde. Max Liebermann's earlier experience in Paris and Barbizon from 1873 to 1878 was similar,[50] although he must have known of the Impressionists, especially since Lepic participated in the first historic exhibition at Nadar's in 1874 as well as in the second Impressionist show in 1876.

Corinth, at any rate, craved the recognition only the Salon could confer. Having determined to remain in Paris until he had exhibited something at the Salon and possibly won at least a *mention honorable,*[51] Corinth found his inspiration in the Louvre and in the Musée du Luxembourg, then the repository of important works that the French state had acquired from the country's leading academicians. The Académie Julian, too, seemed to offer a road to success. Corinth took particular pride in having peers like René Ménard and Etienne Dinet in the studio; both men were already *hors concours,* having sufficiently distinguished themselves so as not to require prior approval to exhibit their works at the Salon. And he was especially delighted to discover that the young history painter Georges Rochegrosse, whose painting of the slaying of Aulus Vitellius he had admired in Munich in 1883, was working in the neighboring studio of Boulanger and Lefebvre.[52]

Robert-Fleury's impact on Corinth's development is difficult to measure. In the course of his weekly critiques Bouguereau, however, soon developed a liking for *le gros Allemand* and after the success of *The Conspiracy* in London, saw that the painting was accepted at the Salon of 1885. Corinth rejoiced at this auspicious development. He wrote in *Legenden aus dem Künstlerleben:*

> In all of Paris there was no one happier than the East Prussian Heinrich Stiemer [Corinth's pseudonym]. He was strutting around like a dandy and intended to get himself a genuine Parisian suit. He stopped in front of every shop to see what else he might buy; . . . each window reflected his massive figure in an entirely new light. "This then is the way a man looks on his first step to fame," he kept telling himself. He was sure now that he would catch up with that fellow Rochegrosse. That no longer worried him.[53]

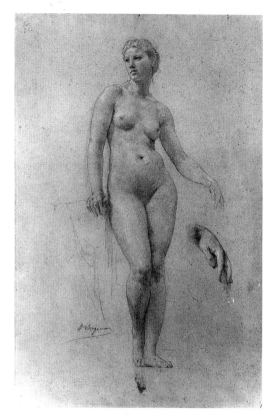

FIGURE 14.
Adolphe William Bouguereau, *A
Nude Study for Venus,* c. 1865. Pencil
heightened with white, 46.2 × 30.3 cm.
Sterling and Francine Clark Art Institute,
Williamstown, Massachusetts (1578).

In his autobiography he wrote that acceptance at the Salon seemed "a prom-
ise for my art in the future . . . that everything would turn out in the best
possible manner."[54] Unfortunately, his painting was displayed near the ceil-
ing. It hung so high that it seemed to him no bigger than a postage stamp—
and apparently had as little effect on the public and the critics.

Of the twenty pictures Corinth is known to have painted in Paris, no fewer
than fifteen are devoted to the nude human figure—a considerable increase
over the two nudes he had painted during his preceding eight years of study,
the *Crucified Thief* (see Fig. 10) and a half-length female nude (B.-C. 11), ap-
parently also done in Löfftz's studio in 1883. The comparatively large number
of nudes from Paris is not surprising, considering the emphasis at the Aca-
démie Julian on working from the live model. According to Hermann Schlitt-
gen, who studied briefly with Lefebvre in 1886, "If the better works reminded
one of anybody, it was Ingres. . . . to represent the nude figure as correctly as
possible . . . was the goal of everyone."[55]

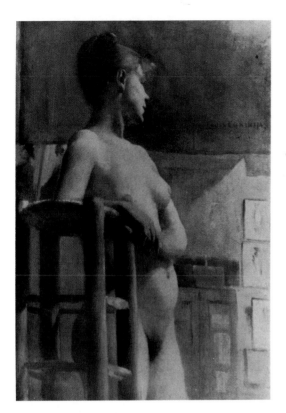

FIGURE 15.
Lovis Corinth, *Female Nude at Atelier Stool*, 1886. Oil on canvas, 73 × 50 cm, B.-C. 29. Present whereabouts unknown. Photo: after Bruckmann.

The nude was not only the focus of the curriculum at Julian's but also an important element in the oeuvre of Bouguereau, whose reputation rested on such a vast gallery of bathers and nymphs that some critics facetiously claimed he kept a studio of nudes the way others ran brothels.[56] Bouguereau continued the tradition of David and Ingres, except that he popularized the severe style of his predecessors by endowing his nudes with greater erotic appeal, an effect he achieved by allowing his models to retain a distinctly "real" look. The preparatory study for Venus (Fig. 14), one of the figures in the monumental ceiling decoration in the concert hall of the Grand-Théâtre in Bordeaux, is typical of Bouguereau's skillful combination of realism and idealization. The head is that of a contemporary woman; the body, however, is exactly eight heads tall, four each above and below the pelvic region.

Corinth's female nude of 1886 (Fig. 15) is one of several of his pictures that exemplify the careful observation of the human figure Schlittgen described. But in his drawings he generally moderated this factual approach by emulating

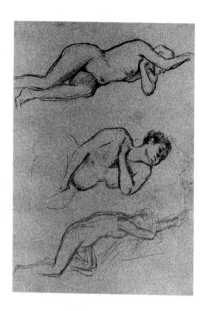

FIGURE 16.
Right: Lovis Corinth, *Three Studies for a Reclining Female Nude,* c. 1884–1886. Charcoal and pencil, 44.7 × 29.5 cm. Kunsthalle zu Kiel. Photo: Horst Uhr.

FIGURE 17.
Opposite: Lovis Corinth, *Reclining Female Nude* (Study for *Jupiter and Antiope*), c. 1885. Pencil, 29.5 × 44.7 cm. Kunsthalle zu Kiel. Photo: Horst Uhr.

Bouguereau's more agreeable style. Indeed, Bouguereau specifically encouraged Corinth to attend to his draftsmanship when he offered the criticism "Ce n'est pas mal, mais ce n'est pas bien dessiné"—an admonition Corinth never forgot.[57] Three drawings on folio 23 verso in the sketchbook in Kiel (Fig. 16) illustrate Corinth's efforts to idealize the figure of a reclining female nude. The rapid sketch at the bottom of the page is followed by a rendering in the center in which the figure's contours are indicated more specifically without suppressing the model's ample forms. In the uppermost drawing the body of the nude is charted once again in successive contours, but this time a reinforced outline reduces the awkward curvature of hip and shoulder to a smoothly flowing rhythm that gives continuity and greater refinement to the model's fleshy forms. In some drawings Corinth tried to work out a system of proportions like the one Bouguereau had used for the figure of Venus. In others, such as the study of a reclining female nude on folio 24 recto of the Kiel sketchbook (Fig. 17), he employed hatching and crosshatching and the alternative method of the *estompe* to give the figure added relief. The generally untidy execution, Corinth's inability to render the interplay of the limbs convincingly, and his consistent avoidance of such complex anatomical details as hands and feet confirm that Bouguereau's criticism was well founded.

This drawing, incidentally, calls attention to a practice popular among the French *pompiers.* By rapidly outlining a crouching male nude in the back-

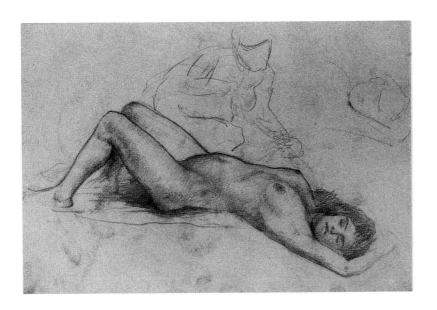

ground, Corinth transformed the original study of the live model, almost play-
fully, into a mythological composition. The mundane Parisian model has be-
come Antiope about to be surprised in her sleep by Jupiter, who approaches
in the guise of a satyr. Paintings of the nude had this particular advantage
of being easily "finished" for the Salon by the addition of a few anecdotal
details. Cabanel's famous *Birth of Venus* (1863; Musée d'Orsay, Paris) and
many a naiad by Jean-Jacques Henner are no more than paintings of nude
models in which minimal accessories supply the requisite iconographic con-
text. They are descendants of Ingres's *La Source* (1856; Musée d'Orsay, Paris)
and belong to a seemingly endless line of nudes shown at the annual Salons
with predictable success. Both Löfftz's *Christ Lamented by the Magdalene* (see
Fig. 9) and, as already noted, Corinth's own *Crucified Thief* (see Fig. 10) bear
witness to the widespread popularity of this approach, although probably
nowhere outside Paris was the custom pursued with the same verve. Bougue-
reau's painting of the Oreads (1902; private collection, Paris), which contains
more than thirty-five such nudes, may be the most extreme example of this
practice. Corinth, possibly inspired by Ingres's 1851 painting of the subject
(Musée d'Orsay, Paris) as well as by Titian's problematic composition in the
Louvre, the so-called *Pardo Venus* (c. 1535–1540/c. 1560), devoted at least six
more pencil studies as well as an oil sketch (B.-C. 28) to the subject of Jupiter
and Antiope. This composition may be related to the painting of a life-size

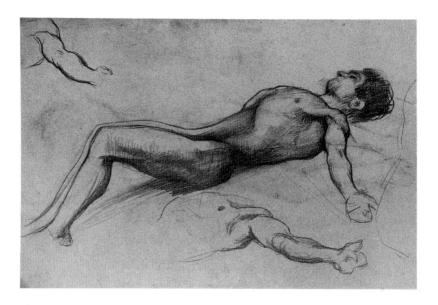

FIGURE 18.
Lovis Corinth, *Recumbent Male Nude,* c.
1886. Pencil, 29.5 × 44.7 cm. Kunsthalle
zu Kiel. Photo: Horst Uhr.

"nymph" Emil Beurmann saw in Corinth's Paris studio, which he said Co-
rinth was working on with the intention of sending it to the Salon.[58] This
painting, if indeed it was ever completed, has long since disappeared. Co-
rinth's hopes for it are suggested by his lighthearted gesture years later of
repeating the composition where he concludes his account of the Académie
Julian in *Legenden aus dem Künstlerleben.* There the recumbent nymph lies
asleep as a satyr, now conspicuously goat legged and horned, approaches
with manifest glee. To the ornate frame of the vignette is affixed a proud
"Hors concours."[59]

Another motif Corinth was working on at this time was "a corpse of Christ
on a red tile floor."[60] His brief but unequivocal description indicates his casual
approach to the subject, and a preparatory drawing in the Kiel sketchbook
(Fig. 18) confirms that this picture, too, was to have been an accurate, though
somewhat idealized, study of a male nude whose posture would suggest the
appropriate iconographic context. This drawing and the studies for *Jupiter
and Antiope* suggest that Corinth's thematic interest was limited to a preoccu-
pation with form as manifested in the model. Many years were to pass before
he saw the human figure as a vessel of emotions whose expressive power
transcended the impeccable rendition of nature as Ingres and Bouguereau
understood it.

Whenever the students at the Académie Julian were not drawing or painting the nude, they were working on figure compositions that had to be completed without the aid of models. This practice allowed them to experiment with the arrangement of figures within a chosen format, to determine the distribution of light and shade, and to examine the effects of the colors they intended to use. Bouguereau, who saw to it that this practice was followed faithfully, usually posted a note near the studio door announcing the individual assignments. This might be a well-known but complex theme, such as "The Entry of Christ into Jerusalem," or something more erudite, like "The Scythian King Scylurus Admonishes His Eighty Sons."[61] Corinth's composition study of 1885, entitled *Unity Gives Strength* (present whereabouts unknown), derives from Plutarch's story, except that he reduced Scylurus's large family to five, a handier number.[62]

Several studies for a Lamentation, probably executed at about the same time, illustrate Corinth's efforts to achieve both variety and unity in a composition involving a similarly heterogeneous, though far less unwieldy, group of figures. They too demonstrate his continued reliance on the leading *pompiers* and can be traced to such prototypes as Henner's paintings *The Dead Christ* (1879; Musée d'Orsay, Paris) and *Christ in the Tomb* (1884; Musée des Beaux-Arts, Lille) and Bouguereau's *Virgin of Consolation* (1877; Musée des Beaux-Arts, Strasbourg).[63]

No other works from Paris shed further light on Corinth's early development. Those he completed in the summer of 1885 and 1886 while traveling in the Black Forest and in Holstein—landscape studies, oil sketches and more finished pictures of country folk, and two plein air portraits—are of only marginal interest. Most were conceived without regard to the tastes prevailing at the Académie Julian. In two exceptions from the summer of 1886, however—compositions known only from later descriptions—Corinth adapted his recent experience of working from the live model to plein air painting. He asked several old men from a home for the aged near the village of Panker in Holstein to pose nude for him in the woods, in the guise of Pan and other forest spirits. Corinth, oblivious to the men's physical discomfort in the brisk forest air, not to mention their reluctance to comply with his unusual request, apparently took delight in the effects of the sunlight flickering across naked bodies. Perhaps the forest interior of 1886 (B.-C. 43), in which a seated nude figure can be seen from the back, originated in this context. No other visual evidence has survived either of these plein air figure compositions or of a large picture Corinth painted inside the old people's home.[64] The men were smoking and reading; the women kept busy spinning or knitting. A soft glow, reflected from a wheat field just outside the window, pervaded the room.[65] Although Corinth

destroyed these paintings because he found fault with them, in the picture of the old people's home he had returned to the pictorial problem of interacting light and interior space that had first occupied him in *The Conspiracy.*

A renewed interest in this problem also prompted the lively figure composition *Cardsharp* (Fig. 19), one of the last pictures Corinth painted in Paris during the spring of 1887. Three cardplayers in a Paris bistro challenge and threaten a cheat; a waiter and an older man look on. Corinth, who had not exhibited at the Salon since the spring of 1885, may have hoped to repeat his London success with a work that offered a similar challenge, except that now he heightened the narrative suspense by emphasizing the transitory moment of the action, as Meissonier had done in a similarly charged picture entitled *The Brawl* (1855; Collection H. M. Queen Elizabeth II). Corinth's care in preparing the painting is evident from preliminary drawings.[66] It is not known, however, whether he submitted the work for acceptance to the Salon in 1887. In any case, the jury rejected all his entries, dealing him a devastating blow. This "misfortune," as he later called it,[67] led him to pack his belongings and return to Königsberg. He eventually destroyed the *Cardsharp*, apparently for the same reason that led him to overpaint the picture rejected in Antwerp.

Despite the disappointing finale to his studies in Paris, Corinth never ceased to respect the discipline he had learned at the Académie Julian, no matter how far his work digressed from the precepts of artists like Bouguereau. In his own teaching manual, published more than twenty years later, he repeatedly emphasized the importance of studying the live model and recommended that the nude be rendered accurately, as if it were but another three-dimensional object like those encountered elsewhere in nature in landscapes, animals, and still life.[68] This advice, true to nineteenth-century academic notions,[69] also confirms the nonpsychological approach to the human figure seen in Corinth's early drawings and paintings of the nude. Besides the concept of form exemplified in the live model, Corinth passed on to his students the principles of composition he had first learned at Julian's. To illustrate the "mental gymnastics" he felt every aspiring artist must learn to do, he published one of his Paris studies for the Lamentation in his teaching manual.[70] An artist approaching the story in Genesis 37:32, where the sons of Jacob bring their father the bloodstained coat of their brother Joseph, he explained, must begin the composition by visualizing gestures and expressions appropriate to the remorse and pity each of the brothers feels in anticipation of the old man's grief.[71] Even Corinth's good friend Walter Leistikow, in an amicable review of Corinth's teaching manual when it was first published in 1908, could not forgo an aside

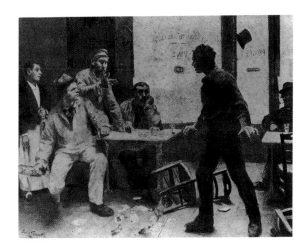

FIGURE 19.
Lovis Corinth, *Cardsharp*, 1887. Oil;
ground and size unknown, B.-C. 50.
Painting destroyed by the artist.
Photo: after Bruckmann.

about Corinth's eccentric approach: "Today, under the banner of Impressionism and a thousand other groping efforts to come up with something new and newer still, . . . Corinth writes a painting manual just as in the good old days when the blessed Saint Academicus was still absolute ruler in the realm of art." [72] When a year earlier Corinth's student Oskar Moll had told him of his plans to go to Paris to study with Henri Matisse, Corinth had gruffly replied: "What do you want to go to Paris for? The old Bouguereau is dead, and there is nothing new." [73]

TWO :: INDECISION
AND
CHANGE

BERLIN, WINTER 1887–88

In the spring of 1887 when Corinth left Paris, he had completed more than a decade of academic study. He might have looked back on this period with a greater sense of accomplishment had he been able to add to his bronze medal for *The Conspiracy* a similar token of recognition for his years at Julian's. As it was, he returned to East Prussia with little more to show than a few studies of the nude model. The knowledge that he was approaching his thirtieth birthday must have weighed heavily on him. Fortunately, he did not suspect that thirteen years of search and experimentation still lay ahead.

Except for a brief visit to the Baltic seacoast, Corinth spent the summer of 1887 in Königsberg. Of the five paintings he completed at this time the portrait of his father (Fig. 20) is the most important. In it once again he depicted a figure in a sunlit interior, except that, as in the portrait of 1883 (see Plate 1), Franz Heinrich does not really occupy that interior but sits in front of it. Daylight, entering through the window at the right, fills the room with a subtle glow, accentuates the structure of the sitter's face, and touches details with a sparkle of bright color. The pale blue of the letter Franz Heinrich holds in his right hand echoes the white and blue of the curtains and the window-pane. Patches of red and yellow enliven the dull green of the tablecloth. Although this portrait was painted only four years after the Munich portrait, Franz Heinrich looks not only markedly older but also much more frail. As in the earlier portrait, the posture is casual, but it fails to convey the same impression of comfort and ease. Instead, Corinth's father is seated rather stiffly in the armchair and seems unable to support his weight without effort. The face is taut, the expression of the eyes weary. Corinth must have begun the portrait shortly after his return from Paris, for at the end of July the painting was included in an exhibition organized by the Berlin Artists' Association at the Glass Palace in Berlin. It was moderately successful at best. According to Corinth, some of the critics "thoroughly flogged" him.[1]

FIGURE 20.
Lovis Corinth, *Portrait of Franz Heinrich
Corinth with a Letter,* 1887. Oil on
canvas, 87 × 105 cm, B.-C. 51. Museum
Ostdeutsche Galerie Regensburg. Photo:
WS-Meisterphoto Wolfram Schmidt.

Despite this inauspicious reception, in October Corinth went to Berlin to
pursue opportunities that by his own account were luring artists to the city:

> Berlin was thriving at the time. The population was expanding, and a strong
> interest in art was just beginning to develop. One could find plenty of newly
> rich bankers who were willing to support the arts, and it was easy for ambitious,
> capable, and truly talented painters to establish art schools of their own. This
> was the reason many young artists moved from Munich to Berlin, and if one
> was lucky enough to be a foreigner, one's fortune was already made.[2]

By the time Corinth arrived, Berlin had already experienced more than a decade of astonishing growth. After 1871 this old seat of the Hohenzollerns, suddenly the capital of a unified German Empire, was transformed into a major metropolis. With the city's intensified economic development, commerce and industry grew at a dizzying rate. As corporations and banks multiplied, immense private fortunes were created. Newcomers arrived by the thousands. In only nine years—from 1864 to 1875—the city's population almost doubled, passing the one-million mark. By 1885 it had increased to nearly a million and a half.[3] In 1872 alone no fewer than forty new construction firms began to operate,[4] gradually pushing the city's perimeter further west; mansions near the Tiergarten soon vied in opulence with the splendid apartment buildings along the Kurfürstendamm.

The visual arts in Berlin were dominated during these years by the Berlin Academy and its influential director Anton von Werner. Werner, still remembered for his photographically accurate depictions of scenes from the Franco-Prussian War, was only thirty-two when he became director of the academy in 1875. From 1887 to 1895 he also served as president of the Berlin Artists' Association, whose members controlled the annual academy-sponsored exhibitions. Until 1885 these exhibitions were predominantly local; not until the academy's centennial anniversary exhibition in 1886 were artists from other German cities and from abroad encouraged to participate in larger numbers. The 1886 exhibition, intended to propel Berlin into the intellectual and artistic community of older, more illustrious European capitals, turned out to be the nation's cultural event of the year and a matter of great national pride. *Die Kunst für Alle,* Germany's leading art journal at the time, devoted ten consecutive biweekly issues to the exhibition.[5] In addition to the German contingent, artists from nine foreign countries exhibited in the newly built Glass Palace— England, Belgium, Holland, the Scandinavian countries, Italy, Spain, and Russia. France—not unexpectedly—chose not to participate.

While the leading academicians reaped their customary accolades and medals from the exhibition, younger, innovative artists did not go unnoticed. Among the Germans was Max Liebermann, who exhibited three paintings: *The Old Men's Home in Amsterdam* (1880–1881; Collection Georg Schäfer, Schweinfurt), *Girls from the Amsterdam Orphanage in a Garden* (1885; Kunsthalle, Hamburg), and *Saying Grace* (1886; private collection). The first two paintings were generally well received. The third elicited mixed reactions. Most critics applauded the sincerity of the religious sentiment portrayed but found Liebermann's unidealized models and their humble milieu offensive.

The same criticism was directed at two religious paintings submitted by Fritz von Uhde, *Come, Lord Jesus, Be Our Guest* (1885; Staatliche Museen zu Berlin, National-Galerie), and *The Last Supper* (1886; present location unknown). But since these paintings made up in anecdotal interest whatever the figures lacked in conventional "beauty of form," Uhde received on the whole a more generous recognition than Liebermann.[6]

The academy exhibition of the following year, to which Corinth sent the recently completed portrait of his father, included few foreign artists. Moreover, most of the established German academicians, apparently not yet recovered from the previous year's exhibition, refrained from showing. A reviewer noted instead a marked increase in the number of younger German artists preoccupied with the same pictorial problem: plein air.[7] Liebermann was represented with his paintings *Beer Garden in Munich* (1884; Bayerische Staatsgemäldesammlungen, Neue Pinakothek, Munich) and *Women Spinning* (1880; painting lost) and Uhde with his first biblical scene in an outdoor setting, *The Sermon on the Mount* (1884; Museum of Fine Arts, Budapest). The exhibition's *succès de scandale* belonged to Max Klinger, whose monumental painting *The Judgment of Paris* (1886–1887; Kunsthistorisches Museum, Vienna) elicited a wave of hostile criticism. Klinger's uncompromising naturalism in depicting the three nude goddesses led the *Kreuzzeitung* to publish a stern editorial on the decay of morals. Critics derided as the ultimate proof of his folly his efforts to fuse the picture and its immediate environment into a *Gesamtkunstwerk* by setting the huge canvas into an elaborate polychrome sculptured frame.[8]

The battle for modern art in Berlin was waged less vociferously in the galleries of two private dealers, Eduard Schulte and Fritz Gurlitt. Schulte, who in 1885 had taken over the former Salon Lepke on Unter den Linden, generally followed the accepted academic trend, though he did not exclude controversial artists altogether. In the winter of 1887–88, besides a number of portraits by Lenbach, he exhibited a group of paintings by Arnold Böcklin, an artist who had only begun to receive some recognition. Gurlitt was more enterprising. Since opening his gallery in 1880, he had displayed the work of painters from throughout Germany. He was among the first to exhibit works by Hans von Marées and Hans Thoma. His gallery was also the only place in Berlin where paintings by the French Impressionists could be seen. In October 1883 Gurlitt exhibited the small but exquisite collection assembled by Carl and Felicie Bernstein, consisting of works by Manet, Monet, Sisley, Pissarro, Gonzalez, and Morisot. Shortly thereafter he showed a selection of

works by Pissarro, Renoir, and Degas sponsored by the Parisian art dealer Paul Durand-Ruel. Gurlitt's exhibitions inspired the young French Symbolist poet and critic Jules Laforgue, who from 1881 to 1886 lived primarily in Berlin, serving as a reader to the German empress Augusta, to write one of the earliest and most incisive analyses of Impressionism.[9]

The artistic milieu Corinth encountered when he arrived in Berlin in October 1887 thus offered the old and established as well as the new. It is not known whether he had visited the Berlin Academy exhibition at the Glass Palace during the summer, but because the portrait of his father was shown there, he was probably aware of the growing reputation of such artists as Liebermann, Uhde, and Klinger. Corinth himself, however, was not one to eagerly follow the avant-garde. His continuing image of himself as a student is suggested by his later confession that he felt "intimidated" on arriving in Berlin; aside from a "pent-up ambition to learn something," he had neither the "courage nor the determination to take any adventurous risks."[10]

Indeed, Corinth's Berlin output, dominated by drawings of male and female nudes, is little more than a continuation of his student work from Paris. Most of these drawings originated at Der Nasse Lappen (The Wet Rag), a private drawing club he joined soon after his arrival. Der Nasse Lappen was founded by Carl Steffeck, who had taught at the Berlin Academy from 1859 until his departure for the academy in Königsberg in 1880. Members of the club met in the evenings to draw after the live model. In the late 1880s the artists who took part in this *Abendakt*, in a studio on Potsdamer Strasse, included the painters Carl Friedrich Koch, Paul Souchay, and Adolf Schlabitz and the sculptor Max Klein. The art historian Heinrich Weizsäcker also occasionally joined the drawing sessions.[11] Corinth soon got to know the most prominent member of the group, Karl Stauffer-Bern, well enough to visit him in his studio on Klopstockstrasse, and the Swiss artist apparently introduced him at this time to Max Klinger and to the Berlin painter Walter Leistikow.

Although Karl Stauffer (1857–1891), a native of Bern, was only a year older than Corinth, he had already made a name for himself as a portraitist among the newly rich of Berlin. He also enjoyed the special favor and protection of Anton von Werner, who had helped him to secure his first important portrait commissions, which in due course included the portrait of the emperor's surgeon, Dr. von Lauer, and a portrait of the emperor himself. Adolph von Menzel, whose portrait Stauffer-Bern etched in 1885, was so impressed with the young man's talent that he frequently invited him to his home for dinner, an honor he bestowed on only a few. It was the "foreigner" Karl Stauffer-Bern

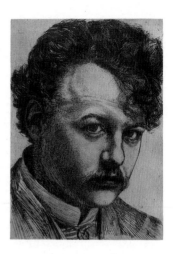

FIGURE 21.
Right: Karl Stauffer-Bern, *Self-Portrait,*
c. 1885. Etching, 35 × 22 cm.
Kunstmuseum Bern (S 10692).

FIGURE 22.
Opposite: Karl Stauffer-Bern, *Recumbent
Male Nude,* 1881. Pencil, 25.0 × 39.5 cm.
Kunstmuseum Bern (A 3461).

whom Corinth clearly had in mind when he wrote of those "ambitious, ca-
pable, and truly talented painters" who had succeeded in launching profit-
able teaching careers in the nation's new capital. For in addition to pursuing
his creative work, Stauffer-Bern both directed the portrait class of the Berlin
Society of Women Artists and Friends of the Arts, whose students in 1885
included Käthe Kollwitz, then eighteen years old, and maintained a small la-
dies' academy of his own.[12]

Stauffer-Bern must have embodied for Corinth the success he himself was
striving for. He had reason to believe the goal within his reach, moreover, for
Stauffer-Bern's work was based on formal principles that Corinth was in the
process of making his own. Both artists had been trained by Löfftz at the
academy in Munich. Stauffer-Bern's reputation today rests primarily on his
prints, although he made no more than thirty-seven.[13] His portrait etchings,
such as the *Self-Portrait* (Fig. 21) of about 1885, convey the sitter's presence
with striking immediacy, a quality he considered indispensable: "In my por-
traits I am not concerned with snappy execution or coloristic appeal but
rather with the mathematically precise reproduction of form and the most
delicate modeling, . . . because a portrait must be above all so lifelike that one
is startled by it."[14]

When drawing the nude model, which he considered the "painter's alpha-
bet" and "the foundation of all art," Stauffer-Bern was guided by the same
desire "to reproduce the exquisite details of nature, to penetrate the secrets of
appearances, and to become a master of what he could see."[15] As a result, his
drawings primarily document visual facts, although the sculptural plasticity
of his figures also has expressive power (Fig. 22). Weizsäcker considered

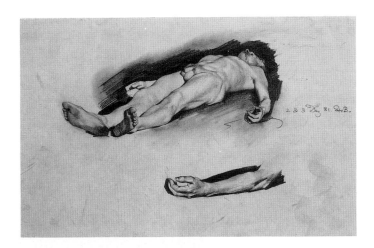

Stauffer-Bern's drawings among the best anywhere: "What a joy it was to leaf
through the portfolios and sketchbooks in his studio at one's leisure! How . . .
the most delicate vibration of form was observed, with what intelligence and
at the same time with what energy, often after several new beginnings, until
the image had been seized."[16]

Since he was not satisfied with the soft gradations obtainable with the etch-
ing needle alone, Stauffer-Bern frequently reworked his plates with the burin
to achieve more emphatic contrasts in value. Emulating the Italian engravers
of the fifteenth century, he applied the burin so that the hatchings do not
follow the round forms of the human body but create shadows with a net-
work of straight, precisely drawn parallel lines.

In addition to portraits and nudes, Stauffer-Bern favored religious composi-
tions. A painting representing Christ in the house of Simon the Pharisee was
to have been one of his major works. Begun in 1884 on a large scale—the can-
vas measured approximately eight by sixteen feet and was projected to con-
tain seventeen life-size figures—it was never completed. From 1886 to 1887 he
worked on a dead Christ motif inspired by Holbein's picture in Basel, and
during the winter of 1887 he painted the *Crucified Christ* (Fig. 23), an impec-
cable anatomical depiction of the model, whose brightly illuminated body is set
off against a dark ground. Sixteen years later Corinth wrote that this painting
was like an "oasis in the desert" for him during that winter, and although by
the time he made the statement he had begun to reject Stauffer-Bern's concep-
tion as too literal, he professed continued respect for the Swiss artist as a
"master of form," emphasizing that the nude human figure could be consid-
ered (as he paraphrased Stauffer-Bern himself) the "Latin of painting."[17]

FIGURE 23.
Right: Karl Stauffer-Bern, *Crucified Christ,*
1887. Oil on canvas, 247 × 168 cm.
Kunstmuseum Bern.

FIGURE 24.
Opposite, left: Lovis Corinth, *Standing
Female Nude,* 1887. Pencil, 52.8 × 34.5
cm. Staatliche Museen, Berlin (DDR).

FIGURE 25.
Opposite, right: Lovis Corinth, *Standing
Female Nude,* 1887–1888. Pencil, 44.7 ×
29.5 cm. Kunsthalle Bremen.

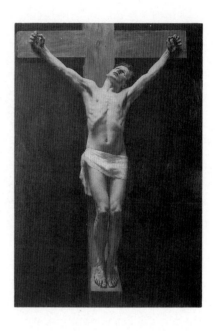

Corinth's contact with Stauffer-Bern, however, was short-lived. Stauffer-Bern tended to be impulsive; he loved to theorize, but without reflecting. According to his biographer Georg Wolf, "Clichés flowed effortlessly into his speech. He preached about art and artistry, demonstrated mature judgment alongside sky-high naïveté, and developed plans on a grand scale for an entire generation of Raphaels and Buonarrotis."[18] Similarly high-flown ideas apparently ended Stauffer-Bern's friendship with Corinth. When on Christmas Eve 1887 he tried to explain to Corinth over a bottle of wine his concept of a *Gesamtkunstwerk* that—like Klinger's—was to unite painting and sculpture, Corinth bluntly countered by quoting a well-known vulgar line from Goethe's *Götz von Berlichingen* and left.[19] The two men never saw each other again. In the spring of 1888 Stauffer-Bern left for Rome to devote himself entirely to the practice of sculpture. His unfortunate love affair with Lydia Welti-Escher, the wife of his influential Swiss patron, led in quick succession to his imprisonment and commitment to mental institutions in Rome and Florence and to his suicide at the age of thirty-three on January 24, 1891. Yet despite the brevity of their relationship, Stauffer-Bern had a decisive effect on Corinth's development and continued to influence him for several years. His example encouraged Corinth's own desire to become a "master of form," and the *Crucified Christ* remained proof that this mastery could be put effectively to the service of a major theme.

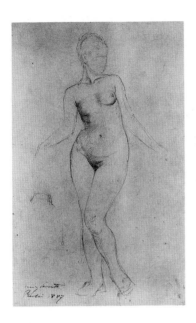

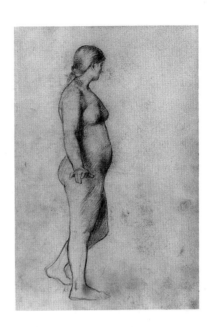

Corinth's Berlin drawings in particular indicate the extent to which he emulated Stauffer-Bern's concept of form. Although relatively few examples have survived, he apparently worked extensively at drawing during the winter of 1887–88. A *mise en place* sketch (Fig. 24) in the idealizing French manner was probably done soon after Corinth arrived in Berlin. Sweeping reinforced contours define the stereometrically simplified body while a gently swaying line of action proceeds from the model's neck through the navel and pubic area to the inner contour of the left leg. Like Bouguereau's *Venus* (see Fig. 14), the figure is eight heads high, with the upper and lower portions of the body containing four heads each. By comparison, several drawings in a sketchbook now in the Kunsthalle in Bremen illustrate how Corinth adopted Stauffer-Bern's emphasis on plasticity of form and painstaking verisimilitude. The drawing of a standing female nude (Fig. 25) on folio 3 recto, for example, is superior to any of Corinth's earlier life drawings in accuracy of rendering. The modeling, contained by smooth contour lines, recalls the parallel hatchings in Stauffer-Bern's prints and makes the supple flesh palpable. The woman, directly observed, conveys the sense of a real, living presence. In several drawings in the Bremen sketchbook the anatomical depiction of the model is complemented by careful studies of detail; in others the sculptural clarity of the figure is enhanced by conspicuous shadows, as in similar drawings by Stauffer-Bern.

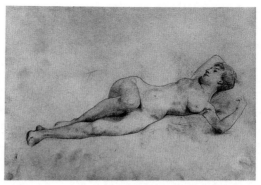

FIGURE 26.
Right: Lovis Corinth, *Reclining Female Nude,* 1887–1888. Pencil, 29.5 × 44.7 cm. Kunsthalle Bremen.

FIGURE 27.
Opposite: Lovis Corinth, *Reclining Female Nude,* 1887. Oil on canvas, 65 × 175 cm, B.-C. 53. Present whereabouts unknown. Photo: after Bruckmann.

Although most of the drawings in the Bremen sketchbook display the same remarkable naturalism, Corinth did not abandon the idealizing tendencies of his French teacher entirely. On the contrary, as his command of life drawing grew, he could not only express the visual data manifested in the model but also achieve a more sophisticated grasp of conceptualized form. His drawing of a reclining female nude (Fig. 26) on folio 28 recto follows the practice of Bouguereau by combining the realistic head of a modern woman with a graceful, idealized body. A transparent chiaroscuro accentuates the soft forms of the model, and delicate flowing contours emphasize the body's sensuousness.

Corinth's works during the Berlin winter culminated in at least two paintings, each depicting a female nude. The smaller of the two (B.-C. 54), dated 1888, is based on a drawing in the Kunsthalle in Hamburg;[20] the other (Fig. 27) bears the date 1887 and was clearly preceded by drawings like the one shown in Figure 26. The 1887 painting is the more finished and more ambitious of the two. The model is shown life-size, reclining on a bed of silky cushions and sheets, her back turned seductively toward the viewer. Both paintings further elaborate Corinth's drawings from life; both are exercises, efforts to endow visual perception with concrete pictorial form. The meticulous and richly nuanced modeling of the flesh parts suggests that these works are those of which Corinth, remembering Bouguereau's criticism of his draftsmanship, later wrote: "I seriously tried to capture the forms by working from the live model; in my pictures there was not to be a speck that was not rigorously studied."[21]

The same disciplined brushwork is seen in the *Self-Portrait* (Fig. 28) from the winter of 1887–88. Like Stauffer-Bern's portrait etchings, the painting projects the artist's physical presence with "startling" immediacy. Although this

effect results partly from the quizzical, apprehensive gaze, it is reinforced by the tangible life-size head emerging from the undifferentiated pictorial ground. The meticulous modeling is in keeping with Stauffer-Bern's precept that "mathematically precise reproduction of form" is the basis of other, more expressive, qualities in a given portrait. Indeed, more than twenty years later Corinth, commenting on the art of portraiture, restated the precept in his own teaching manual with remarkable accuracy:

> A specific individual has here been portrayed, and the first requirement is verisimilitude. Perhaps some will say that in a work of art other qualities could be considered more important, since in most cases only a very few will know the sitter by face. However, such other affective qualities as immediacy of expression and liveliness of conception are only the inevitable result of verisimilitude.[22]

Corinth's awareness of his increasing technical proficiency during the winter of 1887–88 is reflected, at least indirectly, in his decision that his name henceforth should be Lovis. For some time he had been signing his works in capital letters, replacing the *U* in his first name with the less conventional roman *V.* He now began using the *v* for the lower case spelling of his name as well, adopting Lovis as his professional name; legally, however, his name remained unchanged.

In February 1888 Lovis Corinth participated again in an exhibition organized by the Berlin Artists' Association. Two of the paintings he showed, the portrait of a young architect named Tietz, painted the year before, and a picture entitled *Hospital Women at Their Morning Prayer,* were either destroyed by Corinth or overpainted, and nothing is known about them except what can be

FIGURE 28.
Lovis Corinth, *Self-Portrait*, 1887–1888.
Oil on canvas, 53.5 × 43.0 cm, B.-C. 49.
Sammlung Georg Schäfer, Schweinfurt.

gleaned from a reviewer's brief remarks critical of the forced facial expressions in both works. The third painting was Corinth's seasoned prizewinner *The Conspiracy*, which once again drew favorable comments.[23]

Corinth's further efforts to establish himself in Berlin were cut short when his father called him home at Easter time. As the portrait from the previous summer suggests, Franz Heinrich was ailing, and the wish to have his son near him was most likely prompted by a further deterioration of his health.

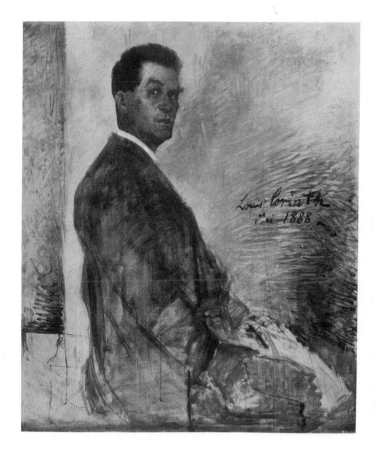

FIGURE 29.
Lovis Corinth, *Portrait of Franz Heinrich Corinth*, 1888. Oil on canvas, 118 × 100 cm, B.-C. 56. Private collection.

KÖNIGSBERG, 1888–1891

The portrait Corinth painted of his father when he returned home in May 1888, however, gives no indication of Franz Heinrich's illness (Fig. 29). On the contrary, the upright posture and alert gaze convey undiminished physical and mental vigor. The sitter is seen from up close and slightly below, his head turned, almost abruptly, toward the viewer. The raised eyebrows and firm mouth give the face a look of quiet resolve. The resulting effect of controlled tension differs considerably from the calm mood of Corinth's earlier portraits

of his father. Psychic energy emanates from the unfinished work, in which only the face has been given definition—again in emulation of Stauffer-Bern's "mathematically precise" rendering of form. The rest of the portrait is barely sketched out, reinforcing the head as the principal carrier of the picture's expressive content. Corinth apparently began the painting as a more developed statement of the formula he had first adopted in the Berlin self-portrait, and he prepared the picture with special care, as several preliminary drawings show. He may have left the painting unfinished because he could not maintain so energetic a conception in the face of his father's true state of health; perhaps the sittings had to be suspended. In any event, the portrait remains more a wishful projection than a record of fact. Corinth's desire to remember Franz Heinrich as he looked in this portrait—psychologically the most interesting one he painted of his father—is evident from his fondness for it. He kept it with him throughout his life and always had it hung opposite his favorite armchair. "I want to look at the old man," he told his wife many years later; "I think of him each day."[24]

Franz Heinrich's vigorous appearance in the portrait was indeed deceptive. When Corinth returned to Königsberg at the end of September from a month of military reserve duty in the nearby town of Pillau, he found his father severely ill and confined to bed. This is how he painted him in October (see Plate 3). The small, intimate canvas is the best of Corinth's early sunlit interiors—a masterpiece that shows him in complete command of his painterly means. The composition recalls Jozef Israëls's *The Widower,* which had inspired Corinth's "fledgling work" *The Conspiracy.* Corinth's sense that the subject fit the anecdotal conventions of late nineteenth-century genre painting is indicated by his own original title for the work, *The Sick Man.*[25] Unlike Israëls, however, Corinth avoided sentimentality by sublimating his empathy in a loving description of the room and its two inhabitants. Franz Heinrich seems to sleep while the young woman briefly stops knitting to gaze at him. The autumn sunlight gleams on the furniture and on the still life of medicine bottles, glasses, and fresh flowers beside the bed. The small carnation withering on the chair is a poignant reminder of the picture's content. Objectivity and simplicity of conception make this painting the most heartfelt of Corinth's early works. With it he also bade his father a tender farewell: Franz Heinrich died on January 10, 1889, a month before his sixtieth birthday.

Corinth inherited three apartment houses his father had bought in Königsberg in the 1870s as well as other substantial investments. He was now financially secure and independent, a fortunate situation indeed, for so far he had found no buyers for his pictures. He was now free to pursue his career virtu-

ally anywhere. Although he had visited Königsberg only intermittently during the preceding nine years—always to see his father—he decided to stay. His decision most likely had to do with his inexperience in administering and supervising his property, and he no doubt thought it wise not to stray too far—for the time being—from the sources of his income.

Soon after his father's death Corinth rented a studio at Rossgärter Passage 1 and resumed contact with some of his former teachers and fellow students from the Königsberg Academy. He also joined the Königsberg Artists' Association and in March 1889 exhibited with the organization for the first time. In addition to a kitchen still life (B.-C. 68), painted over the ill-fated earlier picture from Antwerp, he showed *The Conspiracy* once again, although many Königsbergers had already seen the painting on display in the window of the gallery of Bruno Guttzeit, a local dealer. A reviewer of the exhibition noted this with disappointment and chided Corinth for not submitting any of his more recent works from Paris, some of which had also been exhibited at Guttzeit's.[26] Among the "Parisian" works alluded to were most likely Corinth's Berlin nudes. His decision not to show them in the competitive context of the Königsberg Artists' Association exhibition, which included pictures by Lenbach, Böcklin, and Uhde, suggests that he recognized the tentative character of these works.

From 1889 to 1891 Corinth assimilated his most recent experiences in Paris and Berlin, further developing ideas he had not yet been able to realize fully. For example, in the portrait of Carl Bublitz (Fig. 30) he built on the conception he had first explored in the Berlin self-portrait and in the May 1888 portrait of his father (see Fig. 29). Now, however, he intensified the impression of immediacy by relating the sitter to the viewer through gesture as well as glance. Carl Bublitz (1866–1932), who had also studied at the Königsberg Academy, is depicted half-length in Corinth's studio; he stands next to an empty canvas, echoing its diagonal position in his own animated posture. In the background is a portion of Corinth's only known plein air picture from this period, *Swimming Pond near Grothe, Königsberg* (B.-C. 72), also painted in 1890. Bold contrasts of light and shade, induced by the bright illumination from the left, play a major part in the compositional structure of the Bublitz portrait. And the broad, energetic application of the paint itself suggests palpitating life.

The technique employed in the portrait of Hugo Rogall (Fig. 31), an actor at the Königsberg municipal theater who belonged to Corinth's circle of friends, is more controlled, although here, too, vigorous brushstrokes enliven subordinate areas of the canvas. The conception is as lively as that of the Bublitz portrait, but this sitter's expression and posture are more pointedly provoca-

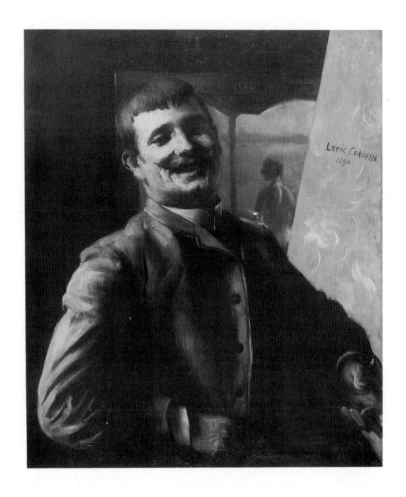

FIGURE 30.
Above: Lovis Corinth, *Portrait of the Painter Carl Bublitz,* 1890. Oil on canvas, 90 × 74 cm, B.-C. 70. Sammlung Georg Schäfer, Schweinfurt.

FIGURE 31.
Opposite: Lovis Corinth, *Portrait of the Actor Hugo Rogall,* 1890. Oil on canvas, 75 × 50 cm, B.-C. 71. Only a fragment of this painting survives; present whereabouts unknown. Photo: after Bruckmann.

tive. The shallow space and simple background help to focus attention on Rogall, whose nonchalance is reinforced by his open jacket and unbuttoned vest. The top hat, set slightly askew, and the jaunty flower in the lapel add affable touches to the otherwise robust, even aggressive, characterization. Unfortunately, Corinth later cut the painting apart, keeping only the fragment with Rogall's head.

Both of these portraits bring to mind Frans Hals, who used posture and gesture to establish a dialogue between his sitters and the viewer. Corinth most likely drew consciously on the Dutch master in his efforts to heighten the illusion of a momentary encounter in which an individual's character reveals itself in emotion and movement. Although he was to explore such baroque elements more fully later, these two portraits mark the first stage in the development of a flamboyant conception now recognized as a characteristic of Corinth's mature style.

FIGURE 32.
Right: Lovis Corinth, *The Old Drinker,*
1889. Oil; ground and size unknown, B.-
C. 67. Present whereabouts unknown.
Photo: after Bruckmann.

FIGURE 33.
Opposite: Lovis Corinth, *Pietà,* 1889. Oil
on canvas, 131 × 163 cm, B.-C. 61.
Formerly Kaiser Friedrich-Museum,
Magdeburg; destroyed 1945. Photo:
Bruckmann.

The Old Drinker (Fig. 32) of 1889 apparently also has Dutch prototypes.
Holding a violin under his left arm, the smiling old man sniffs at a bottle. His
contented look evokes the pleasures of both music and drink. Half-length
figures of musicians and drinkers, usually shown against a neutral ground,
were an invention of the Utrecht Caravaggisti but were also painted fre-
quently by Frans Hals. Opinion differs on what these paintings represent:
subjects from daily life or allegories on the popular theme of the Five Senses.
In Corinth's painting the allegorical reference to hearing, smell, and taste is
clear in the juxtaposition of violin and bottle. In seventeenth-century Dutch
paintings of the type the figures usually wear theatrical costumes that suggest
their allegorical roles. Corinth updated this tradition by placing his merry
toper in a contemporary bohemian context.

Although *The Old Drinker* and the portraits of Bublitz and Rogall derive
much of their interest from Corinth's empathy with his subject, his figure
compositions from these years indicate his continuing preoccupation with
pictorial problems he had tried to solve in Munich and Paris. A motif from
Paris, "a corpse of Christ on a red tile floor," awkwardly drawn in the Kiel
sketchbook (see Fig. 18), provided the inspiration for his first major religious
work, the *Pietà* (Fig. 33) of 1889.[27] As Corinth knew, this weighty subject was
certain to attract public attention. Indeed, paintings of the dead Christ, either
alone or attended by mourners and deriving, more or less, from the time-
honored tradition of Hans Holbein and Annibale Carracci, were featured so
prominently in nineteenth-century exhibitions that even Manet succumbed,

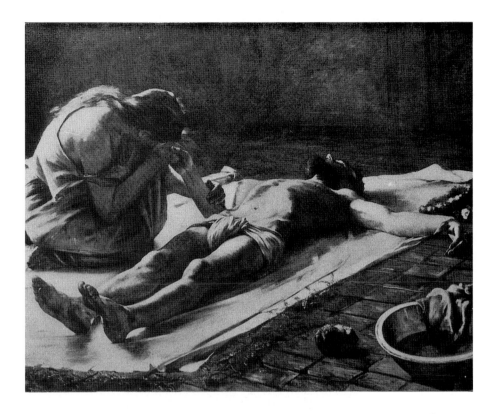

submitting a *Dead Christ with Angels* (Metropolitan Museum of Art, New York) to the Salon in 1864.

In addition to Löfftz's *Christ Lamented by the Magdalene* (see Fig. 9) and Jean-Jacques Henner's various interpretations of the theme, Corinth may have known Böcklin's *Mourning Magdalene* (1867; Kunstmuseum, Basel) as well as Trübner's *Christ in the Tomb* (1874; Bayerische Staatsgemäldesammlungen, Neue Pinakothek, Munich).[28] Like Böcklin and Löfftz he paired the dead Christ with the distraught Magdalene rather than the more conventional figure of Mary. The composition, however, clearly derives from Karl Stauffer-Bern. The diagonally foreshortened figure of the male model, of which Corinth also made a preliminary oil sketch (B.-C. 60), recalls Stauffer-Bern's drawing of 1881 (see Fig. 22), and no doubt the Swiss artist's preoccupation with religious themes during the winter of 1887–88 encouraged Corinth to return to a subject that had first claimed his attention at the Académie Julian.

Seen from above, the pictorial space in the *Pietà* is coextensive with the viewer's own, setting the stage for an empathic experience. The naturalistic figures, illuminated by the bright light from the upper left, lend the scene a

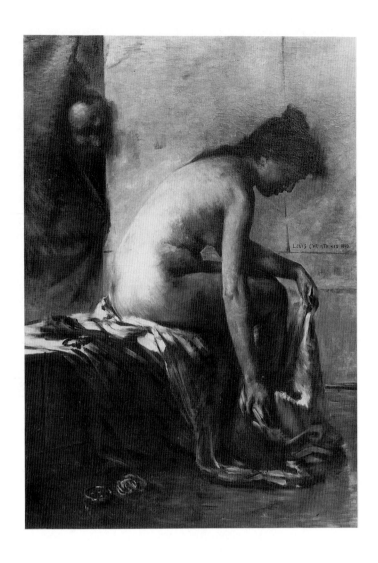

FIGURE 34.
Lovis Corinth, *Susanna in Her Bath*, 1890.
Oil on canvas, 159 × 111 cm B.-C. 74.
Museum Folkwang, Essen (Gertrud und
Wilhelm Giradet Familienstiftung) (349).

startling and unsentimental immediacy. Indeed, a closer examination of Corinth's conception reveals less concern for emotive content than for pictorial structure. The complex pose of the Magdalene and the foreshortened figure of Jesus—set off against the white cloth and the pattern of the tiled floor—are too carefully staged to be convincing in more than formal terms. Yet the contrived composition fulfilled Corinth's highest hopes. Having exhibited the painting in Bruno Guttzeit's gallery in 1889, he sent it to the Paris Salon in 1890, where it was not only accepted but awarded the "so ardently desired" *mention honorable.*[29]

Susanna in Her Bath of 1890, best known today through the somewhat more freely painted but contemporary second version of the picture in the Museum Folkwang (Fig. 34), was also conceived with the typical Salon public in mind and, like the *Pietà,* can be traced to Corinth's student years in Paris. The composition depends on Henner's painting of the same subject (c. 1863; Musée d'Orsay, Paris), which Corinth knew from the collection in the Musée du Luxembourg. Like Henner's painting, the *Susanna* is a standard academic study from life that has been given a biblical meaning with the addition of a few anecdotal accessories. The wall in the background and the curtain through which the lecherous bearded elder peeks delimit the pictorial space and provide an effective foil for the nude body of the model.

Emboldened by the favorable reception of the *Pietà* and possibly hoping to repeat or even improve on his earlier success, Corinth sent the *Susanna* to the Paris Salon in 1891. This time, however, he was less fortunate, although the painting was accepted—in itself no mean achievement considering the large number of works usually rejected by the jury. No doubt the very acceptance of the painting further convinced Corinth that public approval of his work depended on his producing compositions that demonstrated his technical abilities in the context of a "significant" theme.

The seated male nude in *The Prodigal Son* (Fig. 35), painted in 1891, is also still recognizable as a studio model, although here the treatment of the anatomy is woefully inadequate. The limbs are far too long, and even the disheveled heap of straw on which the figure sits cannot disguise the awkward connection between the upper and lower parts of the body. There is also a stylistic dichotomy between the meticulous modeling of the flesh parts and the atmospheric rendering of the rest of the picture (the straw-covered ground and the pigs, for example, are sketchily painted). The lower left corner of the pigsty is taken, without modification, from Corinth's early canvas *Cowbarn* (B.-C. 2), painted at his uncle's farm in Moterau in 1879. Many years later Corinth himself made fun of the technical discrepancies of the 1891

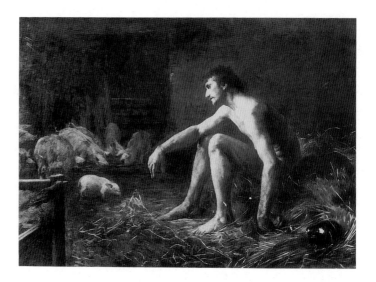

painting when he confessed in a letter to his wife, written on January 26, 1903, that the pigs were really the best part of the picture.[30]

Despite the stylistic ambiguities and the odd handling of the nude model, the painting is of special interest, for in it Corinth may have intended more than merely to solve an academic pictorial problem within a well-known thematic context. It has been suggested, for instance, that in placing the biblical character in a peasant milieu he knew intimately, Corinth may have reflected his own sense of professional and personal isolation.[31] This suggestion merits serious consideration, for despite the honorable mention awarded him by the Salon jury in 1890, in far-off Königsberg Corinth had not achieved professional security. He exhibited regularly with the Königsberg Artists' Association and at Guttzeit's gallery, to be sure, but critics generally qualified their praise of his work. They commented favorably on his technical skill and acknowledged his success in Paris with a measure of pride. But a critic for the *Hartungsche Zeitung*, for instance, writing in the May 5, 1891, issue, noted that despite a remarkable technique, Corinth followed the beaten track so lazily that one should expect little of him in the future.[32] Moreover, considering that his father's death had left Corinth without his only moral support, it is not farfetched to assume that the Prodigal Son, remorseful in his loneliness, had a personal meaning for the painter.

FIGURE 35.
Opposite: Lovis Corinth, *The Prodigal Son,*
1891. Oil on canvas, 112 × 154 cm,
B.-C. 81. Present whereabouts unknown.
Photo: Marburg/Art Resource, New
York.

FIGURE 36.
Left: Lovis Corinth, *Learn to Suffer without
Complaining,* 1891. Crayon, sheet 52 ×
34 cm, image 34.0 × 22.5 cm. Private
collection. Photo courtesy Thomas
Deecke.

Although Corinth explored the extended meaning of literary subjects only
much later, in one composition at this time, awkwardly titled *Learn to Suffer
without Complaining,* he expressed himself allegorically. Corinth first exhibited
the large painting in September 1891, and although it was seen at the Berlin
Secession as late as 1918, when the misery of the First World War gave the
subject renewed meaning, the only evidence of the picture today is a prelimi-
nary sketch (Fig. 36).[33] The title derives from what the German emperor
Friedrich III allegedly said to his son Wilhelm, who was born with a crippled
arm; the picture itself was apparently inspired by the memory of the tragic
and premature death of the emperor in 1888. An enlightened and cultured
monarch whose ascension to the throne had been anticipated with great hope
by a large part of the German nation, Friedrich died of throat cancer after a
reign of only ninety-nine days. In Corinth's preparatory study the emperor,
accompanied by an angel, stands beneath the crucifix in the place tradi-
tionally reserved for John the Evangelist in religious compositions of this
type. Gazing at the cross, the emperor accepts Christ's death with reverence
and resignation. In the context of Friedrich's own suffering, the idea that Co-
rinth undoubtedly wished to convey here is that of an *imitatio Christi.* For the
posture and gesture of the emperor as well as the design of the armor, how-
ever, Corinth relied again on his memories from Paris, since he took these de-

tails, with little change, from Rubens's painting of the presentation of Marie de' Medici's portrait to King Henry IV of France, part of the famous allegorical cycle now in the Louvre.[34]

Corinth may have had his most satisfying intellectual exchange during these years when the Berlin painter Walker Leistikow spent some time in Königsberg in 1890 working on a panorama of the city. The two men had met briefly in Berlin during the winter of 1887–88. In the course of Leistikow's visit their acquaintance developed into a lasting friendship. Leistikow surely gave Corinth an up-to-date account of recent artistic developments in Berlin. He may also have encouraged him to look anew beyond the borders of East Prussia. Corinth's success with the *Pietà* in Paris finally seems to have convinced him that Königsberg could never offer him even a remotely comparable forum. Thus in the fall of 1891, having found a custodian for his property, he returned to Munich. By the beginning of October Corinth was settled in a spacious studio at Giselastrasse 7, in the city's Schwabing district. He was not to exhibit again with the Königsberg Artists' Association until 1899.

A SWARMING BEEHIVE

In his memoirs Corinth compared Munich's artists' community in the 1890s to a "swarming beehive" whose occupants kept searching restlessly for new territory.[35] This appraisal is confirmed by the architect August Endell, who described with astonishment the seemingly endless variety of works exhibited in the Bavarian capital in 1896:

> So many teachers, so many different ways to paint, and theories as plentiful as sand in the sea, one more eccentric and weird than the other. . . . This one wants Greek noses and garments; that one, large philosophical compositions; a third, history paintings; a fourth, village scenes. There are those who insist on plein air and still others who know how to speak profoundly about light and dark. In addition, there is socialism, poor-people painting, mysticism, and symbolism. Everybody has a different ideal.[36]

Diversity, however, was not new to Munich painting in 1896. Although the annual exhibitions at the Glass Palace and the periodic international exhibitions, both sponsored by the conservative Munich Artists' Association, continued to be dominated by the Munich Academy, by the 1880s a number of

fads had made themselves felt, usually begun by artists who had won special acclaim at one of these exhibitions. Bastien-Lepage's painting *The Beggar* (1881 Salon; Statens Museum for Kunst, Copenhagen), for instance, shown at the international exhibition of 1883, inspired works of social content that haunted many a Schwabing studio until 1887, when the idyllic landscapes of the Scottish painters James Guthrie and David Cameron generated a new fashion.[37] The international exhibition of 1888 still gave prominence to naturalistic subjects, but the following year a new kind of idealism emerged, exemplified by the arresting imagery of Arnold Böcklin. Böcklin, condemned a few years earlier as a "fanatic of the hideous and the bizarre" and reviled for depicting "coarse, base emotions reminiscent of the lowest strata of human sensuality,"[38] showed seventeen paintings at the Glass Palace, including his fierce *Battle of Centaurs* (1873; Öffentliche Kunstsammlung Basel, Kunstmuseum). The 1889 exhibition marked the beginning of Böcklin's fame. Soon he was compared to Goethe, Beethoven, Rembrandt, and Phidias and celebrated as the "Shakespeare of painting."[39] The Böcklin cult ultimately reached ridiculous proportions. Soon after the painter's death in 1901 the Berlin critic Hans Rosenhagen wrote with unsurpassed hyperbole: "Böcklin was a hero, he belonged to a divine race[,] . . . he is eternal . . . [and] stands lonely above mankind. Past, present, and future merge in his heart. An extension of the cosmos, he encompasses all being."[40]

At the same exhibition in 1889 the young painter Franz von Stuck won a gold medal and a prize of sixty thousand marks for his *Guardian of Paradise* (1889; Stuck-Jugendstil-Verein, Munich). Whereas Böcklin's naturalism invests his hybrid mythological creatures with an astonishingly real, palpable presence, Stuck's synthesis of the real and the ideal in subject and form relies on naturalistic devices and emblem-like simplifications. The space in his painting is at once atmospheric and flat; the figure of the angel is carefully modeled yet silhouetted as a bold, simplified design. Although Stuck soon followed Böcklin's example and produced a series of strikingly naturalistic images of nymphs, satyrs, and fauns, he also continued in such works as the demonic *Sin* (Bayerische Staatsgemäldesammlungen, Neue Pinakothek, Munich), painted in 1893, to employ—as in *Guardian of Paradise*—a mixture of naturalism and stylization.

During the 1890s the reputation of Klinger and Uhde also rose. Only a few years earlier their ideal subjects had been greeted with skepticism because, like Böcklin's, they did not meet conventional standards of beauty.

Böcklin, Klinger, Uhde, and Stuck suddenly became popular during the last decade of the nineteenth century because these artists satisfied a bur-

geoning need for a "heightened" reality that was part of a broad antiscientific movement in both art and philosophy. This development, eventually felt throughout Europe, originated in France. As early as 1884 the novelist and critic Joris-Karl Huysmans has des Esseintes, the hero of his novel *A rebours*, raise an angry voice against the contemporary infatuation with naturalism: "Nature has served her purpose [and] by the disgusting uniformity of her landscapes and her skies has . . . worn out the attentive patience of the refined. . . . the time has come when nature should be replaced with artificiality as far as possible."[41] Two years later Jean Moréas's manifesto *Le symbolisme* turned against naturalistic writers such as Emile Zola by announcing the advent of literary symbolism in French literature. Like Henri Bergson, who believed intuition the fundamental source of human knowledge, Moréas and his friends were convinced that only the world of ideas offered artists the superior reality they were charged to evoke and to depict. In Germany the novelist and playwright Hermann Bahr echoed this belief when he informed his readers in 1891: "The rule of naturalism is over, its time is up, its magic dispelled, . . . we want to get away from naturalism and reach beyond it."[42] With growing frequency German critics joined the refrain. "Tear off the materialistic blinders; let allegory, the stories of the Bible, Homer be our guides in a world of greater beauty and lofty thought."[43]

Despite the similarity of the rhetoric, these ideas manifested themselves in French and German painting in fundamentally different ways. Whereas most French Symbolists reacted against Impressionism, a movement that had never taken root in Germany, German idealists rebelled against naturalistic and academic landscape and genre painting. Because German artists bypassed the critical intervening stage of Impressionism, with concern for bright color and simplified design, many of their works from the 1890s are ambivalent. Some of them began by emulating Stuck's precarious synthesis and eventually embarked on a process of rigorous stylization that was to culminate in the German *Jugendstil* version of art nouveau. Many others followed the new vogue for the meaningful theme, but, like Böcklin, Uhde, and Klinger, clothed their ideal subject matter in the naturalistic form prevalent during the preceding decades.

In Munich these diverse trends acquired an unexpected forum with the founding of the Munich Secession in 1892,[44] an event that plunged Schwabing's artists' community into turmoil. The Munich Secession brought together artists dissatisfied with the exhibition policies of the Munich Artists' Association, policies jealously guarded by the city's "painter prince" Lenbach. They felt that the annual exhibitions at the Glass Palace were unjustifiably parochial

and included far too few works of true merit. Foreign artists, for instance, were invited only to the special international exhibitions that were generally held every four years. The Secessionists had three major goals: smaller exhibitions, works of higher quality, and annual participation by artists from abroad without regard to their form of artistic expression. The founding members of the Munich Secession were themselves a heterogeneous group. They included, besides Uhde and Stuck, Peter Behrens, Otto Eckmann, Thomas Theodor Heine, Adolf Hölzel, and Wilhelm Trübner. Their first exhibition, which opened June 15, 1893, in a newly erected building at the corner of Prinzregentenstrasse and Pilotystrasse, featured, in addition to their own work, paintings by such diverse artists as Böcklin, Liebermann, Puvis de Chavannes, Degas, Monet, and Carrière. In short, the Munich Secession accommodated virtually everything from Realism, Naturalism, and Impressionism to Symbolism and the budding *Jugendstil* movement.

Petty jealousies explain why several Secessionists, including Behrens, Eckmann, Heine, Trübner, and Schlittgen as well as Carl Strathmann and Max Slevogt, decided later the same year to form a separate Free Association.[45] Through Eckmann they secretly arranged with their old enemy, the Munich Artists' Association, to exhibit independently as a group under the auspices of the association's official program at the Glass Palace. When these plans were discovered, the Munich Secession reacted sharply to the defection and promptly purged its ranks of the offenders. Under pressure from conservative members, the Munich Artists' Association, in turn, was forced to withdraw its permission to exhibit at the Glass Palace, and the renegades thus found themselves between opposing camps. The Free Association was never successful. It held one exhibition in Munich and another, in the fall of 1894, at the gallery of Fritz Gurlitt in Berlin. Interestingly, future exhibitions were to have included a number of French painters of the avant-garde, as Eckmann informed Trübner in a letter dated February 21, 1894. According to this letter, Eckmann had contacted two *indépendants* who had promised to arrange for the submission of works by Anquetin, Toulouse-Lautrec, Gauguin, Denis, and others.[46] Although these names reveal Eckmann's own antinaturalist bias, the Free Association too was made up of artists pursuing a wide range of pictorial expression. Eckmann, whose work showed a growing tendency toward *Jugendstil,* and Trübner, a realist in the Leibl tradition, merely represent the divergent poles.

No wonder Corinth, who had just left the staid provincialism of Königsberg, compared the Munich art scene to a "swarming beehive." And as if his creative energy had been dammed up far too long, he joined passionately, if

not altogether altruistically, in the controversies surrounding the Munich Se-
cession and the ill-fated Free Association. "I was happily carried along in this
stream," he recalled in his memoirs, "proud to be respected as yet another
voice. Moreover, I had the intuitive feeling that as part of this clique I would
be able to get ahead." [47]

As a founding member of both the Munich Secession and the Free Associa-
tion, Corinth entered on a period of cultural politics that for the first time in
his career not only brought him face to face with a variety of modern trends
but also placed him in a competitive situation bound to make him keenly
sensitive to the goals of his own art. The fiasco of the Free Association gave
added direction to his intellectual development. After that episode had pitted
him against both the Munich Artists' Association and the Munich Secession,
he found more congenial company in the literary world. One of his closest
friends at this time was the Bavarian satirist Joseph Ruederer, who lived one
floor below Corinth's studio on Giselastrasse. Ruederer himself was the cen-
ter of a lively literary circle that included Max Halbe, Otto Erich Hartleben,
Eduard von Keyserling, and Frank Wedekind. The novels and plays these
men wrote were often given a first reading at informal gatherings. Corinth,
for instance, was present at the Café Minerva when Wedekind read from his
play *Sonnenspektrum*, and he also attended the tumultuous premier of *Erd-
geist*, the first of Wedekind's Lulu plays. Corinth's own impulse to write,
which eventually developed into a lifelong labor of love, clearly dates from
these years, for he began the first draft of his autobiography in 1892.

Corinth's output increased markedly in the 1890s, and the works he pro-
duced then reflect the artistic and intellectual milieu in which he lived. They
are indebted to several different models and vary greatly in subject matter,
conception, and execution. They also contain the seeds of elements that by
the end of the decade constituted the main features of a distinct style: a highly
energized and mood-inducing painterly treatment, audacious eroticism, and
deep psychological insight.

DIOGENES

Corinth's first major painting from Munich, *Diogenes* (see Plate 4), was the
most ambitious composition he had ever attempted, with no fewer than
twelve almost-life-size figures. Although the canvas bears the date 1892, Co-
rinth must have begun work on it soon after his arrival from Königsberg, for

the picture was being exhibited at the Munich Glass Palace by the end of 1891. The painting depicts the Cynic in the Athenian marketplace, his lamp lit in daylight, as he searches "for an honest man." The subject was especially popular in seventeenth-century Flemish painting. Jordaens depicted it several times, most notably in the large canvas now in Dresden. Corinth's version, however, recalls a lost composition by Rubens, a workshop copy of which is preserved in the Louvre. Corinth's intention to demonstrate again, as in the *Pietà*, his mastery of a large figure composition is evident from the calculated grouping of the figures so as to achieve a variety of postures and textures. Diogenes stands alone, holding up his lamp; the reactions of the eight figures before him range from amused curiosity to outright derision. The postures and gestures of the two naked urchins in the left foreground are sequential, the one leaning forward, supporting his hands on his knees, the other standing upright with arms upraised. The young woman in the center continues the movement, leaning back as she shields her mocking expression with her forearm. The picture opposes old faces to young ones, clothed figures to nudes. Diogenes' weathered old skin contrasts with the youthful skin of the two boys before him. The simplified figures of the nude children in the background similarly correspond to one another. As in the *Pietà*, the figures are illuminated by a strong light from the upper left. Rejecting the idealism with which subjects like this one were traditionally rendered, Corinth, moreover, went so far as to introduce figure types that might have been found in a Munich market square in the 1890s: the old woman with the basket and the couple standing at the far left. In recasting the subject in a naturalistic form, Corinth, like Böcklin, did not hesitate to translate the heroic into the commonplace. And Corinth's *Diogenes*, like Böcklin's work, was not accorded an entirely favorable reception. Indeed, one critic was so horrified by the bluish skin tones of Corinth's figures that he warned of the imminent demise of German art.[48]

BELATED RESPONSES TO MUNICH REALISM

The events surrounding the founding of the Munich Secession in 1892 brought Corinth into close contact with Wilhelm Trübner. Trübner, the only painter of the original Leibl circle still working in Munich, willingly shared his insights and knowledge with younger colleagues. As Corinth wrote in an article first published in 1913, he came to regard Trübner almost as a teacher: "I could

almost pride myself having been his pupil, if one can so call a relationship in which the older artist, drawing on his rich experience, generously gives advice to the younger, who respectfully follows such counsel."[49]

Through Trübner, Corinth was finally introduced to Munich realism of the 1870s, and several of his paintings from 1892 attest to this belated encounter with the Leibl tradition. One of these is the portrait of the landscape painter Benno Becker (see Plate 5). The modeling, especially in the face, is firm, and the dominating gray and white tones are subtly nuanced. Like Leibl's reverie pictures, which are themselves indebted to such French antecedents as Courbet's *After Dinner at Ornans* (1848; Musée des Beaux-Arts, Lille), the painting is half portrait and half genre subject. The sitter's actions emphasize the anecdotal conception of the painting, in contrast to Corinth's two preceding artist portraits of Carl Bublitz and Hugo Rogall (see Figs. 30, 31), in which the postures and gestures underscore the Bohemian character of the individuals portrayed. Yet the 1892 portrait does not lack characterization. The comfortable ambience reinforces the easygoing manner of the sitter; his amused expression suggests a perceptive, if somewhat irreverent, intelligence. Virtually forgotten today, Benno Becker (b. 1860), a native of Memel, was about two years younger than Corinth and played an active role in the Munich artists' community in the 1890s. He was the secretary of Allotria, the social club of the Munich Artists' Association, and later served as secretary of the Munich Secession. He had studied archaeology and art history and also had literary ambitions, writing for both *Die Freie Bühne* and *Pan.* His contributions to the festivities at Allotria include a parody of Goethe's famous Faust monologue that casts Corinth in the role of the seeker of knowledge and truth—pursuing far more earthly pleasures than Goethe describes.[50]

Corinth's encounter with the legacy of the Leibl circle led him to rededicate himself to subjects inspired by his environment and heightened his awareness of pictorial realism as a function of the medium itself. Several of his paintings from 1892 are technically similar to the portrait of Benno Becker. They include *Woman from Dachau Knitting* (B.-C. 93) and *Old Men's Home in Kraiburg* (B.-C. 94), both of which evoke the stillness and rural simplicity that pervade the interiors Leibl had painted during the 1870s and 1880s in Bavarian villages. Other paintings signal a growing reliance on a rapid, sketchy execution that, while still in the service of description, plays more than a purely illustrative role. *At the Breakfast Table* (Fig. 37) is one of these pictures. Here the paint has been applied freely, and the shapes have been simplified and blocked out in bold brushstrokes. Corinth painted the picture during one of his visits to the small Bavarian town of Dachau, where in 1888 Arthur Langhammer together with Adolf Hölzel and Ludwig Dill had founded the artists'

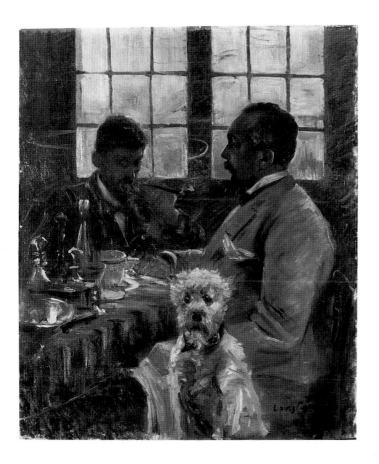

FIGURE 37.
Lovis Corinth, *At the Breakfast Table*,
1892. Oil on canvas, 113 × 95 cm, B.-C.
92. Private collection. Photo courtesy
Eberhard Ruhmer.

group Neu-Dachau. The painting ostensibly depicts Arthur Langhammer
(1855–1901), at left, in the company of another painter named Brand,[51] whose
identity, however, is not known. What interested Corinth here was neither
the individuality of the two men nor the specifics of the setting but the at-
mospheric ambience of the room, whose smoky air is as tangible as the light
that reflects off the objects on the table. Seen against the bright expanse of the
window, the faces of the sitters show relatively little detail. Only Langham-
mer's dog Hipp, whom Corinth commemorated the same year in a separate
painting (B.-C. 91), retains his characteristic expression and appearance.[52]

In the small picture of a slaughterhouse interior (see Plate 6) the sketchy brushwork acquires the visceral expressiveness now recognized as a distinctive feature of Corinth's mature style. Although the painting emphasizes the physical action of the butchers who skin and dress the slaughtered animals, their activity is subordinated to the life of the colors, shades of red shot through with blue, green, yellow, and white. The suspended carcasses dominate the composition, and the swirling brushstrokes, as suggestive as they are descriptive, unify the canvas. In the bright light from the window at the back of the room, the blood rising from the floor and the opalescent entrails give off palpable heat and smells.

FIRST MAJOR LANDSCAPES

Corinth's tendency to subordinate individual forms to a larger whole may have been a consequence of his growing interest in landscape painting. For in outdoor light he faced a wealth of nuances that demanded to be unified within a broad spatial concept. He responded with vibrant tones that translate light and atmosphere into elements of pictorial energy. Corinth's earlier landscapes are informal studies, undertaken largely as exercises. His landscapes from the 1890s, by comparison, result from a serious and sustained commitment to plein air painting.

Corinth's major landscapes begin with the view he painted in the autumn of 1891 from the window of his studio (see Plate 7). With this painting he continued the German Romantic theme of the "open window," though his reinterpretation of the subject is prosaic, like Menzel's window views in Berlin and Winterthur. Across the gardens and fields that at the time gave Schwabing a rural character, the view extends to church towers and smoking chimneys in the distance. White patches of an early snow intermingle with the green of the meadows, and in the humid air the soil and trees take on a reddish tone. The simplified composition evolves from variations of the surface texture, and both the direction of the brushstrokes and the impasto of the swiftly applied patches of color suggest that the motif was constructed right on the canvas.

Most of Corinth's landscapes from this time were painted during the summer months he spent in the picturesque countryside near Munich. They show a considerable debt to the paintings of the Barbizon school, which after the international exhibition in 1869 had helped to redirect Munich landscape painting, encouraging a more intimate conception of nature in contrast to the

Dutch-inspired vistas popular during the first half of the century. The paint-
ers of the Leibl circle, in particular, gave the simplest motif—a clearing in the
underbrush or a cluster of shrubs and trees by a brook or a pond—careful
and sympathetic attention. Corinth's forest interiors from this time show
a similarly circumscribed view. One, the splendid picture now in Dachau
(Fig. 38), is painted so freely that the canvas is almost a flickering patchwork
of brushstrokes. The others are more controlled and elegiac in mood. The
technical and expressive range of these landscapes is illustrated by the paint-
ing in Dachau and the *Large Landscape with Ravens* (Fig. 39) of the same year.
The forest scene is a spontaneous visual response to the evanescent effects of
bright sunlight breaking through foliage; the landscape indicates a more de-
liberate approach, with its simplified composition and the predominant
shades of purple that reinforce the autumnal mood. As in Caspar David
Friedrich's well-known picture in the Kunsthalle in Hamburg, *Hill and Ploughed
Fields near Dresden* (c. 1830s), which Corinth's landscape also resembles struc-
turally, the ravens settle on the harvested fields like harbingers of winter and
approaching death.

Corinth's melancholy conception was apparently inspired by the moody
landscapes of Walter Leistikow (1865–1908), with whom he sometimes
painted in the fall of 1893 near Dachau and at the Starnberger See. Earlier in
the year Leistikow had been to Paris, where he was deeply moved by a per-
formance of Maurice Maeterlinck's *Pelléas et Mélisande* at Lugné-Poé's newly
opened Théâtre de l'Oeuvre. Summarizing his impressions of the play, he
wrote in the July issue of *Die Freie Bühne*: "I do not know of anyone who can
wield the brush better than this poet. His works are spoken painting. And
this performance is one of the greatest works of painting the modern period
has brought forth."[53] At the time, Leistikow himself was in the process of
abandoning his naturalistic approach to landscape painting in favor of a more
evocative rendering. Using simplified patterns of muted colors, he gradually
evolved a pictorial language that conveys a gentle and somber mood, as in his
landscapes of the Grunewald (Fig. 40), in which dark groups of trees stand
silently, silhouetted against the sky and reflected in the waters of a quiet lake
or pond.

Leistikow's influence is also evident in the haunting *Fishermen's Cemetery at
Nidden* (see Plate 8), painted in the summer of 1894 when Corinth traveled to
East Prussia and the Baltic seashore. The melancholy character of the painting
derives not only from the motif but also from the pictorial elements. As in the
autumnal landscape in Frankfurt, purplish tones dominate the variegated col-
ors of the sandy soil. Most of the crosses are painted in somber shades of blue

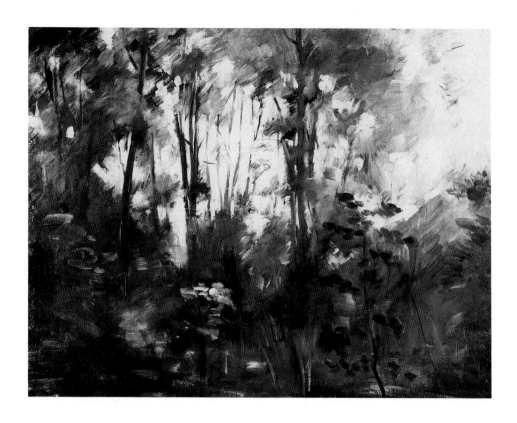

FIGURE 38.
Above: Lovis Corinth, *Forest Interior near Dachau*, 1893. Oil on canvas, 67 × 86 cm, not in B.-C. Kunstsammlungen der Stadt Dachau.

FIGURE 39.
Opposite, top of page: Lovis Corinth, *Large Landscape with Ravens*, 1893. Oil on canvas, 94.5 × 120 cm, B.-C. 100. Städelsches Kunstinstitut Frankfurt (1912). Photo: Ursula Edelmann.

FIGURE 40.
Opposite: Walter Leistikow, *Lake in the Grunewald*, c. 1895. Oil on canvas, 167 × 252 cm, Staatliche Museen zu Berlin, National-Galerie (DDR).

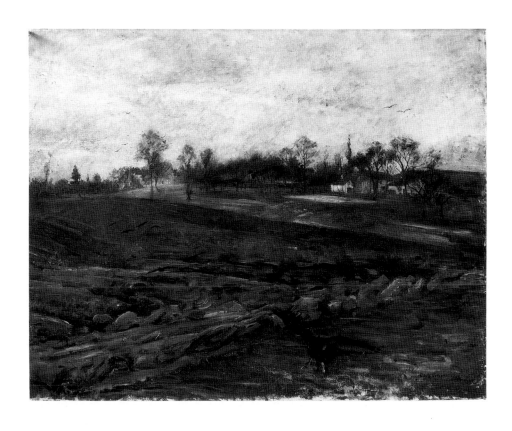

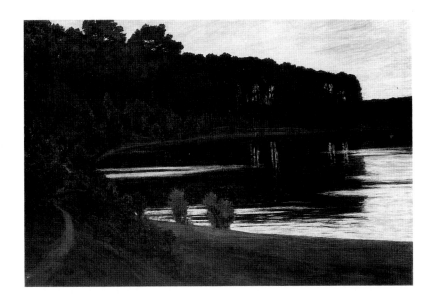

and brown. Only one grave is still tended; the others lie neglected. Here and there flowers survive among the weeds. There is a strangely anthropomorphic quality to the crosses, which almost seem to gaze out to sea. As in the paintings by Caspar David Friedrich in which human figures, seen from the back, stand transfixed before nature, the viewer's feelings are directed beyond the graves to the open water, where boats glide smoothly along the shore.

OTTO ECKMANN AND CARL STRATHMANN

Leistikow's evocative approach to landscape painting touched Corinth at a point in his development when two other friends, Otto Eckmann (1865–1902) and Carl Strathmann (1866–1939), both members of the Munich Secession and subsequently the Free Association, were evolving a radically simplified vocabulary of form. Although Corinth's own creative impulses pointed toward an ever more energetic naturalistic conception, he had some sympathy for his friends' increasingly linear inventions.

Eckmann's early paintings are landscapes similar to Leistikow's in form and expression. But after 1890 he simplified the forms of nature in a way that reveals a strong predilection for ornament. *The Four Ages of Man* (present whereabouts unknown), six panels completed in 1894, was one of his most ambitious works. To demonstrate the parallelism between the life of nature and of man, Eckmann set each of the four inner scenes in an appropriate season of the year and in the outer panels depicted emblematic images of the beginning and end of life: a young plant rising under the first rays of the springtime sun and a dying plant in a winter landscape. With naturalistic modeling and emphatic contours Eckmann trapped the individual forms in a shallow, tapestry-like space. *The Four Ages of Man* turned out to be his last painting. In 1893 Justus Brinckmann, then director of the Museum for Arts and Crafts in Hamburg, had introduced Eckmann to Japanese woodcuts. Their simplified drawing and compositional devices so affected the painter that on November 27, 1894, he auctioned off his entire oeuvre and devoted himself henceforth to the art of graphic design. Many of his woodcut illustrations were published in such journals as the erudite quarterly *Pan* and the popular Munich weeklies *Jugend* and *Simplizissimus*. From evocative lines and arabesques Eckmann developed a repertory of forms that came to be known as floral *Jugendstil* because of its stylized flowers and plants. The style influenced a host of German designers.[54] According to Ahlers-Hestermann, Eckmann had read Schopenhauer, Nietzsche, and Kant and in general was "spiritually more demanding than his easily satisfied colleagues."[55] An analogous pictorial rigor distinguishes

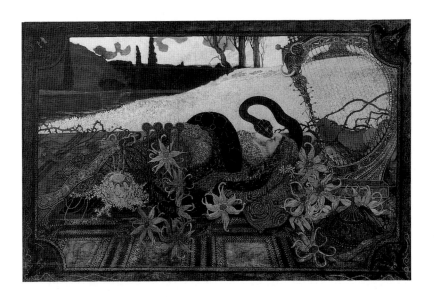

FIGURE 41.
Carl Strathmann, *Salammbô*, 1894–1895.
Mixed media on canvas, 187.5 × 287.0
cm. Kunstsammlungen zu Weimar.

Eckmann's abstractions, especially in comparison with the bizarre imagery of
Carl Strathmann.

Strathmann's curious work occupies an intermediate position between the
art of painting and the crafts. His paintings are strange concoctions studded
with colored glass and artificial gems, foreshadowing similar extravagances
by the Viennese *Jugendstil* painter Gustav Klimt. In Strathmann's painting *Sa-
lammbô* (Fig. 41), inspired by Flaubert's novel, the Carthaginian temptress re-
clines on a carpet spread out on a flower-strewn meadow. Swathed in veils
whose design is as complex as that of the harp beside her head, she submits
to the kiss of the mighty snake that encircles her. Corinth described how
Strathmann, while working on the large picture, gradually covered the origi-
nally nude model with "carpets and fantastic garments of his own invention
so that in the end only a mystical profile and the fingers of one hand pro-
truded from a jumble of embellished textiles. . . . colored stones are sparkling
everywhere; the harp especially is aglitter with fake jewels." According to
Corinth, Strathmann knew "how to glue and sew" these on the canvas "with
admirable skill." [56]

As Corinth's three closest friends embarked on their individual pictorial explorations, Corinth himself experienced a minor crisis that made him unusually receptive to their experiments. Still dissatisfied with his handling of anatomy in *Diogenes* and the *Pietà*, he felt he needed further practice in drawing from the live model. Eckmann, whom Corinth fondly remembered as his "spiritus rector," who supported and steadied him whenever he was in danger of losing his footing,[57] suggested that he try making some prints; Corinth began a series of studies that eventually resulted in his first graphic cycle, *Tragicomedies*, nine etchings completed in 1893 and 1894. Working "daily, for months on end, . . . with individual figures and groups of several models," he was so taken with this project that he, too, was tempted to give up painting for good.[58] Corinth had in mind for the cycle motifs of "eccentric originality," as he put it, with which he hoped to astonish and impress his colleagues.[59] His professed intention explains both the odd emblematic details in some of the compositions and the farcical tone that turns each episode into a true tragicomedy, no matter how serious the subject. The cycle has no thematic unity. Instead, the illustrations follow in random succession.

The first etching in the series, *Walpurgis Night* (Fig. 42), is based on Goethe's description of the witches' nocturnal ride to the Brocken, their annual meeting place in the Harz Mountains. Faintly visible in the background, old Dame Baubo on her sow and several other shadowy figures on brooms hurry through the sky as four youthful witches, accompanied by a flock of ravens, encircle a skull suspended in midair. A shooting star streaks through the sky at the upper right. Surviving drawings for the cycle indicate that Corinth prepared the etchings with considerable care. He began with quick preliminary sketches and then drew the individual figures from the model, subsequently incorporating these studies into a more finished composition drawing for transfer to the copper plate. In *Walpurgis Night* the postures of the floating witches can still be recognized as positions assumed by the models in the studio, standing, sitting, or lying down. There is special emphasis on the contours, and strong contrasts of light and shade render the major figures fully tangible. The composition itself, however, is simplified and derives its effect from the silhouette formed by the interlocking figures. This stylistic ambivalence recalls Stuck's *Guardian of Paradise*, and in the second etching of the cycle, *Paradise Lost* (Fig. 43), the angel's arm from Stuck's painting reappears with only minor modifications. As in the preceding print, the fully modeled figures form a striking pattern against the white paper ground.

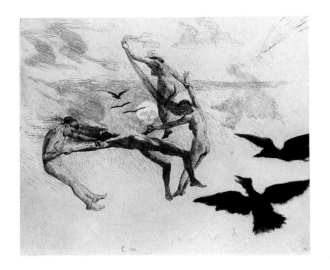

FIGURE 42.
Lovis Corinth, *Tragicomedies: Walpurgis Night*, 1893. Etching, 34.2 × 41.7 cm, Schw. 5 II. Graphische Sammlung Albertina, Vienna (1910/406/5).

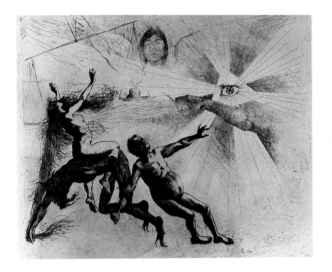

FIGURE 43.
Lovis Corinth, *Tragicomedies: Paradise Lost*, 1893. Etching, 35.0 × 41.8 cm, Schw. 5 III. Graphische Sammlung Albertina, Vienna (1910/406/4).

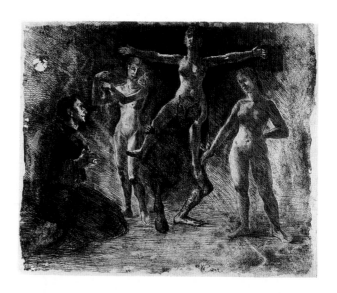

FIGURE 44.
Top of page: Lovis Corinth, *Tragicomedies:
The Temptation of Saint Anthony,* 1894.
Etching, 34.3 × 42.2 cm., Schw. 5 IV.
Graphische Sammlung Albertina, Vienna
(1910/406/8).

FIGURE 45.
Above: Lovis Corinth, *Tragicomedies: The
Women of Weinsberg,* 1894. Etching, 35.0
× 42.5 cm, Schw. 5 VII. Graphische
Sammlung Albertina, Vienna
(1910/406/6).

Here, however, the stylistic ambiguity of the composition is intensified by the emblematic imagery: a large eye in the center of a triangle, symbolizing the Holy Trinity, radiates beams of light; the powerful arm of an otherwise unseen angel brandishes a flaming sword; and the figure of Saint Michael holds aloft the scales that weigh the moral frailty of the human heart.

Three of the five remaining narrative episodes of the cycle have greater stylistic unity. In each of these the naturalistic portrayal of the figures is matched by an appropriately atmospheric setting. *The Temptation of Saint Anthony* (Fig. 44) was clearly inspired by Félicien Rops's woodcut of the same subject. The elongated faces and caps of the men in *The Women of Weinsberg* (Fig. 45) recall similar features in paintings by Dirk Bouts. This print depicts the amusing story told about the siege of the Bavarian town of Weinsberg in 1140, when the Hohenstaufen enemy Conrad III accepted the surrender of the town on the understanding that only the women would be spared; they were allowed to leave the town with whatever they could carry. The resourceful women met the conditions of the agreement by marching forth with their husbands on their backs. In the more familiar subject *Marie Antoinette on Her Way to the Guillotine* (Fig. 46) the unfortunate queen sits stiffly upright in a cart surrounded by a jeering mob. This print would seem to presuppose knowledge of the famous sketch, now in the Louvre, in which Jacques Louis David recorded Marie Antoinette's last journey.

The tension between naturalistic modeling and flat decorative elements is again evident in *Joseph Interprets the Pharaoh's Dreams* (Fig. 47) and *Alexander and Diogenes* (Fig. 48). Amid the splendor of the king's palace Joseph strikes a lively pose as he interprets the dreams of the seven lean years of corn following the seven abundant years. The idea of illustrating the dreams in the diaphanous roundels visible in the archway may have been inspired by Peter von Cornelius's painting of the same subject in the fresco cycle for the Casa Bartholdy in Rome, transferred to the National Gallery in Berlin around 1886. The story of Alexander's encounter with Diogenes is told by Plutarch and Diogenes Laërtius, both of whom describe how Alexander once invited the philosopher to ask any favor. Diogenes, who despised all worldly possessions to the extent of making his home in a tub, requested that Alexander step aside, since the king was shading him from the sun. The rigid figures of Alexander's soldiers form an ornamental screen behind the two men—an amusing contrast with their own relaxed postures. Analogous contrasts in the other prints produce the same effect. For example, against the noble emblem of the all-seeing eye of God the fat figures being carried off by Lucifer appear doubly grotesque; the repose of Pharaoh and his queen intensifies the lively gestures

FIGURE 46.
Top of page: Lovis Corinth, *Tragicomedies:*
Marie Antoinette on Her Way to the
Guillotine, 1894. Etching, 35.0 × 42.3 cm,
Schw. 5 VIII. Graphische Sammlung
Albertina, Vienna (1910/406/7).

FIGURE 47.
Above: Lovis Corinth, *Tragicomedies:*
Joseph Interprets the Pharaoh's Dreams,
1894. Etching, 34.4 × 42.3 cm, Schw. 5 V.
Landesmuseum Mainz, Graphische
Sammlung.

FIGURE 48.
Lovis Corinth, *Tragicomedies: Alexander
and Diogenes*, 1894. Etching, 34.8 × 42.3
cm, Schw. 5 VI. Städtische Galerie im
Lenbachhaus, Munich.

of the jabbering Joseph; and there is no doubt that the hefty women of
Weinsberg are fully up to the task of rescuing their skinny husbands, while
Marie Antoinette seeks to preserve an air of dignity amid the throng.

The title page of the cycle (Fig. 49) is the most stylized of the nine etchings
and sets the tone for the mocking conception that underlies the individual
episodes. Within a frame of predominantly geometric design, Clio, the muse
of history, lifts a curtain to reveal a human skeleton. In the surmounting arch
an enormous face appears, seen from below in strong foreshortening, its
large nose sniffing greedily at a blossom that rises from the panel below. The
arbitrary choice of the themes is summed up in the closing vignette (Fig. 50).
Here a spider in the center of a web contentedly surveys its catch: the flies
trapped in the threads.

Two rapidly sketched pencil drawings now in East Berlin, *The Rape of the
Sabine Women* and *The Prodigal Son*, belong to the themes from which Corinth
assembled *Tragicomedies*, although the episodes themselves were not included
in the cycle. They illustrate the kind of first ideas that preceded the etchings.
Of the two, *The Prodigal Son* (Fig. 51) shows especially well that a humorous
conception guided Corinth from the beginning, for here his last painting from
Königsberg (see Fig. 35) has been turned into a ludicrous persiflage.

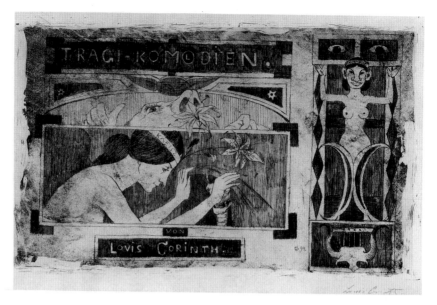

FIGURE 49.
Lovis Corinth, *Tragicomedies:* Title Page,
1894. Etching, 21.0 × 34.5 cm, Schw. 5 I.
Städtische Galerie im Lenbachhaus,
Munich.

It has been suggested that the etchings of *Tragicomedies* were influenced
by Max Klinger's treatise *Malerei und Zeichnung* (Leipzig, 1891),[60] in which the
expressive properties of painting are distinguished from those of the graphic
arts. The eccentric character of the cycle indeed suggests that Corinth was
familiar with Klinger's idea that whereas painting is bound to the material
aspects of things, drawing offers the freedom of poetic license.[61] It is logical to
assume that as Corinth learned the technique of etching, he familiarized him-
self with the thinking of a recognized master in the field. Moreover, since
meeting Klinger in Berlin in the winter of 1887–88 he most likely followed his
work with interest and knew some of the views Klinger expressed privately,
such as the notion that by "placing a carefully modeled object against an un-
definable or neutral background," the graphic medium could "depict ele-
ments of fantasy that painting can command only under certain conditions."[62]
Both *Walpurgis Night* and *Paradise Lost* reflect that approach. But even though
the cycle conforms to Klinger's contention that "all graphic artists develop in
their work a notable tendency toward irony, satire, and caricature,"[63] Corinth
clearly did not share Klinger's underlying ethical disposition. Klinger believed
that graphic artists "prefer to accentuate weaknesses. . . . from their work
rises nearly always one fundamental chord: the world should not be like

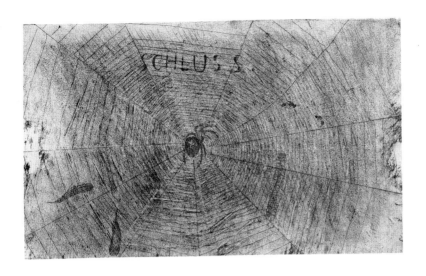

FIGURE 50.
Top of page: Lovis Corinth, *Tragicomedies:*
End Page, 1894. Etching, 21.0 × 34.9 cm,
Schw. 5 IX. Graphische Sammlung
Albertina, Vienna (1910/406/9).

FIGURE 51.
Above: Lovis Corinth, *The Prodigal Son,*
1894. Pencil, 25.6 × 34.4 cm. Staatliche
Museen, Berlin (DDR) (11/6291).

this!"[64] As Corinth himself admitted, *Tragicomedies* was not meant to be critical but "eccentric," and—as the concluding vignette of the cycle illustrates unequivocally—he never pretended to have selected his motifs out of a deeply felt ethical commitment.

In the final analysis, *Tragicomedies* marks an important stage in Corinth's development, for in this cycle he first found the irreverent tone that was to set his mature figure compositions apart from his plodding student work. And he soon learned that the "eccentric originality" with which he had intended to astonish and impress his fellow artists in Munich could also gain him the attention of the public at large. When Corinth exhibited the etchings at Eduard Schulte's gallery in Berlin in the winter of 1894–95, one critic went so far as to rank him with Max Klinger as a printmaker. Calling Corinth a "visionary realist," the same critic praised the cycle for its "raw and instinctual naïveté."[65]

THE TEMPTATION OF *JUGENDSTIL*

Whereas the *Tragicomedies* cycle remains for the most part stylistically ambivalent, a large number of postcards, addressed to Joseph Ruederer and now preserved in the manuscript collection of the Municipal Library in Munich, illustrate the extent to which Corinth allowed himself to be seduced by the radically simplified pictorial language of Eckmann and Strathmann. Datable to the years 1896 to 1898, some of these postcards also bear greetings from Strathmann and may well have been illustrated in collaboration with him (Figs. 52, 53). A strong element of design is common to most of the imagery, as well as a naive, at times even coarse, humor that suggests caricature played an important part in Corinth's exploration of the formal idiom of *Jugendstil*. In a whimsical sketch of about 1896 (Fig. 54), which shows the full-length figure of Benno Becker, a self-portrait in the upper right, and the heads of two other painter friends, Friedrich Wahle (1863–1927) in the upper left and Hermann Eichfeld (b. 1845) in the lower right, Becker's countenance has been transformed into a bizarre configuration of curvilinear patterns and capricious arabesques. Though far removed from the trenchant characterizations of Thomas Theodor Heine and Olaf Gulbransson, whose irreverent parodies appeared regularly in *Jugend* and *Simplizissimus,* the caricature nonetheless approximates their sophisticated use of line.[66]

Ordinarily Corinth's modified naturalism took a less extreme form. In *Faun and Nymphs* (Fig. 55), one of several illustrations he published in the early is-

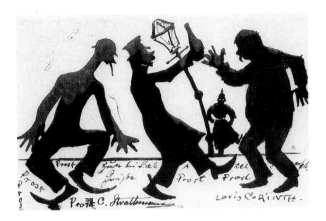

FIGURE 52.
Lovis Corinth (and Carl Strathmann?),
Postcard to Joseph Ruederer, 1897. Pen
and ink, 8.9 × 14.0 cm. Stadtbibliothek,
Handschriften- und Monacensia-
Abteilung, Munich.

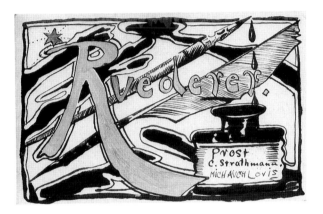

FIGURE 53.
Lovis Corinth, Postcard to Joseph
Ruederer, 1897. Pen, brush, and ink,
8.9 × 14.0 cm. Stadtbibliothek,
Handschriften- und Monacensia-
Abteilung, Munich.

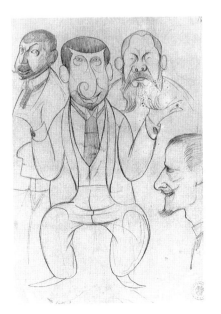

FIGURE 54.
Lovis Corinth, *Caricatures*, c. 1896.
Pencil, 32.6 × 23.7 cm. Formerly
Collection Johannes Guthmann,
Ebenhausen; present whereabouts
unknown. Photo courtesy Hans-Jürgen
Imiela.

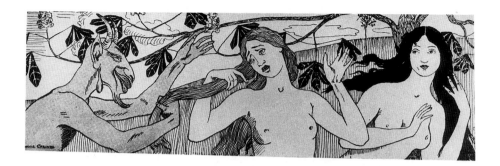

sues of *Jugend*, the landscape has been reduced to a flat background, but the figures, even though there is little modeling, retain mass and weight. They are bound by emphatic contours and linked by a measured flow of gestures, resulting in a eurythmic movement that is predominantly decorative in effect.[67] Closely related to the drawings for *Jugend* are Corinth's illustrations for a collection of short stories by Joseph Ruederer, entitled *Tragikomödien*, published in 1897. In the vignettes simplified figural motifs based on silhouetted forms are framed by floral borders. The full-page illustrations to the individual stories are less stylized but always accentuate the two-dimensional character of the pictorial field.[68]

In *Resurrection* (Fig. 56), one of two closely related drawings of this subject from 1896, Corinth applied the same decorative convention to the biblical motif. The horizontal tomb, placed before a simplified landscape, is guarded by three sleeping soldiers. Supported by two flanking angels, Christ stands in the center, erect and with arms outstretched, his attenuated body compartmentalized as in stained glass or cloisonné enamel. All the figures float weightlessly in a shallow, frieze-like space.

Although Corinth's use of *Jugendstil* formal elements is most evident in his graphic works, his paintings were not entirely immune to the prevailing taste for simplified pictorial structures. But in them the tendency to abstract the forms of nature is always held in check by Corinth's observation of the model, resulting in the stylistic ambiguity already noted in the discussion of *Tragicomedies*. In the small canvas *Adam and Eve* (B.-C. 101), for example, painted in 1893, Corinth subtly stylized the two nude figures without departing from anatomical plausibility. The postures and gestures, however, were contrived so as to form a harmonious pattern against the flat backdrop of the meadow. Two pictures of 1895, *Autumn Flowers* (B.-C. 123) and *Dance of Spring* (B.-C.

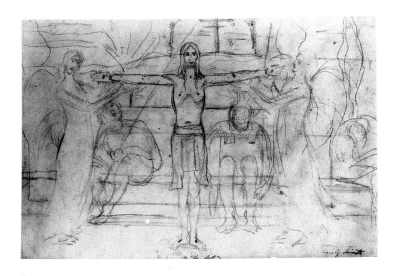

FIGURE 55.
Opposite: Lovis Corinth, *Faun and Nymphs,* 1896. Pen and ink. From *Jugend,* November 28, 1896, p. 456. Photo: Horst Uhr.

FIGURE 56.
Above: Lovis Corinth, *Resurrection,* 1896. Pencil, 30.6 × 46.5 cm. Staatliche Museen, Berlin (DDR) (21/6292).

124), employ the same vertical, flower-strewn space, as does *Nude Girl by the Water* (B.-C. 142) of 1897, a painted version of the illustration Corinth had published in *Jugend* the previous year. *Trifolium* (1897; B.-C. 151) and *Joy of Life* (1898; B.-C. 153) are compositions based on a similarly flowing rhythm of the figures' gestural lines.

The portrait Corinth painted in 1897 of his friend Otto Eckmann (Fig. 57) is of special interest in this context, for here the stylistic features are also the specific attributes of the sitter. The uncial lettering of the inscription along the lower edge of the narrow canvas alludes to the studies Eckmann had begun in an effort to develop a typographic design in harmony with his *Jugendstil* borders and illustrations. Standing before a shallow ground, Eckmann holds a flower signifying his role as the creator and chief exponent of floral *Jugendstil.* The face is meticulously modeled, but the rest of the figure is simplified.

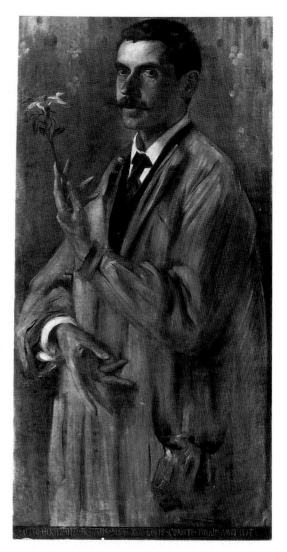

FIGURE 57.
Lovis Corinth, *Portrait of Otto Eckmann*, 1897. Oil on canvas, 110 × 55 cm, B.-C. 141. Hamburger Kunsthalle, Hamburg. Photo: Ralph Kleinhempel.

The ritualistic gesture of the attenuated hands adds a ceremonial touch to Eckmann's demeanor, an impression reinforced by the voluminous folds of the smock, so that the painter has the air of a celebrant of some new aesthetic creed.

The stylistic ambivalence of this and other paintings from the 1890s suggests that in pursuing the pictorial conventions of *Jugendstil*, Corinth simply undertook an exercise in a spirit of camaraderie—allowing himself to be "carried along in this stream," as he put it.[69] Apparently recognizing that he could not reconcile his own strong inclination toward naturalism with the

FIGURE 58.
Above: Lovis Corinth, *Deposition*, 1894.
Etching, 13.0 × 14.5 cm, Schw. 9.
Städtische Galerie im Lenbachhaus,
Munich (G4.515).

FIGURE 59.
Left: Lovis Corinth, *Good Friday*, 1894.
Lithograph, c. 32 × 28 cm, Schw. L8.
Orlando Cedrino, Munich.

decorative idiom of Eckmann and Strathmann, he abandoned his original
intention to print the *Deposition* (Fig. 58) in a specially designed rectangular
lithographic frame (Fig. 59). Instead, he printed the etching separately and
subsequently used the lithographic frame for the image of a nude girl in bed,
a substitution that implies a notable indifference on his part toward the reli-
gious motif. The ecstatic posture and expression of the model, copied from
the painting of a full-length reclining nude of 1893 (B.-C. 109), strike a par-
ticularly odd note in conjunction with the inscription "Good Friday" just
above the frame.

Despite his nonchalance about religious subjects, Corinth returned to the subject of the Deposition in 1895 and explored the multifigure composition of the etching on a more ambitious scale. Although the octagonal field of his large painting (Fig. 60) recalls similar framing devices by Carl Strathmann, he subordinated it to the composition so that neither the naturalistic execution nor the pathos of the conception is diminished. The figures in the foreground, reminiscent of the proletarian types in Fritz von Uhde's religious paintings, are life-size. The compressed space of the print has given way to a more ample grouping, with Christ at the center of a circle formed by the other figures. Mary occupies the same position as in the etching; Joseph of Arimathea helps to support the dead Christ and kisses a corner of the veil draped over Jesus' head; Nicodemus looks on; and John holds the shroud on which the body is laid. Christ's rigid limbs provide a grim counterpoint to the tormented embrace of the grieving Magdalene, now a sensuous nude with long, flowing hair, who presses close to him.

Corinth explained that in this painting he sought to emulate the tight pictorial structure of Mantegna's half-length figure compositions.[70] He also drew on several other sources that happened to be at hand. The anguished gesture of the Magdalene seems to have been derived from that of Rubens's Magdalene in *Christ and the Penitent Sinners* in the Alte Pinakothek, and Corinth's *Deposition* is related thematically and formally to Liberale da Verona's *Entombment*, also in Munich.[71] Liberale's linear style, like that of Mantegna and Botticelli, was popular in the 1890s, and the painting in the Alte Pinakothek was one of Corinth's favorites. Whenever he visited the museum, he made a point of seeing this picture first.[72] Years later, in his teaching manual, he reproduced a detail of Liberale's *Entombment*—cropped so that the figures are shown just down to the waist—to illustrate his discussion of facial expression and gesture.[73]

As with the painstakingly composed *Pietà* in 1890, Corinth's efforts were rewarded. The *Deposition* won a gold medal at the Munich Glass Palace in 1895 and was well received when shown at the international exhibition in Berlin the following year. A reviewer of the Berlin exhibition noted the truth and sincerity of the religious feeling he felt the painting expressed.[74] Corinth, however, seems to have maintained a casual attitude toward the subject, for in a caricature preserved in the Lenbachhaus, he transposed the painting into a ludicrous farce.[75] Self-irony may have led him to mock his own ambition in this way, especially since the *Deposition* turned out to be more than a fleeting

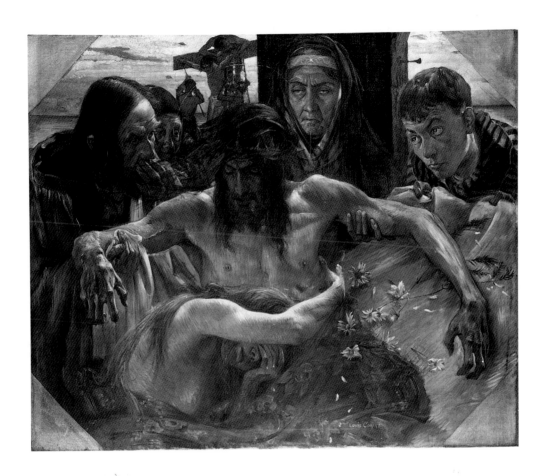

FIGURE 60.
Lovis Corinth, *Deposition*, 1895. Oil on
canvas, 95 × 120 cm, B.-C. 125. Wallraf-
Richartz-Museum, Cologne. Photo:
Rheinisches Bildarchiv.

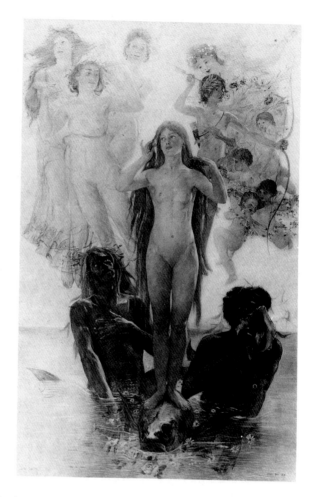

success. Soon after the painting was shown in Berlin, Corinth sold it to Martin Feuerstein for the substantial sum of 1,350 marks. Feuerstein was himself a painter of religious subjects and later taught this genre at the Munich Academy. With this sale Corinth, then thirty-eight years old, made money from his art for the first time. As he confided to Paul Eipper many years later, henceforth he superstitiously made the purchase price of the *Deposition* the basis of all his price calculations, dividing or multiplying it as the occasion demanded.[76]

The success of the *Deposition* greatly strengthened Corinth's self-confidence. In 1896 he accepted his first student, Rudolf Sieger, and in quick succession completed three more ambitious multifigure compositions. As in the *Deposition*, he assured himself of the authority of tradition by drawing on several well-known earlier prototypes, which he updated in terms of more recent popular trends. The remote source of inspiration for the life-size *Birth of Venus* (Fig. 61) was no doubt Botticelli's famous painting in the Uffizi,

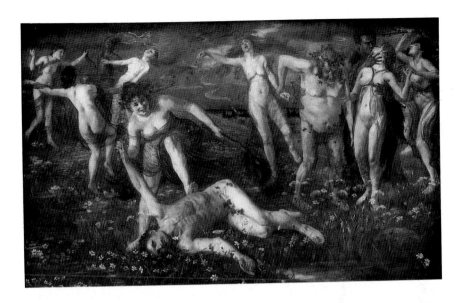

FIGURE 61.
Opposite: Lovis Corinth, *Birth of Venus,*
1896. Oil on canvas, 227 × 142 cm, B.-C.
132. Present whereabouts unknown.
Photo: Bruckmann, Munich.

FIGURE 62.
Above: Lovis Corinth, *Bacchanal,* 1896. Oil
on canvas, 118.7 × 201.0 cm, B.-C. 131.
Städtisches Museum Gelsenkirchen.
Photo: Dieter Grundmann.

modified by the memory of Bouguereau's composition of 1879 (Musée d'Orsay,
Paris), which includes the Triton sounding a conch shell, the frolicking putti,
and the cupid with bows and arrows. Some of the details are found in Böcklin's
Magna Mater fresco of 1868 in Basel and the same painter's *Venus Anadyomene*
of 1872–1873 (private collection), as is the expressive dolphin, to which Co-
rinth added four adolescent female genii. Illuminated from both the right
and the left and set off against a bright ground, the dark-skinned Tritons and
especially the figure of Venus are carefully modeled, evidence of Corinth's
continuing practice of preparing his figure compositions by drawing and
painting directly from the nude.

The *Birth of Venus* remains well within the conventions of academic de-
corum, but in the *Bacchanal* (Fig. 62) Corinth's conception is so broadly comic
that the painting parodies the sources that inspired it. The compositional for-
mat is dependent on Bouguereau's *Education of Bacchus* (1884; private collec-

tion), from which the two bacchants in the foreground have been taken with only minor modifications. Rubens's *Drunken Silenus* in the Alte Pinakothek provided the model for the group in the right half of the painting. The burlesque conception recalls similarly humorous mythologies by Böcklin as well as Corinth's own *Tragicomedies.* In a second bacchanal picture of 1896 (B.-C. 130) Corinth simplified the composition but further accentuated the bawdy humor of the procession. Silenus and his attendants are now the only important figures. They are seen from close up and are silhouetted against the sky, further emphasizing their coarse demeanor and ungainly appearance.

IN THE SIGN OF THE SUPERMAN

The aggressive sensuality of Corinth's bacchanalia can be related to the Nietzschean theory of instinctual man,[77] which inspired belief in the supremacy of instinct over reason. This theory also lay behind Stuck's famous drawing of the mythological goat-god that appeared on the cover of the first issue of *Pan* in April 1895. Announcing the advent of a new man who will rise above bourgeois conventions, this issue also printed several excerpts from Nietzsche's *Also Sprach Zarathustra.* Since the original *Pan* circle—founded in 1892 in the Berlin café Zum schwarzen Ferkel—included both Otto Erich Hartleben and Walter Leistikow, Corinth may well have been aware of this belief in a restorative vitalism as early as 1893. He may also have known of the "classical" *Fasching* parties that Stefan George and Karl Wolfskehl staged in the early 1890s in Wolfskehl's Munich apartment. George would dress up as Julius Caesar or Dante, and Wolfskehl himself once appeared as Dionysus. Perhaps Corinth even met George, who is said to have had frequent contact in 1894 with Thomas Theodor Heine, Hermann Schlittgen, and Otto Eckmann.[78] Be that as it may, Corinth's bacchanalia are a far cry from George's and Wolfskehl's "almost pedantically pedagogic . . . demonstrations of the Nietzschean idea of creative inspiration through Bacchic ecstasy."[79] Like Stuck's equally drastic exaggerations, which elicited from Julius Meier-Graefe the observation that this painter "makes sphinxes out of waitresses and waitresses out of sphinxes,"[80] they belong to the less lofty ambience of the Munich Artists' Association's costume parties like the one organized for February 15, 1898, when under the motto "In Arcadia" the entire Bavarian court theater was transformed into the setting for a "classical carnival." For the stage Lenbach had designed a series of temple fronts behind which emerged the Athenian Acropolis. A statue of Dionysus standing inside a rose arbor occupied a prominent place in the fore-

ground, in conspicuous contrast with a replica of Phidias's Athena Promachos at the far back of the stage. The costumes, while intended to be archaeologically correct, looked comically out of date on the decidedly unclassical wearers.[81] Indeed, an account of the revelers' entrance parade into the theater captures just as fittingly the spirit of Corinth's paintings: "First there came bacchants and satyrs, a prankish lot, red-nosed and big-bellied old men with wine jugs and pouches, followed by cloven-footed, bleating fellows in goat skins. Slowly the procession dispersed . . . to the beer bar to imbibe nectar in a form the Isar-Athenian is most at home with."[82]

Also Nietzschean in inspiration is the unusual pencil and watercolor drawing *It Is Your Destiny* (Fig. 63), whose awkward title derives from the opening line of a poem Max Halbe dedicated to Corinth in 1895:

It is your destiny to wander the earth;
The good fortune of others is denied you.
Headlong you shall wander, seeking,
A restless guest at the richest table.

Whether you roam west or east,
You shall suffer the world's misery.
And though you wander north and south,
You will flourish nowhere.

You are condemned to search the earth;
The good fortune of others is denied you.
The peace of others gives you no rest.
You are a fugitive, a wanderer, a warrior.[83]

Halbe, who describes Corinth in his memoirs as an autodidact, alludes in the poem to what he believed to be Corinth's ultimate goal: the realization of his inner self.[84] The young knight in the drawing, dressed in shining armor, is indeed an idealized self-portrait. Flanked by a sensuous female holding a wineglass adorned with grape leaves and a shrouded old woman with a crown of thorns in one hand and a branch of laurel in the other, the armed hero—like Hercules at the crossroads—must choose between a life of ease and pleasure and the arduous path of virtue rewarded by fame. Naturally, like Hercules, the knight makes the right choice. By allowing his alter ego to reach for the crown of thorns, Corinth metaphorically drew a parallel between his struggle for fulfillment and the Passion of Christ, suggesting that he saw his search as his own *via crucis*—a notion encountered elsewhere in European

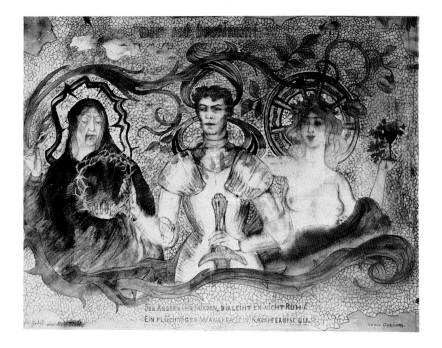

FIGURE 63.
Lovis Corinth, *It Is Your Destiny*, c. 1895.
Pencil and watercolor, 42.5 × 56.0 cm.
Städtische Galerie im Lenbachhaus,
Munich.

painting at the turn of the century, most notably in the work of Gauguin, James Ensor, and Emile Bernard. By inscribing the opening words of Halbe's poem below the upper margin of the drawing and the two concluding lines along the bottom of the sheet, Corinth emphasized the warrior's unceasing, lonely struggle.

The idea of both the poem and the drawing can be traced to the contemporary fascination with the *Übermensch*, to borrow Nietzsche's term, whose virtues were especially those of the warrior and soldier. Indeed, the words of Halbe's poem echo the lofty tones of Zarathustra: "To you I do not recommend peace but conquest. Let your work be struggle. Let your peace be victory."[85] Corinth's own life-long esteem for Nietzsche apparently first developed in the circle of Max Halbe, for whom the philosopher was a favorite author.[86] As noted previously, Eckmann, Corinth's "spiritus rector," had also read Nietzsche, as had Hartleben and Wedekind. Any one of these men could have called Corinth's attention to the introductory studies on Nietzsche that

had been published in 1890 in *Die Freie Bühne* by the young Hungarian Joseph Diner, proclaiming Nietzsche the prophet of a new individualism. In a number of articles in *Die Gegenwart* and *Kunstwart* as well as in a widely read essay, *Friedrich Nietzsche: Seine Persönlichkeit und sein System* (Leipzig, 1890), Ola Hanson, the Swedish critic and novelist, further expounded Nietzsche's idea regarding the individual's right to personal fulfillment. The cult of the individual and the emphasis on personal success and achievement in German culture after 1871, combined with a yearning for a new primitivism and the liberation of human passions, also largely account for the success of Julius Langbehn's book *Rembrandt als Erzieher*, sixty thousand copies of which were printed at the time of its initial publication in 1890, followed by forty subsequent printings in the next two years alone.[87]

From a stylistic point of view, Corinth's Munich drawing is again highly eclectic. The dense mosaic-like background and the ornamental plant motifs derive from Strathmann and Eckmann, while the hieratic composition owes something to Jan Toorop's drawing *The Three Brides* (1893; Rijksmuseum Kröller-Müller, Otterloo), exhibited in 1893 at the Glass Palace in Munich and reproduced in October of that year in *Die Kunst für Alle*. Toorop, too, had made use of stylized forms for expressive and symbolic effects, contrasting forces of good and evil: in his drawing the celestial bride of Christ, holding a stalk of lilies, is on the left; the human virginal bride, surrounded by roses, is in the center; Satan's bride, whose attributes include a collar of skulls and a bowl of blood, stands on the right.

A MOMENT OF TRUTH: *SELF-PORTRAIT WITH SKELETON*

Unlike the idealized *Jugendstil* self-portrait in Figure 63, the *Self-Portrait with Skeleton* (see Plate 9), painted in 1896, shows Corinth without a mask and speaks of a different need for self-assessment. The painting is the first among his self-portraits in which he acknowledged the passage of time, noting his age alongside the signature and the year in the upper right. Although the day and month are not inscribed on the canvas, the painting may indeed have been the first in the long series of Corinth's "birthday pictures," self-portraits he was wont to paint on July 21 or as close to this date as possible. The painting documents Corinth's continued fascination with Böcklin's work, for it clearly derives from the Swiss artist's famous picture of 1872, now in Berlin. The fundamental conception, however, is entirely original, a naturalist's answer to Böcklin's self-conscious posturing. In Böcklin's self-portrait, which also

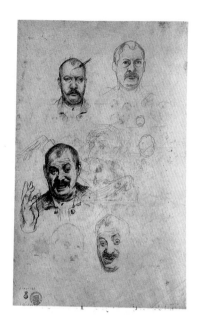

FIGURE 64.
Lovis Corinth, *Self-Portrait Sketches*, c.
1896. Pencil, 47.2 × 30.0 cm. Staatliche
Kunstsammlungen Dresden, Kuperstich-
Kabinett.

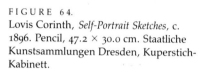

prompted Hans Thoma's similarly romantic *Self-Portrait with Death* (1875;
Staatliche Kunsthalle, Karlsruhe), the painter, palette and paintbrush in hand,
listens to Death as if to an inspiring muse; Death, playing the fiddle, is shown
as a "living" counterpart to the painter, whereas in Corinth's picture the
specter has been reduced to a studio prop. Instead of Böcklin's evocative
chiaroscuro, bright daylight enters the studio through the large window, be-
yond which lies the suburban landscape of Schwabing, with church steeples
and smoking chimneys in the distance. While the skeleton functions as a con-
ventional *memento mori,* Corinth's own likeness is recorded with such honesty
that it is itself an image of transcience. The painter's corpulence belies his age,
thirty-eight; the face is bloated; the eyes are dulled from years of excessive
drinking. An even more incisive description of physical deterioration is com-
municated by the self-portrait sketch in the upper left of a sheet of studies
preserved in Dresden (Fig. 64). These drawings date from about the same
time as the Munich painting and conveniently juxtapose Corinth's stylistic
experiments of these years. The stylized self-portrait in the upper right is
reflective, but the expression remains subordinate to the idiosyncratic drafts-
manship. In the two lower sketches—to the left and below the faint outlines
of a caricature of Otto Eckmann—Corinth mimed what he felt or thought he
felt, resorting to exaggeration. Only in the upper left sketch did he confront
his image with searing objectivity.

Following his break with the Munich Secession, Corinth exhibited only literary or related symbolic subjects at the Munich Glass Palace, apparently because he continued to believe that the key to public acclaim lay in the "meaningful" theme. With the *Crucifixion* (Fig. 65) of 1897 he turned his attention to the most central image of Christian iconography, hallowed by a long tradition in Western art. The extent to which he subordinated himself to that tradition is readily seen when the painting is compared with Max Klinger's self-consciously novel interpretation of the same subject (Fig. 66). Corinth surely knew Klinger's composition, for the painting was exhibited in 1893 at the Glass Palace in Munich, where the uncompromisingly naked Christ caused such an uproar in ecclesiastical circles that the figure had to be covered from the waist down with a piece of cloth. Corinth's conception, by comparison, remains safely within the conventions of the late medieval *Andachtsbild*, although the stylistic handling is as unflinchingly naturalistic as Max Klinger's. The composition closely follows Jordaens's altarpiece in St. Paul's Church in Antwerp, a picture Corinth knew from his sojourn in the Belgian city. Although the two thieves are not included in Jordaens's painting, Corinth derived from that work not only the general distribution of the figures but also some of the details. Within the shallow space the figures are arranged parallel to the picture plane, with John and the Virgin to the left of the cross and the Magdalene and another holy woman to the right. The mourners' gestures and glances achieve a maximum of empathy, keeping the viewer's attention focused on the figure of Christ. When the painting was exhibited at the Munich Glass Palace in 1898, critical attention happened to center on yet another recent picture by Klinger, the monumental *Christ on Olympus* (1897; Museum der bildenden Künste, Leipzig), an ambitious allegory of the victory of Christianity over the gods of ancient Greece. Corinth, who noted somewhat enviously the fuss being made about Klinger's picture,[88] exhibited the *Crucifixion* the following year in Dresden and at Eduard Schulte's gallery in Berlin. Soon afterward the picture was purchased by the Munich manufacturer Ernst Heckert,[89] who subsequently gave it to the Protestant Church in the Bavarian town of Bad Tölz, where the work was installed by November 1901. Although this was the kind of success Corinth had least expected, he was especially proud of it.[90]

During these years Corinth, most likely under the banner of Nietzsche's instinctual man, repeatedly turned his attention to the theme of men's physical dominance over women. In 1894 he depicted the subject three times, in

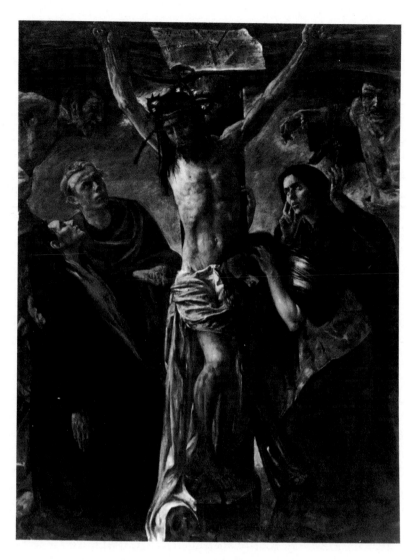

FIGURE 65.
Above: Lovis Corinth, *Crucifixion*, 1897.
Oil on canvas, 229 × 176 cm, B.-C. 138.
Evangelische Kirche, Bad Tölz.

FIGURE 66.
Opposite: Max Klinger, *Crucifixion*, 1890.
Oil on canvas, 251 × 465 cm. Museum
der bildenden Künste Leipzig (1117).

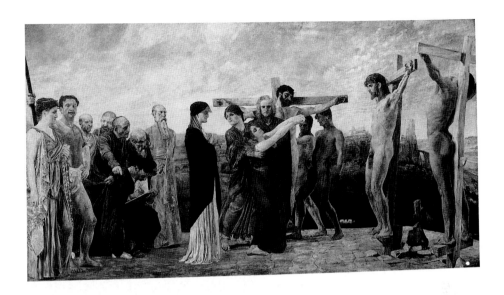

Rape of the Sabine Women, as in the drawing in Berlin already mentioned in connection with *Tragicomedies* (see p. 83), and in two etchings, *Rape* (Schw. 6) and *Abduction* (Schw. 7). In 1895 he made a color lithograph *Rape of Woman* (Schw. L13) and the same year repeated the composition in a bronze relief.[91] Related to these various "rapes" is *Susanna and the Elders* (Fig. 67) of 1897, which places the theme in an Old Testament setting. Like Corinth's earlier version of the subject (see Fig. 34), the painting was derived from a well-known prototype. This time it was Anthony Van Dyck's painting in the Alte Pinakothek that provided the pose and gestures of the voluptuous heroine. The burlesque conception departs notably from the predominantly academic concerns governing the *Susanna* in Essen and reflects both the influence of Böcklin and the tone of Corinth's own recent *Tragicomedies.*

In an independent sketch of the same subject done in 1898 (Fig. 68), Corinth freed himself from his prototype to explore the content in a more purely pictorial manner. The forced physiognomic expressions are now subdued and the lines themselves organized so as to create a dynamic equilibrium of movement and countermovement—a pictorial equivalent, in short, of the conflict that in the painting is no more than a parody. The drawing lacks detail without sacrificing meaning. Suggestion rather than description invests the sketch with the expressive strength that eventually was to distinguish Corinth's mature works.

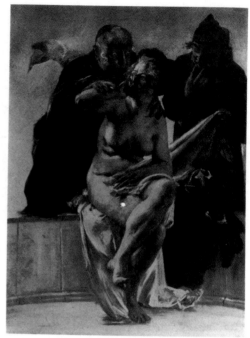

FIGURE 67.
Lovis Corinth, *Susanna and the Elders*,
1897. Oil on canvas, 98 × 74 cm, B.-C.
144. Present whereabouts unknown.
Photo: after Bruckmann.

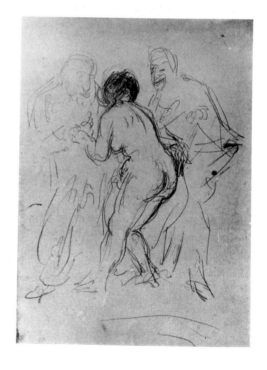

FIGURE 68.
Lovis Corinth, *Susanna and the Elders*,
1898. Pencil, c. 44.0 × 34.5 cm. In
auction at Karl und Faber, Munich, 1974;
present whereabouts unknown. Photo:
after Kuhn.

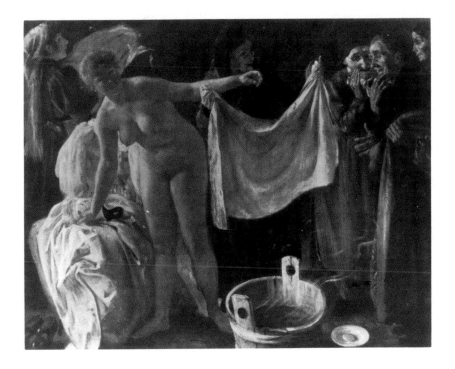

FIGURE 69.
Lovis Corinth, *Witches*, 1897. Oil on
canvas, 94 × 120 cm, B.-C. 145. Present
whereabouts unknown. Photo: after
Bruckmann.

The Nietzschean cult of vitalism rampant in Munich in the 1890s seems to
have had a liberating effect on Corinth, for his themes of conflict between
man and woman mark the onset of a steamy sensuality that was to inform his
works with growing frequency, particularly his depictions of the female nude.
Having drawn and painted the nude for years as if it were but another form
of still life, he now began to see woman both as the catalyst for man's passion
and as a being capable herself of strong physical sensations. The voluptuous
nude in *Witches* (Fig. 69) is fully conscious of her charm. Her bath completed,
she prepares to dress for a costume ball while several old women looking on

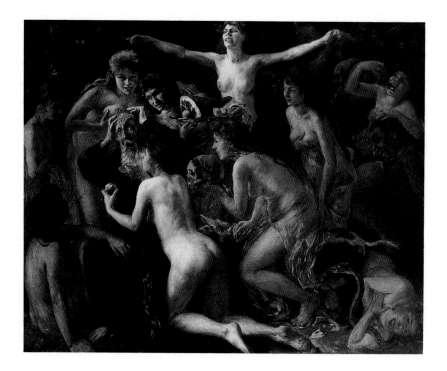

FIGURE 70.
Lovis Corinth, *The Temptation of Saint
Anthony*, 1897. Oil on canvas, 88 × 107
cm, B.-C. 149. Museum Ostdeutsche
Galerie Regensburg.

cackle suggestively. In the *Temptation of Saint Anthony* (Fig. 70) the devil and
the three nudes from the same episode in *Tragicomedies* (see Fig. 44) are sur-
rounded by a considerable following, and the hermit saint finds himself not
merely tempted but set upon by seductive females. Gone is the blasphemous
allusion to the crucifix. Instead, the central nude spreads her arms to raise
her long strands of hair as if about to descend on the saint like a bird of prey.
Some of the nudes offer gifts; others seek to arouse the saint's desire or to
satisfy their own. Devils and human skeletons in the background increase
both the pictorial congestion and the saint's despair. Corinth's painting of the
Crucifixion, Witches, Temptation of Saint Anthony and *Susanna and the Elders* all
in the same year, and seemingly in random order, suggests something of his
casual attitude toward any one theme. Although it is impossible to be spe-
cific, these pictures evidently created some notoriety, as is suggested by a
short story *à clef* by Joseph Ruederer, in which one of the characters asks Co-
rinth whether he was painting only saints and whores.[92]

The extensive iconographic range of Corinth's works from the 1890s is a constant source of frustration to anyone seeking to bring order to the painter's varied output. Indeed, in 1897 he achieved a new level of competence in subjects that had claimed his attention previously: the light-filled interior and the portrait in the open air. In the butcher's store interior (Fig. 71), painted in the small town of Schäftlarn in the Isar Valley, he subordinated the visceral conception of the slaughterhouse scene from 1892 (see Plate 6) to a more controlled structural logic in keeping with the less aggressive character of the subject. The vaults of the setting divide the pictorial field vertically into equal halves; the resulting equilibrium is subtly modified by the scaffolding of the meat racks. The simple ground, painted in relatively unified shades of red and green, provides an effective foil for the multicolored cuts of meat displayed on the counter and suspended from hooks above it. They derive their gleaming texture from the fatty gloss of the paint itself, applied in deft strokes of red and pink shot through with specks of white and purple. Unlike the butcher's store interior that Max Liebermann painted in 1877 in the Dutch town of Dordrecht (Kunstmuseum, Bern), Corinth's painting has an expressive anecdotal content that ultimately allies it to the small slaughterhouse scene of 1892. The butcher's apprentice provokes the viewer's sensibilities by presenting a large dish piled high with pieces of freshly cut meat, his expression of smug self-satisfaction a mocking reminder of the grisly process just completed.

In the portrait of Berta Heck (Fig. 72), the sister of Max Halbe's wife, Corinth achieved a similar unity of structural logic and expressive content. The motif of the young woman seated in a boat, with a male companion just visible behind her, recalls similar paintings by the French Impressionists, in particular Manet's *Boating* (1874; Metropolitan Museum of Art), although it is impossible to say whether Corinth at this point actually knew these pictures. Having set up his canvas at the back of the boat, he apparently executed the painting from start to finish out of doors. But in contrast to the psychologically neutral approach of painters like Manet and Monet, Corinth was clearly unwilling to sacrifice the facial features of the model to the evanescent, form-dissolving effects of light. The brushstrokes, applied broadly to the lake and the distant shoreline and rapidly in the blouse and hat, become more differentiated in the young woman's face, making it both the structural and psychological focus of the composition. Averting her gaze, Berta Heck is absorbed in her innermost thoughts. The simple pictorial structure, dominated by three broad horizontal bands that divide the background, reinforces the picture's

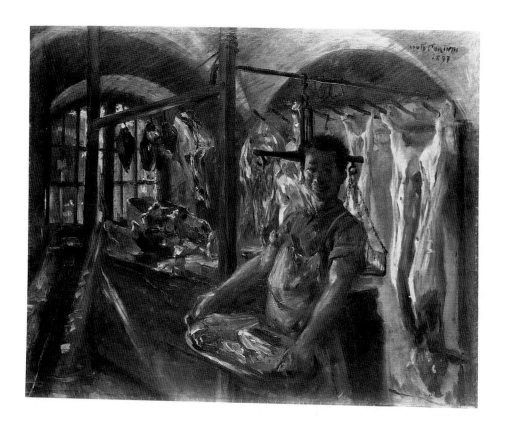

FIGURE 71.
Above: Lovis Corinth, *Butcher's Store at
Schäftlarn*, 1897. Oil on canvas, 69 × 87
cm, B.-C. 147. Kunsthalle Bremen.

FIGURE 72.
Opposite: Lovis Corinth, *Berta Heck in a
Boat*, 1897. Oil on canvas, 57 × 84 cm,
B.-C. 140. Dr. Karl Schmidt, Cologne.
Photo: Marburg/Art Resource, New
York.

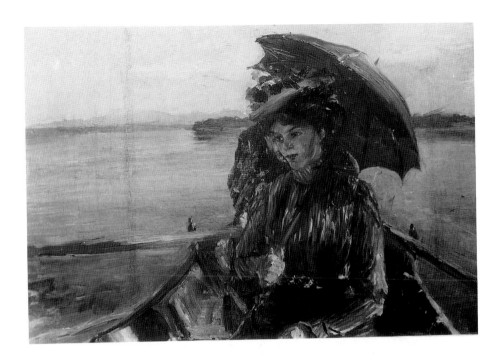

mood of quiet reverie. This sentiment is the result not only of considerable
artistic growth but presumably also of a harmony between painter and model
that prompted Corinth's empathy, allowing him to rise above a mere descrip-
tion of the sitter.

In a similar way only considerable mutual trust can have made possible a
portrait such as the one Corinth painted of Bertha Heck's sister, Luise Halbe,
the following year (Fig. 73). Corinth actually painted two portraits of Max
Halbe's wife at this time. The other, a life-size three-quarter-length portrait
showing her standing in a garden (B.-C. 161), is more formal in conception,
underscores her fashionable appearance, and, as a result, remains psychologi-
cally detached. The small panel in Munich, by comparison, is an unassuming
and personal work, whose closely circumscribed pictorial field emphasizes
the woman's open gaze. The extreme close-up view virtually forces the ob-
server to share in the intimate dialogue between painter and model. Painted
in August 1898 in the village of Ammerland, on the eastern shore of the Starn-
berger See where Max Halbe and his family were spending the summer, the
picture is a plein air portrait by implication only, for its sunny air is entirely a

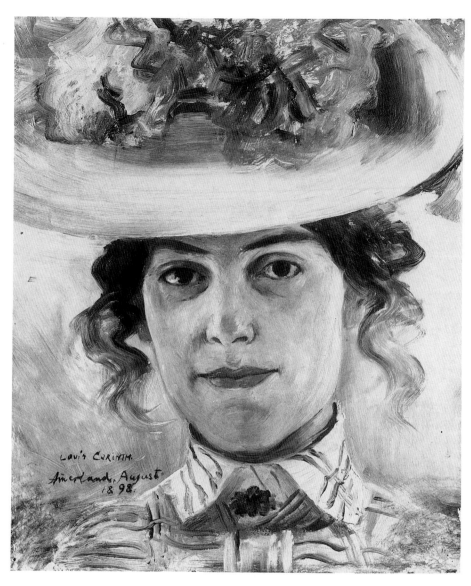

FIGURE 73.
Lovis Corinth, *Portrait of Luise Halbe in a Straw Hat*, 1898. Oil on wood, 35 × 30 cm, B.-C. 160. Städtische Galerie im Lenbachhaus, Munich (G 13.004).

function of the three primaries red, yellow, and blue. As in the portrait of Berta Heck, the brushstrokes have been applied freely only on the periphery of the composition while the face itself is carefully modeled.

Corinth's charming plein air group portrait (see Plate 10), painted in August 1899 in Bernried on the Starnberger See, also originated in the congenial company of Max Halbe's family. Facing the viewer, the playwright sits in a garden, his wife to his left and Berta Heck to his right. The bearded fellow wearing the traditional Bavarian suit and hat is the Viennese writer of comedies Carl Rössler. Like the portrait of Benno Becker and the double portrait of Langhammer and Brand (see Plate 5, Fig. 37), the painting has the character of a genre scene. Max Halbe, with a touch of amusement, looks up from the newspaper as his wife offers Carl Rössler a peach. Berta Heck, about to sip from her cup, smiles at the tempting offer. According to Halbe, the painting was completed in the course of a few morning hours;[93] and there is no reason to doubt that this is so, even though Corinth inscribed the canvas with the dates August 28–31, 1899. Perhaps the inscription refers to the duration of the painter's visit, Rössler's, or both. It is also possible that the picture was painted in several brief morning sittings on the dates inscribed. As in the plein air portraits of Berta Heck and Luise Halbe, the vigorous brushstrokes serve a tightly controlled modeling only in the faces. Despite the seeming spontaneity of the overall execution, it is evident that the composition was carefully planned and nuanced so as to emphasize Corinth's hosts. The women are related on a diagonal axis that intersects a corresponding one for the men, and these structural lines are reinforced by the shades of white that link Luise Halbe and Berta Heck and the darker tones of the men's clothing. Max Halbe and his wife have been given special prominence, he by his frontal position next to the tree trunk that divides the composition in the center and she by her placement in the right foreground and by her action, which provokes the gestures and glances of the other three. Indeed, Luise Halbe is the psychological center of the composition, and the painting itself is a testimony to her charm and the unpretentious hospitality that made the Halbes' home so appealing.

FIRM IN LOYALTY

A far more dispassionate conception governs the ambitious group portrait of twelve members of the Munich Freemason Johannes Lodge (Fig. 74), despite the work's painterly qualities. According to the inscription in the upper right,

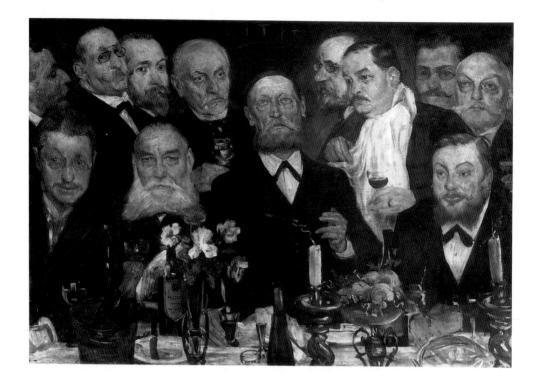

FIGURE 74.
Lovis Corinth, *Firm in Loyalty,*
1898–1899. Oil on canvas, 113.0 × 162.5
cm, B.-C. 164. Städtische Galerie im
Lenbachhaus, Munich.

Corinth first worked on the painting in April and May of 1898 but did not
complete it until May and June the following year. A preliminary watercolor
drawing in the Lenbachhaus bears the date 1897 and anticipates the final
composition closely, except that it includes only nine members of the lodge.
With the possible exception of the portrait of Carl von Gayling (B.-C. 106) of
1893, this painting may have been Corinth's earliest commission. Apparently
he had painted his previous portraits on his own initiative; all depict either
relatives or friends. Corinth may have received the commission because of his
own affiliation with the lodge. A member of the Königsberg Immanuel Lodge
since 1890, he had been a co-founder of the Munich lodge in 1896 and re-
tained membership in that organization for the rest of his life, holding the
office of master of ceremonies.[94] The twelve men, stalwart representatives of
various professions,[95] are closely grouped behind a table laden with glasses,

bottles, and bouquets of flowers. Two candles, no doubt symbolizing two of the three Masonic virtues (wisdom, strength, beauty) have just been extinguished as the master of the lodge, seated in the center, prepares to propose a solemn toast. In the empty space just above his head the initial letters of the lodge's motto, "i[n] T[reue] f[est]" ("firm in loyalty") appear, flanked by two talismanic symbols, a square and interlacing triangles that form the six-pointed star of Solomon's seal. Although Corinth sought to utilize the moment of the collective toast to unify the group, he did not succeed in integrating the twelve individuals psychologically. Only three of the men are absorbed in the proceeding; for the others, participation is perfunctory. It is doubtful that Corinth intended to caricature the collective spirit of this and, by implication, other social institutions of the kind.[96] The scattered psychological energy of the painting can be explained by the extended working process and the assembly of the group portrait from individual portrait studies. Even such masters of this type of painting as Frans Hals and Rembrandt could not always avoid the pitfalls of this working method. The forced physiognomic expressions are simply another result of Corinth's efforts to give the group dramatic cohesion. Late in his life Corinth proudly and fondly remembered the painting as a "Doelenstück," in allusion to the *doelen,* or guards' hall, of seventeenth-century Holland and Dutch group portraits of shooting companies and civic guards.[97] The dazzling manner in which the still-life elements have been painted is indeed worthy of Frans Hals, although the general disposition of the figures—the tight-knit grouping of the heads in two rows—was derived from another source, perhaps one of the late sixteenth-century corporation portraits by Dirk Jacobsz. Often in Dutch group portraits of this type the place above the central figure contains the crest of the guild or a tablet with the names of the persons represented, a device similar to the initial letters of the lodge's motto in Corinth's painting.[98]

NEW FERMENT: THE BERLIN SECESSION

Between the beginning and the completion of the group portrait of the Johannes Lodge lay events that were to be of great consequence for Corinth's career. In December 1898 he traveled to Berlin, where several of his paintings, including the *Crucifixion* (see Fig. 65), were exhibited at the gallery of Eduard Schulte. While in Berlin, he received news that a Leipzig physician, Dr. A. Ulrich, was going to purchase the *Temptation of Saint Anthony.* Still more encouraging was the artistic climate then developing in Berlin under the ener-

getic leadership of Corinth's old friend Walter Leistikow. Since 1892 Leistikow and Max Liebermann had headed the Gruppe der Elf (The Eleven), an informal organization created to provide a forum for modern art through small exhibitions independent of the large shows at the Glass Palace sponsored by the Berlin Artists' Association. Without breaking with the association, the Eleven held their first show on April 3, 1892, at the gallery of Eduard Schulte and continued to exhibit there regularly each spring until 1897.

Meanwhile, the Berlin Artists' Association itself was beginning to stir with a more enterprising spirit. As part of an effort to introduce foreign artists to Berlin, the association decided to invite the Norwegian painter Edvard Munch to mount a major show of his works at the Architektenhaus. The Munch exhibition of fifty-five paintings and oil sketches, including the original version of *Puberty* (1886; destroyed), had hardly opened on November 5, 1892, when Anton von Werner and the Berlin Academy protested. "Formlessness" and "base sensibility" were two of the kinder epithets hurled at Munch by the conservative press.[99] The controversy assumed such proportions that the exhibition closed on November 12. But by November 20 Munch's paintings were being shown at branches of Eduard Schulte's gallery in Düsseldorf and Cologne, and in December they were again on exhibition in Berlin, at the Equitable Palace, this time without any incident. But the affair had dealt a severe blow to the fragile relationship between the Berlin Artists' Association and the Eleven, who had vigorously defended the Norwegian painter's right to exhibit. An uneasy truce ensued until 1898, when the Glass Palace jury's rejection of one of Leistikow's Grunewald landscapes (see Fig. 40) brought about a final rift, precipitating the founding of the Berlin Secession in May of that year.

Liebermann accepted the presidency of the fledgling organization, but Leistikow, who held the office of first secretary, was its driving force. He and his fellow Secessionists saw as their first task the organization of an exhibition that could compete successfully with the next show at the Glass Palace, scheduled to open in May 1899. Fearing that the Secession was not yet ready to stand on its own, they sought additional support by promising exhibition space to artists from other cities in a gallery still to be found. When their efforts to rent suitable exhibition space failed, they decided to build a gallery, raising money from members and wealthy patrons. Many of the contributors were from prominent Jewish families, the mainstay of Berlin's cultural life in the ensuing decades. Among these early patrons of the Berlin Secession were Richard Israel, the owner of the Berlin department store, who promptly bought Leistikow's rejected Grunewald landscape and donated it to the National Gallery; the bankers Julius Stern and Carl Fürstenberg; and cultured industrialists like the young Walther Rathenau.[100]

It was only to be expected that Leistikow would recruit Corinth as yet an-
other supporter of the Secessionist cause. Hoping that lucrative portrait com-
missions might induce Corinth to settle in Berlin, Leistikow sought to in-
troduce him to prominent members of society. But the pastel portrait Corinth
painted in late December 1898 of Leistikow's student Gertrud Sabersky (Col-
lection Lucie Mainzer, Innsbruck) was unfortunately the only commission
he obtained. As a result Corinth returned to Munich about the middle of
January 1899.

Meanwhile, the Berlin Secession had acquired rights to the land next to the
Theater des Westens on Kantstrasse, suitable for the construction of their
own building. Two cousins, Bruno and Paul Cassirer, partners in a recently
opened gallery and publishing firm, agreed to manage the Secession's busi-
ness affairs. In return for their services the Secession granted them privileges
far beyond the customary sales commission of five percent: they held mem-
bership on the executive committee, with an advisory vote, and participated
in selecting and installing works for exhibition.

The first exhibition of the Berlin Secession opened on May 20, 1899, in a
quaint stucco structure made up of a short, squat tower, set aside for adminis-
trative offices, and six adjoining gallery rooms. About three hundred works
were shown, a marked improvement over the mammoth spectacles at the
Berlin Glass Palace. Although the exhibition was devoted mostly to German
art, the open-mindedness pledged by Liebermann in his preface to the cata-
logue was evident in the range of painters represented.[101] They included mem-
bers of the Worpswede colony, such as Fritz Mackensen, Otto Modersohn,
and Hans am Ende; realists like Menzel, Leibl, and Trübner; and such expo-
nents of late nineteenth-century idealism as Böcklin and Stuck. Ferdinand
Hodler's painting The Dispirited (1892; Staatliche Gemäldesammlungen, Neue
Pinakothek, Munich) introduced the Swiss artist for the first time to a large
number of his Berlin colleagues. Max Slevogt sent his ambitious triptych The
Prodigal Son (1898–99; Staatsgalerie, Stuttgart), and Corinth exhibited two
paintings, Returning Bacchants (1898; B.-C. 154), a variation on his bacchanal
of 1896 (see Fig. 62), and a more recent work, Demon (1899; B.-C. 173), a pro-
vocative three-quarter-length femme fatale. Diversity in style and conception,
as epitomized by the works in this first exhibition, remained a guiding prin-
ciple of the Secession throughout its existence.

BERLIN BECKONS ANEW

On October 16, 1899, Corinth returned to Berlin, stopping in Leipzig for a
brief visit with Dr. Ulrich, who had purchased two more paintings. In addi-

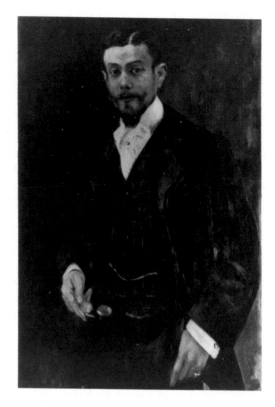

FIGURE 75.
Lovis Corinth, *Portrait of Richard Israel*,
1899. Oil on canvas, 100 × 68 cm, B.-C.
190. Present whereabouts unknown.
Photo: after Bruckmann.

tion to the *Temptation of Saint Anthony*, the physician now also owned *Witches* and the *Self-Portrait with Skeleton*. Corinth went to Berlin this time to oversee the hanging of his paintings for a one-man show at the gallery Reiner and Keller. It opened on October 20 and was well received. In December he participated in an exhibition of German realist painting at the gallery of Bruno and Paul Cassirer. It was most likely Leistikow who had paved the way for this introduction of Corinth's work on a larger scale in Berlin. Corinth, in turn, took the exhibitions as an excuse for an extended stay, an attractive prospect since Berlin was now beckoning in other ways. The portrait commissions that Leistikow had tried to obtain for him the previous winter finally began to materialize, promising sound financial support should he decide to settle permanently in the capital. That he was contemplating such a move is evident from a letter dated December 28, 1899, to Joseph Ruederer, in which Corinth acknowledged his gratitude to Leistikow and also spoke of the congenial relationship developing between him and Max Liebermann.[102] Otto

Eckmann, too, who since 1897 had taught at the Berlin School of Arts and Crafts, did his utmost to make Corinth feel at home. He offered him the best wine from his cellar and asked his wife to prepare Corinth's favorite East Prussian dishes.

The commissioned portraits Corinth painted in the fall of 1899 include that of the gynecologist Dr. Ferdinand Mainzer (B.-C. 187), who had recently married Leistikow's former student Gertrud Sabersky; that of Richard Israel (Fig. 75), Leistikow's benefactor and a generous supporter of the Berlin Secession; and that of Israel's father-in-law, Emil Cohn (B.-C. 183), who owned two Berlin newspapers, the *Volkszeitung* and the *Berliner Tageblatt*. In these works, in contrast to the intimate format he usually chose for the portraits of his friends, Corinth adopted a larger canvas, showing the figures in half and three-quarter length before a neutral ground. There is generally also greater emphasis on the modeling of the individual forms. Verisimilitude and allusion to the sitter's accomplishments were expected in these portraits, and Corinth dutifully delivered psychologically neutral but faithful depictions of the successful physician, merchant, and publisher. At this time Corinth also began a full-length portrait of Israel's wife, Bianca, dressed in an elegant white gown. Dissatisfied with the picture, however, he destroyed it before it was finished.

An interesting and much more personal conception prevails in the portrait of Frau Rosenhagen (Fig. 76), the mother of the Berlin critic Hans Rosenhagen, who was Leistikow's friend and one of the first outspoken defenders of the Berlin Secession. The painting was a labor of love. Corinth knew the sitter well from his previous visit to Berlin and other encounters in Munich, where Rosenhagen and his mother usually stopped each year on their way to their summer retreat. With this painting Corinth returned to a portrait formula that had last occupied him in 1892 (see Plate 5), except that now light also assumes an expressive rather than merely a descriptive function, reinforcing the sitter's dominance over the interior she occupies. Corinth painted Muttchen Rosenhagen, as friends called her, sometime in November—and in the course of a little more than five hours—in the small Berlin apartment she shared with her son.[103] Corinth neither diminished the ravages of old age nor disguised the dour mien of a sitter well known for her cantankerous spirit. The high forehead is exposed, the thinning hair fluffed up above the ears. The cheeks are sunken, the narrow lips firmly closed, the dim eyes surrounded by red circles. Everything about the sitter speaks of resolute composure and of an unmistakable will to control both herself and others. This psychological projection gives meaning to the light that pervades the painting. The light, strongest in the flesh parts, is absorbed by the plush upholstery of the couch and the reddish brown tones of the dress but flickers up again in the pillow

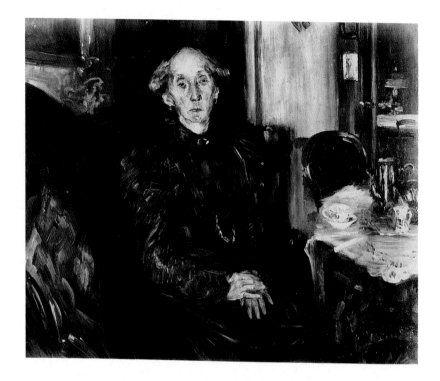

FIGURE 76.
Lovis Corinth, *Portrait of Mother Rosenhagen*, 1899. Oil on canvas, 63 × 78 cm, B.-C. 182. Staatliche Museen Preussischer Kulturbesitz, Nationalgalerie, Berlin (West) (A II 984). Photo: Jörg P. Anders.

and the sleeve, in the brooch, and in the long chain of the gold necklace. From there it gradually invades the rest of the interior, from the sparkling coffee still life and the gleaming furniture and picture frames to the lamp on the table in the adjacent room.[104]

A similar intuitive grasp of the interrelation of content and form is seen in the painting of a reclining female nude (see Plate 11), also painted in Berlin. Here Corinth's depiction of the female body, for so long the subject of formal analysis, has undergone a profound change. Indeed, he had never before captured the erotic allure of the female with such conviction. The ecstatic posture of the model is far removed from the conventional studio pose. She writhes provocatively on disheveled sheets, her voluptuous body set off against the white bedding; the mass of dark hair and the black stockings fur-

ther accentuate the warm skin tones. The broad brushstrokes are in part so independent of any descriptive function that they translate the image into a pictorial metaphor for rapture. Corinth most likely painted the picture in the quarters he had rented during his stay in Berlin at Körnerstrasse 26, and it must have been a rare felicitous moment indeed that allowed him to abandon himself to his own sensual experience and thus to transcend the coy suggestiveness and forced eroticism of his earlier nudes from the 1890s, such as the one he had adapted to his irreverent print *Good Friday* (see Fig. 59). That Corinth painted the picture rapidly and without much premeditation is suggested by the remains of an old signature still visible about halfway up the center of the canvas. Intoxicated by the image before him and seeking to capture the experience quickly, he apparently reached for one of his finished pictures and painted the nude right over it.

Exactly when Corinth began work on the remarkable painting of *Salome* (see Plate 12) is not known. The preliminary oil sketch (B.-C. 170), now in the Busch-Reisinger Museum, is undated; the finished version is inscribed with the year 1900. Corinth may have begun the painting before his journey to Berlin, completing it after his return to Munich in early January 1900.[105] Disregarding traditional conventions, he transposed the familiar subject into a milieu that is not only outrageously modern but also downright commonplace. The makeshift robes and vulgar figure types give the scene the character of a *tableau vivant* staged by studio models at a costume ball. This impression is reinforced by the nonchalant detachment with which the gruesome episode is reenacted. The executioner, still holding the bloody sword, watches with satisfaction as the headless body of the Baptist is carried away. Herod's daughter, arriving as if by chance with her female companions at the site of the beheading, examines the head of Saint John, leaning forward for a better look, her voluptuous breasts almost touching the Baptist's beard. With unruffled curiosity, she daintily pries open one of the saint's eyes, as if to force him to acknowledge her beauty, if only in death. The eight life-size figures, some partly hidden, are grouped in the foreground in a tight-knit composition that is cut on all sides, a device that further intensifies the immediacy of the portrayal. It is as if the viewer too had happened on the scene.

Salome belongs to the general theme of sexual conflict discussed earlier in relation to Corinth's output from Munich. A favorite paradigm of sadistic love in both painting and sculpture by the 1880s,[106] the subject became even more popular after the publication of Oscar Wilde's play in 1893. Yet Corinth apparently did not get to know Wilde's play until 1902, when it was first performed in German translation in Berlin. His Salome, moreover, unlike Wilde's de-

praved vampire, is capricious rather than possessed by evil desires—more
like a character from an Offenbach operetta and similar in spirit to the cari-
cature of Salome that Jules Laforgue published in *La Vogue* in the summer of
1886 in one of his *Moralités légendaires.*[107]

Soon after completing the *Salome,* Corinth applied for the necessary papers
to submit the painting to the upcoming exhibition of the Munich Secession.
He had not exhibited with the group since 1893 and perhaps assumed that his
growing reputation in Berlin had mollified those who still remembered his
role in the "plot" of the Free Association and that he would be welcomed
back into the cultural life of the city. But when the executive board of the
Munich Secession rejected his application, he discovered that the old griev-
ances were still very much alive. Walter Leistikow, on a visit to Munich, praised
the *Salome* highly and told Corinth to send it to the next exhibition of the Berlin
Secession instead, assuring him that it would be enthusiastically received.

This episode taught Corinth that Munich was unlikely to offer him the pro-
fessional satisfaction and financial success he had begun to enjoy in Berlin.
Thus he was happy to accept an invitation from Richard and Bianca Israel to
join them at their country estate at Schulzendorf, not far from Berlin, for an
extended period of work and relaxation. There, between the end of May and
the end of June 1900, Corinth painted three portraits: a full-length portrait of
Bianca Israel in formal evening attire (B.-C. 175), clearly a substitute for the
abortive painting of the previous winter;[108] a more personal and intimate pic-
ture of Bianca Israel seated in the garden (B.-C. 191); and a group portrait of
the four Israel children (B.-C. 195). In July the *Salome* was included in the
second exhibition of the Berlin Secession and, as Leistikow had predicted,
turned out to be a sensational success. "The painting has been executed with
great technical, almost academic bravura," wrote Hans Rosenhagen in his re-
view of the exhibition in *Die Kunst.* "One gets the impression of a certain
perversity. . . . Among all of Corinth's paintings this *Salome* is surely the most
original and interesting."[109] The painting, reproduced as a full-page illustra-
tion accompanying Rosenhagen's review, solidified Corinth's reputation as
one of the most compelling figure painters of his time.

Following a trip with Leistikow through Denmark, Corinth returned briefly
to Munich in early August, but by September he was back in Berlin, where
he took a temporary atelier at Lützowstrasse 82, where both Leistikow and
Edvard Munch had earlier maintained studios. His circle of friends was con-
siderably enlarged when he joined the Freundschafts- und Rosenbund that
Leistikow had founded in honor of Gerhart Hauptmann. Among the group's
regular members—besides Leistikow and Hauptmann himself—were Ludwig

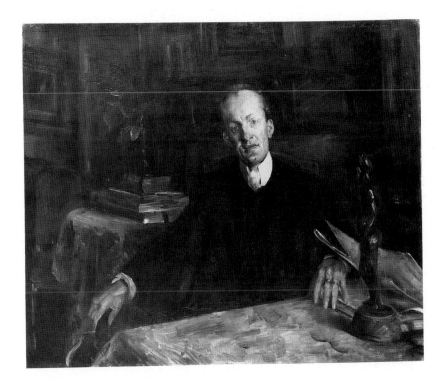

FIGURE 77.
Lovis Corinth, *Portrait of Gerhart
Hauptmann,* 1900. Oil on canvas, 88 ×
107 cm, B.-C. 202. Städtische Kunsthalle
Mannheim.

von Hofmann and the Norwegian painter Bernt Grönvold; depending on the
occasion, this contingent was augmented by various guests. The statutes gov-
erning the group were simple: each member took his turn inviting the others
for dinner; champagne was the official drink. It must have been an odd sight
indeed to watch the initiates take their seats around a table adorned with
roses, for each member also wore a rose garland on his head. One of the more
memorable dinners was the one Gerhart Hauptmann gave in December 1900
at the Palast Hotel after the dress rehearsal of his drama *Michael Kramer:* the
regulars were joined by Otto Brahm, director of the Deutsches Theater; the
actors Rudolf Rittner and Max Reinhardt, both of whom were then still mem-
bers of Brahm's ensemble; and Hauptmann's publisher, Samuel Fischer.

The portrait Corinth painted of Gerhart Hauptmann (Fig. 77) in October
1900 depicts the playwright in the privacy of his study at his home in Berlin-

Grunewald. Hauptmann (1862–1946), not yet thirty-seven years old, was at the height of his career, having attained a reputation as one of the chief exponents of modern drama. His plays include *Vor Sonnenaufgang* (1889), a drama that inaugurated the realist movement on the modern German stage; *Die Weber* (1892), a powerful dramatization of the uprising of the Silesian weavers in 1844; and *Florian Geyer* (1895), a historical play set amid the conflicts of the German Peasants' Rebellion of 1524–1525. *Michael Kramer* was his twelfth and most recent drama.

The prototype for the Hauptmann portrait is the portrait of Frau Rosenhagen (see Fig. 76). Once again the setting manifests the sitter's personality both explicitly and implicitly. Light, most fully concentrated in the face, pervades the painting in ever diminishing nuances. The domestic ambience of the Rosenhagen portrait, however, has given way to one befitting the intellectual and aesthete: the books signify the dramatist's professional life; the statuette on the table may allude to Hauptmann's earlier thoughts of becoming a sculptor. Hauptmann appears frail in the loose-fitting suit and high collar. His nervous fingering of the pages of a book contradicts his relaxed posture and affable expression. He appears at once physically close and psychologically distant, an impression the dramatist apparently conveyed often to those who knew him. According to Max Liebermann, Hauptmann was a man of great charm, but too preoccupied with himself to have any genuine interest in others. A good observer and listener, in conversation he generally revealed little of his own thoughts.[110] He was also rather conceited, as the adulatory atmosphere of the Freundschafts- und Rosenbund makes abundantly clear, and unusually sensitive about his public image. In 1900 he had not yet acquired the physical resemblance to Goethe that later distinguished him, and he was reluctant to be photographed or to have his picture published.[111] In this context Corinth's portrait gains added documentary importance.

In November Corinth had another one-man exhibition in Berlin, this time at the Cassirer gallery. As the year that had begun inauspiciously drew to a close, Corinth enjoyed a fairly secure reputation in the German capital as well as the promise of further personal and financial rewards. The self-portrait (Fig. 78) he painted in Berlin that year suggests his energetic self-confidence. It may be no accident that this self-portrait is also the first painting in which Corinth shows himself with the tools of his profession. Palette and brushes in hand, he stands before the picture of a female nude (B.-C. 193) from the same year. His gaze is both probing and introspective; his posture and gesture

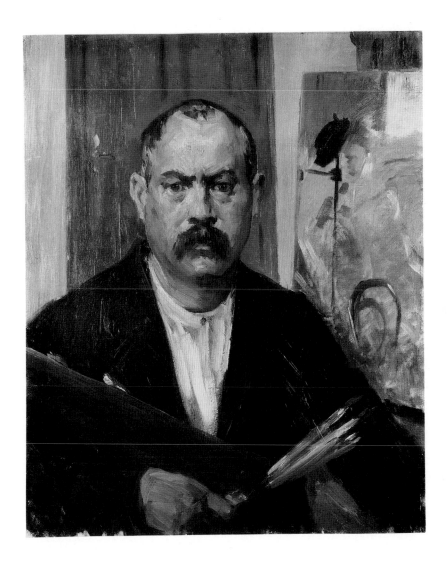

FIGURE 78.
Lovis Corinth, *Self Portrait without Collar*,
1900. Oil on canvas, 73 × 60 cm, B.-C.
198. Berlin Museum, Berlin. Photo:
Hans-Joachim Bartsch.

speak of a resolute commitment to work. By comparison, the preceding *Self-Portrait with Skeleton* (see Plate 9) takes on a pessimistic tone that gives added meaning to the *vanitas* symbol of the studio prop. In the self-portrait of 1900 Corinth confronts his image together with his own "living" art in the form of a painting that bears the reassuring title *Morning*.

Late in December Corinth began another major figure composition, *Perseus and Andromeda* (B.-C. 208), with the clear intention of repeating, possibly even improving upon, the success of the *Salome*. The large scale of the painting—its original dimensions both more than six feet—brought with it repeated frustrations until Corinth finally cut the canvas down to its present, though still substantial, size.[112] Little is known about the reception of the painting at the Berlin Secession exhibition in May 1901. Corinth himself seems to have been pleased only with the figure of the heroine, a naturalistic depiction of the female nude, seen in the uncompromising light of the studio. While he labored on *Perseus and Andromeda,* he also painted several portraits, one of them—most likely the full-length portrait of Frau Liese Simon (B.-C. 197)—a commission obtained on the recommendation of Bianca Israel that netted him 3,500 marks.[113]

Having thought for some time of taking up permanent residence in Berlin, Corinth needed no further encouragement to make up his mind. At the end of March he left for Munich to wind up his affairs there and to arrange for the removal of his belongings to Berlin. In August and September he spent several weeks at Tutzing on the Starnberger See. Max Halbe was there as well, and the two were frequently joined by Frank Wedekind and Eduard von Keyserling.

At Tutzing that summer, on the terrace of Halbe's summer home, Corinth painted Keyserling's portrait (see Plate 13).[114] Eduard von Keyserling (1855–1918) had settled in Munich in 1895 to embark on a literary career. Born and raised on his ancestral estates in western Latvia, he came from a family whose forebears in the fifteenth century had been vassals of the Teutonic Knights. The practice of frequent intermarriage among blood relatives had produced in him a hybrid of intellectual acumen and physical frailty. In 1893 he experienced the first symptoms of an incurable spinal disease, and from 1908 on blindness led him to withdraw gradually from society. World War I cut him off from his Latvian sources of income, and he died in self-imposed seclusion in Munich in 1918. Keyserling's writings grew out of his life experience and his memories. His short stories and novels about the Latvian nobility are pervaded by wistful melancholy at the passing of a cherished way of life. In the

sublimated culture he so sympathetically describes, an almost ritual adherence to conventions is paired with resignation, and even dying out becomes a noble act.

Keyserling was forty-five or forty-six at the time the portrait was painted and had not yet developed his characteristic style as a writer. It is impossible to say whether Corinth knew of the illness that had begun to undermine Keyserling's health. But even if he did, his almost clinical probing of the man's character and physical constitution could not be any less astonishing. Keyserling, shown in three-quarter length and off-center, sits quietly before a simple ground that is divided horizontally about halfway up the canvas into a darker and a lighter bluish gray field animated by vigorous brushstrokes but otherwise devoid of environmental allusions. He holds his hat on his knee as if he had stopped by for only a brief visit. The immediate impression is one of calm and passivity, so unlike the assertive presence that usually marks Corinth's portraits of his male friends. Yet on closer analysis Keyserling's personality expresses itself: in the well-groomed hands, which even in repose betray a nervous sensibility; and in the face, which testifies—despite the quiet demeanor—to a rich emotional life. Indeed, the face carries the full import of the portrait, especially in conjunction with the body, whose frailty is accentuated by the loose-fitting jacket and shirt. Although Corinth limited his palette, color nonetheless plays an important part in the pictorial structure. The white tones of the shirt and vest provide an axis that links the face and the hands, and this axis is reinforced by touches of blue. The same blue is also found in the background but appears in its purest concentration in the stone of Keyserling's ring, in his necktie, and in his large eyes. It would be difficult to find among Corinth's earlier portraits an example of form serving expression more eloquently. With this painting he was on the threshold of a new beginning as a portraitist.

Corinth was aware that with his move from Munich to Berlin a major chapter in his development was coming to an end. In Munich his eyes had first been opened to a wider horizon, and his return to the city in 1891 was prompted in part by memories of his earlier and more innocent student years. Berlin now welcomed him as a mature master. The self-portrait of June 1901 reflects his recognition of this challenge (Fig. 79). Corinth dressed for the occasion with great care, adding for good measure an imposing broad-brimmed hat, as if to reinforce his new professional stature. Gazing pensively into the mirror, he contemplates rather than observes his image. Great calm emanates from the face, the only part of the painting that has been carefully modeled. Even the

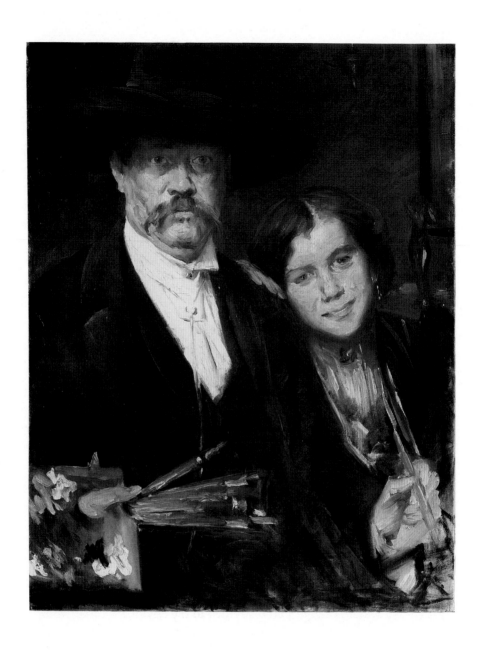

FIGURE 79.
Lovis Corinth, *Self-Portrait with Model*,
1901. Oil on canvas, 88 × 68 cm, B.-C.
216. Kunstmuseum Winterthur.
Photo: Schweizerisches Institut für
Kunstwissenschaft.

Lovis Corinth and Charlotte Berend in Bordighera, 1912. Photo courtesy Wilhelmine Corinth Klopfer.

Lovis Corinth in his Berlin studio, 1919. Corinth is holding an impression of the color lithograph *Walchensee* (Schw. L354).

The Corinth family in Urfeld, summer
1921. From left to right: Thomas, Lovis
Corinth, Wilhelmine with the dog Lord,
and Charlotte Berend. Photo courtesy
Wilhelmine Corinth Klopfer.

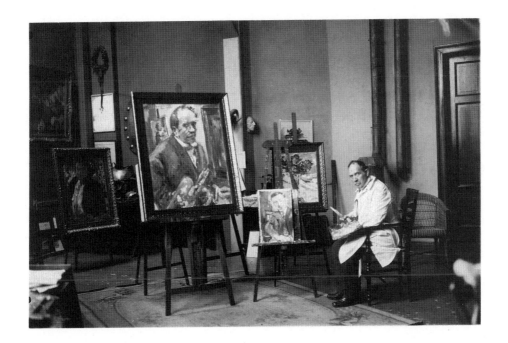

Lovis Corinth in his Berlin studio with
one of his last self-portraits (Fig. 190),
1924.

THREE :: MATURITY

THE BERLIN SECESSION

Corinth's rise to fame in Berlin was closely linked to the growing importance of the Berlin Secession as the strongest and most influential artists' association in Germany. Within a few years of its founding the group's exhibitions eclipsed the much larger shows at the Berlin Glass Palace by appealing to liberal and well-to-do intellectual circles receptive not only to new developments in German art but also to new impulses from abroad. The second exhibition, in May 1900, which paid special tribute to Hans von Marées, the nineteenth-century German painter whose experiments with problems of pictorial structure have since been recognized as milestones in the evolution of modern art and aesthetics, included works by no fewer than forty-four foreigners, among them Pissarro, Monet, Renoir, Rodin, and Whistler. In 1901 the French Impressionists were again well represented, as was van Gogh. Manet made his belated debut in 1902, the year that Wassily Kandinsky exhibited with the Berlin Secession for the first time and Edvard Munch was represented by twenty-eight pictures from his *Frieze of Life* cycle. Toulouse-Lautrec and Cézanne dominated the exhibition in 1903. The names Max Beckmann, Hans Purrmann, and Alexey von Jawlensky were added to the Secession's membership roll in 1904.

In 1902 the Berlin Secession held the first of its annual winter exhibitions devoted exclusively to the graphic arts, an unusual undertaking at the time. These black-and-white exhibitions, as they were called, featured in quick succession the work of such diverse artists as Käthe Kollwitz and Aubrey Beardsley. Emil Nolde, Kandinsky, and Lyonel Feininger participated in the graphic show of 1903. In the winter of 1908 the exhibition was highlighted by a selection of drawings by the early nineteenth-century Berlin realist Franz Krüger and prints by the young men of Die Brücke: Ernst Ludwig Kirchner, Erich Heckel, Karl Schmidt-Rottluff, and Max Pechstein. By 1908 Nolde, Kandinsky, Feininger, and Ernst Barlach had become members of the Berlin Secession. By 1911 the organization had shown the work of virtually every leading artist of the then burgeoning movements of Expressionism, Fauvism, and Cubism.[1]

In its efforts to introduce modern art to Berlin, the Secession found continued and energetic support in Bruno and Paul Cassirer. The two dissolved their partnership in 1901 and henceforth each worked independently. Bruno Cassirer took over the publishing firm and in 1902 founded the journal *Kunst und Künstler,* which developed into Germany's leading art periodical under the editorship first of Emil Heilbut and then of Karl Scheffler. The journal also became an eloquent proponent of the Berlin Secession. Until shortly after the First World War, Bruno Cassirer continued to publish important books on art and aesthetics as well as illustrated books still acclaimed for their handsome typography and design. Paul Cassirer, in turn, assumed responsibility for the Cassirer gallery and remained the sole business manager of the Berlin Secession. After 1908 he reentered the publishing business. In addition to the Paul Cassirer Verlag, he started the Pan Presse, which specialized in luxury editions of books, graphics, and print portfolios; and he created *Pan,* a cultural and political periodical named for the journal founded in 1895 by Julius Meier-Graefe and his two friends the poets Otto Julius Bierbaum and Richard Dehmel. All of these operations came to be closely associated with the Berlin Secession.

In his gallery, Paul Cassirer mounted on the average six major exhibitions a year. He regularly featured the leading exponents of the Berlin Secession and reinforced the organization's international outlook by opening his gallery to artists from abroad. In 1903 he showed works by Munch, Bonnard, Vuillard, Degas, and Monet, and with an exhibition of paintings by El Greco he revived interest in a master whose idiosyncratic style was being revalued as younger artists pursued an analogously expressive use of color and form. In the spring of 1904 Cassirer held the first major exhibition in Germany of oils and watercolors by Cézanne. In 1908 he showed paintings by van Gogh and Jawlensky as well as a series of landscapes by Christian Rohlfs; in 1910 he organized the first major exhibition of works by Kokoschka. Soon Paul Cassirer's salon was known as the country's leading gallery of modern art and the main source for French Impressionist and Post-Impressionist works for museums, galleries, and private collections in central Europe.

Remarkably courageous, the Berlin Secession and Paul Cassirer opposed not only the official Berlin art world, embodied in Anton von Werner and his fellow academicians, but also the aesthetic precepts espoused by the political regime. Indeed, the imperial court took more than a passing interest in such matters. Wilhelm II liked to think of himself as a monarch under whom the arts could prosper. He himself painted, designed monuments, composed music, and occasionally even directed rehearsals at the Royal Opera and the

Royal Theater. His taste was conservative, and—chauvinistic to the core—he
delighted in any artistic effort celebrating the achievements of the house of
Brandenburg-Prussia. A comment in the conservative *Reichsbote* of Febru-
ary 14, 1897, in which the "ridiculous fad for the foreign" is thoroughly dis-
paraged, aptly echoes his suspicion of any cultural influences from abroad:
"The wealthy, educated circles in Germany still have to understand far more
clearly than they do at present that they owe it to the Fatherland and to their
honor to favor German art and thus spur it on to great achievements."[2]

Wilhelm II even liked to foster the illusion that Germany had been ap-
pointed the sole guardian of Western civilization. "To us Germans, great ideals,
more or less lost to other peoples, have become permanent possessions,"[3] he
proclaimed in a speech of September 18, 1901, inaugurating the Siegesallee.
This broad avenue, which leads through the Berlin Tiergarten to the Bran-
denburg Gate, was lined with thirty-two larger-than-life-size statues of his
Hohenzollern forebears carved in Carrara marble under the direction of
Reinhold Begas. He envisioned the lower classes, after a day's hard work, up-
lifted by art, by the contemplation of beauty and the ideal. But he reviled all
art that—in his view—descended to the gutter (he called it *Rinnsteinkunst*)
by depicting misery as more wretched than it really is. A number of writers
and artists had by this time already felt the sting of his criticism. When Gerhart
Hauptmann's working class drama *Die Weber* opened on September 25, 1894,
at the Deutsches Theater, Wilhelm II registered his displeasure by canceling
his subscription to the royal box. When Hauptmann was subsequently recom-
mended for the prestigious Schiller Prize in 1896, the kaiser decided to grant
the award to Ernst von Waldenbruch, his own favorite, who wrote historical
plays in the manner of Schiller's *Wilhelm Tell*. Moreover, the emperor vetoed
the gold medal proposed in 1898 for Käthe Kollwitz in recognition of her
print cycle *The Weavers' Revolt* (1893–1897), a work inspired by Hauptmann's
drama. *Regis voluntas suprema lex* was one of his favorite expressions; and
there was no doubt that he meant what he said.[4]

By deliberately dissociating itself from the Glass Palace, an institution that
enjoyed the emperor's personal patronage, the Berlin Secession aroused the
kaiser's annoyance. By showing, especially in the early exhibitions, works
by Liebermann and Uhde that, though by no means anarchistic, dealt with
working-class themes, the Secession seemed to encourage the kind of art
Wilhelm II dismissed as *Rinnsteinkunst*. And since the work of several Seces-
sionists so obviously tended toward Impressionism, whose French origins
were known even in imperial circles, the Secession quite openly defied the
kaiser's claim that only a genuinely German art had value. The astonishing

success and popularity of the Berlin Secession in the face of such opposition can be explained partly by the political and ideological dimensions that inevitably colored the cultural life of both the German capital and the country as a whole at this time of rising nationalism. As Peter Paret has observed, the opening exhibition of the Berlin Secession resembled "an early election victory by a new political party, which arouses strong positive and negative reactions merely by the fact of its existence."[5]

Lovis Corinth profited immensely from his association with the Berlin Secession. By 1902 he was a member of the executive committee and had signed a contract with the Cassirer Gallery. After Paul Cassirer started up his press, he published two books by the painter: a teaching manual, *Das Erlernen der Malerei* (1908), and a biography of Walter Leistikow (1910). Corinth also illustrated for Paul Cassirer the *Book of Judith* (1910; Schw. L54) and the *Song of Songs* (1911; Schw. L82), both published with the Pan Presse imprint. In 1909 Bruno Cassirer's press brought out Corinth's autobiographical account *Legenden aus dem Künstlerleben*.

From a technical point of view, Corinth's new environment had a liberating effect on his style. As a result of his growing familiarity with French Impressionism, his brushwork became more vibrant, his colors lighter. The same development can be seen in the work of Max Slevogt who, like Corinth, had been a member of the Munich Secession and its rebellious offshoot the Free Association. Slevogt, too, was elected to the executive committee of the Berlin Secession in 1902 and signed a contract with Paul Cassirer. Prior to the arrival of Slevogt and Corinth in Berlin, Max Liebermann had been the most potent artistic force in the Secession. After 1901 the leadership of all three painters was recognized.

A SCHOOL FOR WOMEN PAINTERS: CHARLOTTE BEREND

During the ensuing years Corinth devoted much of his energy to teaching. On October 15, 1901, he opened a private school in his studio on Klopstockstrasse. Like Stauffer-Bern's enterprise earlier, this was planned as a school for women painters, although a small contingent of men rounded out the student body from the very beginning. From 1904 on Corinth taught his students in a second studio he rented on nearby Händelstrasse. He also taught for many years in the school of the sculptor Arthur Lewin-Funcke, which was modeled on the Académie Julian. Only a few of Corinth's students have found a place in the history of art. They include Oskar Moll, Ewald Mataré, and August Macke, all of whom, however, ultimately evolved an art independent of Corinth's example.

Corinth once remarked that the money he had earned from teaching had made him a "well-to-do man."[6] But financial considerations were not the reason that he attended conscientiously to his students for so many years, offering firm but encouraging counsel, impatient only toward those who sought to impress him with technical virtuosity or willfully nurtured stylistic peculiarities.[7] He felt "called" to be a teacher.[8] Whatever he had learned at the academies in Königsberg and Munich and at the Académie Julian in Paris, he now wished to pass on to a younger generation of painters, not only directly but also indirectly, by way of the teaching manual he published in 1908. Corinth in fact looked on teaching as a learning process that further clarified his approach to his own art. As he wrote in his autobiography: "Only now did I grasp many things my teachers had tried to make me understand earlier. To be constantly surrounded by models, moreover, is highly instructive. I suggest that every artist, by all means, seek his final perfection through teaching."[9]

Corinth's School for Women Painters brought him face-to-face with the person who was to play the most decisive role in his subsequent professional and personal life: Charlotte Berend, one of the first students to come knocking at the door of his studio in October 1901. The daughter of a well-to-do cotton importer, Charlotte Berend managed to combine the social conventions of her upbringing with a generous and outgoing spirit. She was twenty-one when she first came to study with Corinth. At least initially the painter must have represented for her something of a father figure, for at forty-three he was only five years younger than her own mother. Despite her youth, however, Charlotte Berend soon developed an intuitive grasp of Corinth's character. Her initiative, resourcefulness, and sensitivity toward his art quickly made her his favorite pupil. In a matter of months their relationship blossomed into mutual affection. They spent a good part of the year 1902 traveling together: they went to Horst on the Pomeranian seacoast in the summer and in early fall to Munich and Tutzing. On March 26 the following year they were married in Berlin.

Nothing is known about Corinth's earlier relationships with women, but it is safe to assume that these were at best casual affairs that meant little to him. Charlotte Berend, as a fellow painter, brought to her role as lover and wife a keen awareness and understanding of his needs as an artist. She was unfailingly supportive whenever he expressed the slightest doubt in his work and knew just how to coax him if the occasion demanded. Corinth, who had spent his childhood in a household devoid of domestic warmth and who as a bachelor had experienced that warmth only in the homes of others, found emotional stability through his marriage to Charlotte Berend.

Corinth's son Thomas was born on October 13, 1904, his daughter Wilhel-
mine on June 13, 1909, one month before the painter's fifty-first birthday.
Charlotte Berend provided the pivotal link in this home of three generations,
and her central role in Corinth's life is amply documented in his work. Not
only are there many portraits of her, but she also appears anonymously in
pictures of nudes, in interiors, and in figure compositions. Many of the paint-
ings and drawings Corinth made of his wife had their origin in a spontaneous
situation she herself created: a new dress or a shawl, her way of twirling a
parasol or adjusting a garter, or simply a clownish face made in jest. It is no
exaggeration to suggest that by her gentle guidance Charlotte Berend single-
handedly enriched Corinth's perception of human nature and unlocked in
him resources that were to bear ample fruit in the years to come.

EARLY PORTRAITS OF CHARLOTTE BEREND

Corinth's first portrait of Charlotte Berend (Fig. 80) is dated July 1, 1902. The
painting was a gift to the student; it bears a dedicatory inscription to "Frl.
Charlotte Berend" and is signed "Herr Lehrer Lovis Corinth." The formal
tone of the inscription is matched by the painter's conception, which stresses
the conventional, representative qualities common to Corinth's full-length
portraits of this type. As in the portraits of 1900 of Bianca Israel (B.-C. 175)
and Margarethe Hauptmann (B.-C. 196) and in the portrait of Frau Simon of
1901 (B.-C. 197), emphasis is on the handsome dress, which is set off to par-
ticular advantage by the shallow, undifferentiated ground. In contrast to the
earlier portraits, however, Corinth gave the painting an allegorical dimension
by adding the twig of rose leaves that Charlotte Berend holds. Read in conjunc-
tion with her white dress, it alludes to her youth and innocence. As he came to
recognize the special attraction Charlotte Berend had for him, Corinth was
surely troubled by their great difference in age; with the allegorical allusion
he may have acknowledged a growing sympathy he was not yet prepared
to state. Charlotte Berend, in turn, perhaps unsure of her feelings toward
Corinth, took refuge in a staged and mannered pose that allowed her to main-
tain psychological distance. That both teacher and student needed the shield
of some playful subterfuge to hide their emotions is confirmed by an episode
that took place while Corinth was at work on the portrait. The package in
which Charlotte Berend had brought the white dress to Corinth's studio also
contained several items she had worn earlier to a ball: a black scarf, a fan, and
a mask. One day, when Corinth asked her about the other contents of the

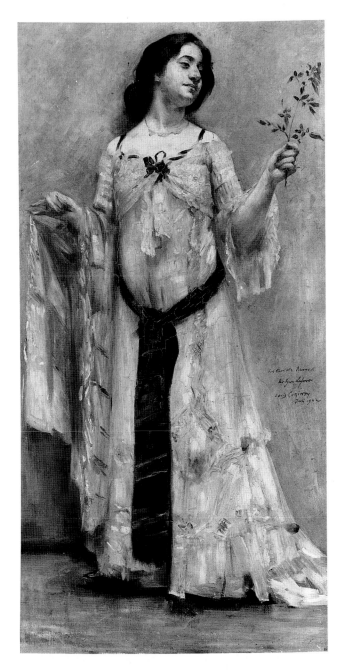

FIGURE 80.
Lovis Corinth, *Portrait of Charlotte Berend in a White Dress*, 1902. Oil on canvas, 105 × 54 cm, B.-C. 241. Berlin Museum, Berlin. Photo: Hans-Joachim Bartsch.

package, she put on the scarf and the mask and fanned herself coquettishly to show him how she had looked at the ball. Corinth was so enthralled that he painted her in this disguise as soon as the first portrait was finished.[10] This second portrait (B.-C. 236) is astonishingly free in execution; in gesture and posture it conveys Charlotte's vivacious temperament far more than the first. But her thoughts remain hidden by the mask.

During the weeks the two spent together at the Pomeranian seacoast, Corinth painted Charlotte Berend four times. Only one of these pictures (Fig. 81) is a portrait in the conventional sense; it is also the most intimate of the four paintings and a testimony to the affection and trust that by then had developed between teacher and student. As in the first portrait from Berlin, the pictorial structure is simple. Only a corner of the window in the upper left enlivens the background. The wildflowers in the glass on the windowsill echo the colored floral pattern of Charlotte's black dress. Her posture is graceful but without affectation, and her open gaze meets the painter's own with sympathy and understanding. Corinth underscored his affection by inscribing the words "Mein Petermannchen" in mirror writing on the arm of the chair.[11] Charlotte Berend had only recently told him how several years earlier, while on vacation with her parents and sister, she had managed to ward off the advances of a snobbish young suitor by pretending that she was not at all the bourgeois girl he wished to court but rather a Gypsy by birth, a foundling and adopted child, whose real parents, members of the tribe Petermann, had abandoned her in infancy. Petermann and the diminutive Petermannchen (sometimes emphasized for greater effect as Petermannchenchen) were henceforth Corinth's names of endearment for Charlotte.[12]

An early pencil drawing of Charlotte Berend (Fig. 82) dates from the trip the lovers took to the Starnberger See in the fall of 1902. Charlotte, who had unexpectedly fallen ill, lies asleep at the couple's inn at Tutzing. The drawing bears eloquent witness to Corinth's empathy. The face is lovingly modeled; only at the periphery of the image does the shading give way to a more summary rendering. The conception recalls the portrait of Luise Halbe from 1898 (see Fig. 73), and the drawing, with an independence of expression previously reserved for Corinth's work in oil, signals a new role for his graphic works. This is seen even more clearly if the drawing is compared to the oil sketch (B.-C. 259) Corinth completed in the course of his vigil at Charlotte's bedside. The oil sketch retains all the freshness and spontaneity of the drawing, making the latter, by implication, an autonomous work of art.[13] Henceforth Corinth's drawings frequently surpassed his paintings in their harmony of content and form.

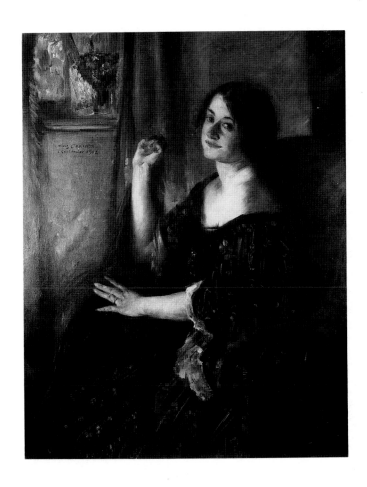

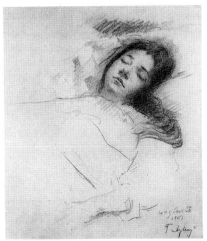

FIGURE 81.
Above: Lovis Corinth, *Petermannchen*, 1902. Oil on canvas, 119 × 95 cm, B.-C. 240. Private collection.

FIGURE 82.
Left: Lovis Corinth, *Charlotte Berend Asleep*, 1902. Pencil, 35.2 × 34.3 cm. Collection, The Museum of Modern Art, New York. The Joan and Lester Avnet Collection.

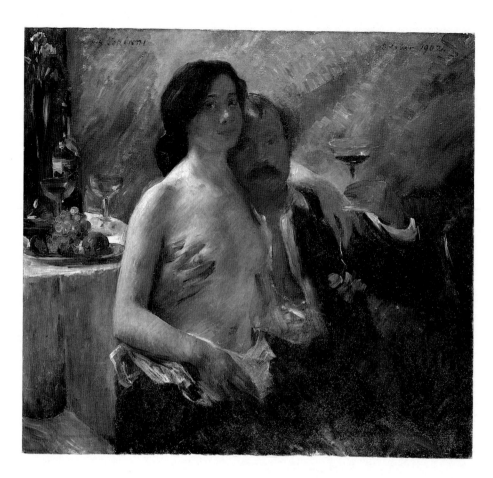

FIGURE 83.
Lovis Corinth, *Self-Portrait with Charlotte Berend and Champagne Glass*, 1902. Oil on canvas, 97 × 107 cm, B.-C. 234. Auctioned July 3, 1979, at Christie's, London; present whereabouts unknown. Photo: Christie's-Artothek.

Charlotte Berend's expanded role in Corinth's life is documented by several paintings from 1902 for which she posed in the nude. They include the large double portrait (Fig. 83) painted in October after the lovers' return from Bavaria. An immense gulf separates this painting from the preceding double portrait (see Fig. 79) in which Corinth, assured in his professional calling, had depicted himself at work in the company of a young model. Primacy of place now belongs to Charlotte Berend. Her body, naked to just below the waist, is fully illuminated, and she engages the viewer's attention with her open gaze. She holds a flower in her left hand, again most likely in symbolic allusion to her youth. Corinth himself looks younger and trimmer than in any of the self-portraits from the 1890s. Supporting Charlotte on his knee, he raises a glass in celebration of their love. According to Charlotte Berend, the idea for the double portrait originated with Corinth himself, and the execution of the painting proceeded as swiftly as the energetic brushstrokes suggest:

> As he began to paint, it seemed to me that I had never known him like this. He rejoiced as he worked . . . and shouted: "How happy this makes me. . . . Just look, the picture is painting itself of its own accord. Come, let's take a short break! I'm going to have some wine, and you have some too." . . . He laughed. "Cheers, my Petermannchen, and now back to work!"[14]

The conception of the painting was no doubt inspired by the famous double portrait in Dresden in which Rembrandt depicted himself with his wife Saskia on his knee. Rembrandt, however, moralized in the manner characteristic of similar seventeenth-century Dutch pictures, painting himself in the guise of the Prodigal Son, warning against frivolous pleasures while ostensibly delighting in them. Although Corinth's painting, too, transcends the specific experience of the two figures, vibrant and tactile brushwork transforms it into an unequivocal evocation of the joy of life.

In June 1903, about three months after his marriage to Charlotte Berend, Corinth returned to the subject of the double portrait in a considerably modified form (Fig. 84). Although Charlotte again occupies the frontal plane of the picture, the painter dominates it, showing himself with the tools of his profession recording the image he sees before him. There is no longer any hint of apprehension about Charlotte's youth, and the intoxication of courtship has given way to a new self-assurance. Corinth has clearly regained control of his emotional life. He confronts himself boldly; Charlotte, her back toward the

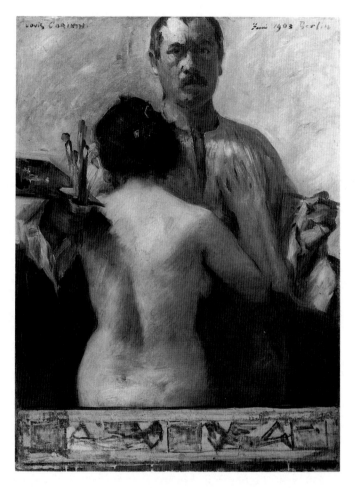

FIGURE 84.
Lovis Corinth, *Self-Portrait with Model*,
1903. Oil on canvas, 121 × 89 cm, B.-C.
256. Kunsthaus Zurich (1951/17).

viewer, stands close to the painter, protected by his arms, but also shielding
him, her gesture at once suppliant and supportive. The emotional equilibrium
the couple has achieved is echoed in the balanced pictorial structure. The two
standing figures emphasize the central vertical axis of the composition; the
painter's hands accentuate the corresponding horizontal division. A few years
later Corinth reproduced a photograph of this painting in his teaching manual
as an example of how to distribute the structural elements in a pictorial field
so as to achieve a well-thought-out, balanced composition.[15]

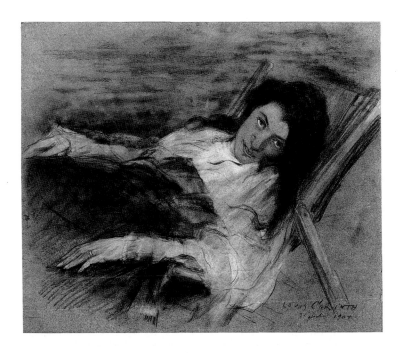

FIGURE 85.
Lovis Corinth, *Charlotte Berend in a Deck
Chair,* 1904. Pastel and charcoal on gray
paper, 49.5 × 60.0 cm. Westfälisches
Landesmuseum für Kunst und
Kulturgeschichte/Westfälischer
Kunstverein, Münster (939 WKV).

CHARLOTTE BEREND AS
MOTHER AND OTHER FAMILY PORTRAITS

The months just before the birth of their two children were for Corinth and
his wife a period of particularly close communion. In the charcoal and pastel
drawing of July 31, 1904 (Fig. 85) Charlotte is six months pregnant. Her intent
look no doubt reflects Corinth's own anxiety as much as it expresses her need
for affection and security. Though contemporary with the painting *In a Deck
Chair* (B.-C. 285), the drawing is not a preliminary study for the picture but,
like the earlier pencil sketch from Tutzing (see Fig. 82), another autonomous
document of the spiritual bond between artist and model.

Corinth was spellbound by the processes of new life as they were revealed to him in the course of his wife's pregnancies. In addition to the picture from July 1904, he painted Charlotte five days before the birth of Thomas (B.-C. 281) and twice in 1909 as she awaited the birth of Wilhelmine. In conception each of these paintings is personal, but the 1909 paintings also speak of Corinth's need to universalize the experience of Charlotte's motherhood. One shows her nude (B.-C. 401); the other (see Plate 14) depicts her seated in Corinth's studio, her breasts partly exposed. Only her posture alludes to her pregnancy. The general disposition of the figure is anticipated in both a canvas (B.-C. 354) and a drypoint (Schw. 27) from 1908 depicting Charlotte seated by a window. But now no environmental allusions interfere with the subject. The subdued colorism reinforces the simple pictorial structure. As in the drawing from July 1904, Charlotte's expression mirrors both trust and devotion. While the painting has rightly been compared to Wilhelm Leibl's portrait of Mina Gedon when she was expecting a child,[16] Corinth himself invited another challenging comparison when he borrowed the title of the picture, *Donna gravida,* from Raphael's panel in the Pitti Palace.

Corinth brought the same empathy with which he had observed his wife during her months of pregnancy to the theme of mother and child. Except for the rather conventional double portrait from 1901 of Gertrud Mainzer and her daughter Lucy (B.-C. 223), the subject does not occur in his earlier work. Only with the birth of his own children did he begin to fathom the bond of parental affection. Whereas Frau Mainzer poses proudly with her daughter in the comfort of her well-appointed Berlin home, the real subject of Corinth's first painting of Charlotte and Thomas (Fig. 86), completed between April and May 1905, is the loving interaction of mother and son. Charlotte holds the boy on her lap, gently directing his attention to the painter, who is thus allowed to share in the spirit that unites the two. Though barefoot, Charlotte wears a splendid dress that lends the painting a festive air reminiscent of Rubens's double portrait in the Alte Pinakothek of Helena Fourment and her son Frans, a picture that may well have influenced Corinth's conception. Indeed, Rubens's unusual group of paintings of his two wives, Isabella Brant and Helena Fourment, and the Rubens children surely furnished the prototypes for Corinth's own family portraits. More intimate than the picture with Thomas is the one Corinth painted in June 1909 (B.-C. 391), four days after the birth of Wilhelmine. As Charlotte nurses the infant, her affection expresses itself eloquently in her tender gaze and protective gesture. The extreme close-up view is no doubt a measure of Corinth's empathic response to the domestic scene.

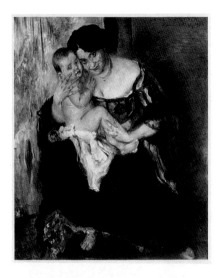

FIGURE 86.
Left: Lovis Corinth, *Mother and Child,*
1905. Oil on canvas, 127 × 107 cm, B.-C.
312. Present whereabouts unknown.
Photo: Marburg/Art Resource, New
York.

FIGURE 87.
Below: Lovis Corinth, *Mother and Child,*
1906. Oil on canvas, 80 × 95 cm, B.-C.
326. Present whereabouts unknown.
Photo: after Bruckmann.

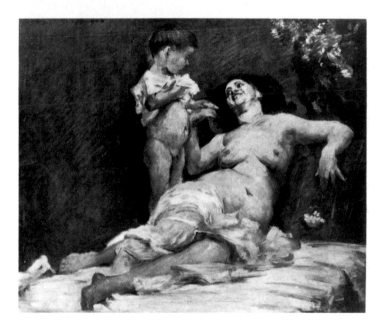

In addition to several portraits of young Thomas (B.-C. 278, 311, 374) and
three more double portraits of Charlotte with Wilhelmine, Thomas, and again
Wilhelmine (B.-C. 392, 393, 456), there are several works that invest the subject
of mother and child with a more general meaning. In a painting of 1906 (Fig. 87)
both Charlotte and Thomas are shown in prototypical nudity. Charlotte re-
clines on a couch and turns, smiling toward the boy. The flower she holds

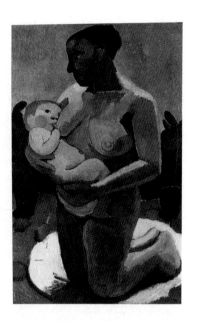

FIGURE 88.
Right: Paula Modersohn-Becker, *Kneeling Mother and Child*, 1907. Oil on canvas, 113 × 74 cm. Staatliche Museen Preussischer Kulturbesitz, Nationalgalerie, Berlin (West) (NG 7/85). Photo: Jörg P. Anders.

FIGURE 89.
Opposite: Lovis Corinth, *The Artist and His Family*, 1909. Oil on canvas, 175 × 166 cm, B.-C. IV. Niedersächsisches Landesmuseum, Landesgalerie, Hannover (KM 7/1918).

and the bouquet in the upper right corner of the composition underscore the allusion to fecundity and new life. Unfortunately, the painting is burdened by the implicit erotic appeal typical of Corinth's mature depictions of the female nude and remains much too close to the model to be convincing in generalized terms. The same physiognomic veracity and forced expression greatly diminish the effect of *Motherly Love* (B.-C. 457), another painting of Charlotte and Thomas, from 1911. The weakness of Corinth's solution in these pictures is especially apparent in comparison with Paula Modersohn-Becker's symbolic representations of about the same time (Fig. 88). Under the influence of van Gogh, Gauguin, and several primitive and antique sources Modersohn-Becker had evolved a simplified and monumental pictorial language with which to express convincingly the eternal truths of womanhood. Her anonymous mothers, painted in flat, warm colors and heavy, volumetric shapes, evoke the generative processes of life.

Corinth's pictures of his young family culminated in the group portrait (Fig. 89) he painted in November 1909. According to Charlotte Berend, he prepared the painting with great care. He selected a canvas that had exactly the same dimensions as the large mirror he was using for the occasion, and he insisted that the four figures pose together as a group rather than individually. While painting, Corinth kept moving back and forth between the canvas and his place in the composition.[17] The arrangement of the figures parallel to the picture plane might easily have resulted in a monotonous group-

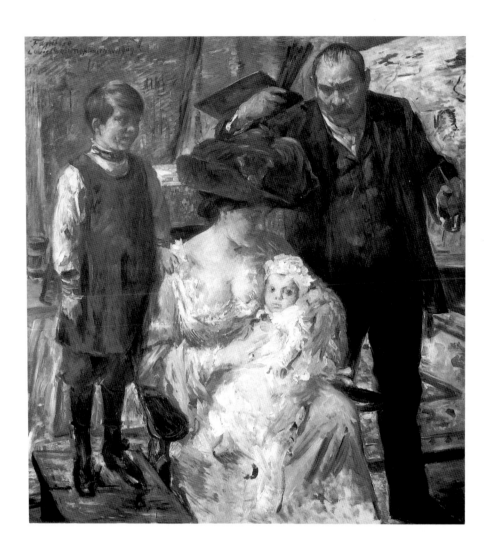

ing had Corinth not enlivened the background with a variety of colors, textures, and shapes and allowed each figure a considerable measure of independence. The painting is indeed a study in contrasts skillfully reconciled. Thomas, who had just turned five, stands on a stool at the left and places one hand on his mother's shoulder. His attention is focused on the canvas on which Corinth is at work. Charlotte Berend, wearing a luxurious dress and a large hat, is seated in the middle, looking down at five-month-old Wilhelmine in her lap. Charlotte is the physical and psychological center of the painting, her role as mother underscored by her intimate contact with both children. Corinth shows himself in the act of painting and thus partakes of the family idyll primarily as an observer. The scattered attention of the various figures finally comes to rest on Wilhelmine, the only one in the group to look straight into the mirror. Corinth also emphasized the relationship of the figures coloristically. White is distributed so as to predominate in Charlotte and Wilhelmine. Shades of brown link the painter and his son. Charlotte, however, shares in both colors to a significant degree and thus further unifies the family gathered around her.

PORTRAITS OF FRIENDS AND OTHER ARTISTS

Except for the works that originated in the intimacy of his family, Corinth painted relatively few portraits between 1902 and 1910. Although the prospect of lucrative portrait commissions had helped persuade him to settle in Berlin, the market for portraits of members of Berlin society close to the Secession turned out to be dominated by Liebermann and Slevogt, and Corinth apparently decided to carve out a special niche for himself by channeling his creative energy into figure compositions instead. Moreover, potential patrons may have thought Corinth uncongenial as a painter, for his portraits did not necessarily flatter, and he approached pictorial problems in decidedly unorthodox ways. He was freer to follow these inclinations when he painted a portrait on his own initiative or, as in the group portrait of the Berlin painter Fritz Rumpf's family (see Plate 15), when he was assured of the client's sympathy and understanding.

This particular painting is as much a painting of light as a representation of individual likenesses. In fact, it can be argued that the painting achieves the character of a group portrait only through the independent agent of light. A comparison in this regard with the painting of the Johannes Lodge (see Fig. 74) is instructive, especially since the two compositions are similar, the figures in

both works having been arranged in two rows parallel to the picture plane. The earlier painting depicts twelve distinct individuals independent of one another; in the 1901 work Corinth managed to unify the group in a way that expresses something about the figures' family relationships. Indeed, the painting is the precursor of the large group portrait he painted of his own family in 1909. Margarethe Rumpf and her six children are seated in the elevated alcove of the family's dining room before a leaded window. The figures are illuminated from several directions and, depending on the strength of the light that envelops them, assert their individuality within the group. Frau Rumpf is seated at the far right of the second row. Her features are the most clearly defined, and she engages the viewer's attention by her gaze. The faces of the boy and the girl at the extreme left are shown in profile silhouetted against the bright window, a view that clearly reveals their resemblance to their mother. Corinth subordinated the younger children to the form-dissolving effects of light according to the development of their features, concentrating the light on the two youngest and enhancing this part of the canvas with special coloristic appeal. The pink dress of the curly-haired boy in the center is brought into harmony with the bright red of his socks and intensified by the adjacent tones of white, orange, and olive green. As in Rembrandt's famous family portrait in Braunschweig, the splendor of the colors transforms the image into something immaterial. The vibrant brushstrokes, too, suggest more than they describe. As they unify the group, they carry a meaning in human terms that transcends the specific character and situation of the individuals portrayed.

When he painted the portrait of the poet Peter Hille (1854–1904) (Fig. 90), Corinth found himself face-to-face with an incorrigible eccentric, and he responded with a character study that, while less subtle, equals in perception the portrait of Eduard von Keyserling (see Plate 13). Hille's shabby appearance and unconventional demeanor made him a curious sight in the bourgeois milieu of the German capital. Yet he was tolerated in the city's intellectual and artistic circles, where he showed up unannounced, carrying a large satchel filled with voided streetcar tickets and the other scraps of paper on which he scribbled his poems and epigrams. Aversion to discipline and disregard for bourgeois conventions were among Hille's character traits, along with an almost childlike innocence that accounted for much of his popularity. Hille, a native of Erwitzen, near Paderborn, rebelled early against the strictures of family life. After working briefly in the late 1870s in Bremen, on the editorial staff of the *Deutsche Monatsblätter* and the *Bremen Tageblatt,* he tried to establish himself as an independent writer in Leipzig. When this effort failed, he went to London to study in the library of the British Museum but

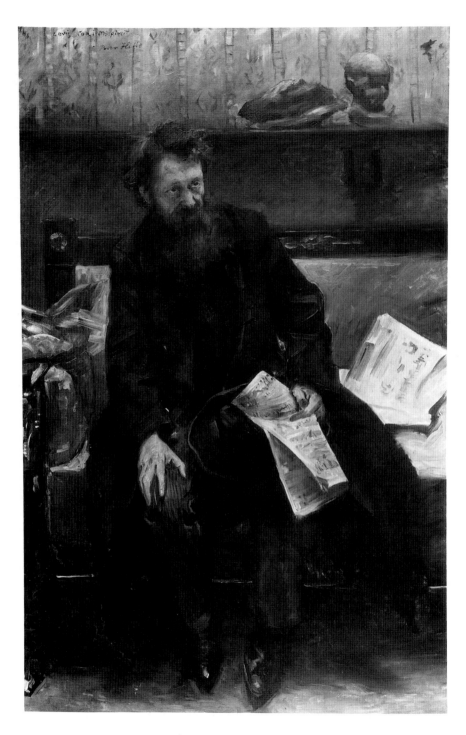

FIGURE 90.
Lovis Corinth, *Portrait of the Poet Peter
Hille,* 1902. Oil on canvas, 190 × 120 cm,
B.-C. 237. Kunsthalle Bremen.

spent most of his time from 1880 to 1882 in the slums of Whitechapel. He subsequently traveled, mostly on foot, as far as Italy and Hungary. While serving as the manager of a small troupe of itinerant actors in Holland, he squandered what remained of a small inheritance from his mother. Although Hille gained recognition in the late 1880s for his novel *Der Sozialist* (1887), he is remembered now more for his Bohemian life-style than his literary output. Always neglectful of his health, he died of a lung hemorrhage in Berlin at the age of forty-nine.

Corinth has spoken of the circumstances that led to the Hille portrait. When he mentioned to Peter Behrens that he was in search of an interesting-looking model, Behrens called Hille to his attention, warning him that the talkative poet was wont to make interminable visits. When Hille came to call on Corinth and began to remove his outer garments, the painter, remembering Behrens's words of caution, quickly told him: "Don't bother. I'll paint you just the way you are."[18] In the large, life-size portrait Peter Hille is indeed still dressed in his overcoat, his hat on his knee. But the anecdote alone hardly explains the painter's conception; only deliberate artistic decisions could have produced so apt a characterization. Everything about the sitter speaks of his restless nature—his fidgety posture, the folds of his coat, and the crumpled hat and sheets of newspaper—and Hille imparts this restlessness to his immediate surroundings, as in the squashed-down pillow at the left. He hovers on the edge of the sofa, his feet hardly seeming to touch the floor, and his gaze is turned upward as if something had suddenly caught his attention. The unusually well-ordered pictorial structure accentuates the disquiet of his bearing. The lines of the sofa and the shelf above it divide the canvas horizontally into parallel planes, providing a sense of stability at odds with the poet's restive figure. The conch shell and the small bust—perennial appurtenances of bourgeois culture—on the shelf above him further signify a world in which Peter Hille is no more than a peripatetic guest.

The otherwise very different portrait of the pianist Conrad Ansorge (1862–1930) is equally perceptive (Fig. 91). Here again Corinth set out to fathom the enigmatic inner life of a creative individual, and his approach to the task is as unconventional as it is successful. One might expect, for instance, to see Ansorge at the piano or, possibly, in the privacy of his study. Instead Corinth painted the musician outdoors, seated in the garden as if relaxing after a walk. What is more, Corinth divided the pictorial field so as to give equal physical weight to the sitter and the landscape. Coloristically, too, these parts of the composition balance, the white of Ansorge's suit holding its own against the green and earth tones of the garden. From an expressive point of view, how-

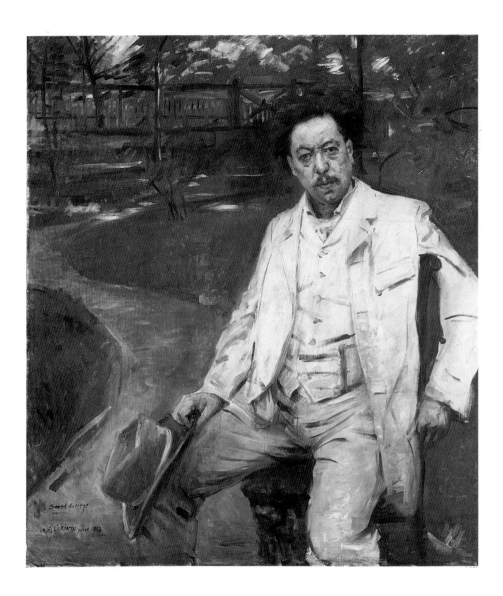

FIGURE 91.
Lovis Corinth, *Portrait of the Pianist
Conrad Ansorge*, 1903. Oil on canvas, 141
× 125 cm, B.-C. 264. Städtische Galerie
im Lenbachhaus, Munich (FH 247).

ever, the musician's spiritual presence dominates the painting. The fence in the background and the vertical axis of the chair lead resolutely to Ansorge's head, which forms the psychological, if not the physical, center of the composition. Even the outdoor light is not allowed to interfere with the modeling of the thoughtful face, encroaching on the sitter only in the quick brushstrokes with which Corinth accented the folds of the suit. Whereas the portraits of Keyserling and Hille bear witness to precarious physical and emotional states, the portrait of Ansorge is the very image of equanimity.

Ansorge, who looks older than his forty-one years, was just beginning his great international career. A native of Silesia, he had studied with Franz Liszt and in 1887 completed a successful first tour of the North American continent. He made his home in Berlin in 1895 but traveled all over Europe and South America giving concerts and recitals. He was especially acclaimed for his interpretation of the great Romantics, Beethoven, Schubert, Schumann, and Chopin; but he was also a keen champion of the works of contemporary composers and himself set to music texts by Stefan George, Alfred Mombert, and Stanisław Przybyzewski. Though famous for his command of the keyboard, Ansorge despised the pursuit of virtuosity for its own sake and distinguished himself among the pianists of his generation by faithfully adhering to a composer's intentions. Sensitivity and intelligence were the hallmarks of his playing and earned him the love and respect of his many students. Corinth, too, perceived the spiritual side of Ansorge as his very essence and underscored it in the portrait.

THE MATURE FIGURE COMPOSITIONS

Although Corinth exhibited several of his portraits—and some, such as the portrait of Peter Hille, elicited much favorable comment—he solidified his reputation in Berlin on the basis of his figure compositions, the works with which he asserted his independence among the leaders of the Berlin Secession. For Liebermann, by comparison, who had long abandoned his earlier aspirations of becoming a history painter, subject matter in painting mattered little or mattered only insofar as it related to purely artistic matters. To him "a well-painted turnip," as he put it, was "as good as a well-painted Madonna."[19] Corinth, in contrast, owed his real recognition to such weighty themes as the Pietà and the Deposition and to his provocative *Salome* and thus had every reason to believe that other paintings like these would continue to attract wide public attention.

The figure compositions from Corinth's early years in Berlin are for the most part large in scale and feature many characters in complicated fore-shortened postures. Because the pictures, like the *Tragicomedies* cycle, explore parodistic elements, they often created something of a spectacle at the exhibitions of the Berlin Secession. The general public greeted them enthusiastically, but critical reaction was usually mixed. Gustav Pauli called Corinth's figure compositions "fatal aberrations of a brilliant technician." [20] Meier-Graefe found in them a gap, difficult to bridge, between content and form. "From many a painting by Lovis Corinth," he observed caustically, "emanates the physical potency of animals in heat. Sometimes one is tempted not to look for fear of having to smell what one sees. Tender souls recoil horror-struck. Painters rejoice." [21] Both Pauli and Meier-Graefe judged Corinth's figure compositions from a pro-Impressionist bias, and in the context of the painter's late works these pictures indeed appear not only superficial but often in bad taste as well. Nonetheless they are important for a full understanding of Corinth's development, for only in relation to them can his final achievement as an artist be appropriately measured.

Naturally, Corinth himself thought highly of these pictures. Summing up his activity during his early years in Berlin, he singled out several of them, convinced that in time they would be counted among his best works. [22] Critical perception and the high quality of Corinth's later output have contradicted his own assessment; yet the original success of his figure compositions affected even the most unsuspecting of his fellow Secessionists. Several melodramatic compositions by Slevogt, such as *Samson Blinded* (1906; private collection), *The Massacre of the Innocents* (1907), *Rape* (1905), *Battle of Titans* (1907) (all in the Niedersächsische Landesgalerie, Hannover), and *Knight and Women* (1902; Staatliche Kunstsammlungen Dresden, Gemäldegalerie Neue Meister), as well as Liebermann's *Samson and Delilah* (1902; Städelsches Kunstinstitut, Städtische Galerie, Frankfurt), their subjects by then so at odds with those of other mature works by both these painters, illustrate how persuasive the popularity of Corinth's figure compositions could be. The effect of Corinth's figure compositions on younger artists like Max Beckmann was more lasting. Indeed, Corinth to a large extent passed on to Beckmann the nineteenth-century tradition of the grand theme. [23] It is difficult, if not impossible, to look at the dynamic figure groupings and rugged brushwork of such early paintings by Beckmann as *Drama* (1906; destroyed in World War II), *Crucifixion* (1909; Collection Georg Schäfer, Schweinfurt), or *Battle of Amazons* (1911; The Robert Gore Rifkind Collection, Beverly Hills) without thinking of the example set by Corinth. Subsequently the younger painter developed out of this tradition new symbols for the visions, aspirations, and suffering of modern man.

FIGURE 92.
Left: Lovis Corinth, *Male Nude*, 1904.
Pencil and crayon heightened with
white; dimensions unknown. Formerly
Collection Johannes Guthmann,
Ebenhausen; present whereabouts
unknown. Photo courtesy Hans-Jürgen
Imiela.

FIGURE 93.
Below: Lovis Corinth, *Reclining Female
Nude*, 1907. Oil on canvas, 96 × 120 cm,
B.-C. 345. Kunsthistorisches Museum,
Vienna (MG 55/ÖG 3809).

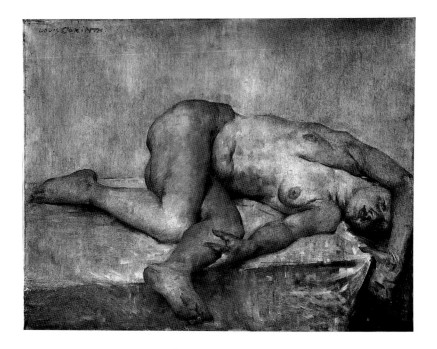

 Not surprisingly, Corinth's academically most ambitious figure composi-
tions date from the years during which he was actively involved in teaching.
The centerpiece of Corinth's teaching program remained the study of the live
model, and the drawing of a male nude (Fig. 92) from December 1904 may
well have been done while he worked alongside his students, as he some-
times did. The same concept of form, epitomized in the complicated posture
and plasticity of the naked body, is seen in the painting from 1907 of a reclin-
ing female nude (Fig. 93). Sprawled awkwardly across a firm support, the

figure was most certainly painted as a demonstration piece, and Corinth pub-
lished the picture as such in his teaching manual—logically enough, in the
chapter on foreshortening.[24] The same illustration further served to support
his view, stated several brief chapters later in the book, that "the model is the
most important aid the painter has at his disposal. He studies it during his
years of training and relies on it when in his paintings he wants to translate
the figures of his imagination into reality."[25]

Several of Corinth's figure compositions are actually no more than expanded
studies of the nude model, a number of figures having been grouped together
in some fashion. These paintings usually bear rather perfunctory titles that
more or less describe what is shown. They include *The Graces* (B.-C. 233), a
depiction of three standing female nudes in almost sequential and comple-
mentary front, back, and side views, and *Girl Friends* (B.-C. 297, 298), two
pictures in which four nude models in a variety of postures crowd around a
chaise lounge. In *Harem* (Fig. 94) Corinth modified this subject only slightly
by adding the figure of a black eunuch. The delightful little cat in the fore-
ground gazes attentively out of the picture and by its prim composure accen-
tuates the languid sensuality of the four women. No wonder pictures like this
helped to establish Corinth as one of the great modern painters of the female
nude and gained him the reputation of a man himself possessed of a robust
libido. It is impossible to say to what extent this reputation was justified.
Apparently, however, Corinth believed that the sensual life of artists was inti-
mately bound up with their creative activity, and he is said to have insisted that
artists not deprive themselves of sexual gratification, since erotic experiences
are wont to increase their creative energy.[26] In his autobiography Corinth ex-
pressed a similar opinion when he spoke of his belief that sexual contact en-
hances an individual's emotional life.[27]

The generally large scale of Corinth's figure compositions more than once
tested his skills to the limit. The fate of the ambitious *Perseus and Andromeda*
(B.-C. 208) has already been mentioned (see p. 124). *Samuel Cursing Saul*
(B.-C. 225), a picture with ten life-size figures painted in 1902, was cut apart
two years later for similar reasons, leaving only three fragments (B.-C. 226–
228). The same misfortune befell the right half of *The Ages of Man* (B.-C. 273,
275), two pictures from 1904 that were originally joined in a monumental
frieze. Corinth is said to have often referred jokingly to this composition as
his "matriculation" picture on account of the thirteen life-size figures—twelve
of them nude, including a woman, five men, and an assortment of children of
all ages—included in it.[28]

FIGURE 94.
Lovis Corinth, *Harem,* 1904. Oil on
canvas, 155 × 140 cm, B.-C. 299.
Hessisches Landesmuseum Darmstadt.

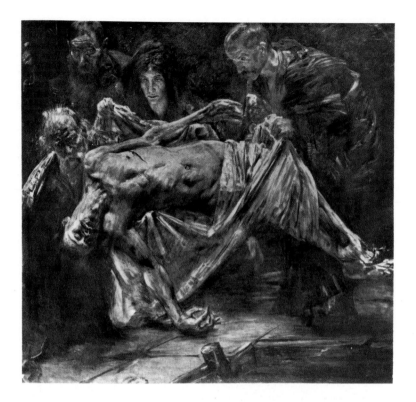

FIGURE 95.
Lovis Corinth, *Entombment*, 1904. Oil
on canvas, 172 × 185 cm, B.-C. 272.
Formerly City Hall, Tapiau; destroyed
1915. Photo: after Bruckmann.

The effort Corinth put into his figure compositions can still be traced in
several surviving preliminary studies. This process is especially well docu-
mented for the *Entombment* (Fig. 95), a large work from 1904 that the painter
subsequently donated to his hometown of Tapiau, although the painting itself
was destroyed when the town was invaded by Russian troops in 1915. The
preparatory drawings for the painting include sketches for the composition
and individual figure studies done to determine the distribution of the figures
and to clarify specific postures and gestures. These drawings were followed
by a tempera sketch and an elaborate charcoal drawing on canvas, both ap-
proximating the scale of the painting. This was the working method Corinth
had learned at the Académie Julian, and, not surprisingly, the original com-

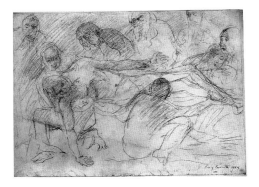

FIGURE 96.
Left: Lovis Corinth, *Entombment,* 1904.
Pencil, 33.6 × 49.2 cm. Staatliche
Graphische Sammlung, Munich
(1919:120).

FIGURE 97.
Below: Lovis Corinth, *Entombment,* 1904.
Charcoal heightened with white, 119.5 ×
180.0 cm. Sammlung Georg Schäfer,
Schweinfurt (271474).

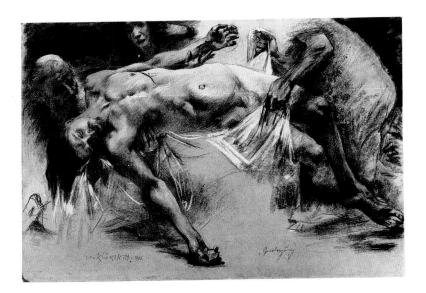

position study for the painting (Fig. 96) has close affinities with one of his
Lamentation drawings from 1884. As mentioned previously, Corinth had kept
that Paris drawing and eventually published it in his teaching manual to illus-
trate the "mental gymnastics" an artist must do to visualize the emotions
appropriate to various participants in a given action. The gestures and ex-
pressions of the figures in the later drawing are intensified, in keeping with
Corinth's mature conception.

 Although he transferred both the stage-like composition and excessive
pathos without major change to a nearly life-size tempera sketch (B.-C. 271),
he ultimately chose a simpler solution for both content and form. In the large
charcoal drawing on canvas (Fig. 97), which bears the incorrect date 1903, the

nine figures of the original composition have been reduced to four, and the
expressions and gestures have been subjected to greater restraint. The figure
of Christ, carefully modeled and heightened with white chalk and circum-
scribed by smooth, reinforced contours, is possibly Corinth's most idealized
and heroic nude. Except for the reversal of the pose, the figure recalls the
youthful, Adonis-like Jesus in Botticelli's famous *Pietà* in the Alte Pinakothek.
Indeed, Botticelli's shallow space and balanced, frieze-like composition may
well have been in Corinth's mind from the beginning. Although he did not
sustain the idealized conception of the charcoal drawing in the painting,
nonetheless—again like Botticelli—he maintained a precarious balance be-
tween overt pathos and introspection.

This borrowing from Botticelli was not an isolated instance. Repeatedly
during these years Corinth turned his attention to artists of the fifteenth and
sixteenth centuries. The vertical space and expressive figure types in *Golgatha*
(B.-C. 306) from 1905 have their antecedents in a *Crucifixion* by Mair von Lands-
hut and in the central panel of the Schöppingen Altarpiece, both then in the
Kaiser-Friedrich-Museum in Berlin.[29] In 1909 Corinth also made several color
drawings after woodcarvings by the Master of Rabenden in the same col-
lection and derived a number of details for the large *Carrying of the Cross* in
Frankfurt (B.-C. 410) from the well-known prints of this subject by the House-
book Master and Martin Schongauer as well as from the corresponding panel
of Hans Multscher's Wurzach Altarpiece, now in West Berlin.[30]

Unlike Max Liebermann, who as late as 1905 reproached Matthias Grü-
newald for having indulged in "painted poetry,"[31] Corinth shared this inter-
est in late medieval German art with several painters of the younger gen-
eration. Ernst Ludwig Kirchner, for example, acknowledged in his chronicle
of Die Brücke the immense debt he and his friends owed to Cranach, Beham,
and other German old masters.[32] Max Beckmann first learned to admire Grü-
newald in 1903, when he saw the Isenheim Altarpiece in Colmar, and he
eventually counted such painters as Gabriel Mälesskircher, Jörg Ratgeb, and
Hans Baldung Grien among those who had given his own art a decisive
direction.[33]

But unlike his younger contemporaries, Corinth was not induced by the
arbitrary color and form of late medieval German art to move away from na-
ture. Aside from borrowing a compositional device now and then and a few
isolated motifs, and no doubt appreciating the grotesque exaggerations of
gesture and expression in these earlier paintings, he remained resolutely
committed to visual truth. A large preliminary figure drawing of Christ for
the *Deposition* (B.-C. 331) from 1906, which vaguely recalls the same scene in a
Lower Rhenish altarpiece from the early sixteenth century in the old Kaiser-
Friedrich-Museum,[34] illustrates just how closely he observed the live model.

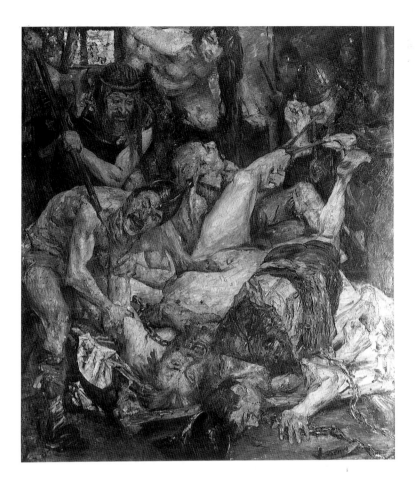

FIGURE 98.
Lovis Corinth, *Samson Taken Captive*,
1907. Oil on canvas, 200 × 175 cm, B.-C.
343. Landesmuseum Mainz.

Details such as the joints of the painfully extended arms are studied right
down to the diagrammatical rendering of the skeletal structure. Corinth's con-
cern for the veracity of the action in this painting is confirmed by Charlotte
Berend, who reports his asking her whether one can really tell exactly how
the nails that still hold Christ's feet fastened to the cross are being removed.[35]

Corinth relied on early German sources only for his Passion scenes; some
of his other figure compositions were derived from the great masters of the
baroque. The *Rape of Woman* (B.-C. 302, 303) from 1904 closely follows Rubens's
Rape of the Daughters of Leucippus in the Alte Pinakothek. *Samson Taken Captive*
(Fig. 98) from 1907 is dependent on Rembrandt's gruesome treatment of the

subject in Frankfurt. In each case, however, Corinth intensified the expressive elements of the prototypes with a more pointed naturalism as well as gestural and facial exaggerations. In the picture of Samson's capture, moreover, he assured himself of the greatest possible empathic response by restaging the event so that the figures occupy a space that seemingly extends the viewer's own. The viewer looks downward at the herculean giant whose figure forms a diagonal that leads the eye further back into the scene. Like Rembrandt, Corinth selected the climactic moment of the story when Samson is over-powered by the Philistines. One of them has already fastened a rope to Sam-son's ankle, two others seek to tie him in chains, and yet another approaches from the upper left, ready to plunge a spear into his eyes. Delilah, kneeling on the bed in the background, leans forward and looks down on the struggle with an expression that combines detached curiosity and cruel satisfaction. The savagery is oddly burlesque because of the crude figure types and the soldier in the lower right, who in the heat of the struggle has been thrown off balance and reacts with humorous consternation to the unexpected loss of his helmet. "Tender souls," as Meier-Graefe observed, might indeed "recoil" from this melee of wildly screaming and kicking figures, but the technical qualities that make "painters rejoice" are evident as well. The subdued earth colors underscore the primeval character of the subject, and the vigorous brushstrokes, reinforced by scrapings with the palette knife, further enliven the violent scene. Corinth ultimately stabilized the centrifugal energy of the composition by arranging the figures, as Rembrandt had done, along two di-agonals that converge on Samson's head. He countered these with repeated vertical accents, the most pronounced of which juxtaposes the heads of Samson and Delilah at either end of the painting's central axis, underscoring structurally the consequences of their fateful encounter.

The *Bathsheba* (B.-C. 349) from 1908 can also be traced to Rembrandt. Once again Corinth modified the prototype by adopting a more provocative frontal view of the subject and by subordinating the Dutchman's poignantly melan-choly mood to a coarse and even vulgar naturalism. The motif of milking the goat in *The Childhood of Zeus* (Fig. 99) is found in both Poussin and Jordaens. Jordaens also anticipated the humorous subplot of the story when instead of painting the nurturing of the infant god, as told by Ovid, he depicted the boy hollering for food because his bowl of milk has been overturned by the goat. Corinth elaborated Jordaens's conception by dwelling on the commotion nec-essary to keep the boy's cries from being overheard by his father Saturn, who had the nasty habit of devouring his children at birth because it was prophesied that one of them would usurp him. Jupiter's mother Rhea had managed to

FIGURE 99.
Lovis Corinth, *The Childhood of Zeus*,
1905. Oil on canvas, 120 × 150 cm, B.-C.
305. Kunsthalle Bremen.

save the child by feeding the unsuspecting Saturn a stone wrapped in swad-
dling clothes and spiriting the newborn off to the slopes of Mount Ida, where
nymphs raised him on wild honey and the milk of the goat Amalthea. In
Corinth's painting nymphs and satyrs join forces in cheering up the bawling
child while his food is being readied, making enough noise in the process to
ensure that the boy's cries are not heard. The nymph Adastreia, with the
unruly young god in her lap, is distinguished from her bucolic sisters by her
decorous gown and restrained demeanor. Seeking to calm the boy, she be-
haves more like a gentle nursemaid than a wild inhabitant of mountains and

grottoes. For the figure of the young god Corinth drew on his sleeping son, Thomas, whom he had watched one evening sprawled naked in his bed.[36] In the course of the preliminary studies for the painting the motif underwent considerable change, but its final state still testifies to Corinth's practice of developing even his imaginary subjects from life. Similarly, the goat and the rabbits in the picture were painted from the "models" that Corinth habitually assembled for such purposes in his studio.

The episode with the sleeping Thomas that helped to inspire the painting accords with Corinth's advice to his students to paint themes whose "universal human" significance can be understood from one's own life experience.[37] His early tendency to see literary subjects as paradigmatic of human situations (see the discussions of Figs. 35 and 36, pp. 61–64) increased markedly with his move to Berlin and his marriage to Charlotte Berend, informing, as already noted, such pictures as the double portrait of 1902 (see Fig. 83) and the 1906 painting of Charlotte and Thomas (see Fig. 87). The list of figure compositions with both an autobiographic and a universal dimension is indeed long and includes paintings like the *Judgment of Paris* (B.-C. 301, 338), *Rape of Woman* (B.-C. 303), and *Faun and Nymph* (B.-C. 325), a subject with which Corinth also decorated his nuptial bed.[38] Similarly, the archetypal episodes he selected in 1904 to signify the various ages of man (B.-C. 273, 275) apparently took on a personal meaning for Corinth during this year when his son was born. Moreover, although there is no evidence that Corinth was religious in the conventional sense, he felt attuned to the feast days of the Christian calendar. Both the *Deposition* from 1906 (B.-C. 331) and *The Carrying of the Cross* from 1909 (B.-C. 410) were painted at Easter time and are specifically so inscribed. And Corinth celebrated his fiftieth birthday in 1908 by painting a melodramatic *Lament of the Dead* (B.-C. 352), transposing the traditional theme of the Pietà into a generalized *memento mori*. These paintings, however, are not necessarily a measure of Corinth's inner commitment to these themes. In 1908, for instance, he painted a second "birthday picture," a surrogate self-portrait in the form of a fettered bull in a stable (B.-C. 360).[39]

The eclecticism for which contemporary critics censored Corinth was also his way of teaching by example, as can be seen from the comments he made in his teaching manual on the subject of personal creativity. Unusually well read himself, he considered the study of the history of art fundamental to an artist's education because it introduced young painters to the famous subjects of the Bible and mythology and helped them to understand the great masters of the past.[40] For him an artist's inventiveness manifested itself less in new subjects than in the manner of conceiving an old subject. And he cited as an

FIGURE 100.
Lovis Corinth, *Odysseus's Fight with the Beggar*, 1903. Oil on canvas, 83 × 108 cm, B.-C. 253. National Gallery, Prague (0-9238).

example the generations of artists from Giotto to Raphael who drew on the same subjects from the Bible and legends but achieved fame and immortality for their individuality.[41] Corinth's crude naturalism and his sensual and often bawdy interpretations of borrowed motifs were for him thus clearly a mark of originality and a means to self-expression.

Not surprisingly, Corinth often pursued his aggressively naturalistic conception as an end in itself. Such compositions as *Samuel Cursing Saul* (B.-C. 225), *Ages of Man* (B.-C. 273, 275), and *Lament of the Dead* (B.-C. 352) are independent of any prototypes, and in each the pictorial world of the painter's imagination takes on a vividly tangible presence. Another eloquent example is the boisterous composition *Odysseus's Fight with the Beggar* (Fig. 100) of

FIGURE 101.
Lovis Corinth, *The Large Martyrdom*,
1907. Oil on canvas, 250 × 190 cm, B.-C.
332. Museum Ostdeutsche Galerie
Regensburg.

1903, whose genesis is well documented, right down to the selection of the
costumes.[42] What makes this particular work especially interesting is that in it
Corinth simultaneously eschewed the academic decorum traditional for such
a subject and followed Homer's story almost to the letter. Homer describes
the events surrounding the long-delayed return of Odysseus to Ithaca in
elaborate detail, including the episode in which the hero, disguised as an old
beggar, finds himself insulted by Irus, a common tramp, who threatens to

drive him from the gate of his own home. A fight between the two soon
ensues, to the great amusement of the suitors who for years had been wooing
Penelope, feasting in Odysseus's palace, and lording it over his people. To
their astonishment, Odysseus "made his shirt a belt and roped his rags
around his loins, baring his hurdler's thighs," and quickly dispatched his op-
ponent by striking Irus a blow to "his jawbone, so that bright red blood came
bubbling forth from his mouth" (*Odyssey* 18.1–109). As in *The Childhood of
Zeus*, Corinth rendered the commotion in Odysseus's house almost audible in
his effort to make the ancient tale come alive.

Similarly remote from convention yet historically justified is the conception
underlying *The Large Martyrdom*, which Corinth painted in 1907 (Fig. 101). To
visualize the scene as clearly as possible, he had a cross made for the occasion
and periodically hoisted the naked model onto it, keeping the unfortunate
fellow strapped there as long as he could possibly bear it. This allowed Corinth
to paint the executioners and their victim at the same time.[43] The proximity of
the figures to the picture surface and the way they are cut by the frame, es-
pecially at the lower margin, almost force the viewer to participate directly in
the cruel action. The man at the lower left, seen obliquely from the back,
reinforces this response by drawing attention to the figure of Christ. The
painting is a far cry from Corinth's earlier *Crucifixion* (see Fig. 65) and from
the exegetic exposition of the subject he was to attempt in the Golgatha Trip-
tych in 1910 (B.-C. 411); both depict Christ's ordeal as a divinely ordained
redemptive sacrifice. There is no such promise of redemption in the unmiti-
gated atrocity of this Crucifixion. The clinical emphasis on the executioners'
matter-of-fact attitude underscores that these are men punishing a fellow hu-
man being.

ROLE PORTRAITS AND SELF-PORTRAITS IN COSTUME

Corinth's figure compositions of these years are closely related to both his
portraits of actors in their roles and his interesting self-portraits and double
portraits in which he wore disguises he associated with prototypical human
experiences. The role portraits were a direct result of Corinth's work for the
theater of Max Reinhardt, with whom he collaborated from 1902 to 1907, con-
tributing designs for costumes, and in some instances sets, for a total of eight
productions. Reinhardt had left Otto Brahm's ensemble at the Deutsches The-
ater in 1902 to become director of the Kleines Theater. The event not only
marked a turning point in Reinhardt's career but also ushered in one of the
most exciting periods in the history of the Berlin theater. When in 1903 the

Kleines Theater proved too small to hold the audiences that Reinhardt's productions attracted, the enterprising young director rented the Neues Theater as well. In 1905 he assumed responsibility for the Deutsches Theater and the following year extended his reign to the Berliner Kammerspiele.

For years Otto Brahm had fought for the recognition of naturalism on the German stage; Reinhardt now sought to reveal the content of any drama through expressive features in both acting and decor.[44] Assigning a significant role to the stage designer, he eventually achieved a synthesis of content and appearance by using sets and costumes not merely to create the illusion of nature and historical plausibility but to reveal the very essence of the play.

This new emphasis on creating an evocative milieu seems to have found its first full expression in Reinhardt's staging of Maeterlinck's *Pelléas und Mélisande*, which opened on April 3, 1903, at the Neues Theater. Corinth designed the costumes for the play and together with Leo Impekoven also worked on the sets. Unfortunately, only a fragmentary image of Corinth's work for the theater can be reconstructed from scattered reviews and a few surviving photographs. That Corinth and Impekoven successfully transformed the naturalistic stage into an instrument of greater expressive force is suggested by Carl Niessen's observation on the scenery for *Pelléas und Mélisande*: "Just as in Maeterlinck's poetic world reality lies behind things and can only be imagined with apprehension and longing, so a mysteriously threatening darkness emanates from the slender gray trees of a forest."[45] And Max Osborne speaks of the same setting as "a fairyland with wide open eyes, a world of mystery and fathomless depth, illumined for a brief moment by a ray of light."[46]

The most controversial play on which Corinth collaborated with Reinhardt was Oscar Wilde's *Salome*, first performed in Germany before a private audience at the Kleines Theater on November 5, 1902. The play premiered before a general audience almost a year later, on September 29, 1903, at the Neues Theater. Corinth designed the costumes; the sculptor Max Kruse was in charge of the sets. Kruse replaced the customary painted backdrop with a new type of three-dimensional stage architecture that was to become a hallmark of Reinhardt's productions. Beyond Herod's palace, flanked by guardian monsters and lions, was a gloomy night landscape. The shadows cast by the statuary and the building blocks of the scenery created a sense of foreboding as soon as the curtain rose. Corinth's costumes added barbaric splendor to this ominous mood. In their garish magnificence, the multicolored robes, encrusted with colored stones, expressed the high-pitched depravity that propelled the lurid plot.

In addition to his work on *Salome* and *Pelléas und Mélisande*, Corinth designed costumes for Hofmannsthal's *Elektra* (1903) and Gorki's *Nachtasyl* (1903), the sets for Wedekind's *König Nicolo* (1903), and perhaps both the sets and costumes for Shakespeare's *Merry Wives of Windsor* (1903). He also designed figurines for the 1907 productions of *Hamlet* and Lessing's *Minna von Barnhelm*.[47]

Corinth's work for the Berlin theater may well have helped to intensify the dramatic character of his contemporary figure compositions, for despite the demands he made on his models, it is unlikely that these paintings were entirely staged in the studio. They resulted from a synthesis of content and appearance, a pictorial challenge to which Corinth alluded in his teaching manual when he explained the special difficulty of depicting an actor in a given role, a task that requires coming to terms not only with the reality of the sitter but also with the illusion of the disguise.[48]

In Gertrud Eysoldt (1870–1955), whom he painted in January 1903 in the title role of Oscar Wilde's *Salome* (Fig. 102), Corinth encountered an unusually versatile actress whose ability to bring to life the heroine's hybrid character allowed him to experience the biblical figure directly. Eysoldt imbued Herodias's daughter with both childlike innocence and lustful cruelty. According to Tilla Durieux, another great exponent of the role, Eysoldt's body resembled that of a child and she knew how to accentuate the ambivalence of her child-woman persona without attracting the attention of the censors.[49] Unlike the anecdotal figure composition he had devoted to the subject in 1900 (see Plate 12), Corinth's role portrait sought to capture the ambiguity of the character's emotions as invoked by Eysoldt. Soon after the play's first private performance at the Kleines Theater, she posed in Corinth's studio, wearing the costume and the jewelry he had designed for her and holding the dish with the Baptist's severed head, a grisly prop borrowed for the occasion from Reinhardt's theater. Unaided by the ambience of the stage action, Eysoldt has assumed the character of the vile princess in the play's closing scene. Her wish fulfilled, Salome has taken possession of her prize and anticipates the ecstasy of kissing the dead prophet's lips. Without any further reference to Wilde's play, Corinth in this portrait represented a generalized image of depravity, partly, perhaps, in response to the then current vogue for pictures of the prototypical *femme fatale* but surely also out of his own interest in the universal human dimension.

The special nature of the Eysoldt-Salome portrait is evident if the painting is compared either with Max Slevogt's portrait of the Philippine dancer Marietta de Rigardo (1904; Staatliche Kunstsammlungen Dresden, Gemäldegalerie Neue

Meister) or with Slevogt's portrait of the singer Francesco d'Andrade in the role of Mozart's Don Giovanni, the so-called *White d'Andrade* (1902; Staatsgalerie, Stuttgart), which was exhibited with great success at the Berlin Secession in 1902. Slevogt re-created in both paintings the excitement of an actual performance and thus—in contrast to Corinth—invited the viewer to experience these pictures in a specifically theatrical context.

Corinth's portrait of Rudolf Rittner (1869–1943) in the role of Florian Geyer (see Plate 16), painted in 1906, is no doubt indebted to Slevogt's example insofar as it emphasizes physical action rather than psychological expression. The painting shows the actor in the climactic scene from the last act of Gerhart Hauptmann's drama about the Peasants' Rebellion. Having sought refuge at Castle Rimpar, Florian Geyer has been routed out by his enemies. Exhausted and outnumbered, he summons all his strength and counters the demand to surrender with a thundering challenge. A few moments later he is killed by a shot from the crossbow of Schäferhans.

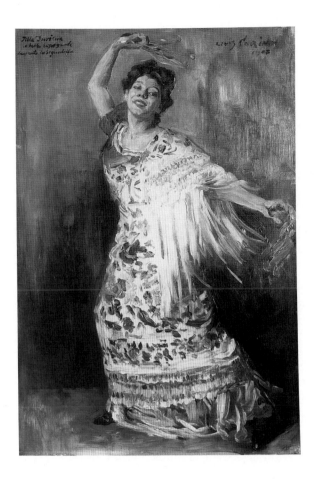

FIGURE 102.
Opposite: Lovis Corinth, *Gertrud Eysoldt as Salome*, 1903. Oil on canvas, 108 × 84 cm, B.-C. 252. Present whereabouts unknown. Photo: after Bruckmann.

FIGURE 103.
Left: Lovis Corinth, *Tilla Durieux as a Spanish Dancer*, 1908. Oil on canvas, 85 × 60 cm, B.-C. 350. Sophie Althaus, Riezlern.

Rittner, whom Max Reinhardt called a man of "healthy, strong, impulsive temperament,"[50] was the ideal interpreter of Hauptmann's hero and secured for *Florian Geyer* a permanent place in the German repertoire when Otto Brahm revived the play at the Berlin Lessingtheater in 1904. In Corinth's painting too the actor and the character have become one. Yet in Rittner's vigorous portrayal Corinth himself found embodied not only the essence of Hauptmann's drama but also a struggle transcending that of the historical person. The large size of the painting monumentalizes one person's battle against an unknown fate. Although Corinth depicted an anecdotal moment in the action, he isolated the actor—as in the Salome portrait of Gertrud Eysoldt—from the larger narrative context of the play, replacing the hall at Rimpar with a neutral ground. And Florian Geyer's enemies are anonymous foes whose threat is all the more awesome because they cannot be seen.

The portrait that Corinth painted in 1908 of Tilla Durieux (Ottilie Godeffroy, 1888–1971; Fig. 103) was not inspired by a theatrical performance. The

actress's posture is motivated by nothing more than the desire to create a mood appropriate to the long-fringed scarf she wears over her left shoulder— a gift from Paul Cassirer, who had brought it earlier in the year from Spain. Nonetheless this painting is connected to the role portraits of Eysoldt and Rittner. The only difference is that Durieux does not play a specific part but expresses her joy in a prototypical context. For the moment she simply *is* "la belle Espagnole dansante la sequedilla," as the inscription—written, though not entirely idiomatically, in French, perhaps in allusion to Bizet's opera—in the upper left corner of the canvas indicates. The ease with which Durieux brought to life virtually any character has become legendary. She played leading roles in the dramas of Shakespeare and Schiller and was equally at home in the naturalist and symbolist plays of Hauptmann, Shaw, Wedekind, and many others. Her range and power of characterization made her the quintessential "Reinhardt actor," for Reinhardt thought of the theater as the collective manifestation of human experience, and he demanded that an actor use a role to fathom his own inner being: "The actor must not disguise but reveal. . . . With the light of the poet he descends to still unpenetrated depths of the human soul, and from there he emerges—hands, eyes, and mouth full of miracles."[51] Tilla Durieux echoed Reinhardt's insistence on self-revelation when she called the actor "an exhibitionist devoted to truth," who tears off every mask before the public until the throbbing flesh lies exposed.[52]

This intuitive approach to acting parallels Corinth's approach to his role portraits, his tendency to enlarge their meaning beyond the historical-ideal truth of the characters depicted, and also sheds light on a group of self-portraits in which he wore various costumes to engage in a self-revelation not possible in the conventional self-portrait. Seven of the eleven self-portraits he painted during his first ten years in Berlin show Corinth in some sort of disguise. In the earliest of these, from 1905, he depicted himself as an ecstatic bacchant with a wreath of vine leaves on his head (see Plate 17). In keeping with Durieux's demand that actors expose themselves in their roles, Corinth here cut through surface appearances by attacking the canvas with ferocious strokes of the palette knife, transferring his heightened emotional state to the texture of the paint itself. According to Charlotte Berend, this disguise came quite naturally to the painter. "When Corinth wound vine leaves in his hair, when he lifted his glass and embraced his bacchic young wife, the world around him changed into the realm of Dionysus, to whom he felt closely allied."[53] In 1908 Corinth elaborated the bacchic allusions of the double portrait of 1902 (see Fig. 83) into a more specific costume piece (B.-C. 355) that does indeed vividly illustrate Charlotte Berend's recollection, except that the bacchante at the painter's side is not his wife but another model who hap-

pened to be conveniently at hand. Corinth's sensuous nature was apparently evident to perceptive eyes in a more public context as well, as the following irreverent description of the painter by Meier-Graefe indicates:

> Like a polar bear with small red eyes he moved through the ballrooms of Berlin. He looked greedily at many a banker and at many a banker's wife as she danced in his arms: a pig ripe for slaughter! It was one of the joys of the Berlin winter to watch him dance. At dinner he always had two jugs of wine next to his plate. People spoke to him about Impressionism and sensibility. Corinth was, in turn, Florian Geyer, Samson, Arminius the Liberator, a tamed Hun. If one half-closed one's eyes, one saw naked limbs move underneath shaggy fur. One young lady swooned.[54]

Closely related to the bacchic self-portraits are two self-portraits, from 1907 (Fig. 104) and 1909 (B.-C. 400). In both Corinth is nude except for a curious headdress of red cloth that trails down over his back and shoulders and, in the earlier work, is gathered up around the waist. In each case the painter projects an image of physical vigor on a primeval level, and both self-portraits have been seen as conjuring up memories of "lost cults, . . . drink offerings, and ancient mysteries."[55] In each work, however, Corinth's skeptical expression as he gazes at his mirror image is puzzling. He seems to be contemplating an illusion he knew he could not represent. The mood of uncertainty is further emphasized by the word *ipse* inscribed on the painting from 1907 and the even more eloquent inscription on the later work: *Aetatis suae LI.* That Corinth's health was seriously undermined at the time he painted these pictures is suggested by the recollections of his student Margarethe Moll. Writing about the circumstances surrounding the portrait he painted of her in 1907 (B.-C. 340), she mentions that the hands of the painter, then only forty-nine years old, trembled noticeably and that during one of their outings Corinth had considerable difficulty entering and leaving their boat without assistance.[56]

In the prototypical roles of these self-portraits that could give his character a generalized dimension, Corinth continued to celebrate the Nietzschean ideal of the natural and instinctual individual who—unhampered by decorum— seeks regeneration in spontaneous actions. Corinth's self-portraits in the armor of a medieval knight are reminiscent of a similar idea expressed in *It Is Your Destiny* (see Fig. 63), the watercolor drawing from the mid-1890s. There are two pictorial sources for these paintings. Corinth no doubt remembered the self-portraits in armor that Wilhelm Trübner had painted in 1899, and a visit in 1907 to Kassel, where he copied Frans Hals's late *Portrait of a Man in a*

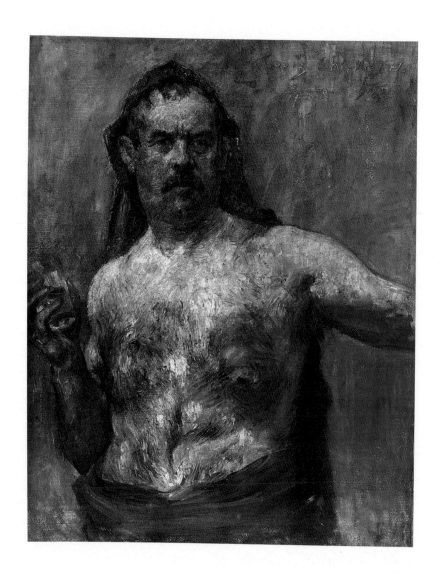

FIGURE 104.
Above: Lovis Corinth, *Self-Portrait with a Glass*, 1907. Oil on canvas, 120 × 100 cm, B.-C. 344. National Gallery, Prague (0-14782). Photo: Jaroslav Jeřábek.

FIGURE 105.
Opposite: Lovis Corinth, *The Victor*, 1910. Oil on canvas, 138 × 110 cm, B.-C. 414. Present whereabouts unknown. Photo: Bruckmann, Munich.

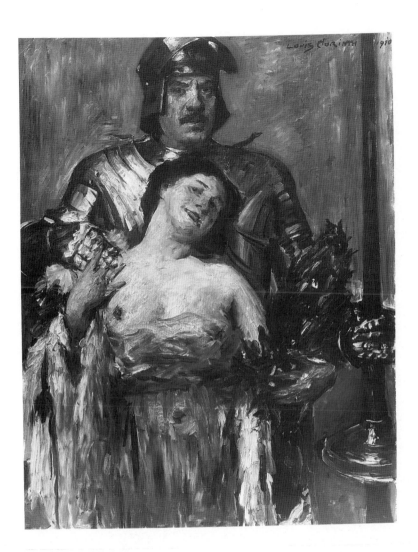

Slouch Hat (B.-C. 333), brought him face-to-face with Rembrandt's animated *Self-Portrait in a Helmet*, one of several early Rembrandt costume self-portraits with which Corinth was surely familiar.

In the double portrait from 1910 (Fig. 105) Corinth places his hand on the shoulder of Charlotte Berend as if taking possession of a prize after a victorious battle. Charlotte Berend, in turn, revels in the strength of the conquering hero, nestling seductively against the gleaming armor. In the self-portrait from 1911 (Fig. 106) and the related bust-length self-portrait from the same year (B.-C. 494) Corinth's expression conveys unyielding determination, the readiness to meet any challenge.

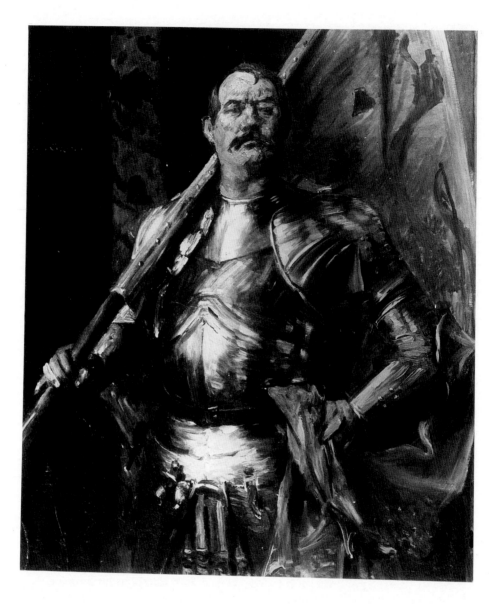

FIGURE 106.
Lovis Corinth, *Self-Portrait as a Standard Bearer*, 1911. Oil on canvas, 146 × 130 cm, B.-C. 496. Present whereabouts unknown. Photo: Marburg/Art Resources, New York.

Both personal aspirations and Nietzschean notions of the warlike *Über-mensch* who sets his own moral code underlie the conception of these paintings. Corinth's almost Darwinian view of life and his belief in the survival of the fittest are suggested by a comment in his autobiography on the faculty intrigues at the Königsberg Academy that eventually led to the resignation of his teacher Otto Edmund Günther:

> Since the battle for existence forces the artist to do his best, the competition is extreme. It does not matter whether his colleagues, even his best friends, perish all around him, as long as he wins out as the strongest. As long as the strength of the victor remains decisive in this battle, nobody needs to be pitied, for it is the fate of the weak to succumb to the strong.[57]

On the following page he added this advice: "Use all your might to achieve your highest goal. For all I care, use your greater strength to push your rivals against the wall until they can no longer gasp."[58]

CONTROVERSIES

For Charlotte Berend Corinth's self-portraits in armor expressed both his success in Berlin and his readiness to defend what he had won.[59] Her interpretation takes on a more specific meaning in the context of controversies in the Berlin Secession that surfaced in 1908 and two years later precipitated a crisis that was to touch Corinth's professional life deeply.

From its inception the Berlin Secession had maintained an open-minded attitude toward the most divergent expressions of modern art in Germany and abroad. But the tolerance of the organization's older members was not without bounds. To Liebermann in particular, and to most members of the executive committee as well, French Impressionism represented the single most important achievement in the development of modern painting. It set the standard for Liebermann's own work; his paintings as well as those of Slevogt and, to a lesser extent, Corinth had come to be seen in the context of Impressionism. Their art was recognized as rooted in visual perception, unlike that of the Post-Impressionists and the adherents of subsequent movements who subordinated nature to a more purely artistic reality divorced from conventional perceptual methods. Although Liebermann himself felt sufficiently secure not to be threatened by experimentation in the arts, he did question whether, as he put it, a "purely intellectual art" can indeed be "true art."[60]

It was perhaps inevitable that in time the executive committee of the Berlin Secession, which was firmly controlled by Liebermann and Paul Cassirer and made the final decisions in selecting works for the annual exhibitions, would be accused of favoritism by some of the younger Secessionists. The first rumblings of discontent apparently made themselves felt in 1905, and they increased over the next few years. Especially frequent were complaints voiced in private about the inordinate control Liebermann and Cassirer exerted over virtually all the affairs of the Secession. Cassirer's methods were indeed often tactless and offended even his fellow members of the executive committee. He was known to rehang paintings on his own before the opening of an exhibition and was not above adding a work previously rejected or removing one that had been accepted.

In Walter Leistikow the Berlin Secession had a skillful administrator who could be counted on to resolve internal conflicts. But when Leistikow died of cancer in July 1908, hostilities flared up unchecked. During the annual general meeting in January 1910 several Secession members openly rebelled against the "tyranny" of Liebermann and Cassirer. In response, Liebermann resigned from the executive committee, followed by Cassirer, Slevogt, Corinth, and several others. Eventually a compromise was reached that allowed Liebermann and his associates to return to the committee; Cassirer chose to take a six-month leave of absence. Any cohesive policy toward the affairs of the Secession was made impossible, however, by continued disagreements between older and newer members. The 1910 exhibition organized by the executive committee turned out to be a disaster. Eighty-nine works by twenty-seven Expressionists, including Kirchner, Heckel, Schmidt-Rottluff, Pechstein, and Nolde were rejected by the jury, among them Nolde's famous canvas of 1909, *Pentecost* (Collection Mara Fehr, Rubigen, Switzerland). Under Pechstein's leadership the rejected artists promptly formed an organization of their own and under the banner of the "New Secession" exhibited their work at the gallery of the Berlin dealer Maximilian Macht concurrently with the show of the Berlin Secession.

The hostilities between the leaders of the Berlin Secession and the Expressionist renegades came to a climax in December, when Nolde wrote a letter to Karl Scheffler, editor of *Kunst und Künstler,* complaining about the manner in which Scheffler had reviewed a number of Nolde's drawings included in an exhibition organized by the New Secession. Nolde's letter quickly degenerated into a venomous attack on Liebermann and the Secession as a whole. He called Liebermann a publicity seeker, accused him of senility, and labeled his work feeble, trashy, and hollow. In a special meeting of the executive commit-

tee held on December 17, Nolde was formally expelled from the Secession over the objections of Liebermann. Tired of the strife and convinced that he had served a good cause long enough, Liebermann resigned as president a week later. Some of his closest friends, in turn, resigned from the executive committee. When Max Slevogt refused to succeed Liebermann, Corinth was elected president of the Berlin Secession.

It turned out that Corinth was even more conservative in his exhibition policy than Liebermann and Cassirer. He also had little interest in the time-consuming administrative tasks required to run the organization effectively or to plan exhibitions. His leadership came in for a good deal of criticism when the first show put together during his tenure opened in 1911. The exhibition was made up of a random selection of works rather than organized, as in the past, around a major established master whose name might have attracted the customary crowd of visitors. With the leading German Expressionists conspicuous by their absence, the avant-garde was represented instead by several French artists that Corinth labeled Expressionists in his foreword to the catalogue: Braque, Derain, Marquet, Picasso, and Henri Rousseau. Among the more advanced German artists were Beckmann, Barlach, and Lehmbruck. Karl Scheffler, displeased with the exhibition, promptly called for another change in leadership: "Good painters can paint," he wrote in his review of the show, "but can't organize. The Secession needs to be directed by a nonartist."[61]

Tensions in the modern movement were heightened still further by *Ein Protest deutscher Künstler,* written and published in 1911 by the landscape painter Carl Vinnen, accusing German critics, dealers, and museum officials of promoting French works of art, thereby depriving German artists of much-needed support.[62] The *Protest,* signed by 140 supporters, lamented that young German artists, to gain recognition, were forced to imitate the French models and in the process lost their cultural identity. Although he admitted that German critics had helped to foster greater understanding of modern art, Vinnen nonetheless accused them of promoting fads and praising theory above individual creativity. The *Protest* also attacked Paul Cassirer and the Berlin Secession, whose exhibitions had done much to promote the French avant-garde. It also singled out the work of the young Expressionists as exemplifying the baneful consequence of the internationalization of modern art.

Corinth's position in this controversy is somewhat ambiguous. In 1910, in an article entitled "Die neueste Malerei," published in *Pan,*[63] he, too, expressed concern that the "faddish imitation" of works by artists like Cézanne, Gauguin, and van Gogh "threatened to destroy . . . German art." He called Cubism an "art of riddles," "Modemalerei" (that is to say "fashionable," rather than

modern, painting) that has nothing in common with "free and noble art."
And he feared that the pursuit of the "iron-clad rules" of such a "mannerism"
would lead to the loss of individuality. But Corinth's criticism has none of the
blatant chauvinism of Vinnen's *Protest*, nor does it call for protectionism. In
fact, Corinth joined Liebermann, Slevogt, Cassirer, and others who in 1911
directed a series of letters and articles against Vinnen. Alfred Walter Heymel,
the Munich collector, writer, and founder of the prestigious Insel Verlag, pub-
lished these as a pamphlet entitled *Im Kampf um die Kunst: Die Antwort auf den
"Protest deutscher Künstler."* [64] To this collection Corinth contributed a mocking
attack on Vinnen's misplaced patriotism, joining Liebermann in suggesting
that the artists who criticized French art might solve their problem by paint-
ing better pictures. [65]

STILL LIFES AND LANDSCAPES

Corinth was at the height of his creative power when the leadership of the
Berlin Secession and—by extension—his own position were so sorely chal-
lenged by restive younger forces. By the end of 1910 his work was known
throughout Germany, through exhibitions as well as reproductions in leading
art journals and local papers. In addition, his periodic writings on art had
given him a voice in German cultural life, his teaching manual had lent para-
digmatic value to his own work, and the autobiographical account of his youth
and early years as a painter, published in 1909 in a somewhat fictionalized
form, more or less acknowledged the historical importance he had come to
place on his achievements.

By 1910 Corinth had absolute command over all the categories of painting
that had occupied him over the years, including still lifes and landscapes,
although these subjects continued to be outnumbered by portraits and figure
compositions. While still-life elements occur in many of Corinth's paintings,
independent still lifes are especially rare among his earliest works. No more
than three (B.-C. 68, 116, 168) are recorded for the entire period from 1879
to 1900. After 1900 they are found with greater frequency: four still lifes are
known from 1901, and by 1910 the yearly output had risen to nine. The in-
crease coincides with Corinth's move to Berlin and his settled home environ-
ment following his marriage to Charlotte Berend. Moreover, Corinth learned
to appreciate still-life painting in the context of his teaching as a useful exer-
cise in depicting a variety of contrasting textures: delicate flowers, the juicy
pulp of fresh fruit, gleaming ceramics, crystal, and metallic objects. [66]

PLATES

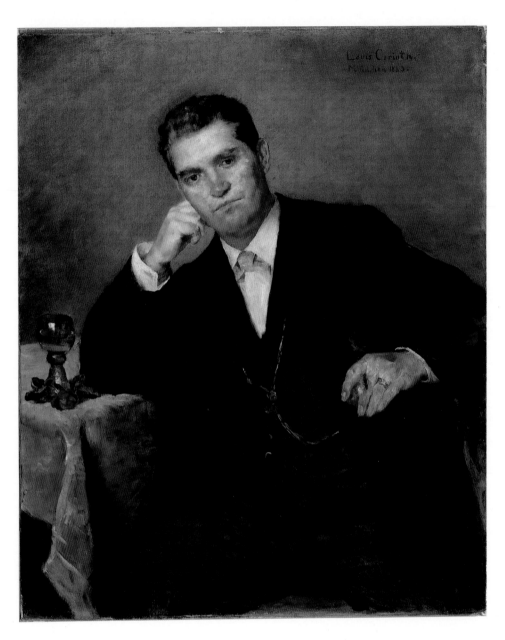

PLATE 1.
Lovis Corinth, *Portrait of Franz Heinrich Corinth with a Wine Glass*, 1883. Oil on canvas, 107 × 88 cm, B.-C. II. Städtische Galerie im Lenbachhaus, Munich (G2275).

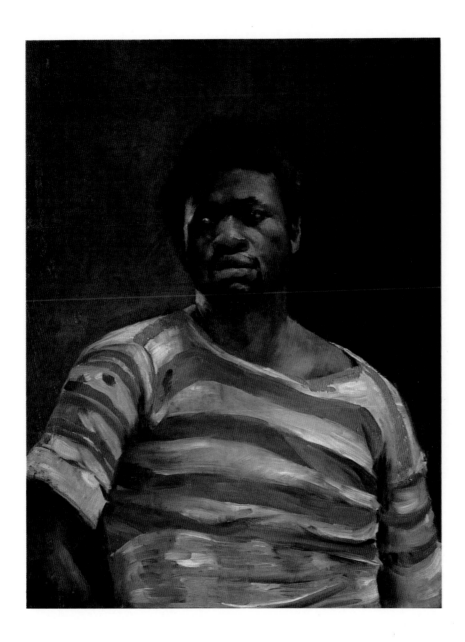

PLATE 2.
Lovis Corinth, *Negro ("Un Othello")*,
1884. Oil on canvas, 78.0 × 58.5 cm,
B.-C. 19. Neue Galerie der Stadt Linz,
Wolfgang-Gurlitt-Museum (23). Photo:
M. Sirotek Fachlabor.

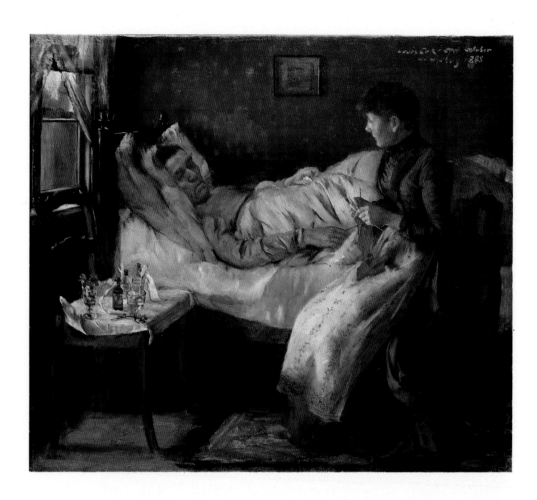

PLATE 3.
Lovis Corinth, *Franz Heinrich Corinth on His Sickbed*, 1888. Oil on canvas, 61.5 × 70.5 cm, B.-C. 57. Städelsches Kunstinstitut, Frankfurt (SG 1182). Photo: Ursula Edelmann.

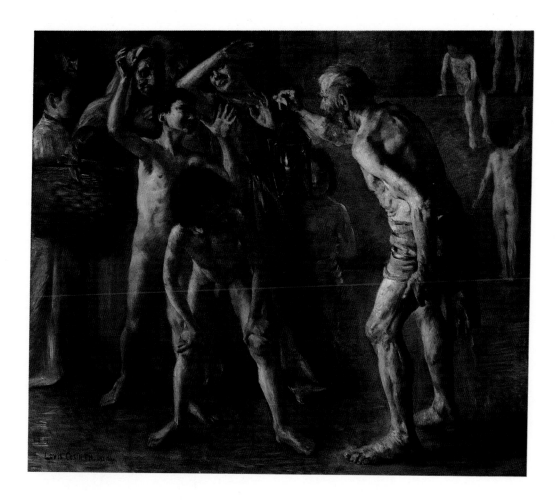

PLATE 4.
Lovis Corinth, *Diogenes*, 1891. Oil on
wood, 178 × 208 cm, B.-C. 86. Museum
Ostdeutsche Galerie Regensburg (3470).
Photo: WS-Meisterphoto Wolfram
Schmidt.

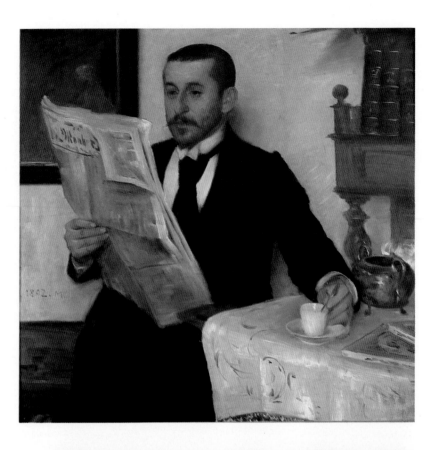

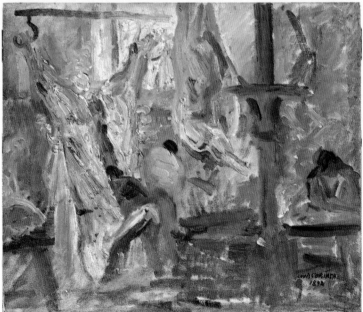

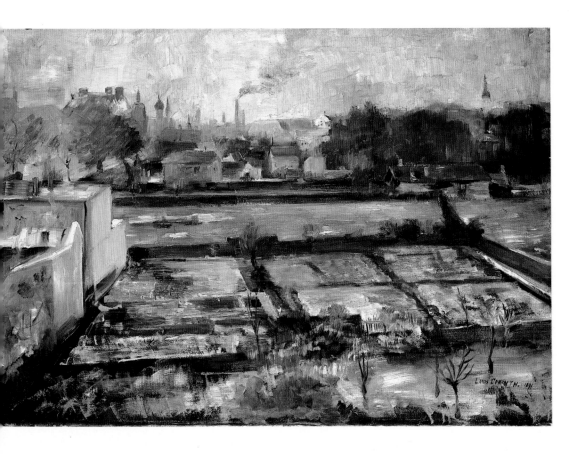

PLATE 5.
Opposite, top of page: Lovis Corinth,
Portrait of the Painter Benno Becker, 1892.
Oil on canvas, 87 × 92 cm, B.-C. 99.
Von der Heydt-Museum der Stadt
Wuppertal, Wuppertal-Elberfeld.

PLATE 6.
Opposite: Lovis Corinth, *Slaughterhouse,*
1892. Oil on canvas on cardboard, 34 ×
41 cm, B.-C. 87. Kunsthalle Bremen
(391-1921/7).

PLATE 7.
Above: Lovis Corinth, *View from the
Studio,* 1891. Oil on canvas, 60.5 ×
88.5 cm, B.-C. 84. Staatliche Kunsthalle
Karlsruhe (2302).

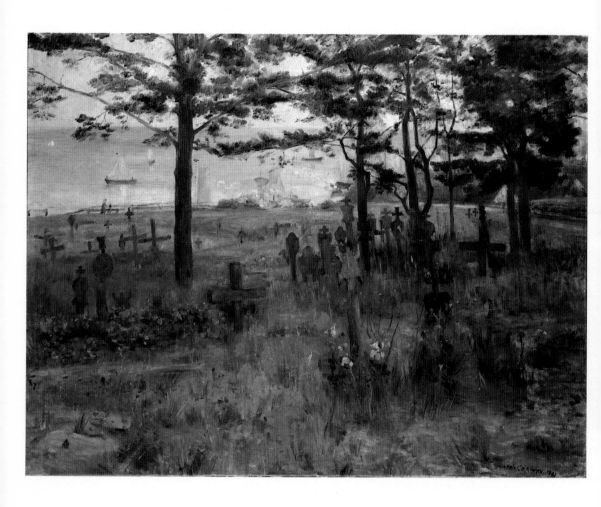

PLATE 8.
Lovis Corinth, *Fishermen's Cemetery at Nidden*, 1894. Oil on canvas, 113 × 148 cm, B.-C. 115. Bayerische Staatsgemäldesammlungen, Munich (12043). Photo: Blauel/Gnamm-Artothek.

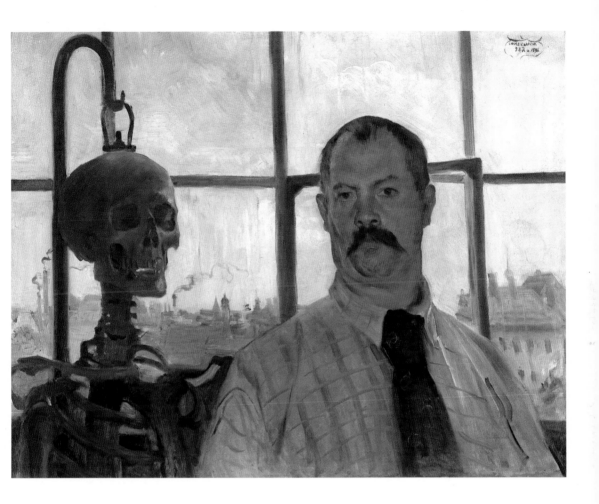

PLATE 9.
Lovis Corinth, *Self-Portrait with Skeleton*,
1896. Oil on canvas, 66 × 86 cm, B.-C.
135. Städtische Galerie im Lenbachhaus,
Munich (G2075). Photo: Joachim Blauel-
Artothek.

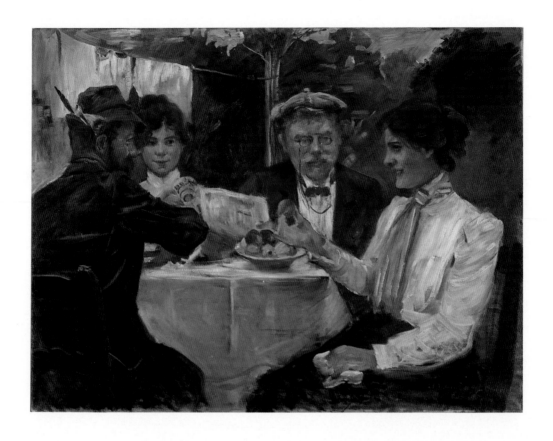

PLATE 10.
Above: Lovis Corinth, *In Max Halbe's Garden,* 1899. Oil on canvas, 75 × 100 cm, B.-C. 185. Städtische Galerie im Lenbachhaus, Munich. Photo: Joachim Blauel-Artothek.

PLATE 11.
Opposite, top of page: Lovis Corinth, *Reclining Female Nude,* 1899. Oil on canvas, 75 × 120 cm, B.-C. 179. Kunsthalle Bremen (187-26/1).

PLATE 12.
Opposite: Lovis Corinth, *Salome,* 1900. Oil on canvas, 127 × 147 cm, B.-C. 171. Museum der bildenden Künste zu Leipzig (1531). Photo: Chr. Sandig.

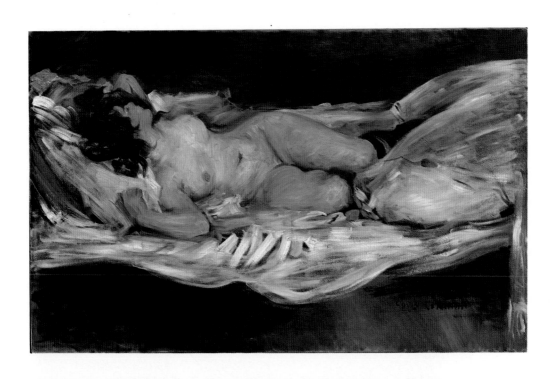

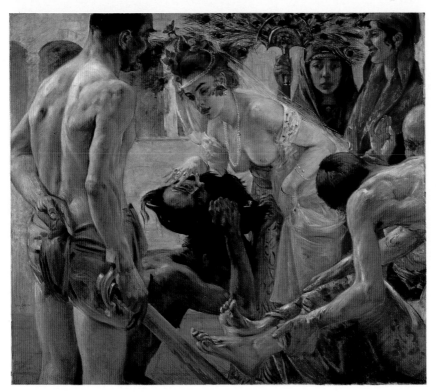

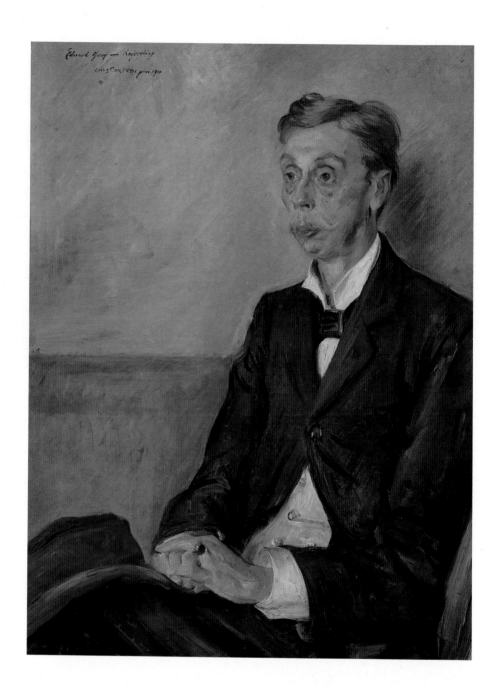

PLATE 13.
Lovis Corinth, *Portrait of Count Eduard Keyserling*, 1900. Oil on canvas, 99.5 × 75.5 cm, B.-C. 205. Bayerische Staatsgemäldesammlungen, Munich (8986). Photo: Joachim Blauel-Artothek.

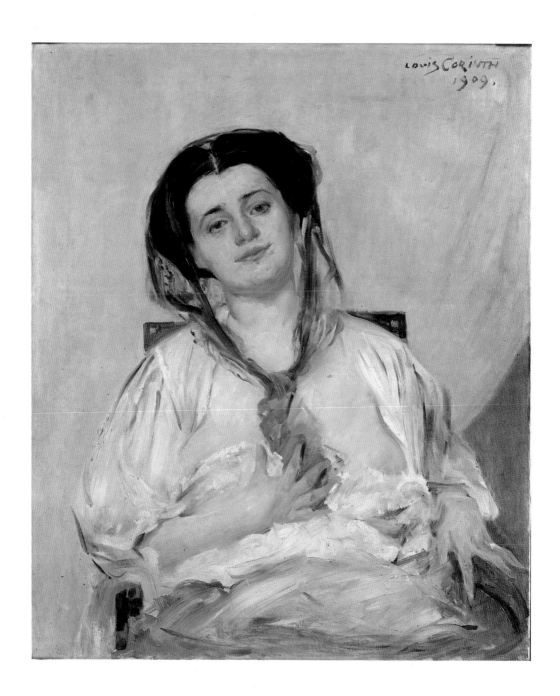

PLATE 14.
Lovis Corinth, *Donna Gravida*, 1909.
Oil on canvas, 95 × 79 cm, B.-C. 394.
Staatliche Museen Preussischer
Kulturbesitz, Nationalgalerie, Berlin
(West) (A II 143/Kat. 1262). Photo: Jörg P.
Anders.

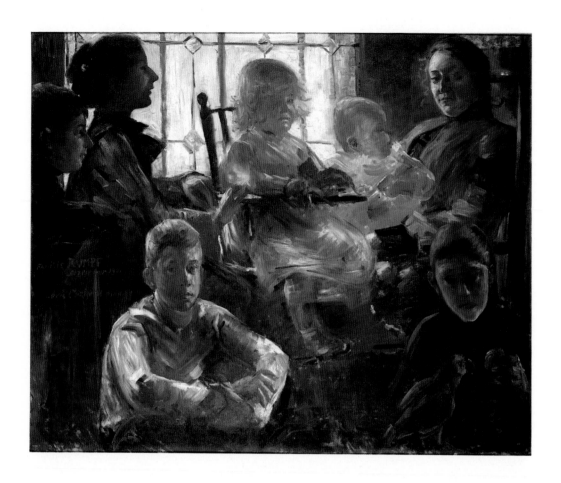

PLATE 15.
Lovis Corinth, *The Family of the Painter Fritz Rumpf*, 1901. Oil on canvas, 114 × 140 cm, B.-C. 219. Staatliche Museen Preussischer Kulturbesitz, Nationalgalerie, Berlin (West) (A II 596). Photo: Jörg P. Anders.

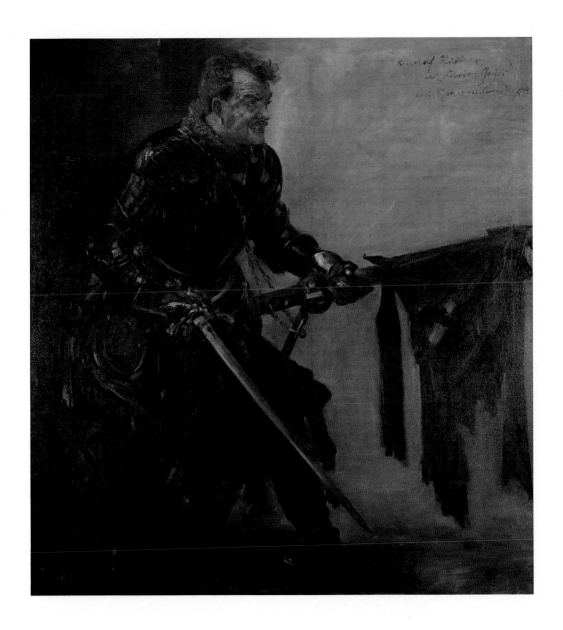

PLATE 16.
Lovis Corinth, *Rudolf Rittner as Florian
Geyer*, 1906. Oil on canvas, 180.5 × 170.5
cm, B.-C. 327. Von der Heydt-Museum
der Stadt Wuppertal, Wuppertal-
Elberfeld.

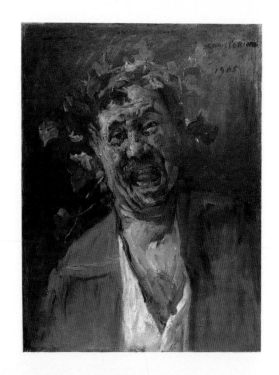

PLATE 17.
Right: Lovis Corinth, *Self-Portrait as a Howling Bacchant*, 1905. Oil on canvas, 67 × 49 cm, B.-C. 304. Insel Hombroich.

PLATE 18.
Below: Lovis Corinth, *Hymn to Michelangelo*, 1911. Oil on canvas, 138 × 199 cm, B.-C. 481. Städtische Galerie im Lenbachhaus, Munich (FH 271).

PLATE 19.
Opposite: Lovis Corinth, *After the Bath*, 1906. Oil on canvas, 80 × 60 cm, B.-C. III. Hamburger Kunsthalle, Hamburg (2375). Photo: Elke Walford.

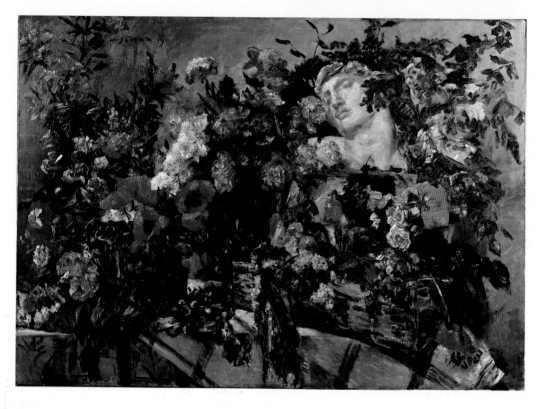

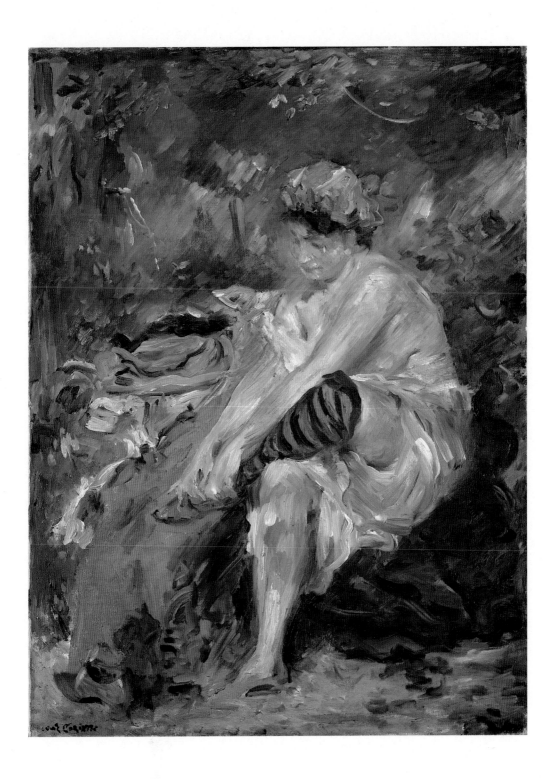

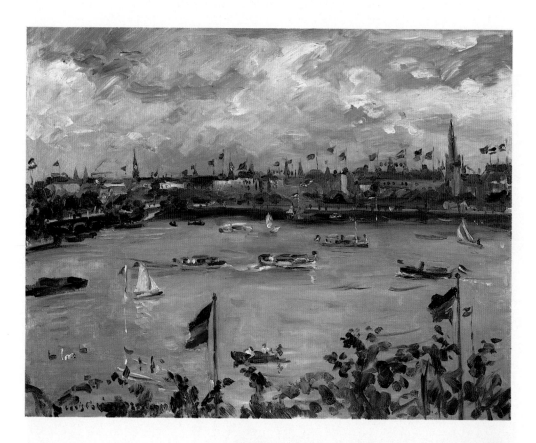

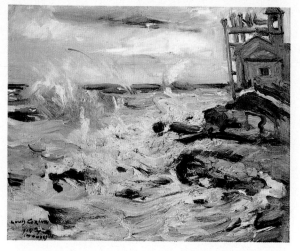

PLATE 20.
Above: Lovis Corinth, *Emperor's Day in Hamburg,* 1911. Oil on canvas, 70.5 × 90.0 cm, B.-C. 483. Wallraf-Richartz-Museum, Cologne (WRM 2585). Photo: Rheinisches Bildarchiv.

PLATE 21.
Right: Lovis Corinth, *Storm at Capo Sant'Ampeglio,* 1912. Oil on canvas, 49 × 61 cm, B.-C. 537. Staatliche Kunstsammlungen Dresden, Gemäldegalerie Neue Meister (2580 G). Photo: Sächsische Landesbibliothek Abt. Deutsche Fotothek/Heselbarth.

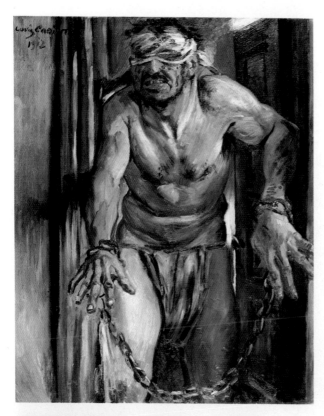

PLATE 22.
Lovis Corinth, *Samson Blinded*, 1912. Oil
on canvas, 130 × 105 cm, B.-C. 520.
Staatliche Museen zu Berlin, National-
Galerie (DDR) (5873).

PLATE 23.
Lovis Corinth, *Still Life with Lilacs*, 1917.
Oil on canvas, 55.2 × 45.0 cm, B.-C. 718.
The Detroit Institute of Arts (Gift of Dr.
and Mrs. Hermann Pinkus) (79.159).

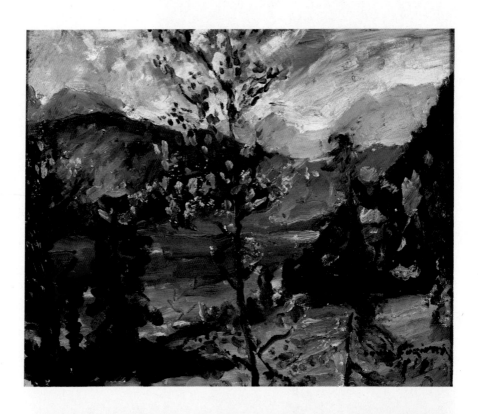

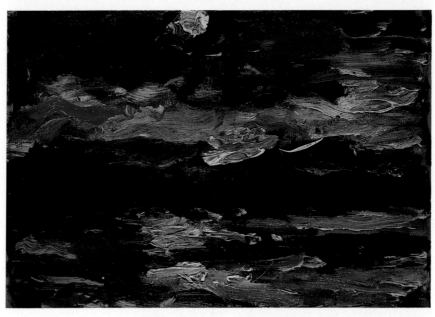

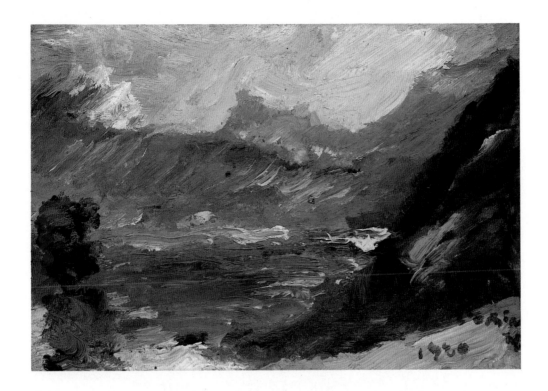

PLATE 24.
Opposite, top of page: Lovis Corinth,
October Snow at the Walchensee, 1919.
Oil on wood, 45 × 56 cm, B.-C. 772.
Staatliche Kunsthalle Karlsruhe.

PLATE 25.
Opposite: Lovis Corinth, *The Walchensee
in Moonlight,* 1920. Oil on wood, 18 ×
26 cm, B.-C. 807. Pfalzgalerie Kaisers-
lautern (53/2).

PLATE 26.
Above: Lovis Corinth, *Walchensee,* 1920.
Oil on wood, 18.5 × 22.0 cm, B.-C. 806.
Hamburger Kunsthalle, Hamburg.
Photo: Elke Walford.

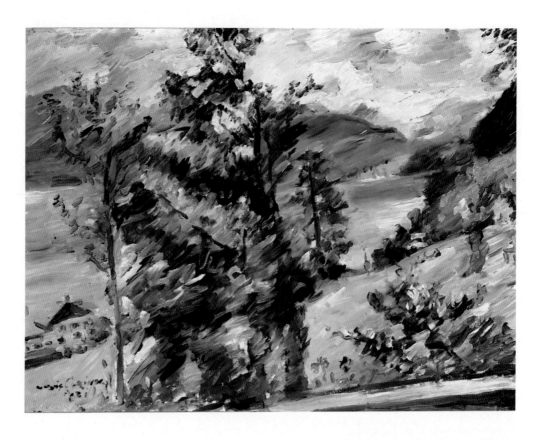

PLATE 27.
Lovis Corinth, *Walchensee: View of the Wetterstein*, 1921. Oil on canvas, 90 × 119 cm, B.-C. XIII. Saarland Museum Saarbrücken, Stiftung Saarländischer Kulturbesitz (1505). Photo: Gerhard Heisler.

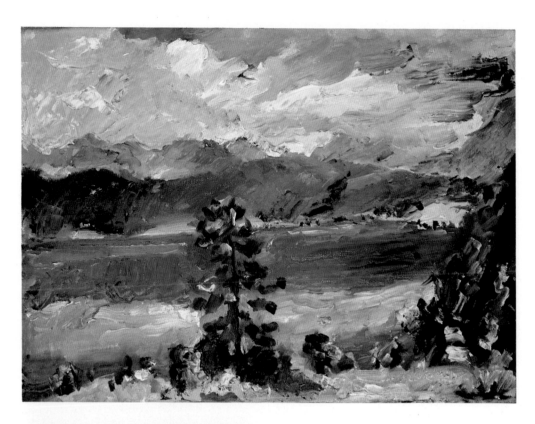

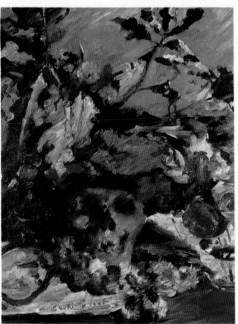

PLATE 28.
Lovis Corinth, *Walchensee with Larch*,
1921. Oil on canvas, 64 × 88 cm, B.-C.
832. Staatliche Museen Preussischer
Kulturbesitz, Nationalgalerie, Berlin
(West) (1381/A II 366). Photo: Jörg P.
Anders.

PLATE 29.
Lovis Corinth, *Still Life with Flowers,
Skull, and Oak Leaves*, 1921. Oil on
canvas, 91 × 71 cm, B.-C. 821. Leopold-
Hoesch-Museum, Düren.

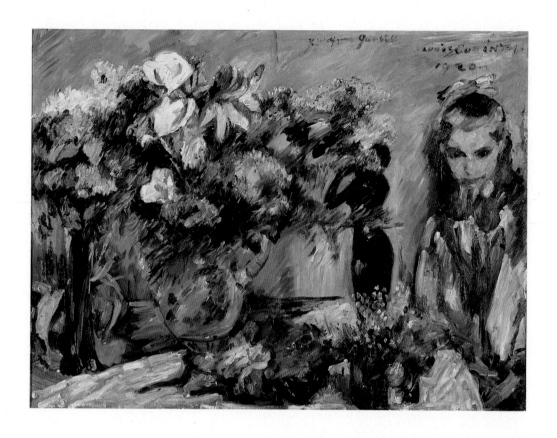

PLATE 30.
Lovis Corinth, *Flowers and Wilhelmine*,
1920. Oil on canvas, 111.0 × 150.5 cm,
B.-C. 795. Öffentliche Kunstsammlung
Basel, Kunstmuseum (1741). Photo:
Hans Hinz.

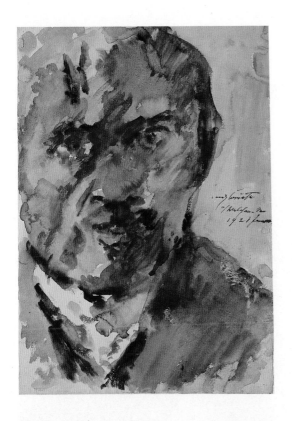

PLATE 31.
Lovis Corinth, *Self-Portrait*, 1921.
Watercolor, 39 × 29 cm. Ulmer Museum,
Ulm (BW 1967.57); on permanent loan
from the State of Baden-Württemberg.
Photo: Bernd Kegler.

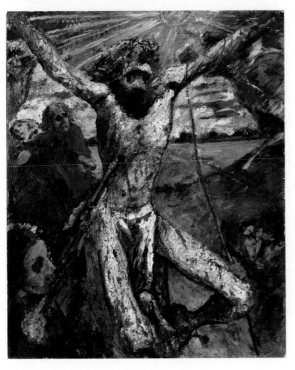

PLATE 32.
Lovis Corinth, *The Red Christ*, 1922. Oil
on wood, 135.7 × 107.7 cm, B.-C. XV.
Staatsgalerie moderner Kunst, Munich
(12383). Photo: Joachim Blauel-Artothek.

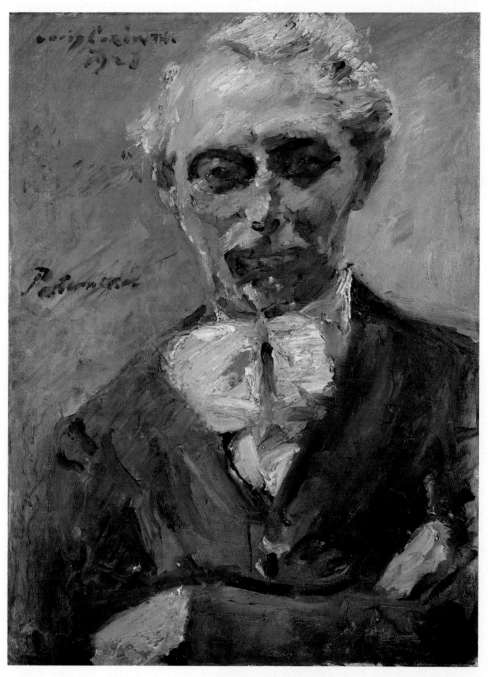

PLATE 33.
Lovis Corinth, *Portrait of the Painter
Leonid Pasternak,* 1923. Oil on canvas,
80 × 60 cm, B.-C. 913. Hamburger
Kunsthalle, Hamburg (2941). Photo: Elke
Walford.

PLATE 34.
Lovis Corinth, *Birth of Venus,* 1923. Oil
on canvas on cardboard, 50 × 40 cm,
B.-C. 920. Galerie G. Paffrath, Düsseldorf
(0282).

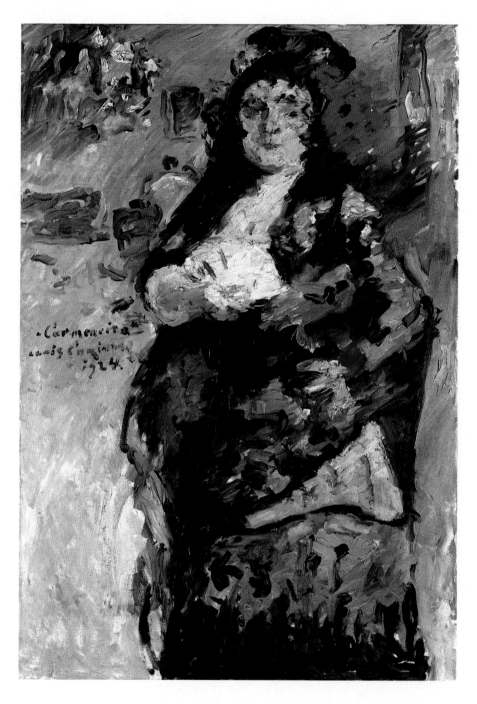

PLATE 35.
Lovis Corinth, *Carmencita*, 1924. Oil
on canvas, 130 × 90 cm, B.-C. 961.
Städelsches Kunstinstitut, Frankfurt
(2064). Photo: Blauel/Gnamm-Artothek.

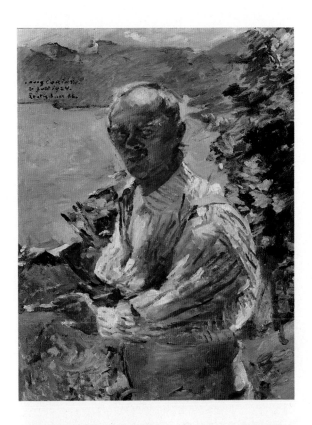

PLATE 36.
Lovis Corinth, *Large Self-Portrait at the Walchensee,* 1924. Oil on canvas, 137.7 × 107.7 cm, B.-C. VII. Bayerische Staatsgemäldesammlungen, Munich (11327). Photo: Joachim Blauel-Artothek.

PLATE 37.
Lovis Corinth, *Larkspur,* 1924. Oil on canvas, 100 × 80 cm, B.-C. XXI. Bayerische Staatsgemäldesammlungen, Munich (9219). Photo: Joachim Blauel-Artothek.

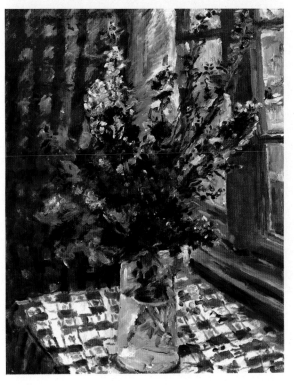

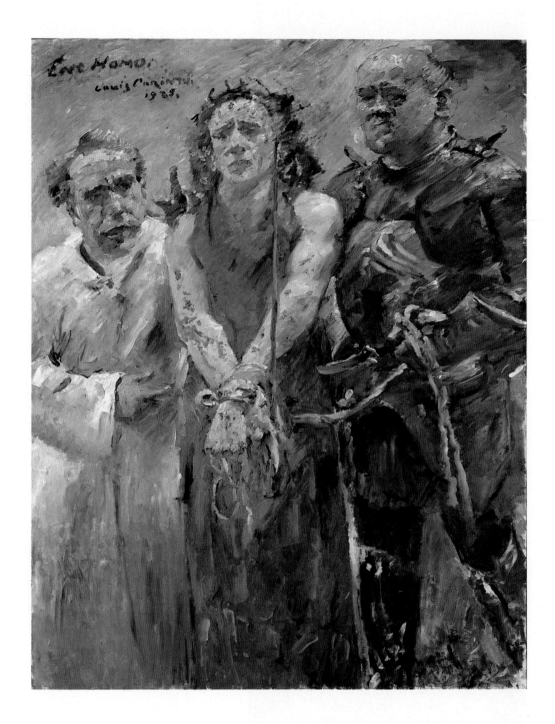

PLATE 38.
Lovis Corinth, *Ecce Homo*, 1925. Oil on
canvas, 190.5 × 150.0 cm, B.-C. XXII.
Öffentliche Kunstsammlung Basel,
Kunstmuseum (1740). Photo: Hans Hinz.

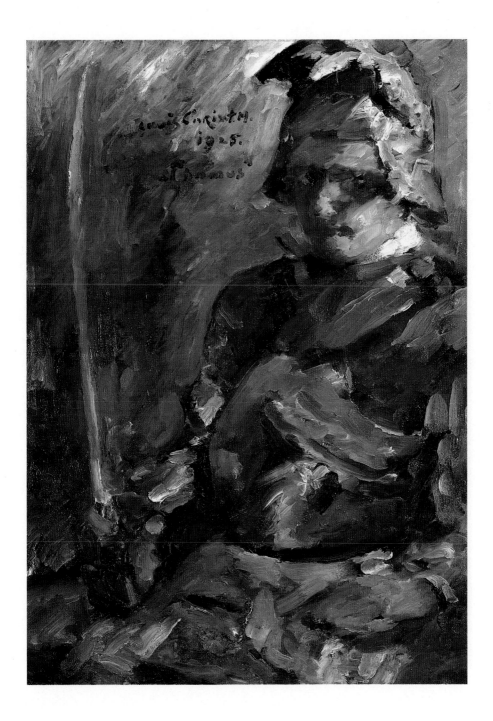

PLATE 39.
Lovis Corinth, *Thomas in Armor,* 1925.
Oil on canvas, 100 × 75 cm, B.-C. VIII.
Museum Folkwang, Essen (309).

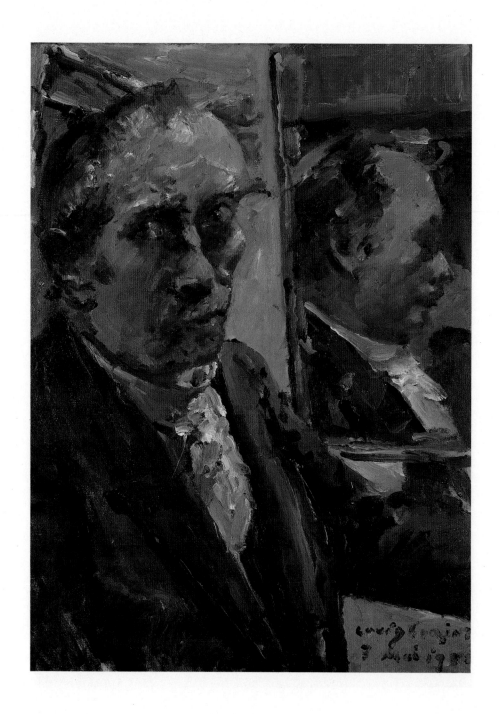

PLATE 40.
Lovis Corinth, *Last Self-Portrait*, 1925.
Oil on canvas, 80.5 × 60.5 cm, B.-C. I.
Kunsthaus Zurich (1867).

Except for his *Kitchen Still Life* from 1889 (B.-C. 68), Corinth's early still lifes
are small and simple: a few pieces of fruit arranged in a dish or on a napkin; a
glass with a flower or two. But he reveals a distinct preference for the exotic
that endows even the least pretentious still life with a touch of splendor. Sea
shells, a pineapple, or a grapefruit, cut open, often enrich an otherwise mod-
est arrangement. Similarly, blossoms of unusual form and size, such as azaleas,
chrysanthemums, roses, lilies, gladiolus, and amaryllis, are predominant in
the flower pieces.

From 1908 on Corinth's still lifes increased in size and became more am-
bitious in conception as he evidently sought to invest them with the impor-
tance previously reserved for his portraits and figure compositions. In an
example from 1910 (Fig. 107) rare objects have been juxtaposed on a white
damask cloth: a Chinese figurine painted in delicate flesh tones and tints of
pale blue edged in gold, a small bronze Persian statuette of a dog, a pitcher of
burnished copper, and, behind them all, a fragile Murano vase, pearl gray
and dark blue. The two pink lilies in the vase gracefully round out the com-
position at the top. This painting is closely related to two other still lifes with
oriental statuettes, one also dated 1910 (B.-C. 448), the other 1911 (B.-C. 449),
both painted at the specific request of a Berlin collector. The commission no
doubt helped to convince Corinth of the value of such pictures, which could,
moreover, further enhance his reputation.

A splendid still life with game (B.-C. 443) of 1910 served as a prelude to a
large canvas (Fig. 108), nearly five by seven feet—which was the first still life
Corinth exhibited at the Berlin Secession. As if to lend respectability to the
undertaking, he assured himself of the authority of tradition. The painting
recalls not only Max Liebermann's ebullient *Kitchen Still Life with Self-Portrait*
from 1873 (Städtische Kunstsammlungen, Gelsenkirchen) but also the works
of Frans Snyders, which often similarly juxtapose living persons and *nature
morte*. The dead fowl, game, vegetables, and bowls of fruit are common de-
tails in works from the Flemish master's studio, as is the two-tiered arrange-
ment, which Corinth enlivened with the diagonal axis of the table. He thus
created an impression of movement that is further intensified by the figure of
Charlotte Berend, who holds aloft a spray of narcissus with one hand and
reaches for a bouquet of roses with the other. A similar energy pervades the
brushstrokes, which unify the pictorial field and underscore the baroque exu-
berance of the conception. The festive mood made the painting an ideal gift
for Charlotte Berend, to whom the canvas is specifically dedicated, partly in
honor of her thirty-first birthday, partly to compensate her for the loss of the
large family picture from 1909 (see Fig. 89), which Corinth had originally

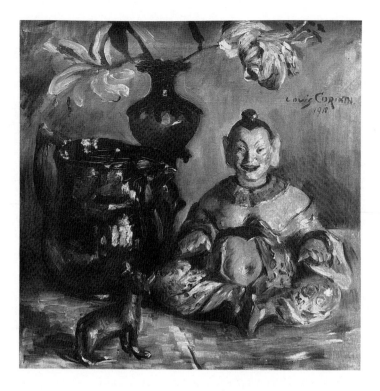

FIGURE 107.
Lovis Corinth, *Still Life with Buddha*,
1910. Oil on canvas, 47 × 47 cm, B.-C.
438. Private collection, Berlin. Photo
courtesy Bernd Schultz.

given to her but subsequently sold to a Berlin collector. The 1911 painting too,
however, was sold soon after being exhibited at the Berlin Secession.

In recompense, Corinth immediately set to work on another, similarly
large, still life for Charlotte, a sumptuous flower piece bearing the poetic title
Hymn to Michelangelo (see Plate 18), in allusion to the plaster-cast head of the
sculptor's *Dying Slave* that emerges from an array of roses, poppies, irises,
and carnations. Although most of the flowers are recognizable, in this canvas
Corinth disregarded the principle on which—according to his own teaching
manual—still-life painting should be based, namely, the characterization of
individual textures. The fluid application of the paint, often in thick blobs
twisted and turned with the brush, lends the vivid colors a life independent
of the forms they ostensibly describe. As a result, this still life is less a paint-
ing of flowers than a depiction of a process that conjures up the very idea

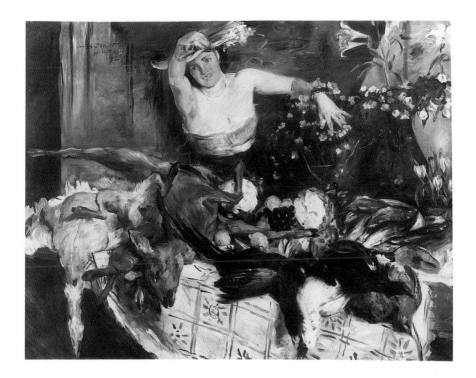

FIGURE 108.
Lovis Corinth, *Large Still Life with Figure*
(*"Birthday Picture"*), 1911. Oil on canvas,
150 × 200 cm, B.-C. 463. Wallraf-
Richartz-Museum, Cologne. Photo:
Rheinisches Bildarchiv.

of flowering. The mournful statue, in contrast, and the cut flowers translate
what is otherwise a jubilant evocation of nature into a poignant *memento mori*.

A similar development from a specific circumscribed view to a unified,
visceral expression is also seen in Corinth's landscapes and in his paintings
whose human figures are integral parts of the landscape—always excepting
his open-air portraits, where the need for verisimilitude would have interfered
with a more generalized rendering of the sitter. Corinth's early landscapes
include urban views, forest interiors, open fields, and scenes near brooks,
lakes, and the sea. In conception and execution they range from the natu-
ralism of the Barbizon and Leibl schools to evocative landscapes in the Ro-
mantic tradition. A more unadulterated pleinairism was the result of Corinth's
early years in Berlin. Unlike the French Impressionists, however, who through

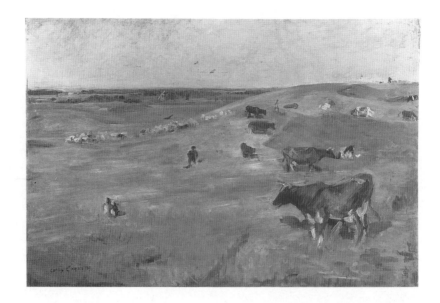

FIGURE 109.
Lovis Corinth, *Cow Pasture*, 1903. Oil on
cardboard, 67.5 × 99.7 cm, B.-C. 268.
Niedersächsisches Landesmuseum,
Landesgalerie, Hannover (KM 135/1949).

a vibrating texture of brushstrokes sought to re-create the atmospheric charac-
ter of a given day, even a given time of day, Corinth opted for a broader and
more simplified execution that gives the impression of movement and light
without dissolving the image into a myriad of colored particles.

In a landscape with cows (Fig. 109), painted in the summer of 1903 at Bruns-
haupten, near the Baltic seacoast, the details of the view are subordinated to
sweeps of color that describe the low-lying terrain while investing it with a
gentle rhythm that seems to extend beyond the confines of the frame. The
ductus of the brush itself conveys the essential character of the landscape.
That the problems of plein air painting were for Corinth only relative is seen
even more clearly in *After the Bath* (see Plate 19), a work completed in 1906
during an excursion to Lychen, in Brandenburg, and executed, in typical Im-
pressionist fashion, while Corinth was seated in a boat. Here the textures are
subordinated to a whirlwind of colors—now ebbing, now flowing—in bursts
of resurgent energy. Although the painting ostensibly depicts Charlotte Be-
rend after a swim in a pond, this is, above all, a quintessential painting of

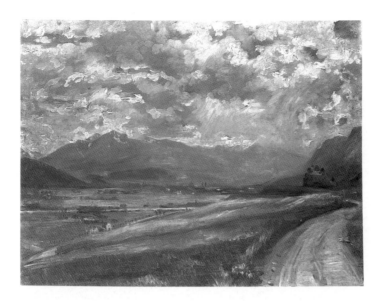

FIGURE 110.
Lovis Corinth, *Inn Valley Landscape*, 1910.
Oil on canvas, 75 × 99 cm, B.-C. 441.
Staatliche Museen Preussischer
Kulturbesitz, Nationalgalerie, Berlin
(West) (NG 1263; A II 263). Photo: Jörg P.
Anders.

summer that transcends both the identity of the sitter and the topography of
the site. In 1910 Corinth applied a similar breadth of execution to his first
great mountain view, the *Inn Valley Landscape* (Fig. 110), in which simplified
horizontal and diagonal bands of terrain gradually lead the eye into the dis-
tance. The all-pervasive bluish light of the river valley further helps to unify
the composition.

Three paintings completed in the late summer of 1911 in Hamburg are high
points among Corinth's landscapes. They were painted on the initiative of
Alfred Lichtwark, director of the Hamburg Kunsthalle, who was assembling
a cycle of pictures specifically devoted to the Hanseatic seaport, comprising
views of the city and its surroundings and portraits of influential men and
women born or active in Hamburg. Lichtwark eventually selected for the
Kunsthalle the view of the Köhlbrand (Fig. 111), the sprawling estuary of the
Elbe River as seen from the suburb of Altona. It was a fitting choice, for the
painting depicts the very lifeline on which the city's prosperity depended.

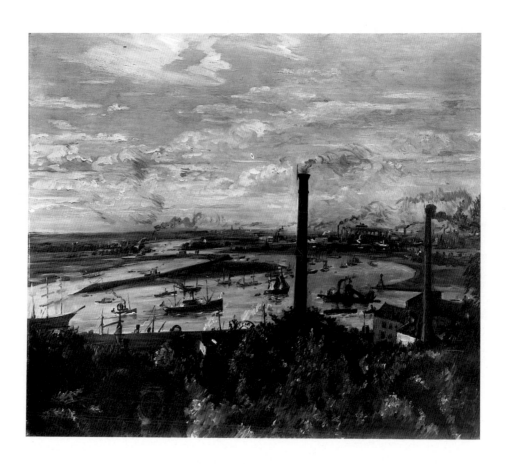

FIGURE 111.
Lovis Corinth, *View of the Köhlbrand*,
1911. Oil on canvas, 114.5 × 135.0 cm,
B.-C. 482. Hamburger Kunsthalle,
Hamburg (1964). Photo: Ralph
Kleinhempel.

The majestic river winds through the countryside, bearing a flotilla of sail-
boats, steamers, and barges. The smokestacks in the foreground and near the
horizon bear witness to the harbor's industrial might. Adopting a pictorial
formula first developed by such sixteenth-century Flemish masters as Patinir,
Corinth conveyed through the panoramic view something of the outward-
looking character that had shaped the city's economic development for
centuries.

In two smaller landscape views from across the basin of the Alster River,
the tributary that links the city with the Elbe, Corinth silhouetted the old
town center, decked out with flags and set for a display of fireworks. The
occasion for the festivities was a visit of the German emperor and empress to
Hamburg in late August to witness the beginning of the Ninth Army Corps'
maneuvers on the parade grounds of Gross-Flottbeck. Despite the closely cir-
cumscribed view Corinth adopted in both works, the festive mood envelop-
ing the city is emphasized more than topography. In the nocturne (B.-C. X),
cascading fireworks and the sparkling lights of the city transform the Alster
basin into a shimmering pond of red, blue, and gold. In the other painting
(see Plate 20) the flags atop the buildings are so large that they have no plau-
sible relation to the structures they surmount and even dwarf most of the
church spires. It is as if the entire city were aflutter with excitement. The
grayish blue light is almost palpable, so emphatic are the brushstrokes that
give substance to the atmosphere.

Corinth's growing interest in still life and landscape was accompanied by
an increasing emphasis on color, especially colored shadows, stimulated by
a renewed acquaintance with the paintings of the French Impressionists, in
particular those of Edouard Manet. Early in 1910 an important exhibition of
French Impressionist paintings was organized in Berlin by Paul Cassirer, who
together with the galleries of Durand-Ruel and Bernheim-Jeune in Paris had
just acquired the prestigious collection of Auguste Pellerin. Many pictures
by Manet were included in the show, notably such important works as *The
Luncheon in the Studio* (1868; Bayerische Staatsgemäldesammlungen, Neue
Pinakothek, Munich), *The Artist (Portrait of Marcellin Desboutin)* (1875; Museu
de Arte, São Paulo), *Nana* (1877; Kunsthalle, Hamburg), and *A Bar at the Folies
Bergères* (1881–1882, Courtauld Institute Galleries, London).[67] Still, the nuances
of mood and the essentially expressive content of Corinth's own mature still
lifes and landscapes only serve to point out the inadequacy of the term *Im-
pressionism* in characterizing his work.

The same can be said of such other German "Impressionists" as Lieber-
mann and Slevogt, both of whom were similarly concerned with finding a

pictorial equivalent not only for *what* they saw but also for *how* they saw it. Their brushwork is sometimes ecstatic, sometimes lyrical, and usually a predominant tonality unifies and reinforces the mood of any given work. Liebermann explained his position in an essay first published in 1904 and entitled, somewhat ambiguously, "Die Phantasie in der Malerei." In it he spoke of the "artistic truth" with which the artist sees nature. For him fantasy in painting had to do not with subject matter but with the way technique successfully recreates in the viewer the sensation the artist experienced while executing the work. Though for Liebermann sensory perception was always the basis of the artistic process, only what the painter manages to extract from nature and renders visible makes him a true artist.[68]

For Slevogt, too, seeing was a selective process conditioned by the painter's disposition. In 1928 he commented on Liebermann's essay:

> The eye is not an instrument like the mirror. The eye is a living conduit to our entire being. It is always self-conscious, always conditioned by some purpose— it is a sieve that allows many things to filter through in the process of seeing. The eye looks, it searches, and whatever it does not understand, it does not see. A hunter does not see like a sailor. Somebody who never hunts cannot see a rabbit even if it is sitting right next to him. The eye sees with much imagination, music, rhythm, and intoxication.[69]

EXPANDED FAME

Between 1909 and 1911 Corinth received several portrait commissions. Although these works are of uneven quality, they are a measure of the growth of his reputation, for in each case the commission originated outside Berlin. In 1909 he painted the portrait of Ludwig Edinger (B.-C. 398), then director of the Senckelberg Neurological Institute in Frankfurt. From Hamburg came commissions for the portraits of Albert Kaumann (B.-C. 431) and Henry Simms (B.-C. 432), both painted in 1910, and for the portrait of Frau Kaumann (B.-C. 485), which dates from 1911. The Hamburg commissions may have come about through the recommendation of Alfred Lichtwark, who was keenly interested in the history of portraiture in the Hanseatic city-state and had published a book on the subject in 1899, urging that the tradition be encouraged and continued.[70] Lichtwark also personally commissioned from Corinth a portrait of Eduard Meyer for the Hamburg Kunsthalle. Meyer was a professor of history at the University of Berlin and a native of Hamburg. For Corinth this

commission was particularly important since by 1910 the Hamburg museum owned twenty-nine paintings by Liebermann and one by Slevogt but none by Corinth himself. Correspondence about this commission shows the extent to which Lichtwark's own views influenced the painter.[71]

Lichtwark first approached Corinth about the Meyer portrait in November 1910. Since at the time Meyer was dean of the Philosophical Faculty at Berlin, Lichtwark suggested that the professor be depicted in academic dress standing by a large window in the dean's office, a suggestion that was not at all frivolous. Lichtwark clearly envisioned a portrait of some official character that would blend with other paintings already in the Kunsthalle collection, such as Liebermann's portrait of Mayor Carl Friedrich Petersen (1891) and Slevogt's portrait of Mayor William Henry O'Swald (1905), in both of which the sitters are depicted in their robes of office. As it turned out, Meyer rejected the idea as too pretentious and persuaded Corinth to paint him wearing an ordinary suit and in the privacy of his study (Fig. 112). Eduard Meyer (1855–1930) is seated nearly full-length before shelves filled with books, with what appears to be the corner of a window in an adjacent room at the upper left; the bright light entering from the right is reflected off the floor. Corinth made no effort to diminish the coarseness of Meyer's features, carefully emphasizing the facial characteristics, just as he attentively modeled the sitter's hands. Although the portrait ostensibly captures Meyer's habitual pose in casual conversation, there is a stiffness about the sitter that is reinforced by the restricted space and the well-ordered division of the background.

Corinth had completed the portrait by January 10, 1911, and a few weeks later sent it to Hamburg. Lichtwark was shocked when he first saw the painting and in a letter dated February 14 informed Corinth of his reaction. He was especially taken aback by the intensity of Meyer's gaze, and it seemed to him that the bright spot beneath the chair, in conjunction with the wall of books, virtually forced the sitter outside the picture frame. Although he acknowledged that he was gradually getting used to the portrait, he suggested that since Corinth now knew Eduard Meyer better, perhaps he could paint him a second time, but—as a pendant to the informal first portrait—wearing academic dress and standing by the large window in the dean's office, as first suggested. As an added inducement, it seems, Lichtwark in the same letter mentioned commissioning from Corinth a Hamburg landscape, a project that soon materialized (see Fig. 111).[72]

Meyer finally consented to Lichtwark's wish for a more "official" portrait, and Corinth began work on the second painting (Fig. 113) in late March. The

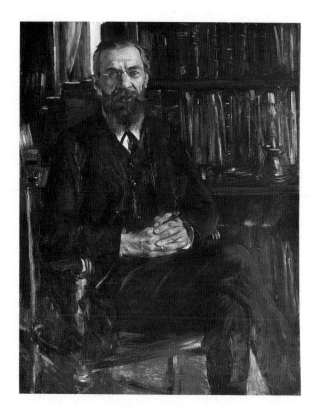

portrait follows Lichtwark's suggestions in virtually every respect. Meyer now wears a dark ultramarine academic robe; but his posture is relaxed, informal. Holding a velvet cap in one hand and a manuscript in the other, he leans on the windowsill in a moment of quiet concentration and reflection. The pages he holds add brightness to the lower left of the composition, balancing the bright expanse of the window.[73] Because window and wall no longer run parallel to the picture plane, as they do in the first portrait, the interior space seems more ample, and the large window extends the view out to a spring day enlivened only by a few specks of green and the pink of a bed of hyacinths. Knobelsdorff's elegant opera house on Unter den Linden and the cupola of St. Hedwig's Cathedral can be seen through the still-barren trees. Since the figure is illuminated from the back, Corinth was able to dispense with the details of individual forms, except for Meyer's head. With the summary treatment of the robe and the hands, however, the head acquires a spiritual strength that

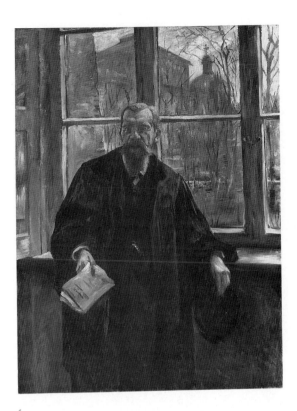

FIGURE 112.
Opposite: Lovis Corinth, *Portrait of Eduard Meyer,* 1911. Oil on canvas, 140 × 108 cm, B.-C. 498. Hamburger Kunsthalle, Hamburg (1820). Photo: Ralph Kleinhempel.

FIGURE 113.
Left: Lovis Corinth, *Portrait of Eduard Meyer as Dean,* 1911. Oil on canvas, 198 × 150 cm, B.-C. 499. Hamburger Kunsthalle, Hamburg (1642). Photo: Ralph Kleinhempel.

transfigures Meyer's countenance, lending him the dignity appropriate to his station in life.

Corinth considered the second Meyer portrait one of his best works, and Lichtwark was equally pleased. He not only followed through on the Hamburg landscape but also commissioned Corinth to paint yet another portrait for the museum's Hamburg gallery. The result was the huge portrait of Carl Hagenbeck (B.-C. 450), painted in October 1911. This portrait is not among Corinth's most successful works, largely because the big-game hunter and founder of the famous Hamburg zoo was forced to share top billing with one of his more spectacular charges, a fierce-looking walrus named Pallas. The painting is at best an interesting, though not entirely felicitous, contribution to the genre of the milieu portrait.

The Lichtwark commissions provide a rare glimpse into Corinth's financial transactions and reveal the prices he was able to obtain for his work at this

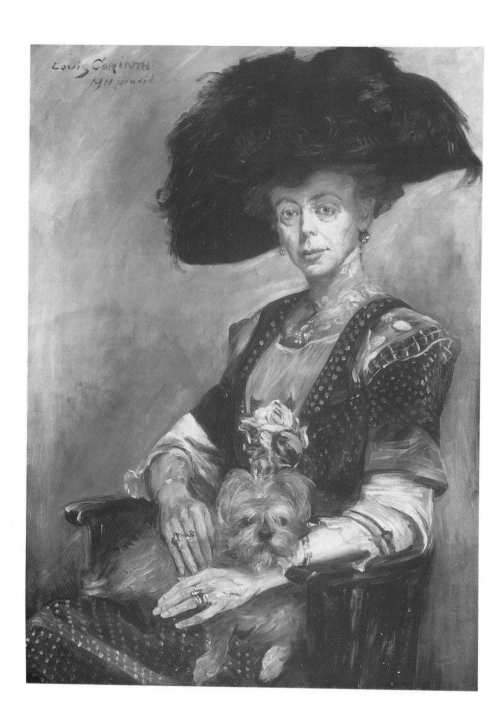

time. The Hamburg Kunsthalle acquired the second Meyer portrait and the
view of the Köhlbrand for 2,500 marks each and the Hagenbeck portrait for
4,000 marks—low prices Corinth apparently agreed to only because he was
eager to see his work in a major museum. When they were exhibited at the
Berlin Secession in 1912, the view of the Köhlbrand was insured for 10,000
marks and the Hagenbeck portrait for 20,000. Corinth informed Lichtwark at
the time that he would gladly work for the Kunsthalle again, but only for
substantially higher prices.[74]

Another impressive portrait from 1911, of Frau Luther (Fig. 114), the wife
of Hermann Luther, a wealthy sugar importer of Magdeburg, demonstrates
again how much the quality of Corinth's portraits depends on his psychologi-
cal response to the sitter. As in the portrait of Eduard von Keyserling from
1900 (see Plate 13), similar to this one in form and conception, the figure is
seen against a neutral ground, and Corinth relied on blue to unify the com-
position, although here the colors are more vivid. Clearly Corinth was fasci-
nated by Frau Luther's elegant demeanor. Yet her stylish appearance in no
way interferes with her psychological presence. On the contrary, the face is
modeled and characterized carefully, even unsparingly, with special emphasis
on the puffy skin around the eyes. The enlarged veins accentuate the sen-
sitivity of the well-groomed hands. Frau Luther may wear her striking dress
and hat with nonchalance and gaze at the viewer with the self-assurance of
her class, but her proud bearing and splendid wardrobe only serve to high-
light her frailty and the onset of physical decay.

Corinth's output during 1911 was prodigious. He completed at least sixty-
three paintings and made sixty prints, including twenty-six color lithograph
illustrations for the *Song of Songs* (Schw. L82) published by Paul Cassirer's Pan
Presse. His paintings by now numbered more than five hundred works, and
Georg Biermann was ready to begin work on the first monograph on the art-
ist. But on December 11 of this year, his most productive thus far, Corinth
was felled by a stroke.

FIGURE 114.
Lovis Corinth, *Portrait of Frau Luther*,
1911. Oil on canvas, 115.5 × 86.0 cm,
B.-C. IX. Niedersächsisches
Landesmuseum, Landesgalerie,
Hannover (KM 137/1949).

FOUR :: CRISIS

JOB

Although Corinth recovered his physical strength within months, he never overcame the long-term consequences of his illness. Forever after he limped when tired, and his left hand no longer obeyed when he tried to perform intricate tasks. His right hand was affected too and trembled severely. Yet this infirmity did not fundamentally interfere with his ability to paint. A film made of Corinth at work on a painting in 1923 shows that his brush grew steady the moment it touched the canvas and was thereby given additional support.[1] An occasional physiognomic oddity and the character of his brushstrokes, which often follow a predominantly diagonal direction from the upper right to the lower left, are the only reminders of his handicap. Rarely, however, do these technical peculiarities diminish the quality of Corinth's paintings and graphics. On the contrary, Corinth eventually achieved a new synthesis of content and form that often endows his late works with great profundity.

Corinth had come face-to-face with death, and in one form or another virtually all his subsequent works bear the mark of this experience. This is true even of the still lifes and landscape paintings to which he devoted more and more energy, sublimating, as it were, the vigor of his earlier work in visions of nature that are splendid in their amplitude but rarely without a touch of pathos. Nor did Corinth's illness impair his creative drive. The years from 1912 to his death in 1925 turned out to be his most productive. Close to five hundred paintings, over eight hundred prints, and scores of watercolors and drawings—in short, more than half of all his works—date from this time.

Initially, the period following the stroke was one of reproach and bitter self-examination. Corinth blamed his excessive drinking for his illness and vowed to give his life a new direction:

> My entire life passed before me, a life which in this lonely battle seemed more precious now than when I was young and strong. I was forced to reckon with myself. Job called to me: Gird up thy loins like a man for I will demand of thee, and answer thou me! "Where wast thou when I created thee?" Thus my path was to be illuminated once more. But time seemed so very short.[2]

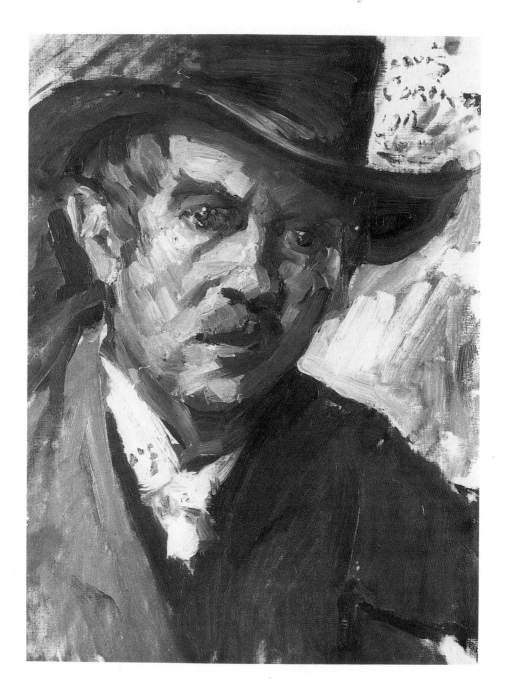

FIGURE 115.
Lovis Corinth, *Self-Portrait*, 1912. Oil on
canvas, 49 × 36 cm, B.-C. 546. Anna
Held Audette, New Haven, Connecticut.
Photo courtesy Julius S. Held.

While still on his sickbed, Corinth asked for pencil and paper and sketched a series of horrible monsters and strange, ghost-like images of famous figures from history.[3] None of these drawings seems to have survived. Apparently Corinth was unable to resume work in a more premeditated manner until February 1912. Charlotte Berend accompanied him as he returned to his studio for the first time, and she watched as he gazed long into the familiar large mirror.[4] Again and again he moaned in despair. Then suddenly he reached for palette and paint and quickly dashed off the first in a long series of poignant self-portraits that were to focus on his physical frailty and mental anguish (Fig. 115). Sweeping brushstrokes follow the outlines of the coat and hat. In the face the paint is applied in small patches heightened with dabs of white and red that give the skin a peculiar restlessness. Devoid of conventional textural distinction, the face seems in a state of flux. Beneath the broad brim of the hat Corinth's features are smaller and more delicate than in the previous self-portraits. The eyes reflect profound sadness. This is no longer the face of the victorious warrior or of Nietzsche's natural man but rather that of one who has recognized and acknowledges the precariousness of his condition.

Even when Corinth donned his beloved armor during these weeks, as for instance for the etching *The Knight* (Fig. 116), the resulting self-portrait differs markedly from the earlier extroversive self-portraits of this type. The helmet now weighs heavily on his head, and neither his posture nor his demeanor fits the assumed role. Corinth portrays himself with etching needle and copper plate, actively pursuing his craft, and in this context the knightly trappings signify his valiant efforts to regain his ability to work.

Henceforth Corinth tended to identify more deeply with subjects that center on human suffering, as in *Job and His Friends* (Fig. 117), a pencil drawing done on tracing paper over a copper plate (Schw. 85) that is one of the earliest surviving works from the time after his stroke. The Old Testament tale of woe no doubt mirrors Corinth's own frame of mind.[5] Indeed, the ill and sorely tested Job of the drawing bears Corinth's features and has draped over his head the same cloth the painter wears in the two costume self-portraits from 1907 (see Fig. 104) and 1909 (B.-C. 400). Job's withered right arm and leg, reversed in the etching for which the drawing was made, allude only too clearly to Corinth's own affliction. Technically, too, the drawing betrays the painter's physical impairment. The lack of conventional modeling sets the drawing apart from the meticulous anatomical studies of the preceding decade. The figures appear flat, and their spatial relation to one another is unclear.

Charlotte Berend has written of Corinth's anxiety and depression during these months and of his exhaustion following even the slightest physical exertion.[6] Through cheerful encouragement she tried to alleviate his recurrent fears of impending senility, and she aided him as he struggled to summon up his strength. She laid out the colors before him, placed palette and brushes in his encumbered left hand, and removed them from his stiff and swollen fingers when he had finished painting. When his own hand failed to provide adequate support, she gently and tactfully helped to steady his sketchbook.

Several works executed between the end of February and the end of April 1912 document Corinth's efforts to regain full control over the artist's craft. They were done in the small Riviera town of Bordighera, where Charlotte Berend had taken him to spare him the long Berlin winter. In the self-portrait drawing now in Bremen (Fig. 118) Corinth's vacant stare testifies eloquently to the sense of loss and resignation that frequently overcame him at this time. The emphatic contour line encircling the head has been drawn with noticeable strain. The random patches of gray and black barely manage to suggest the texture of hair. Careful modeling has given way to crude hatchings that no longer have any consistent relation to the anatomical structure they are intended to define. The illuminated left side of the face still suggests a fair degree of plasticity, but the opposite side remains flat. The nose is blunted and abnormally elongated, as if the face had gone soft in an irreversible process of dissolution. Corinth's physical and mental state give the laconic inscription "ich" at the lower center of the sheet the character of a poignant confession.

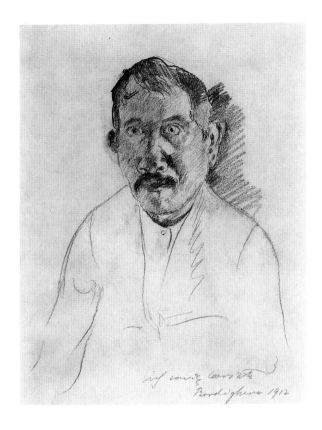

FIGURE 116.
Opposite, left: Lovis Corinth, *The Knight
(Self-Portrait),* 1912. Etching, 18.0 × 13.8
cm, Schw. 86. Kunsthalle Bremen
(42/127).

FIGURE 117.
Opposite, right: Lovis Corinth, *Job and His
Friends,* 1912. Pencil on transfer paper,
29.2 × 22.2 cm. Formerly Allan Frumkin
Gallery, New York; present whereabouts
unknown. Photo: Horst Uhr.

FIGURE 118.
Above: Lovis Corinth, *Self-Portrait,* 1912.
Pencil, 33.5 × 26.0 cm. Kunsthalle
Bremen (1970/158) Photo: Stickelmann.

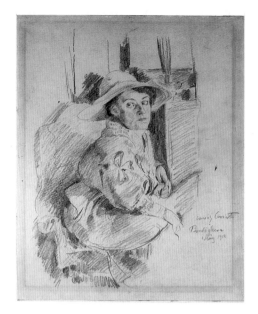

FIGURE 119.
Lovis Corinth, *Portrait of Charlotte Berend*,
1912. Pencil and colored crayons on
cardboard, 46.0 × 37.7 cm. Wallraf-
Richartz-Museum, Cologne (1950/46).
Photo: Rheinisches Bildarchiv.

The effort it cost Corinth to maintain consistency in the tangible character
of a given subject is also seen in a drawing of Charlotte Berend (Fig. 119). The
general conception is more ambitious than that of the preceding self-portrait,
the nearly full-length seated figure having been placed in a vaguely circum-
scribed interior space. Diagonal hatchings in the sitter's face continue to de-
fine form, but in the rest of the figure they fail to render texture and mass
convincingly. Charlotte's dress only seems voluminous; on closer examina-
tion it looks lifeless and flat. The lack of plausible anatomical articulation re-
sults in a strong sense of compression, as if the figure were cowering in an
awkwardly strained posture. Moreover, Charlotte, who had a natural flair
for posing, appears ill at ease. She faces her husband, but her eyes evade his
gaze. Her acute awareness of the physical and psychological tensions involved
in the making of this portrait no doubt accounts for the anxiety she herself
projects. A similar air of apprehension pervades the painting *Lady with a Fan*
(B.-C. 517), although here Charlotte's likeness is subordinated to the summary
treatment of the individual forms.

 Different ambiguities mark the plein air portrait Corinth painted of Charlotte
Berend on the balcony of their hotel in Bordighera (Fig. 120). Here the prob-
lem is primarily one of pictorial structure. Despite the pronounced diagonal
of the balcony railing, the painting essentially lacks perspective, resulting in

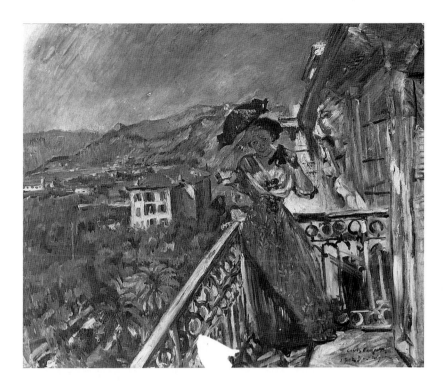

FIGURE 120.
Lovis Corinth, *On the Balcony in
Bordighera*, 1912. Oil on canvas, 83.5 ×
105.0 cm, B.-C. 540. Museum Folkwang,
Essen (241).

abrupt transitions from the figure to the surrounding space. The vertical lines
of the hotel's facade do not match, and the building appears to be leaning
toward the left. The resulting impression of instability is reinforced by the
diagonal shadow that falls across Charlotte's dress and by the position of her
parasol, while the intense blue that dominates the color scheme adds an un-
expectedly strident tone.[7] In the landscape view at the left, which Corinth
recorded a second time in a separate, smaller, canvas (B.-C. 539), the pigments
are applied in predominantly parallel strokes that do not convey the varied
texture of the terrain. This method of applying the paint is found earlier in
subordinate areas of Corinth's works but henceforth came to be employed
frequently in other, more dominant, parts of his pictures as well since he
evidently found it easier to manipulate the brush in this manner. The slanting
brushstrokes further flatten this part of the canvas.

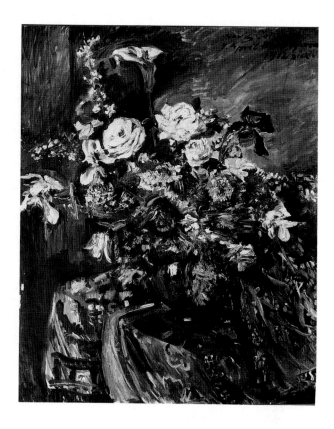

FIGURE 121.
Lovis Corinth, *Riviera Flowers*, 1912. Oil
on canvas, 120 × 100 cm, B.-C. 512.
Staatliche Kunstsammlungen Dresden,
Gemäldegalerie Neue Meister (2580 H).
Photo: Deutsche Fotothek.

As if testing his powers of observation, Corinth also turned his attention at
this time to an ambitious floral still life (Fig. 121) that in both size and concep-
tion rivals the sumptuous floral pieces from the preceding year. The extended
inscription, "Lovis Corinth/1. April Bordighera/1912 pinxit," may well indi-
cate that Corinth considered the painting a major work, and the carefully con-
trived composition reinforces the impression that the painting did not indeed
result from an incidental exercise. Seen against a ground divided into four
more or less equal components, the flowers occupy the very center of the
painting, their shapes echoed in abstracted form by the colors of the table-
cloth. The brushstrokes in the flowers are sufficiently controlled so as to render
the various species recognizable: calla lilies, roses, tulips, a purple iris, and

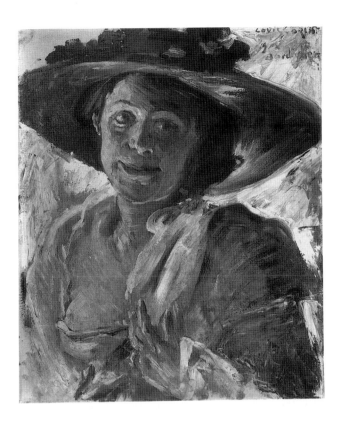

FIGURE 122.
Lovis Corinth, *Portrait of Charlotte Berend*, 1912. Oil on canvas, 59 × 49 cm, B.-C. 519. Staatliche Museen zu Berlin, National-Galerie (DDR) (957).

sprigs of mimosa and apple blossoms are gathered in a ceramic vase. Yet instead of the élan typical of Corinth's previous floral still lifes, the bouquet conveys an air of restlessness, an impression of struggle. Some of the brushstrokes are notably brittle, negating the delicacy of the textures they are intended to define. And a pronounced suggestion of movement toward the lower right, where the composition remains curiously open-ended as if subject to some inexplicable gravitational force, undermines the viewer's own sense of equilibrium, creating the uncomfortable feeling that the flowers are being swept away.

Corinth's recovery in Bordighera of his ability to communicate a visual impression in a commensurately evocative form is seen in yet another portrait of Charlotte Berend (Fig. 122). The portrait was prompted, as so often in the past, by Charlotte's habit of striking an artful pose, this time with a white fur cape draped casually over her shoulder.[8] The couple had just returned to their hotel room from a ride in the town's annual spring flower parade, and the lingering joy of the shared experience seemingly allowed both painter and

model to dispel the tensions that might otherwise have interfered with the felicitous conception. In this painting Corinth managed to recapture the intimacy that characterizes his earlier portraits of Charlotte. The fashionable dress and hat reinforce her vivacity and charm, while the extreme close-up view allows for a maximum of psychological rapport. Corinth set himself here the challenging task of painting against the light, and any lack of detail follows logically from the strong contrasts in illumination. Only in Charlotte's face, shielded by the brim of her hat and thus less susceptible to the form-dissolving effects of the enveloping light, do the brushstrokes delineate the familiar traits with greater precision.

A similarly successful fusion of content and form can be seen in the small seascape *Storm at Capo Sant'Ampeglio* (see Plate 21). Corinth had discovered the picturesque promontory during an excursion and was immediately taken by the spectacle of the waves battering the rock-strewn shore. He had by then sufficiently recovered to paint the view under less-than-ideal weather conditions, braving a brisk wind that kept tugging at his easel. According to Charlotte Berend, he painted the picture as in a trance, immersing himself in the experience of the moment.[9] And as so often in the past when his interest was aroused, vision and experience merged in a work that is more than a topographical record. The creative energy unlocked by the painter's empathic response dominates the descriptive details, as swirls of paint slash across the canvas.

Corinth's resurgent self-confidence was profoundly shaken when news reached him from Berlin that Paul Cassirer was circulating the rumor that the painter had become mentally incompetent, that the stroke had left him insane.[10] Although this gossip was malicious, Corinth's illness had prevented him from attending personally to preparations for the 1912 annual exhibition of the Berlin Secession, scheduled to open in early April. Cassirer and Liebermann, therefore, had taken over the responsibility of organizing the show. No doubt in this context Corinth's anxiety about his health acquired a new urgency.

RIVALS

Other signs in the German art world were bound to heighten Corinth's concern about resuming his professional life. For as he struggled to recapture the momentum of his career, younger artists, expounding aesthetic principles at variance with his own, were gaining broader public support. The opening exhibition of the New Secession in May 1910 had marked the beginning of a

process that would eventually dislodge the Berlin Secession from the center of modern art in Germany. In 1911 exhibitions of paintings and graphics by the artists of Die Brücke were held at the Berlin gallery of Fritz Gurlitt as well as at galleries in Danzig, Schwerin, Lübeck, Düren, München-Gladbach, and Dresden. The same year the New Secession organized two exhibitions in Berlin, with works by Heckel, Otto Mueller, Pechstein, Schmidt-Rottluff, Kandinsky, Jawlensky, and Nolde. The Brücke painters continued their association with the New Secession until the fall of 1911, when they withdrew, pledging to exhibit henceforth only as a group. By the end of the year they had all settled in Berlin and in the spring of 1912 were again featured at the gallery of Fritz Gurlitt. The Gurlitt exhibition was soon followed by a show at the Commeter Gallery in Hamburg. In Munich, meanwhile, the first Blaue Reiter exhibition opened at the Neue Galerie Thannhauser in December 1911 and subsequently traveled to Berlin and Cologne, while in the Bavarian capital the group mounted a second show at the gallery of Hans Goltz.

In 1910 the Expressionists had found an enterprising champion in the Berlin publisher Herwarth Walden, who featured their drawings and prints in the avant-garde literary weekly *Der Sturm* and from 1912 on organized at the galleries of *Der Sturm* a series of pioneering exhibitions that included works by the members of Der Blaue Reiter, Kokoschka, Fauves like Derain and Vlaminck, and leading Cubists and Futurists. In 1912 Walden also published Filippo Tommaso Marinetti's "Manifesto of Futurism" and the more specific "Futurist Painting: Technical Manifesto" as well as an essay by Kandinsky, "The Language of Form and Color," the sixth chapter of the Russian painter's book *Concerning the Spiritual in Art*. In Cologne Karl Osthaus organized the monumental fourth exhibition of the Düsseldorf Sonderbund, open from May to September 1912. This, the most important German exhibition of modern art ever held, was international in scope and served as a prelude to Herwarth Walden's First German Autumn Salon of the following year, which brought together an impressive collection of paintings and works of sculpture by some ninety artists from fifteen different countries.[11]

The Berlin Secession had never mounted exhibitions of such magnitude and importance. The annual exhibition of 1912 in particular was a lackluster affair. Faced with an unexpected responsibility, Cassirer and Liebermann— who had hardly concerned themselves with the administrative affairs of the association since the debacle of 1910—had too little time to prepare a competitive show. One of their more memorable efforts on behalf of the Secession, however, resulted in Max Pechstein's return to the association. For this Pechstein was expelled from Die Brücke, since he had defied the group's decision to exhibit only jointly.

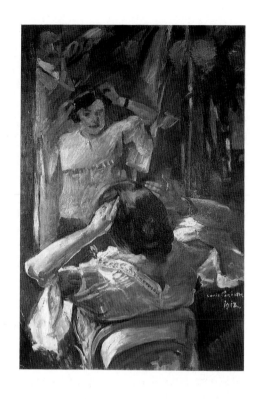

FIGURE 123.
Above: Lovis Corinth, *Before the Mirror,*
1912. Oil on canvas, 140 × 93 cm,
B.-C. 533. Private collection. Photo:
John D. Schiff.

FIGURE 124.
Right: Lovis Corinth, *At the Toilet Table,*
1911. Oil on canvas, 120 × 90 cm, B.-C.
502. Hamburger Kunsthalle, Hamburg
(1857). Photo: Ralph Kleinhempel.

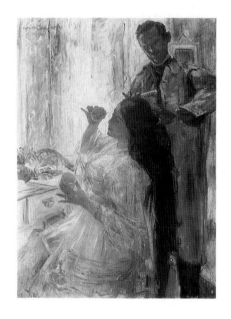

Corinth's health continued to improve rapidly. By the end of April 1912 he was back in Berlin. He spent the summer months in the Bavarian village of Bernried, on the west bank of the Starnberger See, occasionally receiving old friends and other visitors, such as Carl Strathmann, Wilhelm Trübner, and the art historian Georg Biermann, who was then working on his Corinth monograph.

Corinth's work for the remainder of 1912 varies in conception and execution and includes several pieces with which he sought to reestablish continuity with his development prior to the stroke. He completed *Paradise* (B.-C. 523), a large canvas depicting Adam and Eve surrounded by animals in a verdant landscape. Nearly finished before his illness, this painting apparently required little further work. The interior *Before the Mirror* (Fig. 123) is a different case. This painting rephrases a picture from 1911 (Fig. 124) showing Charlotte Berend in her boudoir attended by a hairdresser. The later work shows an astonishing change. The high-keyed tones of the earlier painting have given way to colder hues of greater opacity; the fields of color are separated by large areas of black; the brushstrokes have been applied flatly, with little variation in accent or direction. Corinth also modified the composition so as to include himself in the reflection in the mirror, in the act of painting, making this work yet another double portrait of the Corinth couple. But the features of both their faces are so generalized that the two figures appear virtually faceless. This results in a marked psychological distance, especially in comparison with the earlier, erotically charged, double portraits. At the same time there is a new tension in the juxtaposition of Charlotte, who arranges her hair before the mirror, and the painter, who has assumed the role of a distant observer. This juxtaposition is surely not accidental: it is safe to assume that both husband and wife questioned the nature of their future marital life. Charlotte Berend, at least in her later memoirs, ruefully reflects on her age—thirty-one—at the time of Corinth's illness.[12] Corinth was fifty-three. On some occasions, despite her devotion, Charlotte must have rebelled inwardly against the restrictions of life with the aging painter. And as for Corinth, with this painting he concluded the series of double portraits of himself and his wife.

The handsome portrait of Charlotte Berend, now in Nuremberg (Fig. 125), seems to contradict these observations, at least initially, for the extreme close-up view suggests intimacy once again. Yet the elegant clothing, underscored by the white glove and the veiled hat, tends to conceal the sitter, whereas in

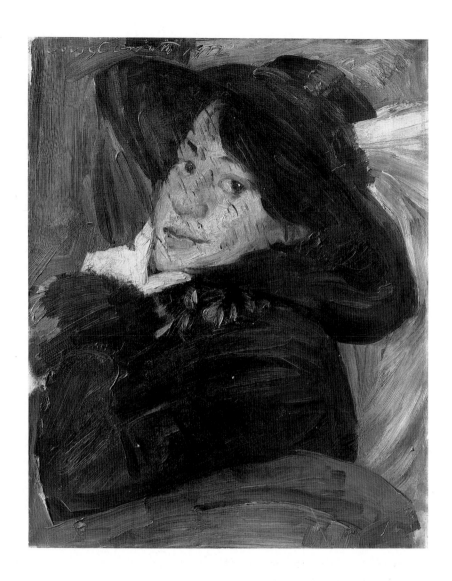

FIGURE 125.
Lovis Corinth, *Portrait of Charlotte Berend*,
1912. Oil on canvas, 64 × 50 cm, B.-C.
532. Germanisches Nationalmuseum,
Nuremberg (St. Nbg. Gm. 993).

the preceding portrait from Bordighera (see Fig. 122) the dress still accentuates Charlotte's sensuous charm. In no previous portrait—with the possible exception of the drawing from March 1, 1912 (see Fig. 119)—does Charlotte Berend appear so buttoned up. Despite her physical proximity and open gaze, she seems remote, as if she had become for the painter an ideal image inhabiting a world he no longer really shared. And in fact Corinth subsequently painted fewer depictions of Charlotte Berend than during the first nine years of their marriage. Although she is shown anonymously in eight—possibly nine—other paintings (B.-C. 553, 577, 579, 584, 658, 699, 704, 738a, 961), the actual portraits where she is specifically identified number only seven (B.-C. 624, 651, 685, 736, 837, 838, 846), as compared with more than sixty paintings in which she appeared before 1912. Furthermore, in all of these later portraits Corinth's view of his wife is markedly detached. Depending on the painterly technique employed, her features are either blurred or psychologically neutral.

The technique employed in the Nuremberg portrait of Charlotte Berend is also noteworthy. The paint has been applied less erratically than in the works that just precede it. The brushstrokes no longer flicker across the canvas but follow broadly sweeping rhythms that lend clarity to the composition. The result is a new sense of calm, shared by several of Corinth's paintings from the latter half of 1912. In the self-portrait he painted in August at Bernried (Fig. 126) the modeling is firm, and the structural clarity is reinforced by the simple color scheme: the flesh tones and the yellow of the hat are set off against a palette of blue, white, and green. The effect of the high-keyed colors is cheerful. To judge from his appearance, Corinth had made a remarkable recovery. Although his look remains serious, the despair and resignation of the self-portraits from the first half of the year have disappeared. The firm gaze and resolute mouth speak instead of renewed commitment and determination.

But Corinth also continued to reflect deeply on his condition. This is evident from the compelling *Samson Blinded* (see Plate 22), one of the few figure compositions he painted in 1912. This is a fairly large picture, painted in bold, simplified strokes. A world of difference separates it from Corinth's earlier treatment of the theme (see Fig. 98). The composition from 1907 typifies his extroversive showpieces of foreshortened bodies and complicated postures; the later one is simple, dominated by the single figure of the mutilated hero who blindly gropes through an open door, his hands in chains, his eyes covered with a bloodstained cloth. The shocking immediacy of the portrayal elicits both sympathy and revulsion. As in the drawing of Job (see Fig. 117), Corinth saw in Samson's anguish a "universal human" significance. Samson's

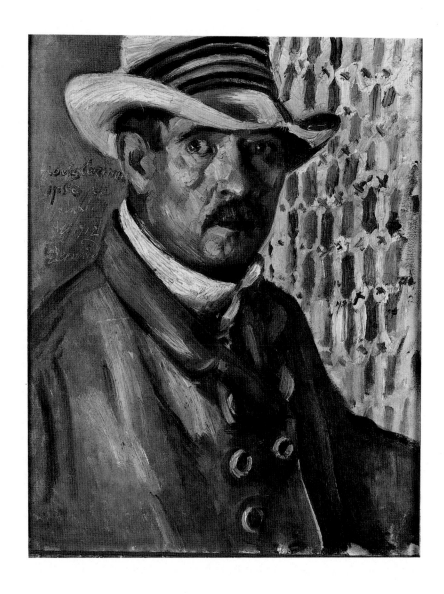

FIGURE 126.
Lovis Corinth, *Self-Portrait in Panama Hat*,
1912. Oil on canvas, 66 × 52 cm, B.-C.
515. Kunstmuseum Lucerne. Photo:
Robert Baumann.

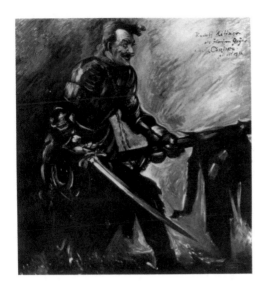

FIGURE 127.
Lovis Corinth, *Rudolf Rittner as Florian
Geyer*, 1912. Oil on canvas, 180 × 170 cm,
B.-C. 521. Formerly in the Collection of
the City of Berlin; present whereabouts
unknown. Photo: after Bruckmann.

features resemble the painter's own, and the setting is not a biblical recon-
struction but a modern domestic interior. Both *Job and His Friends* and *Samson
Blinded* suggest that Corinth's attitude toward religious subjects had under-
gone a profound change. No longer satisfied with the mere re-creation of bib-
lical narratives, he had come to subordinate the specific to the generalized
and universal. As a result, the content of these works is intensified in a new
personal context.

By the end of 1912 Corinth's health had sufficiently improved that he could
announce his candidacy for reelection to the presidency of the Berlin Seces-
sion. When Paul Cassirer was nominated as well, Corinth withdrew from
consideration. Cassirer was elected in December 1912 and, in a gesture of
appeasement, offered to mount a major retrospective of Corinth's work at the
Secession galleries. This exhibition, held from the end of January to the end
of February 1913, featured more than two hundred paintings representing all
the major stages of Corinth's development, from his student years in Königs-
berg to the period following the stroke. In his preface to the catalogue Corinth
acknowledged the difficult circumstances under which his latest works had
come into being: "My most recent pictures . . . were initially hard to do be-
cause of many a fateful affliction, but I hope that I have overcome these impedi-
ments, and I intend to continue on my path."[13] The one work that Corinth
was unable to obtain for the retrospective was the portrait of Rudolf Rittner
in the role of Florian Geyer (see Plate 16), because the owner of the painting
refused to part with it.[14] The refusal upset Corinth immensely until Cassirer
suggested that he paint the picture a second time from memory.[15] The sec-
ond version (Fig. 127), with virtually the same dimensions as the first, is both

FIGURE 128.
Lovis Corinth, *Bowling Alley*, 1913. Oil
on canvas, 83.2 × 61.0 cm, B.-C. XI.
Niedersächsisches Landesmuseum,
Landesgalerie, Hannover (KM 140/1949).

simpler and more expressive. The brushstrokes, far from serving textural dis-
tinctions, define the image only broadly. There is also less concern for ana-
tomical plausibility, and the fierceness of Hauptmann's embattled hero has
been intensified almost to the point of caricature. In his determination to in-
clude a picture of Florian Geyer in the exhibition, Corinth was clearly moti-
vated less by a desire to demonstrate his undiminished skill as a portraitist
than by his personal identification with the leader of the Peasants' Rebellion.
Corinth in fact used the image of Florian Geyer for the color lithograph he
prepared as a poster for the exhibition.

During 1913 Corinth traveled extensively. In March Charlotte Berend ac-
companied him again to the Riviera, this time to the French resorts of Menton
and Beaulieu. In April he spent several days in Düsseldorf and Mannheim
in connection with an exhibition of his works there that followed the large
retrospective in Berlin. In July and August he vacationed with his family in
the Tyrolean hamlet of Sankt Ulrich and spent most of September at Klein-
Niendorf, in the Baltic Sea province of Mecklenburg. The itinerary alone sug-
gests that he had fairly well recovered. But his works from that year remain
uneven in quality and often betray a continuing struggle. In the painting of
an outdoor bowling alley, for instance (Fig. 128), done at Klein-Niendorf, the
opacity of the saturated hues and the systematic brushstrokes deprive the land-
scape of its atmospheric character and depth. The *Self-Portrait with Tyrolean
Hat* (Fig. 129), in contrast, from Sankt Ulrich, indicates both greater technical
control and superior conception. Everything about the painting suggests en-
ergy: Corinth's firm grasp of the brushes, the determined expression, the res-
olute turn of the head. The jaunty hat even adds a touch of frivolity to the
portrayal. All this is underscored by the affirmatory "Ego" of the inscription.

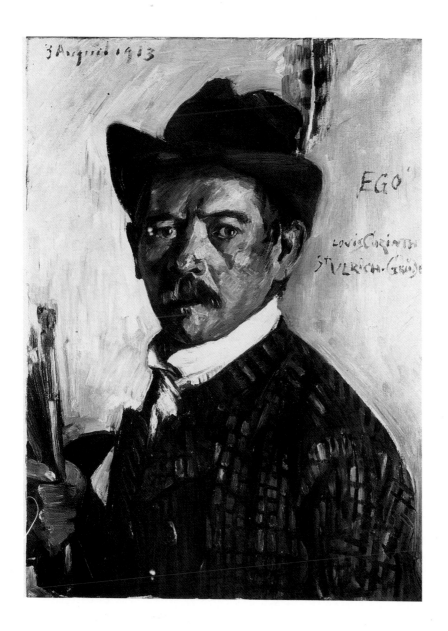

FIGURE 129.
Lovis Corinth, *Self-Portrait with Tyrolean Hat*, 1913. Oil on canvas, 80.5 × 60.0 cm, B.-C. 586. Museum Folkwang, Essen (356).

In some respects Corinth's professional battle had just begun. Recognizing that the Berlin Secession had to compete with many new galleries and artists' associations, Paul Cassirer moved quickly to instill in the organization a more enterprising spirit. He mobilized the group's progressive forces by enlarging the executive committee and adding a new committee in charge of exhibitions, chairing both committees himself. From an artistic point of view the annual exhibition of the Berlin Secession in 1913 more than justified Cassirer's autocratic methods. It was an impressive show that offered a broad overview of the genesis and development of modern art. Featured among the pioneers of the modern movement were Cézanne, van Gogh, Seurat, and Toulouse-Lautrec. The younger generation of foreign painters was represented by the Fauves, including Matisse, Derain, van Dongen, Friesz, Marquet, and Vlaminck. Liebermann and Trübner were each given an entire room. Another room, dominated by Matisse's large canvas *Dance* (1910; Hermitage, Leningrad) was set aside for German sculptors, among them Barlach, Lehmbruck, and Georg Kolbe. Also on exhibit were paintings by Kokoschka, Beckmann, Christian Rohlfs, and former members of Die Brücke, the group having only recently disbanded.

Not everyone was happy with the exhibition, however. Thirteen members of the Berlin Secession whose entries had been rejected claimed that they had been sacrificed to Cassirer's desire to gain control of the organization. They accused him, as well as Liebermann and the three jurors of the show—Max Slevogt, Käthe Kollwitz, and Louis Touaillon—of duplicity and proceeded to exhibit their works independently in a rented shop not far from the Secession galleries. At a specially convened general meeting Slevogt demanded that the thirteen leave the organization. When they refused, Slevogt, Liebermann, Cassirer, and thirty-nine others resigned instead, including Beckmann, Kollwitz, and Barlach. Corinth, however, whose relationship with Paul Cassirer had been strained for some time, stayed with the thirteen malcontents, even though, artistically speaking, they were hardly a match for those who had resigned. Karl Scheffler noted the irony of this development: "It was a grotesque situation: those who remained legally constituted the Secession, whose ideals—since they were less talented—they were unable to uphold, while those who resigned embodied the group's spirit, even though they could no longer claim to be members of the Berlin Secession."[16]

Corinth was elected president of what was henceforth known as the Rump Secession, and he retained this office until his death. Since the building used by the Berlin Secession on the Kurfürstendamm was legally owned by a cor-

poration headed by Paul Cassirer, the Rump Secession lost its exhibition space. Not until 1915 did the organization acquire a new building, also on the Kurfürstendamm, but the Rump Secession was never strong enough to develop a vigorous exhibition policy. It had little impact on developments in German art and was finally dissolved in 1932. Those who had resigned from the Secession fared much better, at least initially. In the autumn of 1913 they sponsored an exhibition that featured works by Munch, Picasso, and the Expressionists. In 1914 they founded the Free Secession, with Liebermann as honorary president, and marked the event with an exhibition that included Liebermann, Beckmann, Slevogt, and the former members of Die Brücke as well as Feininger, Karl Hofer, Ludwig Meidner, Max Oppenheimer, Hans Purrmann, and Corinth's former student Oskar Moll. Among the sculptors were Barlach, Lehmbruck, and Kolbe. Exhibiting as guests were Auguste Rodin, Ferdinand Hodler, Adolf von Hildebrand, Ernesto de Fiori, Aristide Maillol, Gerhard Marcks, and René Sintenis. Cassirer, unwilling to continue as business manager, played only a marginal role in the new association, and without his support the Free Secession never achieved the financial success of the old Berlin Secession. Nonetheless, the Free Secession remained a strong force in German cultural life. When the activities of the group ceased at the height of the postwar inflation in 1923, the membership stood at 144— including the country's leading painters, sculptors, and graphic artists.[17]

CREDO

What compelled Corinth to side with a group of minor artists? Was it loyalty? Sheer bullheadedness fostered by bad feelings between him and Cassirer? Or was it the need, as a new generation of artists was announcing ever more vociferously the end of an era, to affirm his faith in the tradition out of which he had developed? A case can be made for the latter supposition, for Corinth himself had said this much in the catalogue to the retrospective of 1913: "Just as in the history of art the present is built upon the past, I am going to remain faithful to my heritage."[18] In the preface to the same catalogue he had made a further point of distancing himself from the avant-garde: "Even if today new developments manifest themselves, I cannot, just to remain modern, change my conviction so that I can be given a designation whose desirability I find questionable."[19]

In the context of Corinth's illness and the subsequent quarrels in the ranks of the Berlin Secession, his hostility toward the avant-garde—first manifested

in his 1910 article in *Pan*—does indeed take on a new dimension. Corinth's need to rebuild his career in the tradition he knew best does not make his intolerance any more defensible, but it accounts for the urgency with which he sought to justify his position. His need to safeguard the basis of his art at a moment of great personal vulnerability both modifies and explains his attacks on artists, especially those who had strayed from a quintessentially European tradition.

Corinth's strongest disdain for their work as well as his strongest defense of the principles he stood for is contained in an address he gave before the Free Student Association of Berlin in January 1914.[20] This address is both a warning against imitating modern trends from abroad and a plea to respect the old masters. In it Corinth laments the adoption by many young German painters of Cubism and its various offshoots, whose pictorial laws led them to sacrifice their individuality: "I would be delighted if our time would bring forth someone who with one kick of his foot would turn these mathematical tricks upside down."

Matisse and his followers do not fare much better. Corinth accuses Matisse of having turned the "sensitive, awkward . . . expression" of tribal art into a "fad." Commenting on the "impossible anatomical constructions" of the nudes in Matisse's *Dance*, the painting that had hung in the last exhibition of the old Berlin Secession, he asserts that even "the boldest fantasies of an African craftsman could not have produced a greater caricature of the naked European man or woman." Referring within a larger context to the great popularity of Matisse's studio, Corinth says facetiously of his own former student Oskar Moll, who in 1907 had gone to Paris to study with the French painter: "It was a miracle: to the amazement of all who knew him, he returned after hardly more than three months totally transformed. He left as a blond, fair-skinned *Allemand* and came back as a Congo Negro; in his portfolio there were but a few studies of curves that looked as if they had been drawn by Negro youths."

The Italian Futurists' insistence that artists turn away from the past and from conventional methods provoke Corinth's bitterest scorn. After quoting extensively from various Futurist articles that had appeared in the magazine *Lacerba*, he suggests that these artists ought not to be allowed to exhibit, since by their own admission they were not to be taken seriously.

Early in the address Corinth defines the term *modern* as it relates to art. Modern paintings are those that have retained their freshness through the centuries—the work of Rembrandt, Frans Hals, and Velázquez, for example. Paintings produced solely in response to contemporary trends are nothing

more than *Modebilder*, "fashionable" pictures, bound in time to lose their interest and appeal. Corinth concludes by calling the students' attention to the specifically German tradition of Grünewald, Dürer, and Holbein, emphasizing the need for solid training as a safeguard against the temptation to follow and to imitate.

> It is necessary to set for the young student . . . the highest goal and to allow him to reach this goal [only] through untiring industry and the most determined willpower. If he is trained in all aspects of his craft and sufficiently grounded in all the fundamentals, the student will no longer be impressed by anything foreign and will rarely be tempted by the wish: I, too, would like to do that. Because he follows a different goal: to fulfill himself and to develop his own personality. . . . We must have the highest esteem for the masters of the past. . . . Whoever does not honor the past has no hopeful prospects for the future, and it would be better were such a person to take a millstone and go where the water is deepest.

Corinth felt strongly enough about these views to publish the speech in pamphlet form [21] and also summarized his main points in a short article in the *Berliner Tageblatt*. [22] Conceived as a "summons to young people," this article condemns once more the readiness of his younger contemporaries to sacrifice art to what he considered short-lived fads. Stating that without an understanding of the old masters artists can achieve neither "self-knowledge" nor "self-conquest," he accuses the new generation of scorning the study of nature and expresses the hope that someday discipline and hard work will again replace "frivolous license."

Corinth returned to these thoughts in his autobiography in the autumn of 1914, moved in part by feelings of patriotism at the beginning of the First World War. [23] The tendency of young German painters to neglect the old masters in favor of the faddish imitation of the "naïveté of exotic wild men" seemed to him a "virtual epidemic" that had originated in France among artists of French, Spanish, and Balkan origins, and he warns against the leveling effect of this "Franco-Slavic international art." He disdains the last exhibition of the old Berlin Secession as a "witches' sabbath," where despite the large number of works shown, there was so much emphasis on similar pictorial methods that the paintings looked as if they had all come from the same studio.

In defending the study of nature and the old masters Corinth implicitly defends his own artistic tools and the principles he had espoused for years. Indeed, if Corinth expresses anything like a credo, he does so in his address

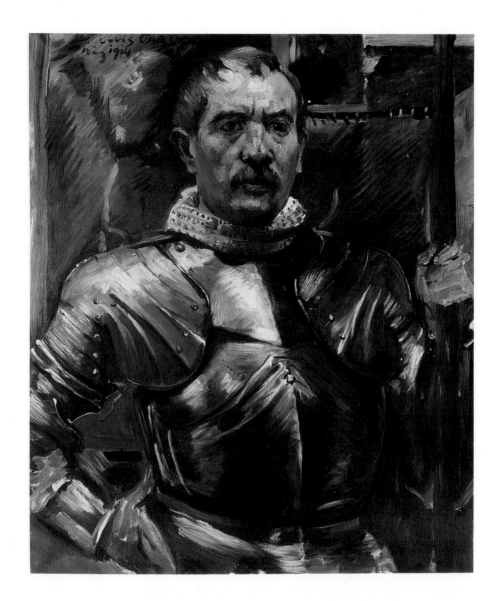

FIGURE 130.
Lovis Corinth, *Self-Portrait in Armor*,
1914. Oil on canvas, 100 × 85 cm, B.-C.
621. Hamburger Kunsthalle, Hamburg
(1964). Photo: Ralph Kleinhempel.

to the Berlin art students. That he was not really hostile to foreign art is evident from his own development. Yet he did not share the view, common among the avant-garde, that to create something new, the artist must destroy the old. On the contrary, Corinth had a keen sense of history and saw himself as a link in a chain encompassing both German and non-German sources. But he was also an individualist who believed that an artist's individuality lay in the way he transformed tradition without abandoning it. Corinth's own work—as Hilton Kramer once observed—is like a "hinge on which a rich inheritance undergoes a profound metamorphosis into the peculiar stringencies of the modern era."[24] *Self-knowledge* and *self-conquest* were Corinth's words for the process, and at no time in his career did he feel a greater need to defend what they stood for than during the years that immediately followed his illness.

The self-portrait of March 1914 (Fig. 130) is more or less contemporary with Corinth's "summons to young people." Yet if the picture was intended to conjure up a commensurately martial air, the results are not convincing. The posture recalls the cocky stance of earlier self-portraits in armor (see Figs. 105, 106), but as in the etching from 1912 (see Fig. 116), the painter's expression fails to support the role. The hard, gleaming metal contrasts sharply with the texture of the skin, and as if to soften the pressure of the armor, Corinth has wound a scarf around his neck, isolating the head both physically and psychologically—an impression reinforced by the probing gaze. It is as if Corinth had begun to recognize the absurdity of the costume, as if he were becoming dimly aware that he could not develop further without accepting new premises.[25]

THE GENESIS OF A NEW "EXPRESSIONISM"

During the years 1913–1914 Corinth's pictorial conception began to undergo profound changes. As if to prove to himself that he could still handle even the most physically challenging assignment, he executed at this time a set of wall decorations for the Villa Katzenellenbogen, at Freienhagen, near Berlin, comprising ten large tempera paintings on canvas (B.-C. 567, 568, 571, 573, 609–614) illustrating episodes and individual figures from Homer and Ariosto. In these paintings, as well as in the preliminary drawings he made for the project, he continued to strive for anatomical accuracy and complicated foreshortened postures. Similar in conception and execution are several contemporary paintings of the female nude (B.-C. 561, 562, 564, 566) as well as the

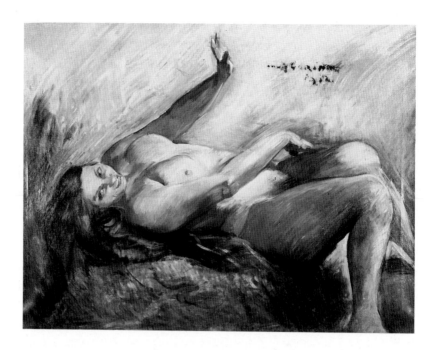

FIGURE 131.
Lovis Corinth, *Potiphar's Wife,* 1914. Oil
on canvas, 107 × 148 cm, B.-C. 605.
Hessisches Landesmuseum Darmstadt
(on loan from a private collection).

composition *Ariadne on the Island of Naxos* (B.-C. 569). The two versions of
Joseph and Potiphar's Wife (B.-C. 606, 607) from 1914, in contrast, announce a
different approach. In the preparatory painting in Darmstadt (Fig. 131) only
Potiphar's wife is shown, reclining in an attitude of physical abandon. The
brushstrokes, while simplified, emphasize the voluptuous forms of the anat-
omy; the heroine's lascivious gaze makes the viewer an unwitting accomplice
in her amorous pursuit. In the two finished versions, of which the one in Kre-
feld may serve as a representative example (Fig. 132), the explicit eroticism
of the subject has been subordinated to a much freer execution. The brush-
strokes cascade downward from the upper right to the lower left, creating a
suggestive rather than a descriptive ambience. Although the facial expres-
sions and the anatomy of the nude are overspecific, even these exaggerations
become bearable with the otherwise sketchy application of paint.

There is evidence that Corinth's drawings played an important role in his
gradual acceptance of a language of form far less dependent on observation
and description than heretofore. In one of the preliminary drawings for *Sam-*

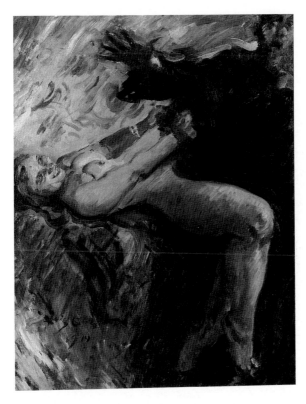

FIGURE 132.
Lovis Corinth, *Joseph and Potiphar's Wife*,
1914. Oil on canvas, 77 × 62 cm, B.-C.
607. Kaiser Wilhelm Museum, Krefeld.

son Blinded (Fig. 133), inscribed incorrectly in the lower right corner with the
year 1913, Corinth heightened the expressive content by subjecting the anat-
omy to violent dislocations. The contours are not carefully controlled but torn.
The widely spaced diagonal shading, freed from the necessity of modeling,
respects the surface character of the sheet. Corinth did not apply the same
simplified approach to the painting itself, however, but limited such formal
explorations to the graphic medium.

In *Ecce Homo* (Fig. 134), a 1913 drawing in lithographic crayon and water-
color, description is subordinated still further to suggestion. The web of
diaphanous lines is given only slight definition by the colored wash; and
since neither setting nor groundline is indicated, the image rises mysteriously
into the pictorial space. Unlike conventional representations of the subject,
which usually objectify the episode entirely within the confines of the pic-
ture, Corinth's drawing forces the viewer into a real dialogue with the figures
shown because it is the viewer whom Pilate addresses with his questioning
gesture.

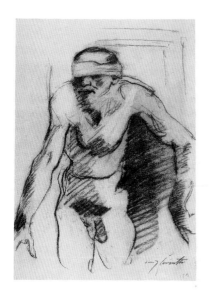

FIGURE 133.
Above: Lovis Corinth, *Samson Blinded,*
1912. Crayon, 46.6 × 34.0 cm, Staatliche
Museen, Berlin (DDR) (25/7826).

FIGURE 134.
Above, right: Lovis Corinth, *Ecce Homo,*
1913. Pencil and watercolor, 33.7 × 25.4
cm, Eidgenössische Technische
Hochschule, Zurich.

FIGURE 135.
Below: Lovis Corinth, *The Carrying of the
Cross,* 1916. Pencil, 25 × 35 cm,
Kunsthaus Zurich (1935/25). Photo:
Walter Drayer.

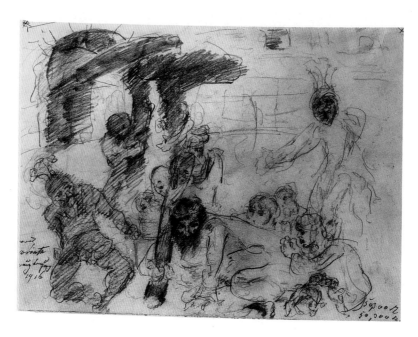

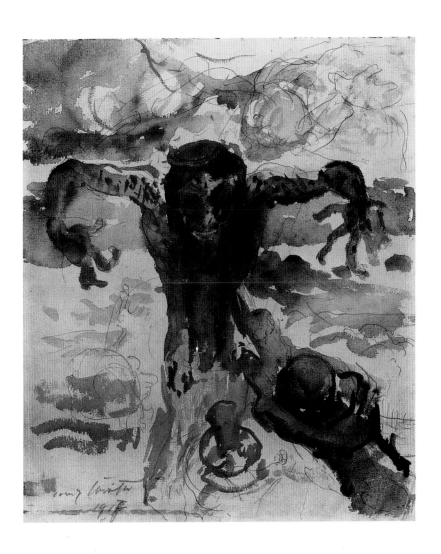

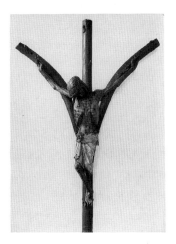

FIGURE 136.
Above: Lovis Corinth, *Crucified Christ*,
1917. Pencil and watercolor, 33.5 × 28.5
cm. Städtische Galerie im Lenbachhaus,
Munich (G 15.679).

FIGURE 137.
Left: Anonymous German, Plague
Crucifix, early 14th century. St. Maria im
Kapitol, Cologne. Photo: Rheinisches
Bildarchiv.

There can be no doubt that *Ecce Homo* is yet another work steeped in Corinth's personal experience, part of his continuing effort to mythologize the events of his life in paradigmatic literary subjects. This personal component accounts for much of the drawing's formal audacity and meaning. Moreover, it was conceived as an independent work, not as a study for some painting or print. Among Corinth's paintings only two figure compositions suggest that he was prepared as early as 1913 to accept a comparatively sketchy execution as a "finished" work in that medium as well. One is the anecdotal *Christmas Eve* (B.-C. 577), a painting of Charlotte Berend in the disguise of Santa Claus presenting gifts to the Corinth children; the other is the so-called *Small Martyrdom* (B.-C. 558), which Corinth had begun in 1908 with the aid of a model strapped to a custom-made cross. In 1913, having added the figures of Mary, Longinus, and an executioner, he decided to sign the canvas, although it still retained the appearance of a preliminary oil sketch.

Corinth's development as a draftsman was not as consistent, however, as the above examples suggest. Indeed, in many drawings he reverted to his earlier academic conception. Not until 1916 did he explore more fully the departure from nature and the expressive handling of the graphic medium that distinguish the drawings *Samson Blinded* and *Ecce Homo*. The frieze-like composition of *The Carrying of the Cross* (Fig. 135) harks back to Martin Schongauer's famous print. But even though the architectural setting allows the drawing to be understood in terms of depth, real space has collapsed. The arch of the city gate in the upper left and the crosses of Christ and the two thieves are merely suggested by overlapping amorphous shapes that occupy the same plane. The contours of the figures have been negated by the blurring effect of the superimposed shading. Surface has begun to replace line; mass has been reduced to tone.

Corinth's development as a draftsman culminates in the watercolor drawing *Crucified Christ* (Fig. 136) of 1917. Here the horrid figure of Christ rises to the picture surface like a specter, virtually undefined in texture and mass. As in the *Ecce Homo*, the proximity of the frame propels the image into the viewer's space and consciousness. Removed from a larger narrative context, like the terrifying German plague crucifixes from the fourteenth century (Fig. 137), this *Crucified Christ* is the very incarnation of physical and psychic pain.

Without completely abandoning his faith in visual experience, Corinth openly renounced the academic ideals of his student years and earlier career when he wrote in October 1917 to the editor of *Deutsche Kunst und Dekoration:* "The hastiest sketch done before nature has greater artistic value than the most conscientiously painted composition pieced together in the studio."[26]

That Corinth's development as a draftsman had brought him to this recognition is evident not only from the drawings themselves but also from their new importance in his work. By 1916 there is little difference in form or conception between a drawing such as *The Carrying of the Cross* and the two lithographs (Schw. L245, L246) and the etching (Schw. 263) for which the drawing was a preliminary study. Still more striking is the evolving reversal in the relationship of Corinth's drawings to his paintings. His earlier drawings were subordinated to the paintings, serving generally as preparatory sketches. And even when conceived as independent works, they never seriously challenged the prodigious output of his brush. From 1914 on, however, he sought to impart the expressive force of his drawings to his painting as well—though not yet to new works; instead he subjected earlier paintings to the dynamics of his new drawing style by turning paintings into prints. Earlier he had made etchings after a number of his paintings, but always with the intent of reproducing the originals fairly closely. Not until his drawing style had matured did he begin to impose the same expressive simplifications on the graphic repetitions of earlier paintings. Compositions such as *Harem* (see Fig. 94) and *Susanna and the Elders* (B.-C. 387), both typical examples of Corinth's earlier extroversive manner, were among the first of his paintings to be so recast (Fig. 138).[27]

Not surprisingly, Corinth's development as a draftsman is closely linked to his growing skill as an illustrator. His earliest illustrations, a series of marginal vignettes and full-page drawings for Joseph Ruederer's collection of short stories, *Tragikomödien*, were done in 1896. They were carefully prepared after many studies of the live model. He did not undertake his next illustrations until 1910, when Paul Cassirer commissioned him to execute twenty-two color lithographs for *The Book of Judith* (Schw. L54). These, as well as the twenty-six color lithographs for *The Song of Songs* (Schw. L82) from the following year, are still not true illustrations but are more akin to small-scale history paintings, rivaling rather than enhancing the text. They too are based on a large number of preliminary studies and, like Corinth's paintings at this time, emphasize complicated postures and a strong sense of plasticity. In these respects they differ sharply from contemporary illustrations by Max Slevogt, whose imagination took flight without the aid of a model. Slevogt's activity as an illustrator began on a large scale much earlier than Corinth's. His nearly 150 pen-and-ink drawings for *Ali Baba*, of which forty-four were published by Bruno Cassirer in 1903, are lively improvisations that blend, rather than compete, with the text, prodding the reader's imagination at every turn of the page. Corinth first achieved a comparable degree of spontaneity in 1913 with his

FIGURE 138.
Above: Lovis Corinth, *Harem,* 1914.
Etching, 18.1 × 16.4 cm, Schw. 170.
Staatliche Graphische Sammlung,
Munich.

FIGURE 139.
Right: Lovis Corinth, *Count Durande and
Francoeur,* from Achim von Arnim, *Der
Tolle Invalide auf Fort Ratonneau,* 1916.
Lithograph, 45.5 × 30.2 cm, Schw.
L269 V. Staatliche Graphische
Sammlung, Munich.

lithographs for episodes from *The Thousand and One Nights* (Schw. L140) and for "Le Connestable" (Schw. L143), a story from Balzac's *Contes drolatiques*. His real breakthrough as an illustrator, however, came in 1916 with the lithographs for Achim von Arnim's *Der Tolle Invalide auf Fort Ratonneau* (Fig. 139): these no longer look like individually framed pictures but appear to grow organically from the pages of the book.

Perhaps a renewed awareness of Max Klinger's views on the freer relation of the graphic arts to the world of nature helped to change the position of the drawings in Corinth's work,[28] for his paintings continued to show a similarly expressive distance from nature only sporadically. A third version of Joseph and Potiphar's Wife in 1915, for example, was cast in a deliberately controlled form (B.-C. 657). Only in 1917 do Corinth's paintings also begin to show a more consistent use of evocative color and form and a diminished reliance on pure observation.

The stylistic evolution of Corinth's late work is most readily documented in the numerous still lifes he painted beginning in 1912. As in the example from Bordighera (see Fig. 121), he initially aimed for sumptuous effects, with showy flowers in expensive vases, often juxtaposed with bowls of rare fruit and confections. The earliest examples still show the environmental context of the various objects, but beginning in 1915 (Fig. 140) space is increasingly neglected, and the objects are usually observed from above, so that they appear more randomly distributed across the surface of the canvas. Although the pears and apples in the Schweinfurt painting are modeled, the other elements of the still life lack textural distinction. Even the statuette at the upper right has little representational value and functions primarily as part of the pictorial structure. The colors, on the whole, are somber, and black has been used profusely in both the shadows and the ground. More genial in expression is the still life from 1916 (Fig. 141). As in the preceding painting, the downward view flattens the imagery, and black is again a major feature in the composition, although its effect is lightened by the cheerful hues of the Chinese figurine, the darkly glowing red of the lobsters, and the shades of white and blue that flash across the table cloth.

The evocative *Still Life with Lilacs* (see Plate 23), painted in 1917, helps to explain Corinth's new way of seeing nature. In it the tangible image, perhaps more overtly than ever before, was largely a pretext for revealing—in the process of painting itself—the inner meaning of the picture. In that sense Corinth approached the subject exactly like the Expressionists, who similarly were less concerned with resemblance than with artistic vision and who sought

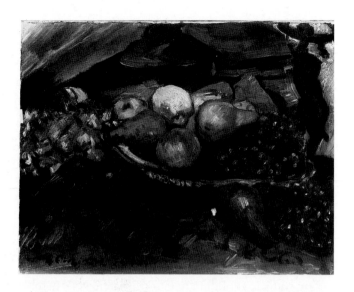

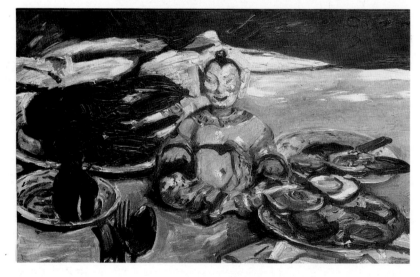

FIGURE 140.
Top of page: Lovis Corinth, *Still Life with Fruit,* 1915. Oil on canvas, 55.5 × 70.5 cm, B.-C. 644. Sammlung Georg Schäfer, Schweinfurt.

FIGURE 141.
Above: Lovis Corinth, *Still Life with Buddha, Lobster, and Oysters,* 1916. Oil on canvas, 55 × 88 cm, B.-C. 664. Galerie G. Paffrath, Düsseldorf.

to penetrate appearances to lay bare the inner essence of things. The flowers
are dissolved in a torrent of brushstrokes that follow the familiar diagonal
direction from upper right to lower left. The entire surface of the canvas vi-
brates, producing an impression of restlessness and excitement that unifies
the picture but does not allow the eye to focus on any specific detail. Light
from the upper right falls on the flowers yet scarcely penetrates beyond the
uppermost blossoms of the bouquet. Except for a few touches of bright red,
green, and white, the flowers remain in darkness, as shades of somber green
and purple are enveloped in strokes of deep black. Beneath the painting's
blustering vigor one senses a profound disquietude and an awareness that
decay eventually embraces all living things. Prodigiously wasteful in their
splendor, the lilacs seem consumed from within and thus take on the charac-
ter of a metaphoric image into which the painter projected the knowledge of
his own physical frailty.

In his portraits, too—again more or less consistently only from 1917 on—
Corinth adopted a similarly expressive pictorial structure. Most of these works
(commissioned portraits are the exception among them) depict members of
the painter's family and friends; and this private character most likely encour-
aged the greater freedom in conception and execution. Initially Corinth con-
tinues to emphasize verisimilitude, but optical truth yields increasingly to
subjective interpretation. This is apparent even in the portrait of Wilhelmine
from 1915 (Fig. 142), in which Corinth projected his own psychological dis-
position onto his daughter, then only six years old. The window, through
which no light penetrates, and the back of the chair, echoing the posture
of the girl's arms, enclose her and restrict her movement. Amid the vivid
touches of color, the face, surmounted by the broad-brimmed hat, remains a
center of calm. And only the face has been given definition; the rest of the
body is simplified. This pictorial isolation of the girl's features also under-
scores her solitude. Gazing at the viewer with large, pensive eyes, she has no
real contact with the toy she holds. Of the children's portraits of the modern
period only Edvard Munch's famous painting *Puberty* conveys a more poi-
gnant impression of loneliness, although in the very different context of ex-
plicitly adolescent anxieties.[29]

A more conventional conception governs the portrait of Karl Schwarz (Fig.
143) from 1916. Schwarz is seated quietly, his hat on his knee, his left hand
clutching a walking cane. Corinth clearly did not record the sitter's fastidious
appearance without a touch of irony. At the same time, he was sensitive to
the sitter's inner life. Karl Schwarz averts his gaze, but the feverish glow of

the eyes belies the placid demeanor, while the fashionable suit and accessories emphasize his frailty. Karl Schwarz (1885–1962) lived indeed in a constant state of delicate health. Employed as a reader for the publishing house of Fritz Gurlitt, he was completing his oeuvre catalogue of Corinth's graphics at the time of the portrait. The Milwaukee portrait itself originated in the context of this work, as did a second, more simplified but anecdotal, portrait from the same year, now in Aachen (B.-C. 666), which depicts Schwarz in the process of examining one of Corinth's portfolios.[30]

FIGURE 142.
Opposite: Lovis Corinth, *Wilhelmine with a Ball*, 1915. Oil on canvas, 95 × 72 cm, B.-C. 652. Landesmuseum Oldenburg (LMO 13.328).

FIGURE 143.
Above: Lovis Corinth, *Portrait of Dr. Karl Schwarz*, 1916. Oil on canvas, 104.9 × 80.0 cm, B.-C. 667. Milwaukee Art Museum Collection (Gift of Thomas Corinth). Photo: P. Richard Eells.

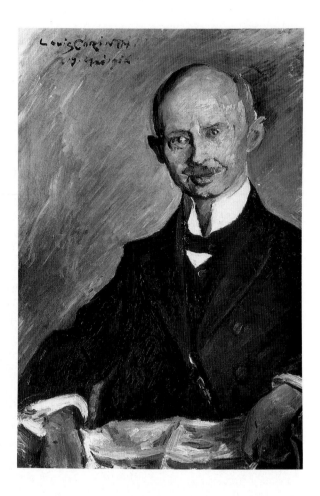

FIGURE 144.
Lovis Corinth, *Portrait of Otto Winter*,
1916. Oil on canvas, 90.6 × 61.2 cm, B.-C.
668. Niedersächsisches Landesmuseum,
Landesgalerie, Hannover (KM 23/1950).

The range of expressive possibilities that Corinth could summon up by 1916 is illustrated by his portrait of the Hannover pharmacist Otto Winter (b. 1855) (Fig. 144), an avid collector who owned several paintings by Corinth as well as works by the Expressionists, such as Kokoschka's famous 1914 allegory *The Tempest* (now in the Kunstmuseum, Basel). Although Corinth made Winter's head more prominent than his hands and torso, he nonetheless subordinated the facial features to the general effect. The sitter's expression is kindly, benevolent—in sharp contrast to the ominous picture ground, pervaded by an unpleasant sulfurous yellow. Furthermore, any sense of stability and emo-

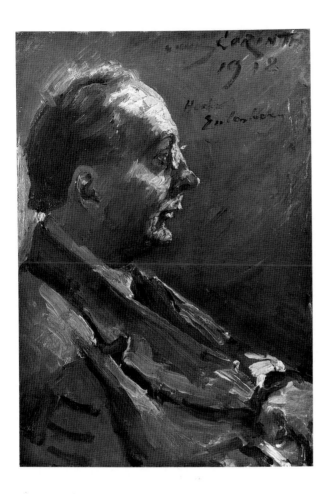

FIGURE 145.
Lovis Corinth, *Portrait of Herbert
Eulenberg*, 1918. Oil on canvas on panel,
71 × 50 cm, B.-C. 732. Kunstmuseum
Düsseldorf (M 5307). Photo:
Landschaftsverband Rheinland/
Landesbildstelle Rheinland.

tional assurance is undermined by the labile character of the pictorial struc-
ture. The asymmetrical placement of the figure and the gravitational pull ef-
fected by the slashing brushstrokes introduce an element of transience that in
one way or another informs all of Corinth's subsequent portraits. In the por-
trait of Herbert Eulenberg (1876–1949) (Fig. 145), for example, the writer who
in 1917 published a short pamphlet on Corinth,[31] all the forms have become
fluid. As if destroyed from within, the skin appears broken, and the darkest
values of the yellowish ocher tonality that dominates the portrait seem to
ooze through to the surface.[32]

Corinth's increasing pessimism, originally induced by his illness, was further nurtured by the cataclysmic events of the First World War, which he witnessed, though from a distance, with profound anxiety. His initial response to the outbreak of the war was, like that of many Germans, one of patriotic fervor. "Each German considers himself the special protector of the German hearth," he wrote at the outbreak of the war, evoking the memory of Bismarck, Blücher, and Luther. "The German Empire was resurrected anew through blood and iron in 1871, and the one who created Germany is one of the greatest men of our dear fatherland."[33] He spoke of the "courage" with which the "frivolous games" of the enemy were being warded off and of the "furor teutonicus" that would soon demonstrate to the world that peace in Germany was not to be disturbed with impunity.[34] He was deeply distressed by the Russian invasion of East Prussia in late August 1914 and by the subsequent devastation of many villages and towns, including Tapiau, where his painting *Entombment* (see Fig. 95) was destroyed in an attack on the city hall. It was in this general context that he referred to the war as a "Holy War."[35] Thomas Mann, incidentally, expressed his own patriotic sentiments in similar terms when early in the war he summoned his fellow Germans to recall the courageous example of Frederick the Great. Drawing a parallel between the coalition formed against Prussia in 1756, after Frederick had invaded Saxony in the name of self-defense, and the coalition formed against Germany in 1914, after the Germans had moved into Belgium with the same excuse, Mann wrote: "Today, Germany is Frederick the Great; . . . his soul . . . has reawakened in us."[36]

Corinth's most extensive pictorial response to the war is found in his graphics. During the initial and most volatile phase of the conflict he turned repeatedly to prototypical themes of aggression and combat: warriors attacking defenseless women or protecting them; knights engaged in battle or preparing for war. The subjects of Florian Geyer (see Plate 16, Fig. 127) and *The Victor* (see Fig. 105) also reappeared in 1914 (Schw. 171, 173), as did characters from other earlier paintings, although in a more generalized form to suit the new context. From *The Fight between Penelope's Suitors and Odysseus* (B.-C. 571), for example, one of the temperas for the Villa Katzenellenbogen, Corinth selected several figures, divesting them of their original identity to achieve a more universal meaning (Fig. 146). Other themes include the prototypical warrior *Saint George* (Schw. 187) and *Joan of Arc* (Fig. 147). The latter, too, was updated to reflect the new war. Although the heroine retains her medieval

FIGURE 146.
Lovis Corinth, *Warriors (Odysseus and the Suitors)*, 1914. Etching, 25.7 × 18.5 cm, Schw. 172. Staatliche Graphische Sammlung, Munich.

FIGURE 147.
Lovis Corinth, *Joan of Arc*, 1914. Etching and drypoint, 24.4 × 19.4 cm, Schw. 188. Orlando Cedrino, Munich.

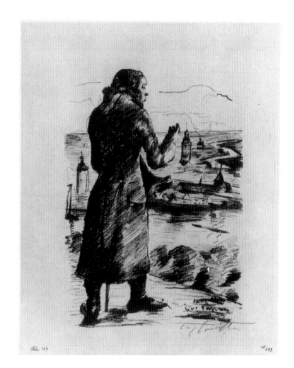

FIGURE 148.
Lovis Corinth, *"Barbarians": Immanuel
Kant*, 1915. Lithograph, c. 28.5 × 20.0
cm, Schw. L207. Kunsthalle Bremen
(40/563).

armor, among the combatants are a German and a French soldier in modern
uniform, and the year 1914 is prominently inscribed inside a glory of light at
the top of the composition.

Corinth repeated both the Joan of Arc and the Florian Geyer in 1915 (Schw.
L201, L202) for one of the *Krieg und Kunst* series, portfolios of original litho-
graphs published under the auspices of the Berlin Secession in support of the
war effort. Other lithographs by Corinth from that year for *Krieg und Kunst*
include *Cain* (Schw. L208) and portrayals of such German political and cul-
tural heroes as Bismarck (Schw. L212) and Immanuel Kant (Fig. 148). The lat-
ter depicts the Königsberg philosopher looking down on his native city and
includes in the title the word *Barbarians* in allusion to the recent invasion of
East Prussia. Kant was not only dear to Corinth as a fellow East Prussian but
also widely appreciated at the time for such "Germanic" qualities as his blond
hair and steadfast, manly character. Like Johann Gottlieb Fichte, whose repu-
tation was being cultivated anew by the Fichte Society founded at the out-
break of the war, Kant was seen as a fighter for the worldwide cultural mission
of the German people.[37]

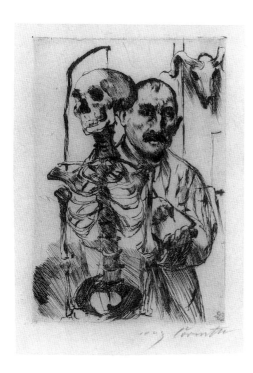

FIGURE 149.
Lovis Corinth, *Artist and Death II*, 1916.
Etching, 18.0 × 12.4 cm, Schw. 239.
Kunsthalle Bremen (42/119).

The patriotic sentiment of Corinth's graphics was echoed many times over by other German artists, in *Krieg und Kunst* and in such wartime broadsheets as *Kriegszeit* and *Künstlerflugblätter,* both published by Paul Cassirer.[38] For *Kriegszeit* Ernst Barlach, for example, produced in 1914 the lithograph *Holy War,* based on his famous sculpture *Avenger* from the same year; other contributions by Barlach with such titles as *First Victory Then Peace* and *Heavy Attack* suggest the same pugnacious tone.

As the war progressed, Corinth grew increasingly distraught. The thought of death dominates two etchings from 1916 that show Corinth himself at work. In one of them (Fig. 149) he is virtually hemmed in by the human skeleton, familiar from the self-portrait in Munich (see Plate 9), and the skull of a ram attached to the back wall of the studio. In the second etching (Schw. 238) Corinth has turned away from his mirror image and sadly contemplates the macabre prop. Subjects from the Bible began to supplant the themes of aggression. Two Gethsemane scenes (Schw. 213, 214) date from 1915; in 1916 Corinth made the three prints of *The Carrying of the Cross* (Schw. L245, L246, 263; see Fig. 135), a *Crucifixion* (Schw. L285), and a set of six lithographs il-

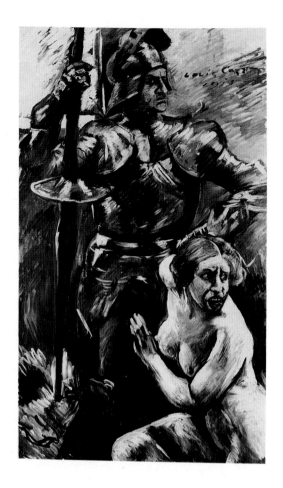

FIGURE 150.
Lovis Corinth, *Beneath the Shield of Arms,*
1915. Oil and tempera on canvas, 200 ×
120 cm, B.-C. 656. Ostpreussisches
Landesmuseum Lüneburg.

lustrating episodes from the Apocalypse (Schw. L296). Here parallels can
again be drawn between Corinth and the Expressionists. In 1916 Barlach trans-
formed the idealized avenger of *Holy War* into a grotesque killer in a draw-
ing and subsequent lithograph entitled *Episode from a Modern Dance of Death.*
Rohlfs, Hofer, and Lehmbruck evoked the collective misery of the war in nu-
merous paradigmatic portrayals of anguish, while with more than a touch of
self-identification both Beckmann and Kokoschka turned repeatedly during
these years to the iconography of Christ's Passion.

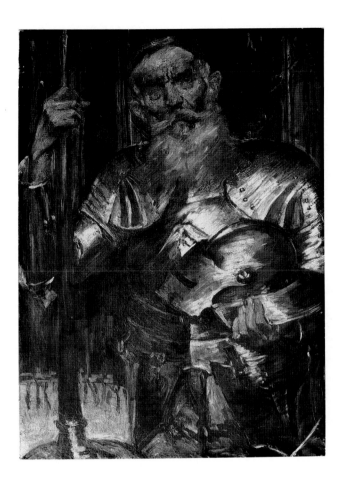

FIGURE 151.
Lovis Corinth, *Old Man in Armor,* 1915.
Oil on canvas, 125 × 91 cm, B. C. 654.
Bezirksmuseum Cottbus; on loan to
Staatliche Museen zu Berlin, National-
Galerie (DDR).

Themes of war are less frequent in Corinth's paintings. In 1914 he painted
a knight in armor attacking a naked woman (B.-C. 619), and in 1915 he re-
sponded to the news that German troops had once again freed East Prussia
from Russian occupation by painting a knight as a woman's stalwart protector
(Fig. 150), inscribing the canvas "In Memory of the Assault on Memel."[39] Two
other works from 1915 commemorate German heroes—*Death Mask of Frederick
the Great* (B.-C. 653) and *Martin Luther* (B.-C. 655)—and a third depicts an old
man in armor (Fig. 151); the model's feeble posture and dim gaze contrast

sharply with the rigid strength of the weapons, testimony to a brave spirit
seeking to defy the infirmities of old age. *Borussia* (B.-C. 705), the picture of
an Athena-like Mother Prussia protecting a group of children around her; *Cain*
(Fig. 152), a horrid rendering of the archetypal theme of fratricide; and a paint-
ing of yet another aged warrior, the historical figure Götz von Berlichingen
(Fig. 153), all date from 1917. The knight, though fully armed for battle, is
engaged not in martial pursuits but in committing his memoirs to paper. He
writes with his left hand while his iron right hand, fashioned after his real
hand was shot away during a siege, weighs heavily on the table. This work
and the painting of the old man in armor from 1915 were preceded by etch-
ings (Schw. 163B, 288), and it is difficult not to interpret both as surrogate
self-portraits acknowledging that Corinth, too, experienced the war only from
a distance. In the painting of Götz von Berlichingen, as in the earlier *Samson
Blinded* (see Plate 22), the setting is a modern interior. Indeed, the framed

FIGURE 152.
Opposite: Lovis Corinth, *Cain,* 1917. Oil
on canvas, 140 × 115 cm, B.-C. 708.
Kunstmuseum Düsseldorf (M 1986-4).
Photo: Landesverband Rheinland/
Landesbildstelle Rheinland.

FIGURE 153.
Above: Lovis Corinth, *Götz von
Berlichingen,* 1917. Oil on canvas, 85 ×
100 cm, B.-C. 725. Museum für Kunst
und Kulturgeschichte der Stadt
Dortmund
(C 4790).

FIGURE 154.
Lovis Corinth, *Self-Portrait in a White
Smock*, 1918. Oil on canvas, 105 × 80 cm,
B.-C. 734. Wallraf-Richartz-Museum,
Cologne. Photo: Rheinisches Bildarchiv.

works of art in the background evoke the ambience of Corinth's own studio, where he often sat during these years engaged, like Götz, in writing his autobiography.

The theme of aggression is embodied once again in *Rape* (B.-C. 726), a painting from 1918, while *Young David* (B.-C. 731) from the same year conjures up the hope for victory and deliverance. Corinth's inability to sustain this hope, however, is evident from his diary. "It is horrible and terribly sad," the entry for October 17, 1918, concludes, that "after the war there will be peace, but it will arrive like the peace of the grave."[40] On November 3, the day of the armistice, he wrote: "The world of Bismarck and the Hohenzollerns has ceased to be. . . . A world of enemies has finally conquered us."[41] Two days later he wrote a single line in his diary, Hector's prophecy of the fall of Troy: "The day will come when sacred Ilion will fall, Priam too, and the people of the brave king."[42] In Corinth's final war painting his armor lies discarded, like a useless prop, on the floor of his studio (B.-C. 727).

Germany's defeat in the war was a harsh blow for Corinth, the more so since as a native East Prussian he identified personally with the Prussian state. As late as November 1, 1918, he still expressed the hope that the kaiser, no matter what his shortcomings and blunders, would not be forced to abdicate, that he would be supported, if need be, by the military.[43] Even after the outbreak of the revolution Corinth declared proudly: "I consider myself a Prussian and a German of the Empire."[44]

Despite Corinth's trials during these years, his reputation continued to grow. The year 1917 in particular brought him much professional satisfaction. Major exhibitions of his works were held at the Kunsthalle in Mannheim and at the Kestner-Museum in Hannover; the Delphin Verlag published Herbert Eulenberg's biographical essay; and Fritz Gurlitt brought out Karl Schwarz's catalogue of Corinth's graphics. To cap it all, the Prussian Ministry of Culture bestowed on Corinth the title Professor, and the city magistrates of Tapiau made him an honorary citizen. The second edition of Corinth's autobiographical account *Legenden aus dem Künstlerleben* was published in 1918; in early March of that year the Berlin Secession opened a large retrospective in celebration of his sixtieth birthday.

Corinth himself marked the occasion with a self-portrait (Fig. 154). The colorism of this painting is unusually subdued: tones of white and gray predominate, enlivened sparsely with touches of green, yellow, and rose. The pictorial structure, as in Poussin's famous self-portrait in the Louvre, is determined by the framed canvases in the background. The bold brushstrokes,

FIGURE 155.
Lovis Corinth, *Self-Portrait at the Easel*,
1918. Etching, 25 × 18 cm, Schw. 337.
Staatliche Museen Preussischer
Kulturbesitz, Kupferstichkabinett, Berlin
(West) (192-1931). Photo: Jörg P. Anders.

however, defy the strict logic of the composition, as does the painter's ex-
pressive gaze. Once again Corinth depicted himself in the act of painting.
Prominently inscribed with roman numerals designating his age, the picture
testifies to his undiminished commitment to his work. Several years later,
reminiscing about the events of 1918, he did indeed write in his diary: "I had
hoped to contribute to the recovery of Germany by creating works as good
as I could possibly make them."[45] That his studio had become a place of ref-
uge in a chaotic world is also suggested by the self-portrait etching inscribed
"Revolution/10. November 1918" (Fig. 155). Whereas images of death had
set an apprehensive tone for the two self-portrait etchings from 1916, here
Corinth, surrounded by the implements of his profession, records his like-
ness with quiet resolution, a pillar of calm in a world gone berserk.

The real celebration of Corinth's sixtieth birthday, on July 21, took place
in the secluded hamlet of Urfeld, at the shores of the Walchensee, in Upper
Bavaria, where the painter and his family had taken lodgings at the Hotel
Fischer am See. Although he was deeply moved by the beauty of the Wal-
chensee, Germany's largest and deepest Alpine lake, he did not yet realize
that this encounter with Urfeld and its environs would open a whole new
chapter in his life.

FIVE :: SENEX

WALCHENSEE

Almost eighty, or nearly one-third, of all Corinth's pictures between 1918 and 1925 were painted at the Walchensee. His etchings and lithographs of the lake during the same period include no fewer than five print cycles; and he produced, in addition, an impressive number of watercolors and drawings of the subject. The paintings of the Walchensee won immediate acclaim and sold well. When Erich Goeritz, a wealthy textile manufacturer from Chemnitz who owned one of the major private collections of Corinth's works, wanted to purchase two Walchensee landscapes in September 1921, he learned, even before he could discuss prices, that the paintings had already been sold. "I am distressed," he wrote to Corinth, "but please remember me in the future, because I must have a Walchensee landscape to round out my . . . collection."[1] According to Corinth, "every Berliner" wanted to have a painting of the Walchensee; and museums and galleries were eager to acquire Walchensee landscapes "by any means."[2]

Corinth's earlier landscapes were the result of a portrait and figure painter's sporadic excursions; this new preoccupation marks a major departure. The popularity of these landscapes and the attendant financial rewards, however, were not necessarily the primary reason for their sudden preponderance. Neither did the lake serve merely as a convenient visual stimulus for Corinth's creative energy, although there are Walchensee landscapes that retain all the freshness and immediacy of the painter's sensory perceptions. But for the most part the mountain landscape at the Walchensee clearly satisfied a more profound need. Unlike the analytical Cézanne, who in his long series of paintings and watercolors of Mont Sainte-Victoire was concerned above all with problems of form, Corinth looked at the lake as into a mirror in which he discovered a reflection of his innermost sensations; or, more accurately, he projected his own feelings into the evocative landscape. This synthesis of visual sensation and inner vision allowed landscape painting to become finally an integral part of his work.

In the course of sixteen trips to the Walchensee Corinth painted the lake in all seasons, at all times of the day, and at night, when the moon stood high above the mountains. Collectively, these works epitomize the eternal cycle of nature; Corinth's sense that he was himself a part of it can be seen from the self-portraits and the portraits of members of his family that he painted against the backdrop of the lake and its environs.

The Walchensee, or "Lake of the Volcae," from the name of Celtic tribes that had originally settled in the region, lies about forty miles south of Munich, close to the Austrian border near Mittenwald, on what used to be called the Italian Road. On September 7, 1786, Goethe had passed the lake on his way south and stopped briefly to make a drawing of the small twelfth-century chapel that still stands near the southern shore; it is visible in the far distance in several of Corinth's paintings.[3] The most spectacular approach to the Walchensee is from the north, via the town of Kochel on the picturesque Kochel See, by way of the winding loops of the Kesselberg Road, which at its highest elevation provides the first glimpse of the lake, bordered by dark, wooded slopes and backed by the bare cliffs of the Karwendel massif and the Wetterstein. The road continues along the western shore of the lake, wedged between the water and the mountains that descend rapidly into the lake. Nineteenth-century travel books noted the changeable character of the Walchensee, somber in the foreboding stillness of a cloudy day (the monks at nearby Benediktbeuren called it the lake of silence), glistening in the sun.[4] Corinth, too, responded to the lake's many moods, his sensibilities sharpened by his visual acuity:

> The lake changes from one mysterious color and mood to another. It can sparkle like an emerald, turn blue like a sapphire; suddenly amethysts glitter amid the mighty setting of the old black firs whose reflections in the clear water are darker still. . . . The Walchensee is breathtakingly beautiful when the sky is clear but ominous when the powers of nature are raging. . . . They call it the lake of suicides. Down in the valley stands a small locked shed in which the victims of the lake are gathered. The black reflections on the water only make the horror still more dreadful.[5]

The elemental character of the Walchensee, so unlike the domesticated ambience of the Starnberger See where Corinth had so often spent time in the 1890s, clearly played a major role in his turn toward landscape painting. Although modern tourism has diminished the magic of the remote mountain lake, in 1918 the region was still largely unspoiled. The small hamlet of Urfeld, nestled in the northernmost corner of the lake, had two hotels, Fischer am

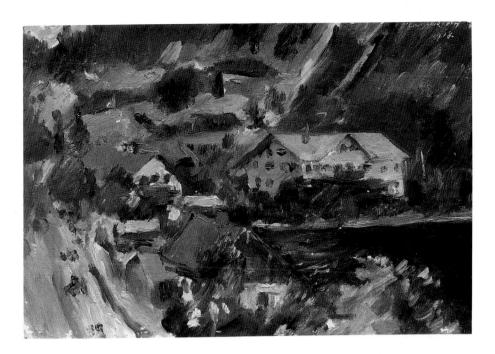

FIGURE 156.
Lovis Corinth, *Walchensee: Village Street*,
1918. Oil on canvas, 28 × 42 cm, B.-C.
739. Formerly Kunsthalle Bremen
(painting lost). Photo: Stickelmann.

See and Jäger am See. There were a few vacation homes and a tiny post office,
but no shops. Provisions had to be obtained in Kochel; from there the only
access to Urfeld was on foot or by horse-drawn vehicle.

Corinth painted his first Walchensee landscapes from the balcony of the
Hotel Fischer am See. According to Charlotte Berend, the earliest of these is a
small canvas depicting several rooftops and a view of the Hotel Jäger am See
facing the north shore (Fig. 156).[6] Two other paintings extend the view pro-
gressively across the lake to the east (B.-C. 738) and southwest (B.-C. 737),
completing the panorama of the Walchensee as seen from Urfeld. The three
paintings share the same degree of objectivity. Corinth was no doubt attracted
to the physical beauty of the setting, but he remained as yet a dispassionate
observer. His gaze followed the shoreline almost cautiously, as if he felt it
necessary to get to know the terrain by taking a careful inventory of it, right
down to the pedestrians in the village street and the fishermen in their boats.
Both a watercolor, dated July 20, 1918, and the earliest etching of the lake

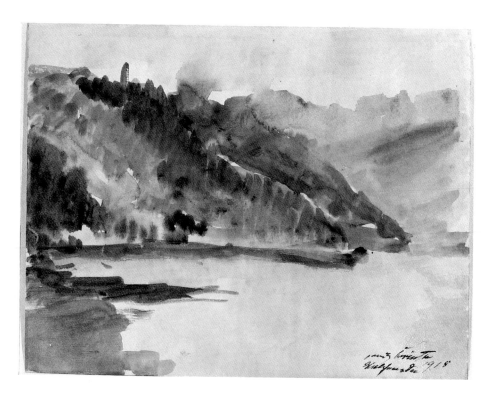

FIGURE 157.
Lovis Corinth, *Walchensee*, 1918.
Watercolor, 21.0 × 27.5 cm, The Galerie
St. Etienne, New York.

(Schw. 348) show the same view as one of the first paintings (B.-C. 737) and
are similarly objective.[7] The importance of Corinth's watercolors in maturing
his conception of the Walchensee in his paintings is evident from two further
examples, both of which stand out for their expressive character. In the view
toward the slopes of the Jochberg across the northern end of the lake (Fig.
157) the washes have been applied in broad, simplified patterns ranging from
pink and purple to deep brown and blue, interspersed with touches of ultra-
marine and a cool lime green. The watercolor not only describes the terrain
but also expresses a sentiment at once tender and forceful. Even more strik-
ing is *Mountain Landscape with a Full Moon* (Fig. 158). In it Corinth responded
to the primeval character of the landscape, subordinating all incidental details
to the independent language of the colors. The moon high above the Kar-
wendel massif touches the sky with pink and white; the lake and the moun-
tains are enveloped in unifying hues of purple and blue; and the vigorous

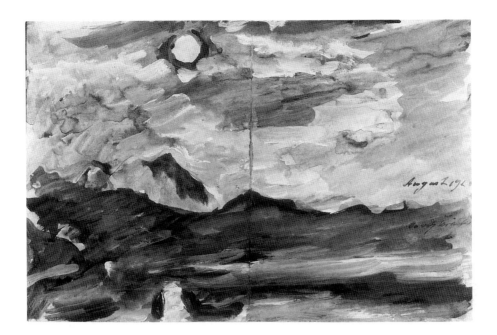

FIGURE 158.
Lovis Corinth, *Mountain Landscape with a
Full Moon*, 1918. Watercolor and
gouache, 20.7 × 31.5 cm.
Niedersächsisches Landesmuseum,
Landesgalerie, Hannover (KM 164/1949).

brushstrokes invest the landscape with an intensity that belies the nocturnal
calm. With this, his first night landscape of the Walchensee, Corinth discov-
ered what is probably the lake's most haunting mood. Heinrich Noë, the most
indefatigable of the nineteenth-century travelers who visited this Alpine re-
gion, described such a moonlit night, when the mountains are illuminated by
a "mysterious glow" and the lake is at once "like molten gold" and "black as
a raven"; when "clouds hover above the mountains of the southern shore,"
and "long white veils of fog . . . [that] flow down from the Karwendel . . .
are caught in the many tree tops and disappear in the darkness of the lower
forests."[8]

 Charlotte Berend recognized how deeply the haunting beauty of the Wal-
chensee impressed Corinth. When he told her during one of their walks in
the countryside that he had recently sold a painting for the substantial sum of
thirty thousand marks, she seized the opportunity: "Give me the money; I am

going to build you a house here."[9] Corinth, not wishing to be burdened with
the task of overseeing such a project, was reluctant but agreed when Charlotte
promised to shoulder the responsibilities of planning and supervising the
construction. Work on the two-story house, built of wood in the local Bavarian
style, began about a year later, in August 1919. By October of the same year
Haus Petermann, as the chalet was fittingly called, was nearly completed.
Charlotte had selected a site on the west slope high above Urfeld and had
prudently acquired adjoining land to ensure an unimpeded view toward the
south, facing the Karwendel and the Herzogstand. With a balcony and a ter-
race in front, the house overlooked virtually the entire panorama of the lake,
all the way from the Jochberg in the northeast to the Wetterstein in the ex-
treme southwest.

For the gable of the house Corinth painted in the summer of 1919 a large,
expressive *Pietà* (B.-C. 754). He seems to have intended eventually to cover all
the exterior walls with paintings, an idea that his family greeted with some-
thing less than enthusiasm—understandably perhaps, given the grim charac-
ter of the initial piece of decoration. In 1920 only two more large panels were
completed, depicting the evangelists Matthew and Luke with their respective
attributes (B.-C. 788). In a more lighthearted vein, in 1919 Corinth painted a
gouache triptych for the living room: Helios, preceded by Aurora scattering
flowers, guides his chariot into the sky above the Jochberg; the allegory is
flanked by a girl and a youth, both dancing, dressed in Bavarian peasant
costumes.[10] In 1921 he painted a nymph surprised by a satyr (B.-C. 817) on the
bathroom door and adorned an octagonal table top with flowers (B.-C. 822).

In the summer of 1919 Corinth painted four more pictures of the lake itself.
Three of these show the view from the balcony of the Hotel Fischer am See
(B.-C. 767, 769, 771); the fourth (B.-C. 768) may have been painted from the
elevated building site for the future Haus Petermann. In the course of a return
visit in October, Corinth painted the lake for the first time from the terrace of
the nearly completed new house (see Plate 24). This painting anticipates in
several ways his more mature treatment of the subject. The landscape encom-
passes enough details to assure topographical accuracy, but the emphasis is
on the coloristic harmony that evokes the cool brilliance of an autumn day.
The hues range from the yellowish green of the meadow in the foreground to
the blue-green of the lake and the pale shades of violet in the distant moun-
tains, capped with the white of an early snow. The larch tree in the lower left,
which still survives at the edge of the meadow where the slope begins to drop
off sharply toward the lake, appears for the first time in this painting, as do
several younger trees closer to the terrace, providing vertical accents to the

predominantly horizontal configuration of the terrain. The landscape does not yet share the painterly freedom of the preceding watercolors, but the summary treatment of the major scenic components invests the picture with a monumentality that belies its relatively small size.

The Corinth family returned to Urfeld for the Christmas holidays, at which time Corinth painted his first two Walchensee snow landscapes (B.-C. 773, 775). A print portfolio suggests the extent to which the Walchensee had by then become an integral part of his life and work. The subject of the portfolio is the painter and his family circle. Entitled *At the Corinthians,* the group of fourteen etchings (Schw. 380) juxtaposes Haus Petermann with the Corinths' home and studio in Berlin and includes four additional prints done at Urfeld in the autumn of 1919: Thomas rowing on the lake; Wilhelmine at breakfast on the terrace; a sheet with sketches of both children in Bavarian costumes; and Franz, the handy man, who looked after the daily chores.

In subsequent paintings of the Walchensee Corinth explored vantage points other than those easily accessible from the house, such as the pass up the Kesselberg Road (B.-C. 811) or the slope of the Herzogstand (B.-C. 810, XIV, 836, XVI, 921). He also painted landscapes with more closely circumscribed views: of the entrance to the grounds, of the terrace and fountain in front of Haus Petermann, and of the garden (B.-C. 812, 813, XVIII, 922, 924, 926–928). Corinth's preferred view, however, remained the one from the terrace, usually toward the south and southwest, with the stately larch tree and a quaint cottage nearby serving as focal points in the middle ground. Often the Hotel Fischer am See with its picturesque rooftop (long since enlarged and modified) is visible at the edge of the lake. Although the pictorial structure of these views is similar, the painter's conceptual approach varies greatly. During the summer of 1920 alone Corinth painted nine Walchensee landscapes, including four nocturnes. The latter range from the silvery blue *Moonlit Landscape in June* (Fig. 159) and the similarly lyrical *Midsummer Night* (B.-C. 804) to the brooding *Walchensee in Moonlight* (Fig. 160) and the near-abstract composition with the same title (see Plate 25) that recalls the bold watercolor of 1918 (see Fig. 158). The unifying atmosphere of the night landscape surely encouraged the formal solutions common to these nocturnes, but their tactile forms are also elusive—as if the very essence of nature, life in all its impermanence, were revealed in one last evanescent glow. This subjective interpretation is supported by Corinth's working methods. Charlotte Berend has written of Corinth's inner preparation for his night landscapes, the tension of translating into pictorial form an image he had nurtured in his imagination all day long and the physical and emotional exhaustion that followed:

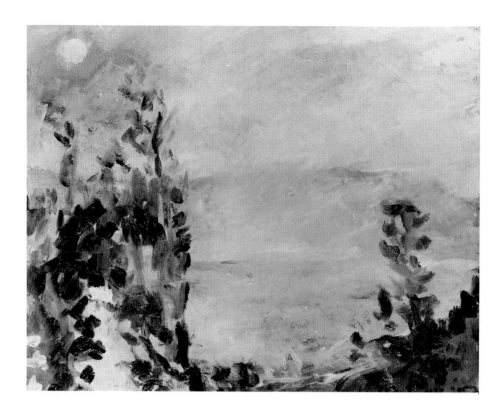

FIGURE 159.
Lovis Corinth, *Moonlit Landscape in June,*
1920. Oil on cardboard, 59 × 72 cm, B.-C.
809. Private collection. Photo:
Rheinländer.

Whenever he planned to paint a night picture, it was difficult to get a word out
of him all day long. Lost in thought, he sat in his chair. As soon as it grew dark,
he became restless. Now and then he stepped out . . . onto the terrace to scru-
tinize the lake and the sky; he kept anxiously pacing back and forth. He did not
touch his evening meal. . . . In the waning light of the day he laid the colors out
on the palette and hauled the easel and the canvas outside. . . . All of a sudden
Lovis pulled himself together. He stepped close to me and whispered, almost
inaudibly, "Petermannchen!" I then watched from the bay window as he picked
up the brushes and the palette. Calmly and resolutely he stood by the canvas. It
was as if his body were being absorbed by the moonlight. Only the face was still
recognizable . . . and the hand, moving with alarming swiftness across the can-
vas. He was now painting the picture that he already carried complete in his
imagination. Most of the time he needed only twenty minutes, half an hour at
the most. I remained quietly at the table in the bay when Corinth came back in
through the door, bent over and tired. He looked haggard. He stared at me with
wide-open eyes. They had a strange and mysterious glow. I could tell that he
was still far away.[11]

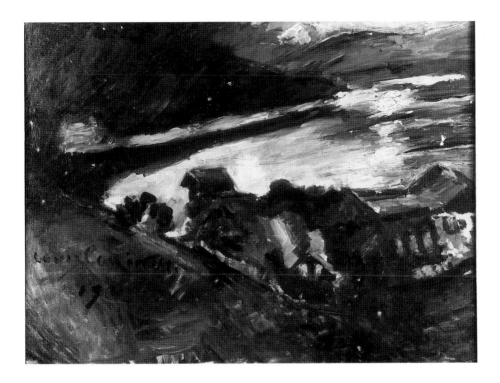

FIGURE 160.
Lovis Corinth, *The Walchensee in
Moonlight*, 1920. Oil on canvas, 78 × 106
cm, B.-C. 810. Städtische Galerie im
Lenbachhaus, Munich.

In only one daylight picture of this time (see Plate 26) did Corinth achieve
the same allusive equilibrium of content and form as in his nocturnes. In this
painting the terrain is highly simplified, and as a result the landscape remains
somewhere between the real and the imagined. Like the moonlit landscape in
Kaiserslautern (see Plate 25), this picture is painted on a small wood panel.
Corinth evidently considered both works no more than oil sketches, for in the
larger paintings of that summer, especially in two landscapes now in Mann-
heim and Dresden (B.-C. 808, 811), he continued to adhere to a far greater
degree of objectivity.

Corinth's prints of 1920 include two more evocative night landscapes, a
color lithograph (M. 473), and the first in a group of eight etchings that make
up the cycle *At the Walchensee* (Schw. 432), to which Corinth added a portrait
of the painter Friedrich Prölss (b. 1855), a friend from his years in Munich
then living in nearby Mittenwald.[12] The remaining prints of the cycle depict
more narrowly circumscribed views; some, indeed, are of individual motifs,

FIGURE 161.
Lovis Corinth, *House at the Walchensee,*
1920. Drypoint, 24.5 × 32.0 cm, Schw.
449, M. 731. Kunsthalle Bremen (41/2).

such as Corinth's beloved larch tree, a billy goat grazing near the house, and Strolch, the Corinth kitten, lazily stretched out on the stump of a felled tree. The atmosphere in all these etchings is transparent, the result of Corinth's preferred etching technique, the drypoint, which invests each line with a velvety texture. An independent drypoint of 1920 (Fig. 161), included three years later in yet another Walchensee cycle (M. 727-732), is a particularly fine example of Corinth's ability to capture, even in the limited tonal range of black and white, the light and atmosphere of the lake without diminishing the imposing character of the landscape. The graphic pattern is of the utmost economy: a gossamer web of lines interwoven with aggregates of silken black. The paper ground and the graphic pattern are perfectly balanced, as is the pictorial structure with its complementary action of horizontals and verticals.

Corinth's drypoints of the lake are like chamber music in relation to the resonant sound of his corresponding watercolors and oils. Although he always executed his Walchensee drypoints from nature, drawing directly on the copper plate without the aid of preparatory studies, he never bothered to reverse the composition: the experience of the lake as a whole was more important to him than absolute topographical accuracy. His prints of the lake are thus actually mirror images of the real view. His lithographs of the Walchensee, on the other hand, are, topographically speaking, more "correct" since they were done on transfer paper. When this paper was placed face down on the lithographic stone or zinc, the crayon was deposited on the plate, and in the subsequent process of printing the image was reversed again.

In 1921 the development of Corinth's Walchensee paintings entered a new stage, in which surface texture opened up. Often, as in the dazzling *View of the Wetterstein* (see Plate 27), the brushstrokes slash across the canvas, yielding a blurred image, as if the lake and the mountains were seen in rapid motion from the window of a speeding train.[13] In other pictures, such as the Walchensee landscape in Berlin (see Plate 28), the paint has been applied in a heavy impasto, similarly freeing the pictorial structure from the view itself. In each instance the glowing colors reinforce the energetic bluster of the brushstrokes. Yet despite their physical beauty, there is something tragic about these paintings, for they suggest a sense of irrevocable loss, as if these views of nature could be arrested for only one intoxicating moment.[14] These Walchensee landscapes anticipate by several years, and may indeed have influenced, the equally personal landscapes Oskar Kokoschka painted in the later 1920s; and for Corinth as later for Kokoschka, these landscapes derive as much from inner life as from sensory perception. As such, they are a tribute both to the elemental forces of nature and the ephemeral nature of life.

METAPHORS OF TRANSIENCE

Corinth's more than seventy still lifes of this period constitute the single largest category of his paintings during the last seven years of his life and for that reason alone provide the most reliable documentation for the evolution of his late style. From a purely iconographic point of view, there is little change from Corinth's earlier still lifes: most are floral pieces, alternating now and then with game, fish, fruit, vegetables, and confections; and, as earlier, emphasis is on luxuriant arrangements. Conceptually, these works are linked to the probing still lifes immediately following Corinth's stroke, except that the simultaneous allusion to efflorescence and imminent decay is now both more consistent and more insistent (Fig. 162). The flowers are nearly always shown in full bloom. Environmental allusions play a role only to provide an appropriate coloristic touch; even the vases containing the flowers are treated in a cursory way. Light falls on some flowers, allowing them to glow, while others sink into deep shadows. The blossoms are rarely individualized since—as in the Walchensee landscapes—Corinth was seeking to convey the totality of a given experience and expression. Technically, too, these still lifes display the same idiosyncrasies as the paintings of the Walchensee. The fluid texture of the example in Düren (see Plate 29), similar to that of the landscapes from the same year, makes it virtually impossible to identify the flowers. They have been trans-

FIGURE 162.
Lovis Corinth, *Chrysanthemums and Calla,*
1920. Oil on canvas, 70 × 60 cm, B.-C.
790. Niedersächsisches Landesmuseum,
Landesgalerie, Hannover (KM 147/1949).

formed into an active mass of color. From beneath them a human skull pro-
trudes, a macabre reminder of transience. In the large bouquet of chrysan-
themums from 1922 (Fig. 163), slashes of red, white, and green paint cover
the picture surface, sometimes flowing into each other, wet on wet, in inter-
mediary shades of violet and gray. Corinth has attacked the canvas here as in
a fury, stabbing at it with the palette knife and the brush. In paintings such as
these he had reached a point where the process of becoming and the process
of dissolution were no longer mutually exclusive.

On three occasions between 1919 and 1923 Corinth dealt with the subject
of transience in a more conventional way by juxtaposing lavish arrays of cut
flowers with depictions of young women. Two of these paintings (B.-C. 762,
XVII) are modern-dress versions of the traditional theme of Flora; the third,
and most poignant, is a picture of his eleven-year-old daughter Wilhelmine
standing next to a table on which are placed a bronze statuette and several
bouquets (see Plate 30). This painting derives from the buoyant still life por-
trait of Charlotte Berend with game and flowers from 1911 (see Fig. 108). Now,
however, the earlier expression of *joie de vivre* has given way to a mood of

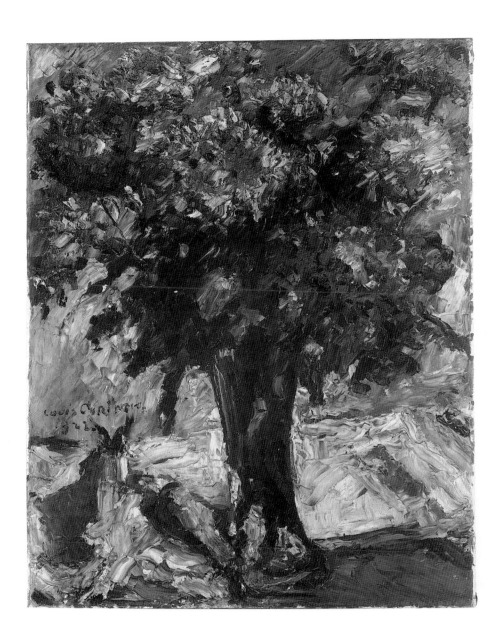

FIGURE 163.
Lovis Corinth, *Chrysanthemums*, 1922.
Oil on canvas, 97 × 78 cm, B.-C. 852.
Hamburger Kunsthalle, Hamburg (5101).
Photo: Ralph Kleinhempel.

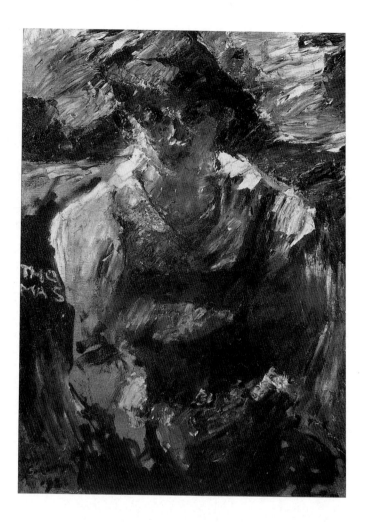

profound melancholy. Except for the large showy blossoms of the amaryllis, the flowers are for the most part appropriate to the girl's own stage of life: clusters of lilacs, a small vase with lilies of the valley, and a pot of red tulips that Wilhelmine holds in her hands. As in the independent still lifes with flowers, the blossoms appear as if dissolved from within, as patches of black paint push through the variegated colors. And as in similar compositions by Degas, the young girl has been relegated to the extreme side of the pictorial space. She gazes earnestly at the beholder; her body and face have been accommodated both coloristically and texturally to the flowers as if to emphasize their common fate.

Similar analogies between the life of nature and human life unify a group of plein air portraits and self-portraits painted at Urfeld (B.-C. 835, 837, 838,

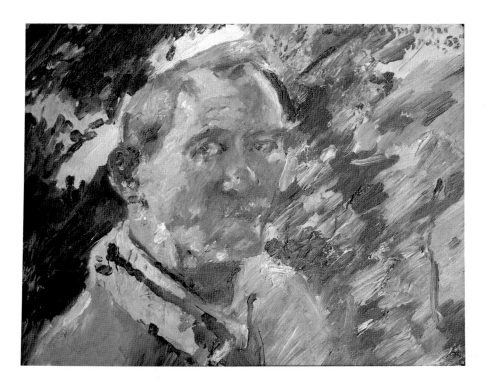

FIGURE 164.
Opposite: Lovis Corinth, *Portrait of the Artist's Son, Thomas,* 1921. Oil on canvas, 87 × 65 cm, B.-C. 835. Staatliche Museen Preussischer Kulturbesitz, Nationalgalerie, Berlin (West) (B 549 Kat. 34) Photo: Jörg P. Anders.

FIGURE 165.
Above: Lovis Corinth, *Small Self-Portrait at the Walchensee,* 1921. Oil on canvas, 68 × 80 cm, B.-C. 845. Private collection. Photo courtesy Werner Timm.

845, 863, 871, 925, VII). In these the facial traits of the sitters are, for the most part, subordinated to the all-consuming outdoor light. Even in close-up views, as in the portrait of Thomas from the summer of 1921 (Fig. 164), the colors are freed from their purely descriptive function. Wearing Bavarian lederhosen and a Tyrolean hat, Thomas sits on the terrace of Haus Petermann, enveloped in dazzling light that etches itself into his skin and dissolves his face, hands, and body in a burst of incandescent color. In the still more extreme close-up view of Corinth's self-portrait from the same summer (Fig. 165) the head has been accommodated to the structure of the terrain. The surface of the entire canvas has been transformed seemingly into a molten mass, and the textures are dominated by the tactile character of the paint itself.

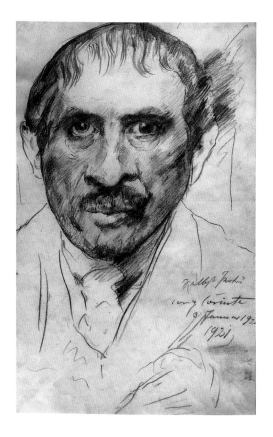

FIGURE 166.
Right: Lovis Corinth, *Self-Portrait*, 1921.
Pencil, 44.5 × 28.0 cm. Kunsthaus
Zurich (1924/10).

FIGURE 167.
Opposite, left: Lovis Corinth, *Death and the
Artist*, 1920–1921. Soft-ground etching
and drypoint, 28 × 18 cm, M. 546.
Staatliche Museen Preussischer
Kulturbesitz, Kupferstichkabinett, Berlin
(West). Photo: Jörg P. Anders.

FIGURE 168.
Opposite, right: Lovis Corinth, *Self-
Portrait*, 1921. Pencil, 22 × 14 cm.
Graphische Sammlung Albertina,
Vienna.

This painting, executed on Corinth's sixty-third birthday, is only one in a
series of self-portraits from 1921 in which he explored with ever new varia-
tions the threatening signs of his progressive physical deterioration. Always
observed from up close, the face as depicted frequently differs markedly from
Corinth's own. Each self-portrait is like a fragmentary thought, determined by
the mood of a given hour rather than by any quest for conventional verisimili-
tude. In that sense, these self-portraits are truly images of Corinth's inner life.
As was the case in the development of the Walchensee landscapes, watercol-
ors lead the way. In a sheet from January (see Plate 31) the expression of a
moment is reinforced by the asymmetrical placement of the head; the wild,
aggressive gaze finds its pictorial equivalent in the tortuous paths of the col-
ors. It is as if Corinth had flung the colors at his mirror image in disgust. Dingy
shades of red, green, gray, and brown are enlivened sparingly in the shirt
by the white paper ground. The only truly glowing colors are the touches of
cobalt blue in the eyes and at the nostrils and the speck of bright red in one
corner of the mouth. In a pencil drawing from the same month (Fig. 166) the
contemptuous fury of the watercolor has given way to a more controlled ex-

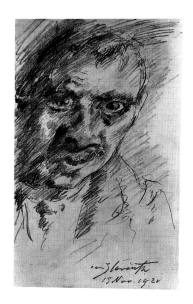

pression of resignation and sadness. The head slants toward the left, but the modeling and the emphatic contour around the face are executed with deliberate care. Corinth's gaze is both attentive and distant, intent on grasping the image but also reflective and inward. One eye remains focused on the subject, the other, noticeably enlarged, has an eerie, visionary glow. The drawing is closely related to a similarly poignant etching of about the same time, entitled *Death and the Artist* (Fig. 167). The print includes a human skull and a more mundane *memento mori* symbol in the form of a watch prominently displayed on the artist's wrist. The print is the first in a cycle of six etchings that make up *Dance of Death* (M. 546–551), in which each episode illustrates a prototypical stage of human life: men and women, alone and in pairs, in youth, in the prime of life, and in old age, face the specter of their inevitable mortality. In the self-portrait drawing of November 15 (Fig. 168) the impression is again that of a barely controlled inner crisis. The slashing lines betray considerable agitation. Although the eyes and the nose retain their definition, the right side of the face is distorted as in a curved mirror, and the form begins to scatter with centrifugal force.

These self-portraits indicate Corinth's dread of old age and decrepitude. They are silent moans, similar in their emotional range to the confessions that fill the later pages of his diary. There too, he poured out his fears of impending senility, his intermittent feelings of self-doubt, and his anguish at the political turmoil of the postwar years, although the very uncertainties of the period sometimes also aroused him to bouts of renewed purpose, as if his work could save both himself and the German nation. "As long as I can walk on this earth and am able to work," Corinth wrote in 1922, "I shall go on painting as I always have. I don't think anyone will be able to say that I was untrue to myself. . . . Maybe I will be praised someday as a soldier who has remained steadfast at his post." At the end of the year he laments the loss of the political stability that had prevailed in the old empire: "I have lost the ground from underneath my feet. I am floating on air and don't feel about art as strongly as I used to." But he quickly rallies: "Would energy help? I am determined, and nothing shall prevent me. Germany shall still be proud of me. . . . I can work better and longer than a young man." A paragraph written on January 11, 1923, concludes: "Never will I allow my God-given talent to be destroyed. I am going to stand my ground and still produce so much that the world will be astonished. The country is crushed. 'Let's get on with the work!'" In subsequent entries from 1923 this optimism gives way to despondency and despair:

> There has not been a day in my life when I was not tempted to make an end of it. . . . I discovered that my painting is indeed nothing but rubbish. Life is pointless, without any hope, a black curtain. . . . I rage at myself and at my work. Forgetting my better judgment, I feel like screaming forth at the world: What do you see in a wretched fellow like me! Can't you tell that I don't amount to anything—that I am no artist, nothing! I am desperately discouraged—I cannot see a ray of sunshine anywhere around me; my life has been wasted. The thought of putting an end to it haunts me.

But this pessimistic outburst, too, concludes more reasonably:

> Paroxysms . . . always abate. It would be terrible otherwise, and as with a convalescent, one's spirits gradually revive. There is soon joy again in working; indeed, in time one rediscovers one's self-respect through one's work and whispers when nobody is listening: "You are quite a fellow."[15]

The extremes of Corinth's emotional life give all his works from these years their true content. Even the late landscapes and still lifes share in this process of self-revelation. Although still dependent on nature, alternately tender, euphoric, and desolate, they owe more to the painter's inner life than to optical verity. For that reason alone his late work cannot be labeled Impressionistic, the more so since the term is hardly applicable to much of his earlier output. At most Corinth sought to reconcile Impressionist techniques with a deliberately conceptual approach. As Bernard Myers so aptly says of these late works, "The representational is only a point of departure for a . . . metaphysical analysis proceeding from the emotions." [16]

THE RED CHRIST

The figure compositions to which Corinth had once turned so frequently on account of their "universal human" significance, diminished in number as landscapes and still lifes became more meaningful in personal terms. In 1919 there were still six such paintings, but in 1920 and 1921 there were only two for each year. In 1922 there is only one, *The Red Christ* (see Plate 32), surely Corinth's most horrific interpretation of the subject. The simplified composition as well as the searing nature of the conception is anticipated in the watercolor of 1917 (see Fig. 136), which may well have served as a model for the painting. In the painting, however, the scene is considerably enlarged: Longinus, in the lower left corner of the panel, pierces Christ's side with a lance; another soldier, in the lower right corner, holds aloft the sponge soaked in vinegar offered to Christ just before he died. The figures of the two thieves who were crucified with Christ are dimly visible in the two upper corners. In the middle ground, at some distance, Saint John supports the Virgin, who is overcome with grief.

Although the traditional features of the scene are thus all recognizable, the painting is nonetheless no more a narrative than the watercolor of 1917. The emaciated figure of Christ, seemingly suspended from the picture frame rather than from the cross, is splayed across the pictorial field like some hieroglyphic symbol of pain. The colors have been smeared on the panel in thick globs, then scraped and scumbled with the palette knife and the brush. Virtually everywhere there are spurts of bright red.

The individual faces, like masks, embody a wide range of psychological states: evil, indifference, compassion, and unspeakable horror. Just as Christ's

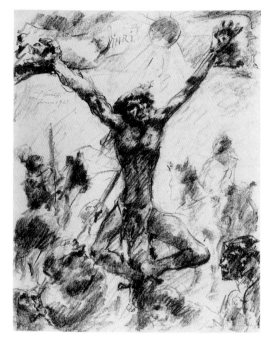

FIGURE 169.
Right: Lovis Corinth, *Crucifixion*, 1923.
Lithographic crayon, 63 × 50 cm.
Staatliche Museen, Berlin (DDR).

FIGURE 170.
Below: Lovis Corinth, *Death of Jesus*, 1923.
Lithograph, 50 × 64 cm, M. 694.
Hamburger Kunsthalle, Hamburg
(1961/234). Photo: Ralph Kleinhempel.

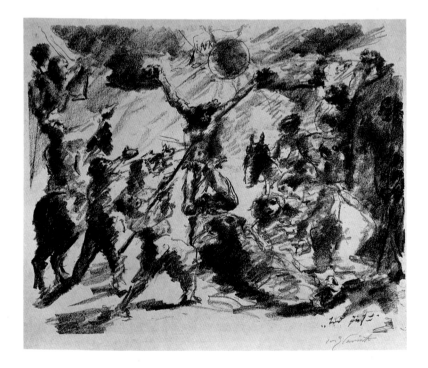

body dominates the pictorial structure, so the howling darkness of his coun-
tenance governs the painting's terrifying mood. What personal anguish must
have motivated so gruesome a conception! Not even Beckmann or Nolde,
who years earlier had turned to Christ's Passion in their search for paradig-
matic examples of man's suffering, ever managed to approach the intensity of
Corinth's brutal image of pain. The only valid comparison is with Matthias
Grünewald, who has left us similarly memorable depictions of superhuman
agony.

In a crayon drawing of 1923 (Fig. 169) Corinth returned to the subject of
The Red Christ in slightly modified form. Here the individual figures appear
as if floating in a spatial void. Like vapors that congeal temporarily, they are
about to vanish. The drawing evidently served as a study for the lithograph
Death of Jesus (Fig. 170) of the same year. Although in the print the narrative
has been considerably amplified, here, too, the palpable character of Corinth's
earlier compositions of this type has given way to the allusive expressiveness
of his late style.

LATE GRAPHICS AND GRAPHIC CYCLES

The homogeneity of form and expression in Corinth's paintings, drawings,
and prints of this time ushered in yet another phase in his graphic output.
Almost as if he intended to measure the distance he had traveled, or—more
likely—propelled by a compulsive need to recast his earlier extroversive art
into the emotive pictorial language of his late style, he resumed the habit,
first noted in his graphic production from 1914, of reworking some of his earlier
paintings in his late drawing style. A cycle of thirteen etchings of 1919, en-
titled *Ancient Legends* (Schw. 351), includes nine such repetitions. Among the
four additional repetitions of the same year are new versions of the very early
Swimming Pond at Grothe (B.-C. 72) of 1890 (Schw. 363) and the successful
Salome (see Plate 12) of 1900 (Schw. 367). Corinth's prints of 1920 include new
renditions of his two Salon entries, *Susanna in Her Bath* (see Fig. 34; M. 465)
and the prize-winning *Pietà* (see Fig. 33). In the print after the *Pietà* (Fig. 171)
he virtually tore to shreds the "corpse of Christ on a red tile floor" that for so
long had not satisfied him with respect to "form." The climax of this com-
pulsive revision of earlier work was reached in 1921–1922, when Corinth
published a group of ten etchings under the title *Compositions* (M. 553–565),
each based on one of his typical earlier exhibition pieces, including the paint-
ing *Entombment* (see Fig. 95) of 1904. His new approach to this particular work

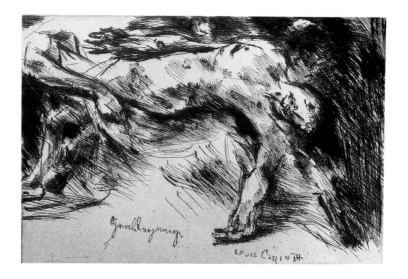

FIGURE 171.
Top of page: Lovis Corinth, *Pietà,,* 1920.
Drypoint, 26.5 × 32.7 cm, M. 472.
Hamburger Kunsthalle, Hamburg
(1929/138). Photo: Ralph Kleinhempel.

FIGURE 172.
Above: Lovis Corinth, *Entombment,*
1920–1921. Drypoint, 21 × 31 cm., M.
556. Landesmuseum Mainz, Graphische
Sammlung.

is of special interest because as his point of departure for the print (Fig. 172) he selected not the finished painting but the life-size cartoon that had preceded it (see Fig. 97). Nothing could reveal Corinth's intention more clearly, for, having singled out this particular drawing, surely one of the most idealized human figures in his entire oeuvre, he proceeded to repudiate the academic nude that had preoccupied him for so many years.

The maturing of Corinth's late graphic style coincides with an impressive output of illustrations for biblical, historical, biographical, and other literary texts. As a result of the publication of Karl Schwarz's catalogue in 1917, a general appreciation for Corinth's printed graphics had developed. Several subsequent publications by the same author,[17] culminating in 1922 in a second, much enlarged, edition of the catalogue, stimulated interest in Corinth's graphic production still further. As the attention of print collectors grew, so did the business acumen of publishers of print portfolios and illustrated books. The Fritz Gurlitt Press and the Propyläen-Verlag in Berlin, F. Bruckmann in Munich, and E. A. Seemann in Leipzig were among the firms with which Corinth signed contracts for a variety of projects. In addition to individual prints and such series as the Walchensee views, the *Ancient Legends, Compositions,* and the *Dance of Death* cycle already mentioned, he completed between 1919 and 1923 no fewer than twenty other print portfolios and illustrated books comprising nearly four hundred etchings and lithographs. Among these are *Anne Boleyn* (Schw. L428, L429) and a sequel of prints illustrating scenes at the court of Henry VIII (Schw. L430). Although the *Anne Boleyn* series was for a text by Herbert Eulenberg, much of the inspiration for both cycles came from the filming of the story—with Henny Porten and Emil Jannings in the leading roles—which Corinth was invited to watch at the Babelsberg Studios in Potsdam.[18] Illustrations for three poems, Friedrich von Schiller's *Der Venuswagen* (Schw. L383), Gottfried August Bürger's *Die Königin von Golkonde* (M. 499–511), and the *Dafnislieder* of Arno Holz (M. 733–743), revive memories of Corinth's earlier sensuous art. Like the contemporary *Love Affairs of Zeus* (Schw. L401), they include captivating scenes of lovers locked in rapturous embrace. The provocative character of the actions depicted in the illustrations to Schiller's poem (Fig. 173) is underscored by pithy inscriptions.

Corinth also illustrated some of the great classics: Shakespeare's *King Lear* (M. 491–498) and Schiller's *Wilhelm Tell* (M. 775–796), *Die Räuber* (M. 797–808), and *Wallensteins Lager* (M. 809–814). Twice he turned to the story of Götz von Berlichingen, first in 1919, when he made illustrations to Franz von Steigerwald's 1731 biography (Schw. L399), which had already inspired the young Goethe, and again in 1920–1921, when he illustrated the text of Goethe's

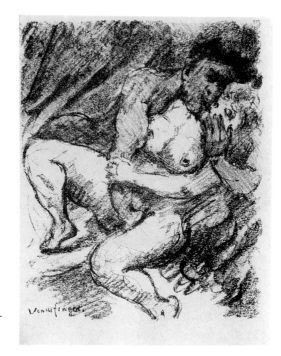

FIGURE 173.
Lovis Corinth, *Venus Finger*, from *Der Venuswagen: Ein Gedicht von Friedrich von Schiller, 1781*, 1919. Photo courtesy Hans-Jürgen Imiela.

FIGURE 174.
Lovis Corinth, *Frederick the Great on His Deathbed*. Color lithograph, 32.3 × 25.3 cm, M. 618; from the cycle *Fridericus Rex*, 1922 (M. 593–640). Staatliche Museen Preussischer Kulturbesitz, Kupferstichkabinett, Berlin (West). Photo: Jörg P. Anders.

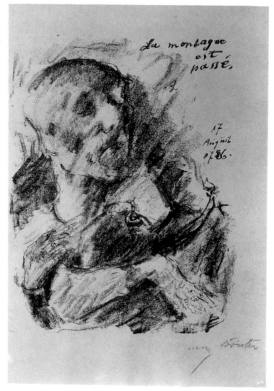

drama (M. 512–538). The life of Martin Luther, with a text by Tim Klein (Schw. L444), also dates from 1919. In 1922 Corinth completed his most extensive single cycle, *Fridericus Rex* (M. 593–640), a set of forty-eight color lithographs published in two portfolios.[19] The engaging narrative tone of this cycle and the whimsical exaggerations of physiognomy and gesture—as in Corinth's illustrations of 1923 for Jonathan Swift's *Gulliver's Travels* (M. 641–666)—are reminiscent of Corinth's earlier parodic *Tragicomedies* (see Figs. 42–50).

At the same time, the choice of such protagonists as Luther, Götz, and Frederick the Great implies again a measure of self-identification with embattled German heroes. This is further supported by several more self-portraits in armor, one decorating the title page of the *Anne Boleyn* series (Schw. L428, II), a *Flagbearer* of 1920 (Schw. 396) and a *Victor* of 1920–1921 (M. 564), the latter two done after earlier paintings (see Figs. 105, 106). The first *Götz* cycle begins with a repetition of the painting of 1917 (see Fig. 153), showing the aged warrior seated at his desk, writing his memoirs (Schw. L399, III). In the next-to-last print Götz has laid aside his armor and halberd (Schw. L399, XVI); the inscription beneath the illustration reads in translation: "Everyone will know what pain I have suffered." For the episode in the second cycle where Götz resists his captors (M. 530), Corinth drew on his earlier portraits of Rudolf Rittner in the role of Florian Geyer (see Plate 16, Fig. 127).

The first portfolio of *Fridericus Rex* emphasizes Frederick's endurance in the face of misfortunes: the traumatic conflicts between the young prince and his father; the First Silesian War; and Frederick's severest test, the Seven-Year War against the coalition of Austria, Russia, and France. The next-to-last print, inscribed "La montagne est passé/ 17 August 1786," shows the monarch on his deathbed (Fig. 174), a subject often depicted by other artists, usually to preserve a historical record of the dying king surrounded by attendants and members of his court. Corinth's only interest, however, is the deceased monarch, stripped of the accoutrements of the royal household. The dead king's face is based on the death mask in the Hohenzollern Museum that Corinth had drawn as early as September 1908.[20] During the war, in 1915, he had painted a picture of the death mask, starkly contrasting light and shade (B.-C. 653). The motif recurs in the second portfolio of *Fridericus Rex* (M. 637), followed by illustrations of the empty sedan chair in which the ailing king was carried (M. 638) and Frederick's disembodied uniform and hat, supported by the lifeless armature of a mannequin (M. 639). In 1923 Otto Gebühr, who played the title role in the hugely successful *Fridericus* films produced at about that time, gave Corinth a copy of Frederick's death mask, which the painter promptly displayed in his studio.[21]

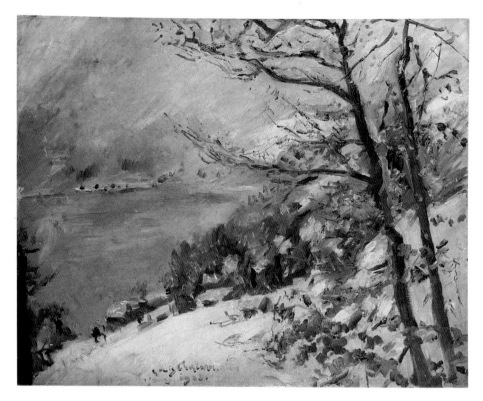

FIGURE 175.
Lovis Corinth, *The Walchensee in Winter*,
1923. Oil on canvas, 70 × 90 cm, B.-C.
897. Städelsches Kunstinstitut, Frankfurt
(SG 1132).

CORINTH'S *ALTERSSTIL*

Corinth's print portfolios and book illustrations clearly went a long way toward compensating for the diminished number of figure paintings after 1919. Walchensee landscapes and still lifes continued to dominate his watercolors and oils. This intensive preoccupation with nature, the need to capture a momentary sensation quickly, seems in turn to have contributed to yet another stage in the evolution of Corinth's late style. Although there are antecedents, even a cursory look at his pictures from 1923 reveals a more consistently fluid application of paint. The colors seem to have been laid on in caressing strokes, and even the dabs of impasto seem light. Brushed into each other right on the canvas, the colors yield transitional hues, often of great delicacy. Like a living, moving substance, they ebb and flow across the pictorial field, producing the impression of a mysterious connection of all material substance. It is as if Corinth were no longer looking at but through nature, as through a translucent veil.

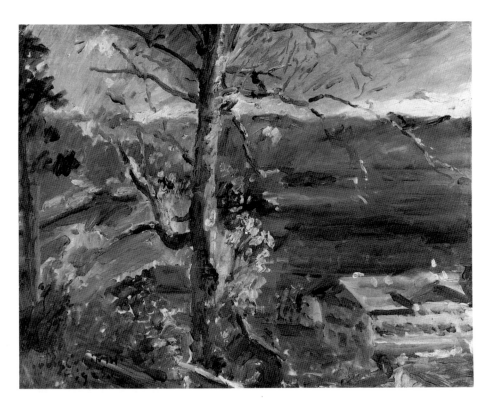

FIGURE 176.
Lovis Corinth, *Tree at the Walchensee,*
1923. Oil on canvas, 70 × 91 cm, B.-C.
930. Kunsthaus Zurich (2417). Photo:
Walter Drayer.

The winter landscape in Frankfurt (Fig. 175) dated January 1, 1923, is one
of these works. It is a painting of extraordinary structural and coloristic sim-
plicity. It could almost be called monochromatic were it not for the pale violet
of the clouds, the pale blue of the frozen lake, and the bronze-brown hues of
the leaves still clinging to the trees on the right. The luminous white of the
snowy landscape nonetheless unifies sky, lake, and terrain, and the constant
blending of tones and the fluid treatment heighten the pictorial unity still
further. Throughout, the landscape is so expressive of atmospheric life that
one can almost feel the clammy air of the winter day. In the Walchensee land-
scape in Zurich (Fig. 176), a painting of great pictorial richness and emotional
appeal, there is both drama and lyrical calm. A barren tree stands out against
the luminous distance, its winding branches evoking both struggle and en-
durance. Several features contribute to the painting's suggestive power: the
magnificent blue that unites sky, mountains, and lake; the misty forms of the

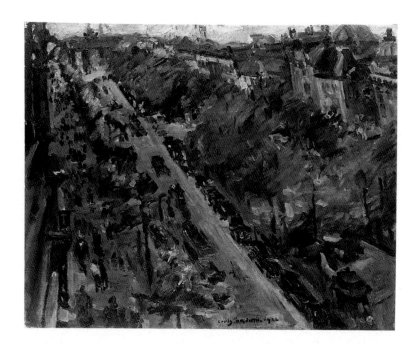

FIGURE 177.
Lovis Corinth, *Unter den Linden, Berlin*,
1922. Oil on canvas, 70.5 × 90.0 cm,
B.-C. 893. Von der Heydt-Museum der
Stadt Wuppertal, Wuppertal-Elberfeld.

houses by the edge of the water, which seem to float as in a mirage; and the
opalescent luster of the tree itself, its trunk and branches sparkling with color
as if still pervaded by a mysterious inner life.

In two contemporary city views of Berlin even the urban landscape appears
similarly transfigured. The visual sensations of the crowded boulevard Unter
den Linden (Fig. 177), viewed from the second floor of the Restaurant Hiller
in 1922, yield a panorama of blurred accents reminiscent of similar paintings
by the French Impressionists. Unlike Monet and Pissarro, however, Corinth
imposed the ceaseless change of color on the pictorial structure: the pro-
nounced diagonal of the tree-lined street seems to exert a gravitational pull,
and everything slants precariously as if about to fall, the façades of the houses
as well as the mighty columns of the Brandenburg Gate.

Even in the close-up view of the Berlin royal palace (Fig. 178), the tactile
substance of mortar and stone has given way to the diaphanous texture of
the picture surface. Although seen head-on and occupying virtually the en-

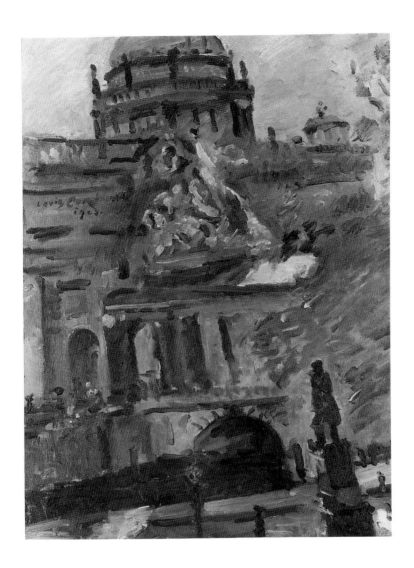

FIGURE 178.
Lovis Corinth, *Schlossfreiheit, Berlin*, 1923.
Oil on canvas, 104 × 79 cm, B.-C. 894.
Staatliche Museen Preussischer
Kulturbesitz, Nationalgalerie, Berlin
(West). Photo: Jörg P. Anders.

tire pictorial field, the building remains strangely disembodied. With its architectural elements dislodged, its structure shifts. The cupola sits askew above Eosander von Göthe's sumptuous gateway in the west front facing the Schlossfreiheit, literally "freedom of the palace," so named for the remission of taxes that earlier inhabitants of the palace grounds enjoyed. Reinhold Begas's monument to Wilhelm I, the founder of the Second German Empire, looms in the right foreground, separated from the deserted palace by a dark canal that seems to tunnel directly beneath the building. The inconsequence of the palace's tangible character to Corinth is indicated by his affixing his signature and the date of the painting to the swaying entablature of the façade.

The same allusive transparency makes itself felt in Corinth's late still lifes. It no longer matters what flowers are depicted (Fig. 179) or whether a still life is of fruit or of cuts of meat and fish arranged in a bowl or on a kitchen counter. In every instance the substances dissolve into a coruscating display of color.

Because color also preponderates over physical resemblance in Corinth's late portraits, in all his work after 1922 there is only one truly formal portrait. The other portraits—of colleagues, friends, and members of Corinth's immediate family—were all painted on his own initiative. These too, pervaded by Corinth's awareness of his increasingly frail condition, are really expressions of his own self and thus among the most explicit statements of his mature conception. Three compelling examples date from 1923. In the portrait of the Russian painter Leonid Pasternak (see Plate 33), the father of the famous poet and novelist, the sitter is seen from up close in a casual pose, arms folded across his chest. Light tones predominate, their oscillating life reinforced by the vivid brushstrokes, in keeping with what by all accounts was a strikingly debonair appearance. Yet in the shadows of the mouth there is a disturbing darkness; the eyes appear clouded and dim; the skull seems to protrude right through the eroding texture of the skin, giving the face a mocking, indeed sinister, expression.

Leonid Osipovich Pasternak (1862–1945), who had settled in Berlin in 1921, had written to Corinth to express his admiration for works of the painter he had recently seen, most likely at the former Kronprinzenpalais, where in the summer of 1923 the National Gallery featured a large exhibition of Corinth's work, drawn entirely from private collections. Corinth replied by asking Pasternak to come and sit for the portrait, complimenting the Russian on his good looks. "Were I a woman," Pasternak wrote to a friend on July 18, 1923,

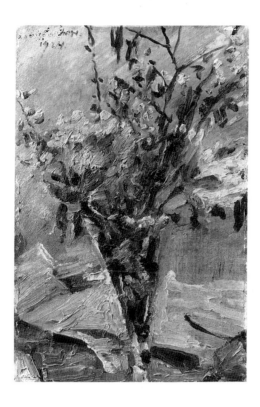

FIGURE 179.
Lovis Corinth, *Spring Flowers in a Fluted
Vase*, 1924. Oil on canvas, 61 × 41 cm,
B.-C. 937. Wallraf-Richartz-Museum,
Cologne. Photo: Rheinisches Bildarchiv.

"I would have been proud."[22] On December 2 he described Corinth's work on
the portrait in greater detail:

> When he was painting me, the expression in his eyes was almost terrifying!
> Whether it's the result of his illness or of an intent fixation on his subject, he is
> beginning to squint; his left arm is paralyzed, so he presses the palette convul-
> sively to his body; he stands there bowed down, perhaps trying to overcome
> superhuman torment. And for three hours at a stretch he stands like this in front
> of his canvas.[23]

Pasternak, in return, painted Corinth with palette in hand, stooped, working
at the easel, his eyes fixed on the subject with fierce determination. But Pas-
ternak's own ingratiating style could hardly communicate "superhuman tor-
ment," and consequently the expressive character of his portrait of Corinth
remains somewhat forced.[24]

Corinth's awareness of human transience, so eloquently expressed in the
diaphanous structure of the Pasternak portrait, reaches a point of passionate

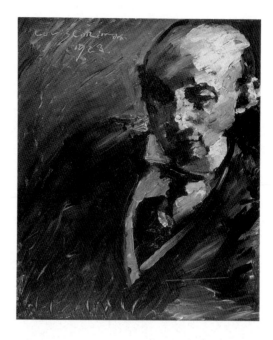

FIGURE 180.
Lovis Corinth, *Portrait of Alfred Kuhn*,
1923. Oil on cardboard, 61 × 51 cm, B.-C
915. Private Collection, Austria. Photo
courtesy Bernd Schultz.

defiance in the portrait of Alfred Kuhn (Fig. 180). Here the figure has been
pushed to the extreme side of the composition. Torso and ground, with the
same textural characteristics, flow into each other in a torrent of brushstrokes.
The head, stretched out of shape, dissolves between a burst of light and the
silvery gray pallor of the colors. Kuhn, who at the time was preparing his mo-
nograph on the painter, was fully aware of the extent to which Corinth had
come to see in nature a mere pretext for revealing the world of his imagination:

> For the old Corinth the world was only a shell inhabited by a slowly disintegrat-
> ing body, only an opportunity to receive new inspirations for visions of color.
> When one sat opposite him during these last years and talked to him, one soon
> became aware that the conversation did not interest him in the least, that his
> gaze, so firmly fixed, was not intended for anyone in particular, and it could
> happen that Corinth would suddenly say such things as, "Hold still, that yellow
> forehead interests me," or "What a strange color there is in your eyes right
> now."[25]

Among the most remarkable of all of Corinth's late works is his portrait of the
Norwegian painter Bernt Grönvold (Fig. 181). The two had first met at the
Académie Julian but had not seen each other in fifteen years. When Grönvold
(1859–1923) called on him in his Berlin studio, Corinth was struck by the old

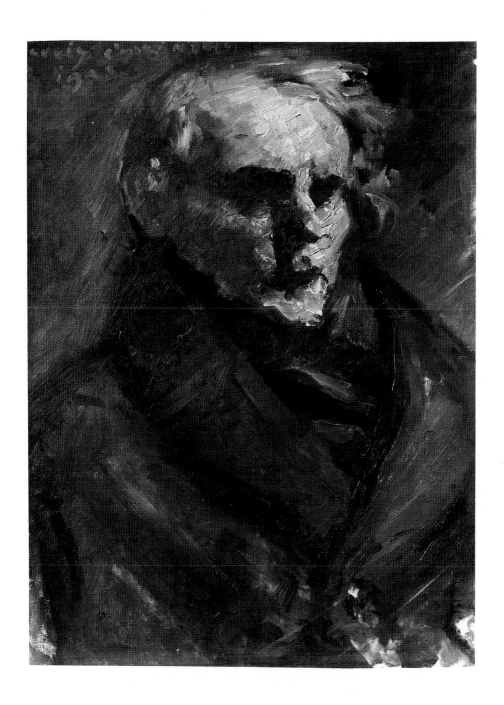

FIGURE 181.
Lovis Corinth, *Portrait of the Painter Bernt Grönvold*, 1923. Oil on canvas, 80 × 60 cm, B.-C. XX, Kunsthalle Bremen (683-1953/22).

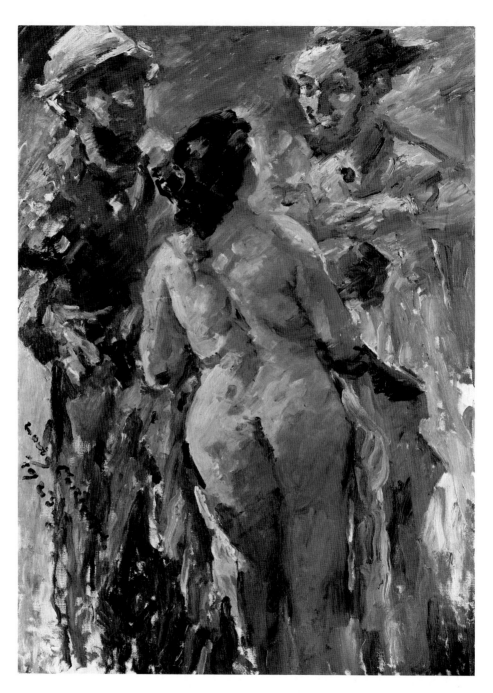

FIGURE 182.
Lovis Corinth, *Susanna and the Elders,*
1923. Oil on canvas, 150.5 × 111.0 cm,
B.-C. 910. Niedersächsisches
Landesmuseum, Landesgalerie,
Hannover (KM 123/1954).

FIGURE 183.
Lovis Corinth, *Susanna and the Elders*,
1898 and 1923. Pencil and watercolor,
c. 44.0 × 34.5 cm. Present whereabouts
unknown (see Fig. 68). Photo courtesy
Thomas Deecke.

friend's altered appearance and immediately asked to paint him. Dressed in a
curious old-fashioned coat tailored to his own specifications, the eccentric
Norwegian consented, but he requested that Corinth not paint his eyes. The
portrait was completed in a matter of two hours, and Grönvold left without
giving it even a glance, professing later that since he had asked Corinth not to
paint the eyes, he did not think that he had the right to look at the painting.
When he saw the portrait by chance a short time later, he exclaimed in sur-
prise: "Why, I look like a ghost!"[26] Grönvold does indeed inhabit a world
whose mystery can hardly be fathomed. The colors are muted: against the
overall tonality of blue, gray, and black the pale skin tones and wisps of white
hair stand out in an eerie light. The deathly pallor of the complexion is re-
lieved only sparingly by touches of red in the right ear and temple and in
Corinth's signature and date on the picture. The visionary quality of the por-
trait is intensified by the greenish blue haze of the background. It is actually
impossible to speak of figure and ground as separate since they share the
same amorphous texture. As the skull is revealed beneath the skin, the cavi-
ties fill with impenetrable shadows. It is as if a human life were being slowly
extinguished. Grönvold died, apparently unexpectedly, not long after the
portrait was painted.[27]

Twice in 1923 Corinth turned to figure compositions that had last occupied
him many years earlier, in each case rejecting the academic principles that
had governed such compositions before to achieve the final sublimation of his
earlier sensuous style. He began *Susanna and the Elders* (Fig. 182) by adding
to the drawing of 1898 (see Fig. 68) a watercolor wash (Fig. 183). This draw-

ing was unusual because it anticipated the expressive vigor of Corinth's more mature works; thus it was apparently no accident that the painter found the sketch still useful a quarter of a century later. In the painting itself, however, the baroque qualities of the drawing—exploiting movements and gestures and light and shade for picturesque effects—have been replaced by an action that is essentially static. At the same time there is a more profound human implication in the way Susanna, shielding herself with her robes, stands defiantly before her would-be seducers. Hers is a heroic courage summoned in the face of the greatest possible odds. The voluptuous form of the female nude still contains the memory of Corinth's earlier displays of feminine allure; but now the texture of the flesh is subordinated to the breadth and vigor of the painterly treatment. The drama of the action, too, is vested in the life of the paint itself—impressively so, since the three figures are approximately life-size. Creamy shades of pink and rose, accented with touches of white, gray, and pale blue, stream downward from the upper part of the composition. Near the lower margin and on both sides, the forms dissolve into pure abstractions.

The much smaller panel *Birth of Venus* (see Plate 34) similarly goes back to a work from the 1890s (see Fig. 61), although a watercolor from 1916 (Fig. 184) may have served as a less distant mediator. In any event, the earlier memories of Botticelli, Bouguereau, and Böcklin have been drowned in color. The colors, in turn, are expressive rather than descriptive. It is hard to imagine a more apt pictorial equivalent of the goddess's miraculous birth than the radiant blues, pinks, and whites that Corinth whisked up with the aid of the palette knife. But Corinth himself continued to see the painting primarily as illustrative. He would often look at it and remark with amusement: "The cupids are really flying."[28]

The ambivalence between form and formlessness gives Corinth's late work its particular tension. It is an ambivalence, however, only for the viewer—not, evidently, for the painter himself. As late as 1920, in the third edition of his teaching manual, Corinth still defined painting as an art "that reproduces on a two-dimensional plane what the eye sees in nature." He goes on to say that "all objects that are freestanding in nature must be made to appear three-dimensional and surrounded by light; the properties of the terrain, and everything that is in it, must be arranged in relation to one another, all the way to the horizon, so that a projection of depth is achieved."[29] These, of course, are Corinth's words to the beginner; he encourages the experienced student "to throw all caution to the wind, to follow his instincts and finish the painting in a few hours."[30] Mistakes are excused as long as the character of a given

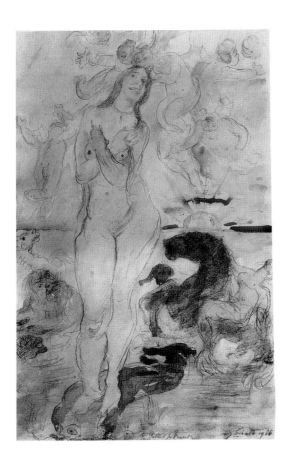

FIGURE 184.
Lovis Corinth, *Birth of Venus,* 1916.
Pencil, crayon, and watercolor.
Dimensions and present whereabouts
unknown. Photo: Marburg/Art
Resources, New York.

image has been captured. "No spot in a painting must lack life," he concludes; "a picture is finished when it is painted well. . . . even a well-painted sketch is finished."[31] In short, Corinth ultimately gives priority to the process of painting without abandoning subject matter altogether.

Corinth's late paintings often balance "on the edge"[32] between formation and dissolution. This process has meaning to the extent that it reflects the painter's innermost disposition. *Carmencita* (see Plate 35), the last portrait Corinth painted of Charlotte Berend, is a good case in point. The origins of the portrait were innocent enough: a costume ball at the Berlin Secession on February 28, 1924. Charlotte was dressed in the traditional gown of a Spanish woman. Corinth's costume was improvised more casually: with a fake beard, a red scarf around his waist, and a Christmas tree ornament pinned to his

chest he looked, perhaps, like a caricature of a high official. In her recollections of the evening Berend could not help acknowledging the disparity in age between herself and her husband:

> For me this was the first time that I could try out the steps of the new dances. I looked pretty stylish and danced . . . with one partner after another. In the process I completely forgot my obligations to Corinth. I caught a glimpse of him once in a while as he sat by himself, abandoned, old, and lonesome . . .; I had the gnawing feeling that I should really join him, but then I kept forgetting it, for hours on end. . . . By closing time . . . he said, "Now you are going to sit down for a while." That I did, and my admirers came buzzing to the table and buzzed off again when they heard that for this evening I was through dancing.[33]

A few days later Charlotte asked Corinth whether he felt like painting her in the handsome Spanish dress. No prompting was needed. With the glowing lights of the chandelier in the couple's living room setting a festive tone, Corinth completed the portrait in two short evenings. To stay in character, Charlotte kept chanting melodies from Bizet's *Carmen*. The painting itself, however, is far from lighthearted. To be sure, the colors are exhilarating, and the room behind Charlotte glows. The brushstrokes reinforce the scintillating life of the colors, following, as in many of Corinth's late works, a predominantly diagonal direction from the upper right to the lower left. In addition, there are independent brushmarks of varying strength and direction. Passages of heavy impasto vie with dabs of great transparency, so that the pictorial structure seems perpetually to ripple. The figure of Charlotte, shown life-size, is pushed close to the picture frame. Her ebullient temperament, her capacity for living life to the fullest, even the formidable strength of her personality find eloquent expression in her opulent appearance. To that extent the painting might be called the culmination of Corinth's portraits of Charlotte as well as a document of a particular way of life.

The painting is also, however, a farewell, for its initially festive mood does not withstand prolonged scrutiny. Despite Charlotte's implied physical presence, there is no real physical substance. For all its massiveness the figure succumbs to the labile character of the pictorial structure; the lower half of the figure in particular seems to sag. Although from a distance the facial expression seems aloof, the features are far too blurred to be psychologically accessible. It is as if Charlotte had receded into a world the painter no longer shares. As Hans-Jürgen Imiela has aptly observed, Corinth's *Carmencita* has "something of the character of a widow's portrait."[34]

There is a similar ambivalence about Corinth's portrait of Wilhelmine (Fig. 185), painted in July 1924. Nothing could evoke better the bloom of youth than the white frills of the dress accented with tones of pale yellow, lime green, and rose. Yet the figure is seen as through a veil; the features grow indistinct as if the girl were no more than a distant vision.

Whatever the personal implications for the old painter, both the Carmencita portrait and the portrait of Wilhelmine were conceived in accordance with a fundamental distinction—today it would be called sexism—that Corinth advocated in portraits of women as opposed to portraits of men. "In the case of men," he writes in his teaching manual, "interest will be in the spiritual physiognomic character, in sensitive hands, in a peculiar posture whereas in portraits of women, concern will be more with the effect of the colors. A man must always be interpreted more from an intellectual point of view, a woman more decoratively."[35] This distinction explains why even Corinth's earlier portraits of Charlotte, no matter how sensitive, show her most often in the stereotypical roles of lover, wife, and mother and only rarely as a professional artist in her own right. The emphasis on the cerebral component in male sitters, in contrast, accounts in the late works for such striking, if overwrought, physiognomic studies as the second portrait of Herbert Eulenberg (Fig. 186). Here the poet's inner radiance breaks through the fragile shell of the body; the eyes glow feverishly, wide open as if he were entranced by a horrible vision.

From 1924 on virtually all of Corinth's male sitters share this terrified expression. The most notable exception is the portrait of Friedrich Ebert (Fig. 187), the first president of the Weimar Republic. Although the technical execution does not differ fundamentally from that of other paintings of the same year, the conception is formal, evidently precluding a more personal treatment. The portrait was painted on Corinth's initiative. By his own admission, he was intrigued by Ebert's "fascinating ugliness."[36] Without diminishing the coarseness of the features, he nonetheless stressed the innate dignity of the saddler-turned-statesman. Ebert's humble origins, in fact, endeared him to Corinth: "I don't want to deny that I found in him a man whom, on account of my own background, I understood better than the titled and the rich. I find people of my sort easier to deal with."[37] By the time Corinth painted the portrait he had learned to accommodate himself to the republic. Whereas in 1918 he had lamented the spread of socialism in Germany, Ebert was for Corinth now the embodiment of the new order and thus worthy of the same respect the painter had formerly accorded the emperor. "I did not see in Ebert the social democrat," he wrote in his diary, "but the head of the German state."[38]

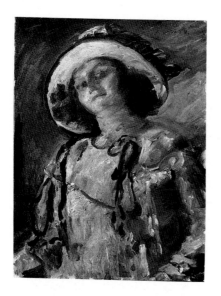

FIGURE 185.
Lovis Corinth, *Wilhelmine in a Yellow Hat*, 1924. Oil on canvas, 85 × 65 cm, B.-C. 947. Museum für Kunst und Kulturgeschichte, Lübeck.

FIGURE 186.
Lovis Corinth, *Portrait of Herbert Eulenberg*, 1924. Oil on canvas, 60 × 49 cm, B.-C. 952. Kunsthistorisches Museum, Vienna (NG 51).

Corinth had met Ebert informally on a number of occasions. At one of Ebert's receptions the critic Paul Fechter was also present. When he noticed that Corinth was having difficulty lighting a cigar, he rushed to help him, a gesture that the painter acknowledged gratefully. Fechter's subsequent account of the episode is also one of the most moving descriptions of the old Corinth:

> The way he looked at me was really the most unforgettable part of this small incident. His broad peasant face, which had never acquired the look of a Berliner, was dominated by two beautiful brown eyes. They were the eyes of a sick, wounded animal . . . filled with the silent moan: "I cannot go on any longer." They were the eyes of a painter. . . . of a man who in his suffering was absorbing the world only passively, who could no longer grasp, hold, and form the world according to his own will but had to accept what was offered, who was no longer even master of himself and his body. This was the gaze of one . . . who has . . . only lived for the visible, and who now, without any words, silently acknowledged with these eyes the smallest kindness shown to him. They took possession of my face. I could feel how for one brief moment he fixed the image in his mind with all his power. But then the silence and the sickness of the animal came once again to the fore, as if he were already far removed from the world of those around him and no longer shared anything with them but that certain waiting for something.[39]

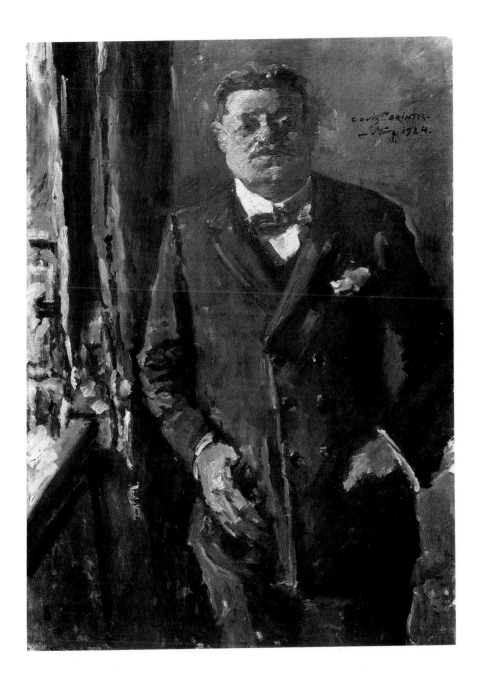

FIGURE 187.
Lovis Corinth, *Portrait of Friedrich Ebert*,
1924. Oil on canvas, 140 × 100 cm, B.-C.
968. Öffentliche Kunstsammlung Basel,
Kunstmuseum (1699).

While Fechter's eloquence bears the stamp of poetic license (Corinth's eyes, for example, were blue, rather than brown), the fundamental truth of his observations is corroborated by others who encountered the painter during these years. Wilhelm Hausenstein was struck at about the same time by Corinth's way of observing the world around him, the eyes far apart, as if seemingly no longer looking in one direction:

> Under his gaze life parted like a curtain, and in the center there was something like the silhouette or the shadow of death. . . . I shall remember this gaze in the hour of my own death; this is how one sees when the world is dissolving. Then one looks not only into depths that were previously hidden but also to both sides—things become deep, and they become wide; they reach to the left and to the right, and the sides, too, become depths.[40]

Far less poetically, Karl Schwarz bluntly calls Corinth a "gruff man" whom illness had turned into a "wreck."[41] Likewise, Alfred Kuhn, who saw Corinth often in connection with the monograph he was then preparing, describes him as a "stooped man" with an "emaciated body, . . . a shuffling walk, and trembling, red, swollen hands." "Listening to his halting, grumbling speech," Kuhn continues, "one would scarcely have thought that this was one of Germany's greatest living artists. But seeing him at some public function, . . . sitting up straight, one was tempted to think of the old Rembrandt: the same ragged features, the same expressive mouth, . . . and the same faraway gaze."[42] Both Kuhn and Schwarz, however, make the point that Corinth's frailty in no way hindered his productivity. Kuhn speaks of "miraculous works" created by the "helpless hands of an old man."[43] Schwarz writes of the astonishing energy Corinth summoned while painting: "When he stood before the easel, it was as if a vulcano erupted. He flung the paint at the canvas, groaned and moaned, cursed and thundered, totally oblivious to the world around him."[44] In the excitement of painting, moreover, Corinth surmounted his impediments by resorting at times to impromptu measures as long as they yielded the desired results. Rudolf Grossmann, one of the younger members of the Berlin Secession, whose portrait Corinth painted in 1924 (B.-C.965), writes: "He knows how to take advantage of his diminished locomotive powers. . . . His hand gropes about on the palette and gradually turns as red as madder. . . . Often he uses the other trembling hand like a mahlstick for support to give a particular tone greater definition. . . . At the end, after two and a half hours of uninterrupted work, . . . he lowered his hands; they were as red as blood, as if he had burrowed into my intestines."[45]

At this time in his life painting was for Corinth no longer just a calling or an occupation but a necessity; not merely a way of life but a way to survive. He needed to work, if only to maintain his inner balance. Corinth's late self-portraits give a vivid account of his emotional disposition. As always, they are rooted in a search for truth and an intense integration of his physical and psychic life. Some are pervaded by an undertone of resignation. But again and again the painter rallies and confronts himself, pencil or palette and brushes in hand, in a renewed gesture of self-challenge. In the self-portrait of June 21, 1923 (Fig. 188), Corinth is a quiet, thoughtful observer of his appearance. While the right arm, reversed in the mirror image, suggests the momentary action of painting, the face mirrors both sadness and fatigue. Broad patches of light and dark merged by fluid halftones render the textures indistinct; the forms seem about to dissolve.

Exactly a month later, on his sixty-fifth birthday, Corinth painted himself again at the Walchensee (Fig. 189). The eyes are clear, the face smooth, the expression probing but unhampered by fear or skepticism. Unlike the first Walchensee self-portrait of 1921 (Fig. 165), the painting asserts the figure's independence vis-à-vis the terrain. Corinth towers above the lake, like the old tree in the Walchensee landscape of the same summer (see Fig. 176), impaired but not yet beaten. How quickly, however, his moods tended to change is evident from a long lament in his diary, written not long after the completion of the self-portrait. Dismissing any claim to "virtuosity," he speaks of the "sicknesses," the "paralysis," and the "awful tremor of the right hand" that made any technical display in his late work impossible.

> A constant ambition to achieve a goal I never reached has made my life bitter, and each piece of work ended in depression when I thought of having to continue this life! To be sure, whenever I compared my work with that of others, it seemed to me that I was as good as or better than anyone else. . . . Liebermann once told me that one must have everything to discover how unimportant everything is. For my part, however, I am sickened by everything. I don't even want to have what I still could achieve because it disgusts me already. Perhaps it is the sad state of Germany today that bears responsibility for this disgust. The times for us old ones have changed so much. . . . it's wretched. . . . most sad, very sad. And the future is hidden by the darkest curtain.

Corinth then goes on to praise Charlotte Berend for having made his anguish bearable. Calling her his "guardian spirit," he concludes: "People will have

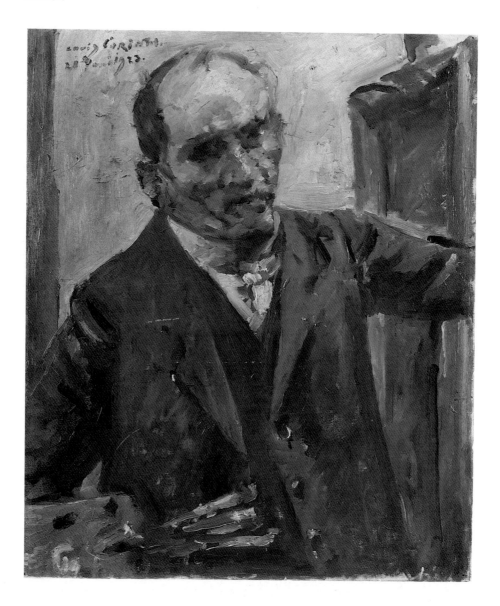

her to thank if in my later days I still managed to produce a few good things."[46]

The self-portrait of April 1, 1924 (Fig. 190), now in New York, mirrors the ambivalence of Corinth's thoughts. The face speaks of both apprehension and resolve. There is something defensive about the stooped posture, an impression reinforced by the palette, held perpendicular to the picture plane like a shield. The pictures displayed in the background press hard upon the painter. Cramping his field of action, they are also a reminder of an obligation not yet entirely fulfilled.

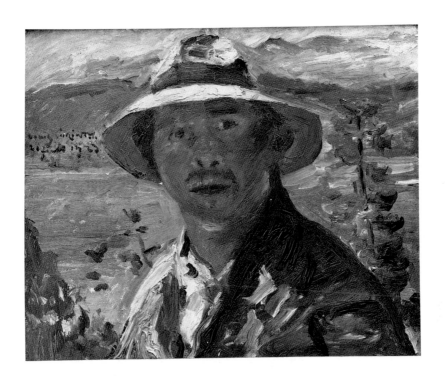

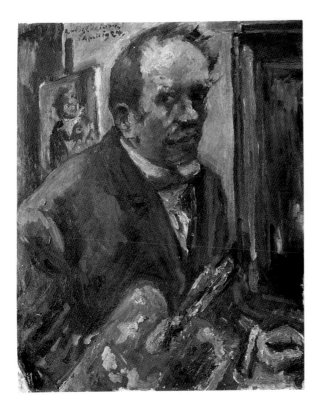

FIGURE 188.
Opposite: Lovis Corinth, *Self-Portrait with Palette*, 1923. Oil on canvas, 90.2 × 75.5 cm, B.-C. 916. Staatsgalerie Stuttgart (2457).

FIGURE 189.
Above: Lovis Corinth, *Self-Portrait in a Straw Hat*, 1923. Oil on cardboard, 70 × 85 cm, B.-C. 925. Kunstmuseum Bern (1488).

FIGURE 190.
Left: Lovis Corinth, *Self-Portrait with Palette*, 1924. Oil on canvas, 100.0 × 80.3 cm, B.-C. 967. Collection, The Museum of Modern Art, New York (Gift of Curt Valentin).

If the New York self-portrait suggests constriction and weary vigilance, the self-portrait (see Plate 36) Corinth painted at the Walchensee on July 21, 1924, his sixty-sixth birthday, conveys openness and serene assurance. The physical energy required to paint the life-size picture in the heat of the midday sun, to haul the heavy canvas intermittently indoors to examine the effect of the colors in a more diffuse light, as Charlotte Berend relates,[47] must have been formidable. Corinth does indeed seem rejuvenated. He stands erect, his shirt inflated by a breeze; his face aglow with sunshine; his gaze attentive, absorbed not by self-scrutiny but solely by the painterly task at hand. Although he stands high above the lake, painter and landscape are unified. The green of the trees and the meadow and the blue of the lake, mountains, and sky have invaded the shadows of the trousers and the shirt, where they are complemented by stripes of red, purple, yellow, and brown. The warm tones find their greatest concentration in the skin tones, which stand out resonantly against the cool ground of the landscape. "This portrait contains all of Urfeld," Charlotte Berend writes in her diary, "the wind, . . . the radiance of summer in all its fullness and bliss."[48] Many years later she recalled that Corinth told her at that time, "I want to live to be seventy. I still don't have any wrinkles or a single gray hair on my head. I would like to paint myself with a wrinkled face and white hair; that would make a completely different picture."[49]

"TRUE ART MEANS SEEKING TO CAPTURE THE UNREAL"

Corinth had hardly finished the self-portrait when he was already at work on the splendid still life of larkspur (see Plate 37). The bouquet was a birthday gift from Wilhelmine, and the large dimensions of the painting lend the simple flowers an appropriately festive air. As in the Walchensee birthday self-portrait, warm and cool tones complement each other. There is also an unexpected renewed commitment to interior space. The checkered table cloth and the window framed by a white lace curtain convey something of the room's rustic charm. Yet structural ambiguities, as nearly always in Corinth's late works, prevail: the vase leans toward the right, and there is a notable divergence between the left and right corners of the table and between the windowsill and window frames. In the end, however, these instabilities are resolved in the stalks of the flowers radiating outward from the very center of the composition. The result is a dynamic equilibrium that defies the logic of statics.

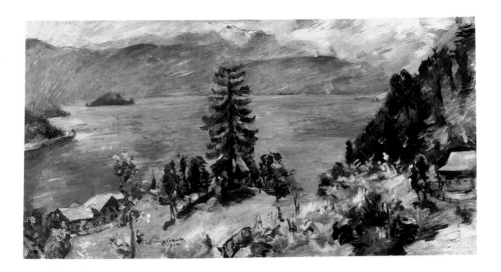

FIGURE 191.
Lovis Corinth, *Walchensee: View from the
Kanzel,* 1924. Oil on canvas, 100 × 200
cm, B.-C. 955. Wallraf-Richartz-Museum,
Cologne. Photo: Rheinisches Bildarchiv.

During that summer Corinth also painted seven Walchensee landscapes.
These included two nocturnes (B.-C. 953, 954), two views of the Jochberg (B.-C.
956, 958), and a view of the lake shrouded in morning fog (B.-C. 959). The
most unusual of all is the large panorama (Fig. 191), now in Cologne. Like the
preceding birthday self-portrait and the still life of larkspur, the painting con-
veys a sense of serene detachment. The landscape is actually made up of two
views: at left, a corner of the northeast shore, the green island of Sassau, and
the Hotel Fischer am See; at right, toward the southwest, the slope leading up
to the Herzogstand. On the opposite side of the lake lies the extended chain
of the Karwendel, and almost in the center of the canvas, unifying the com-
position, Corinth's favorite larch tree stands on its own promontory overlook-
ing the water. The brushstrokes are vivid but of a uniformly soft texture that
enhances the breadth of the view and contributes to the impression of an all-
pervasive calm. One is tempted to call the landscape "classical," so much
does the painting depend on both the ordering of human reason and the laws
of nature.[50]

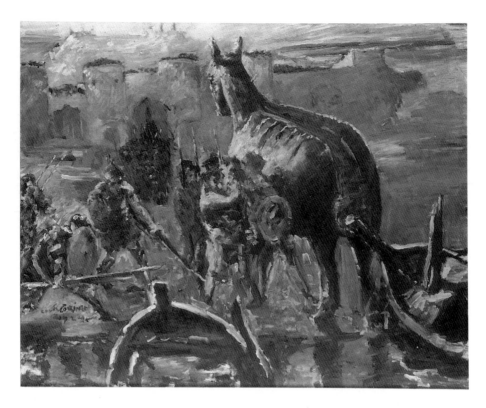

FIGURE 192.
Lovis Corinth, *The Trojan Horse*, 1924. Oil
on canvas, 105 × 135 cm, B.-C. 960.
Staatliche Museen Preussischer
Kulturbesitz, Nationalgalerie, Berlin
(West) (NG 1522; A II 488). Photo: Jörg P.
Anders.

Corinth's love of a good story depicted with verve revives briefly in *The
Trojan Horse* (Fig. 192), painted in the fall or early winter of 1924. The subject
is rare in art, perhaps because the story lacks a major human character. Co-
rinth, too, was forced to select a subplot of the epic to highlight the drama
of deception and folly. Facing the gate of the walled city, the sham animal
stands stiffly by the seashore. Two derelict boats, left behind by the Greeks,
lie in the shallow water nearby, their prows pointing no less menacingly in
the same direction. All the action centers on the lone Greek who professes
that he was abandoned by his compatriots on the beach. Having been cap-
tured by a small advance troop of Trojans, he tells them the story of the
curious idol as Odysseus had instructed him to do. Two armed warriors

watch over him with furious determination, unaware of the real danger at hand. The city gate has already been opened, and from it stream more troops and the dark throng of the curious. The jewel-like colors, pearly grays and sapphire blue augmented with turquoise and touches of red, pink, and pale yellow, lend the story the air of a remote fantasy. Despite the seeming informality of the melee, the pictorial structure is rigorously ordered. The action is contained within horizontal bands formed by the sea, sky, and city walls. Corresponding accents divide the composition vertically, with the main episode, surmounted by the horse's head, occupying the center of the canvas. Historians have interpreted Corinth's choice of this subject, with all its tragic consequences, in the context of both his personal life and the contemporary political situation, fraught with instability and potential upheaval.[51] Even if they are correct, Corinth managed to convey his thoughts in a light-hearted way.

After the serene confidence of this painting and the preceding works from Urfeld, the pessimistic mood of the two Walchensee landscapes (B.-C. 979, 980) Corinth painted in early January 1925 is doubly disturbing. Both paintings are relatively small and show the view to the south, across the lake. Their expressive character suggests a turmoil that goes beyond the wintry melancholy of the scene. The barren branches in the foreground struggle upward; the *repoussoir* of the larch tree looms above a landscape of near apocalyptic gloom. Equally foreboding is the landscape in a watercolor of the same time (Fig. 193). Here the foreground bears only a vague resemblance to topographical fact. The familiar forms are truncated and shattered. Even the surface of the lake appears fractured in the light of the setting sun. Greater calm pervades a watercolor begun on January 8 (Fig. 194), although the predominantly dark tones give this landscape, too, a haunting character. For some reason Corinth did not finish this watercolor.[52] He left Urfeld the same day. In the context of what turned out to be his last visit to the Walchensee, this view of the lake appears in retrospect like a sad, tender farewell.

After his return to Berlin Corinth's productivity diminished markedly. Perhaps no more than four paintings date from the period between mid-January and early April. His responsibilities as president of the Berlin Secession and two short trips to Hamburg in late January and early February do not entirely explain this sudden reduction in his output. Even his diary remains silent until March 31, when he writes of the favorable reception accorded to his recent Walchensee landscapes, to two views of Lake of Lucerne (B.-C. 950, 951) painted during a trip to Switzerland in May 1924 to attend a large Corinth exhibition in Zurich, and to *The Trojan Horse*. He goes on to say that he is

FIGURE 193.
Top of page: Lovis Corinth, *Walchensee,*
1925. Watercolor, 50.4 × 67.7 cm.
Staatliche Museen, Berlin (DDR)
(27/6129).

FIGURE 194.
Above: Lovis Corinth, *Walchensee,* 1925.
Watercolor, 32.0 × 48.3 cm. Private
collection, United States. Photo: Eric
Pollitzer, courtesy The Galerie St.
Etienne, New York.

emphasizing these works only because he has been depressed of late as perhaps never before in his life:

> I could scream. All painting disgusts me. Why shall I keep on working? Everything is trash. This dreadful effort to keep on working is enough to make me sick. I am in my sixty-seventh year and this summer will begin my sixty-eighth. What is there still to come of it? Old age takes hold of me more and more; my physical strength declines. Senility? I always pray that I do not become senile. The fear of it is horrible.[53]

Then, on a more positive note, he begins to speculate on aesthetic matters:

> I have discovered something new. True art means seeking to capture the unreal. This is the highest goal! We find "unreality" in Shakespeare's *Midsummer Night's Dream*, in *Hamlet*, in all his works. Goethe, too, is a master of it, in *Egmont*. All art that shows right to the nth degree what everything is supposed to mean is bad. Even Leibl in his detailed works is "unreal"! All . . . realists are bunglers. . . . Only one name glows in the darkness: Rembrandt.[54]

That this "unreality" of which Corinth speaks was not primarily a matter of style is evident from his references to works of literature as well as to the art of Wilhelm Leibl. In his own work he had, at any rate, long ago abandoned conventional verisimilitude. This, for him, could hardly have been a new discovery. "Unreality" was for Corinth rather a matter of conception; it was the inner life of a picture, whatever was susceptive to empathy and interpretation. The evocative language of his late style, tending toward abstraction but never yielding to it, had merely prompted this recognition.

Corinth's productivity resumed at an accelerated rate with the portrait, painted on April 4, of Georg Brandes (Georg Morris Cohen; 1842–1927), the Danish literary historian and early expert on Nietzsche (Fig. 195). Corinth had first met him in October 1900 at the home of Max Liebermann,[55] remembering with relish the animated dialogue between Liebermann and Brandes and, above all, the latter's gift for repartee. He recalled Brandes's personality as "glittering" and "sparkling."[56] The intervening twenty-five years had apparently not diminished his wit and lively intelligence. When a speaking engagement brought him back to Berlin in the spring of 1925, Corinth took advantage of the occasion to paint the scholar in his lodgings at the Hotel Kaiserhof, still at breakfast, dressed in a gold-embroidered robe of black silk.

In the portrait, however, details of costume and physiognomy are of little consequence. All that Corinth sought to capture was the essence of Brandes's lively intelligence. The quivering brushstrokes give credence to the scintillating personality and conjure up an impression of restlessness and tension that is further underscored by the asymmetrical placement of the sitter. Flashes of light to the left of the head are balanced on the right by a shock of white hair. At the same time, the phosphorescent colors suggest decay. The predominantly dark tones are pervaded by strokes of dull green and muted yellow and sparing touches of red and brown, equally subdued. As in the portrait of Bernt Grönvold (see Fig. 181), the sitter seems more like an apparition than a living person.

Only a few days later, on April 13 (it was Easter Monday), Corinth began work on what is generally considered his greatest religious painting, the *Ecce Homo* (see Plate 38). He wrote in his diary, "I am about to start a large picture. It will be an Ecce Homo. I am going to complete it, for the Easter time has increased my energy. As an artist I feel a profound affinity for the events of the Bible and its feast days."[57] The huge painting—the figures are larger than life-size—was indeed finished in a matter of days. Both form and conception are indebted to the watercolor of 1913 (see Fig. 134), which may have served as the source of inspiration. The heads rise similarly from the left to the right, and Pilate's gesture encourages the viewer's empathic response. The painting is more rigorously structured, however, than the watercolor. Christ's bound wrists and the rod he holds intersect to form a cross in the very center of the canvas, lending stability to the figures emerging from the amorphous ground. The colors reinforce this implied centrality. The bluish white of Pilate's robe darkens in the guard's armor to slate gray, whereas Christ's mantle glows in shades of a dark, rich red.

Following his old practice, Corinth painted the picture with the aid of models. The painter Paul Paeschke took on the role of the guard, the writer Michael Grusemann that of Pontius Pilate; Corinth's former student Leo Michelson was the model for Christ. The costumes, too, were selected in Corinth's typically perfunctory manner. Pilate's robe is nothing more than an ordinary painter's smock; the equally anachronistic suit of armor was apparently always to be found somewhere in the studio; the red of Christ's garment is based on the memory of a similarly colored blanket Corinth had recently encountered on the overnight train from Munich to Berlin. In the final analysis, however, these props do not matter. There is no real distinction of textures, and the brushstrokes have largely divested the ashen faces of their

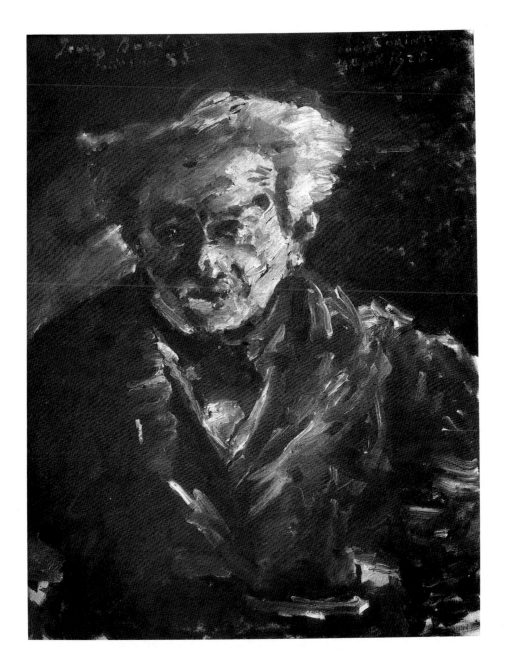

FIGURE 195.
Lovis Corinth, *Portrait of Georg Brandes,*
1925. Oil on canvas, 90 × 70 cm, B.-C.
982. Koninklijk Museum voor Schone
Kunsten, Antwerp.

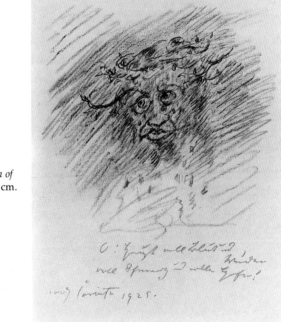

FIGURE 196.
Lovis Corinth, *Self-Portrait as the Man of Sorrows*, 1925. Color crayon, 30 × 24 cm. Private collection.

individualized character. What remains is a poignant evocation of human suffering, not intense and melodramatic, as in *The Red Christ* (see Plate 32), but resigned and conducive to contemplation.

Corinth repeated the *Ecce Homo* almost immediately in a drypoint (M. 884). A second drypoint, known in two states (M. 881, 882), depicts the Resurrection. His comments on the latter are of interest, for they indicate how he transmuted the vividly imagined scenario into a work of expressive simplicity. "What fascinated me about this motif," he writes, "is how . . . on this most beautiful spring morning the women come to the sepulcher, bringing spices and annointing oils; how the disciples Peter and John hurry there, filled with curiosity; and especially how John, being quicker than Peter, arrives first at the tomb and looks inside."[58] The print itself shows nothing of the sort. All that can be made out are four, possibly five, indistinct figures, one crouching, in an interior dimly lit by a supernatural light. Apparently a drawing of the head of Christ wearing the crown of thorns (Fig. 196) dates from about the same time. Reproduced on the last page of Corinth's autobiography, this drawing has always been seen as a self-portrait; and there is indeed a resemblance between the bloodstained features of this Jesus and Corinth's own. In the context of the aging artist's repeated outbursts of anxi-

ety and self-pity, the opening lines of Paul Gerhardt's hymn, "O Haupt voll Blut und Wunden voll Schmerz und voller Hohn," written in red crayon across the bottom of the sheet, further underscore the drawing's autobiographical character.

Also autobiographical, but in a different way, is the portrait of Thomas (see Plate 39) in Essen. Painted on May 3, the picture can be understood as a juxtaposition of different generations, a theme Corinth had explored on a number of occasions: in the handsome double portrait of 1919 of Wilhelmine and her grandmother Hedwig Berend (B.-C. V), in an etching of 1924 (M. 847) entitled *Old Lovis and Young Thomas,* and in a contemporary variation of the print (M. 848). In the Essen portrait the juxtaposition is only implied. Here attention is on the armor that the painter himself had worn so often with pride; it has now been passed on to the son. "I wanted the sword in your hand to gleam like a flash of lightning," Corinth remarked after finishing the picture.[59] Yet twenty-year-old Thomas seems ill at ease in the warrior's role; his posture is awkward and stiff, his gaze full of apprehension. Or could the apprehension be Corinth's own, projected onto the sitter in the knowledge that neither armor nor sword will ultimately protect him against the vicissitudes of life? From a purely technical point of view, the painting is a jewel among Corinth's last paintings, dominated by a harmony of soft grays and pale greens, accented with light blue and brilliant highlights of white. The metallic sheen of the armor dissolves in the frothy texture of the paint. "No spot . . . lacks life," could have been Corinth's own satisfied assessment.

Early in June Corinth also turned his attention once more to the subject of the female nude. In *The Fair Imperia* (Fig. 197) the proud courtesan of Balzac's *Contes drolatiques,* flanked by attendants, stands disrobed before the impecunious young suitor who had dared to enter her chamber. Her body glows like a gem amid a myriad of mixed hues—lavender, pink, red, yellow, and white—alluring in its warm, mature sensuality. Yet in the light that falls on her, she also appears transfigured, a remote manifestation of the ideal femininity that had inspired Corinth so often.

About a month earlier, on May 7, Corinth had completed what turned out to be his last self-portrait in oil (see Plate 40). The painting is similar in composition to the self-portrait of April 1, 1924 (Fig. 190), except that instead of the picture on the studio wall, there is now a mirror in which Corinth's face is reflected a second time in profile. The tension of the earlier self-portrait has given way to a quieter expression: the posture is relaxed, the eyes convey profound sadness, the face looks tired but no longer harried. Signaling Corinth's

progressive physical deterioration, the skin has become delicate and thin, giving new prominence to the bone structure. In the reflection in the mirror, however, the face looks not only younger but also more calm. The quiet tonality of the painting, with its pervasive grays and browns, underscores its expressive content.

Sometime between May 5 and May 8 Corinth also wrote the last entry in his diary. The text has all the qualities of a final statement; it is as calm and detached as the last self-portrait. His thoughts are of his early childhood and he dwells at length on the memory of his mother, on her harsh life, and on her death, which he had witnessed at the age of fourteen. With a confession of his deep affection for his father he concludes: "How can I not be satisfied. Unfortunately, my parents never knew. They would have applauded my success. . . . Even the ambition of my mother would have been completely satisfied."[60]

Corinth apparently had a premonition of death when he painted the *Ecce Homo*. "Perhaps this is going to be my last picture," he told Leo Michelson, his model for the figure of Christ.[61] Yet early in June he was busy making his usual preparations for the summer, ordering and stretching canvases in anticipation of his birthday self-portrait and the landscapes he intended to paint in Urfeld. He even felt enterprising enough to ask Michelson to accompany him to Amsterdam for a fresh look at the paintings of Rembrandt and Frans Hals.

Corinth and Michelson left Berlin on June 16. After stopping briefly in Düsseldorf, they continued by steamer down the Rhine to Holland, taking up residence in the Hotel de l'Europe in Amsterdam. Corinth was eager to explore the city he had last visited more than forty years earlier. His renewed acquaintance with the great masters of the Dutch school seems to have rejuvenated him. In the Rijksmuseum he moved excitedly from picture to picture. He was especially struck by the similarity between Carel Fabritius's *Salome* and his own painting of the subject. Apparently he had never seen Fabritius's picture, not even in a reproduction. He also found time to make an etching of one of the canals (M. 886) and to record other views of the city in a drawing and three watercolors. But on June 22 Corinth suddenly fell ill with pneumonia. Charlotte and the children were immediately summoned to his bedside. After a few days he rallied enough to persuade Charlotte to go to the museum to look at the paintings of Rembrandt and at Fabritius's *Salome*. And sometime in early July he was well enough to be transferred to the Grand Hotel in Zandvoort, on the coast near Haarlem, to a quiet room overlooking the dunes, where he could recuperate, perhaps for the rest of the summer. By

July 12, however, he had suffered a severe relapse, and from then on his condition deteriorated irreversibly. He spoke rarely and eventually ceased speaking altogether. He slipped into a coma on July 16 and died peacefully the following afternoon. Four days later—it would have been Corinth's sixty-seventh birthday—a memorial service was held at the Berlin Secession, and his body was cremated. On November 11 the painter's ashes were laid to rest in the forest cemetery at Stahnsdorf, on the outskirts of Berlin.

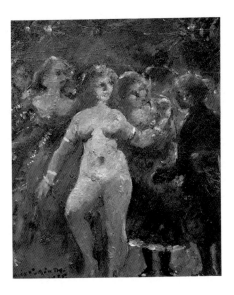

FIGURE 197.
Lovis Corinth, *The Fair Imperia*, 1925.
Oil on wood, 57 × 48 cm, B.-C. XXIV.
Private collection.

NOTES

INTRODUCTION

1. Hans-Jürgen Imiela, *Max Slevogt* (Karlsruhe: Braun, 1968), p. 107.
2. Lovis Corinth, *Gesammelte Schriften* (Berlin: Fritz Gurlitt Verlag, 1920), p. 44.
3. Ibid., p. 45.
4. See the perceptive analysis of the early critical literature on Corinth by Carla Schulz-Hoffmann, "Corinth im Urteil der Kunstkritik bis 1945," in the exhibition catalogue *Lovis Corinth, 1858–1925: Gemälde und Druckgraphik,* ed. Armin Zweite (Munich: Städtische Galerie im Lenbachhaus, 1975), pp. 102–109.
5. Edward Jewell in the exhibition catalogue *Lovis Corinth (1858–1925): Paintings, Drawings, Prints* (New York: Galerie St. Etienne, 1947), p. 3.
6. Quoted from Anita Brenner's review in the *Brooklyn Daily Eagle,* in the exhibition catalogue *Lovis Corinth: Paintings from 1913–1925* (New York: Westermann Gallery, 1939), not paginated.
7. Quoted from the catalogue *Lovis Corinth, 1858–1925: Retrospective Exhibition 1950–51,* not paginated.
8. See the exhibition catalogue *Lovis Corinth* (New York: Gallery of Modern Art, 1964), p. 25.
9. Wolfgang Max Faust and Gerd de Vries, *Hunger nach Bildern: Deutsche Malerei der Gegenwart* (Cologne: DuMont, 1982).
10. See Georg Bussmann, *Lovis Corinth: Carmencita. Malerei an der Kante* (Frankfurt: Fischer Taschenbuch, 1985); Klaus Fussmann, "The Colors of Dirt," *Art Forum* (1986): 106–109; *Lovis Corinth, 1858–1925,* exhibition catalogue, ed. Zdenek Felix (Cologne: DuMont, 1985); Christos M. Joachimides, Norman Rosenthal, and Wieland Schmied, eds., *Deutsche Kunst im 20. Jahrhundert: Malerei und Plastik, 1905–1985* (Munich: Prestel, 1986).

1 YOUTH AND STUDENT YEARS

1. Corinth, *Gesammelte Schriften* (Berlin: Fritz Gurlitt Verlag, 1920), p. 11.
2. Corinth, *Selbstbiographie* (Leipzig: Hirzel, 1926), p. 194.
3. Ibid., p. 190.
4. Ibid., p. 191.
5. Ibid., pp. 12–13.
6. Ibid., p. 181.

7. Corinth's earliest notes for the first chapter of the *Selbstbiographie* go back to the year 1892. They are included, together with original drafts for parts of *Legenden aus dem Künstlerleben* (some of which were not used in the final text), in Thomas Corinth, ed., *Lovis Corinth: Eine Dokumentation* (Tübingen: Wasmuth, 1979), pp. 17, 20–31, 40.

8. Corinth, *Gesammelte Schriften*, p. 12.

9. These early drawings are still in the possession of the artist's family. For a reproduction of *Rain Landscape*, the caricature of Corinth's teacher in the schoolyard, see Lovis Corinth, *Legenden aus dem Künstlerleben*, 3d ed. (Berlin: Bruno Cassirer, 1918), p. 25.

10. The drawing is not dated but is most likely identical with the first self-portrait Corinth is said to have made in 1873; see Charlotte Berend-Corinth, *Die Gemälde von Lovis Corinth* (Munich: Bruckmann, 1958), p. 187. Alfred Rohde, *Der junge Corinth* (Berlin: Rembrandt, 1941), p. 11, fig. 1, dates the drawing 1876.

11. Berend-Corinth, *Die Gemälde von Lovis Corinth*, lists forty-two self-portraits. Not included in her oeuvre catalogue is the one Corinth painted in Paris in 1886; see Rohde, *Der junge Corinth*, frontispiece. The oeuvre catalogues of Corinth's prints, Karl Schwarz, *Das graphische Werk von Lovis Corinth*, 3d enl. ed. (San Francisco: Alan Wofsy Fine Arts, 1985), and Heinrich Müller, *Die späte Graphik von Lovis Corinth* (Hamburg: Lichtwarkstiftung, 1960), account for a total of seventy self-portraits. The number of self-portraits among Corinth's drawings and watercolors cannot be determined, but it most likely exceeds the combined total of the self-portraits among his paintings and prints.

12. Stadt-Museum, Königsberg, *Die Gemälde des Königsberger Stadt-Museums* (Kunstsammlungen Stadt Königsberg, 1884), pp. 16–22.

13. Nikolaus Pevsner, *Academies of Art: Past and Present* (Cambridge: Cambridge University Press, 1940), p. 167; Ulrich Baltzer, "Aus den Anfängen der Königsberger Kunstakademie," in *Königsberger Beiträge* (1929), pp. 10–18.

14. See Lovis Corinth, "Ein Brief des Künstlers an den Herausgeber," *Deutsche Kunst und Dekoration* 41 (1917–1918): 31; and Thomas Corinth, *Lovis Corinth: Eine Dokumentation*, p. 228.

15. Corinth, *Selbstbiographie*, p. 72.

16. Ibid., p. 69. The *Mater dolorosa* of Trossin's engraving is now considered an old copy of the head of the Virgin from Guido Reni's large Crucifixion Altarpiece of 1616–1617 (Pinacoteca Nationale, Bologna), painted for the Capuchin Church outside Bologna. See D. Stephen Pepper, *Guido Reni* (Oxford: Phaidon, 1984), no. 55, pp. 234–235.

17. Corinth, *Selbstbiographie*, p. 68.

18. Corinth, *Legenden aus dem Künstlerleben*, pp. 27–29.

19. Corinth, *Selbstbiographie*, p. 92.

20. Ibid., p. 94.

21. Quoted in the exhibition catalogue *München, 1869–1958: Aufbruch zur modernen Kunst* (Munich: Haus der Kunst, 1958), p. 28.

22. Ibid., p. 24.

23. Wolfgang Becker, *Paris und die deutsche Malerei, 1750–1840*, Studien zur Kunstgeschichte des neunzehnten Jahrhunderts 10 (Munich: Prestel, [1971]), p. 16.

24. Corinth, *Selbstbiographie*, pp. 85–86.

25. U. W. Züricher, ed., *Familienbriefe und Gedichte von Karl Stauffer-Bern* (Leipzig: Insel, 1914), pp. 130–131.

26. Ibid., pp. 115–116.

27. Ibid.

28. See Horst Uhr, "Lovis Corinth's Formation in the Academic Tradition: Evidence of the Kiel Sketchbook and Related Student Drawings," *Arts Magazine* 53 (1978): 87–88, fig. 4.

29. Lovis Corinth, *Das Erlernen der Malerei,* 3d ed. (Berlin, 1920; Hildesheim: Gerstenberg, 1979), p. 136.

30. Corinth, *Gesammelte Schriften,* p. 33.

31. Corinth, *Legenden aus dem Künstlerleben,* pp. 54–55, and *Selbstbiographie,* pp. 100–101.

32. See Erich Hancke, *Max Liebermann: Sein Leben und seine Werke,* 2d ed. (Berlin: Bruno Cassirer, 1923), pp. 79–80.

33. Corinth, *Selbstbiographie,* p. 102.

34. Ibid.

35. On the artists' association *Als Ik Kan,* see Jean F. Buyck, "Antwerp, *Als Ik Kan,* and the Problem of Provincialism," in the exhibition catalogue *Belgian Art, 1800–1914* (Brooklyn, N.Y.: Brooklyn Museum, 1980), pp. 71–80.

36. Corinth, *Legenden aus dem Künstlerleben,* p. 55.

37. See Buyck, "Antwerp, *Als Ik Kan,* and Provincialism," pp. 73–74.

38. Georg Biermann, *Lovis Corinth,* 2d ed. (Bielefeld: Velhagen und Klasing, 1922), pp. 39–40; Rohde, *Der junge Corinth,* p. 96; Alfred Kuhn, *Lovis Corinth* (Berlin: Propyläen, 1925), p. 45; Gert von der Osten, *Lovis Corinth,* 2d rev. ed. (Munich: Bruckmann, 1959), p. 22.

39. Corinth, *Gesammelte Schriften,* p. 35.

40. According to Corinth, the rejected picture was entitled *In Fear.* And according to Wilhelmine Corinth Klopfer, the painting survives, although its present whereabouts is unknown (letter dated March 9, 1989, to the author). Corinth was evidently thinking of some other work, just as he mentioned quite incorrectly that the painting *In Fear* was the only picture he completed in Antwerp. See Corinth, "Ein Brief des Künstlers." A photograph of *In Fear* is reproduced in Thomas Corinth, *Lovis Corinth: Eine Dokumentation,* p. 438, fig. 17.

41. Corinth, *Selbstbiographie,* p. 102.

42. Lajos [Ludwig] Hevesi, *Altkunst-Neukunst: Wien, 1894–1908* (Vienna: C. Konegen, 1909), pp. 581–582.

43. On the Académie Julian, see Lovis Corinth, "In der Akademie Julian," *Kunst und Künstler* 3 (1905): 18–24; Hevesi, *Altkunst-Neukunst,* pp. 579–588; Corinth, *Legenden aus dem Künstlerleben,* pp. 50–68; William Rothenstein, *Men and Memories: Recollections of William Rothenstein, 1872–1900* (New York: Coward-McCann, 1931), 1: 36–50; Archibald Standish Hartrick, *A Painter's Pilgrimage through Fifty Years* (Cambridge: Cambridge University Press, 1939), pp. 13–27; Hermann Schlittgen, *Erinnerungen* (Hamburg-Begedorf: Stromverlag, 1947), pp. 121–130; John Rewald, *Post-Impressionism from Van Gogh to Gauguin,* 2d ed. (New York: Museum of Modern Art, 1962), pp. 272–274; John Milner, *The Studios of Paris: The Capital of Art in the Late Nineteenth Century* (New Haven, Conn.: Yale University Press, 1988), pp. 11–14; Catherine Fehrer, "New Light on the Académie Julian and Its Founder (Rodolphe Julian)," *Gazette des Beaux-Arts* 103 (1984): 207–216.

44. See *Kunst und Künstler* 3 (1905): 22.

45. It is unlikely that, as Beatrice Pages has suggested, the inscription was intended to refer to the title of the famous war memorial of 1882 by Antonin Mercié in the French town of Belfort. The similarity between the inscription "Quand même" at Julian's and the title of Mercié's patriotic monument, *Quand même! ou L'Alsacienne des Tuileries,* is simply a coincidence. See Beatrice Pages, trans., "Un étudiant Allemand à Paris à l'Académie Julian," *Gazette des Beaux-Arts* 97 (1981): 225, n. 8. (This is a French translation of Corinth's article "In der Akademie Julian.")

46. Cf. Corinth, *Legenden aus dem Künstlerleben,* p. 57. The portrait drawing of Calame, dated 1884, is preserved in the Kestner-Museum, Hannover; a gouache portrait of Blaas (1885; private collection) is reproduced in the exhibition catalogue *Lovis Corinth. Das Porträt* (Karlsruhe: Badischer Kunstverein, 1967), no. 92.

47. Corinth, *Selbstbiographie*, p. 105.

48. Corinth, *Gesammelte Schriften*, p. 30.

49. Ibid., p. 108.

50. Hancke, *Max Liebermann*, p. 78.

51. Corinth, *Legenden aus dem Künstlerleben*, p. 52.

52. Corinth, "In der Akademie Julian," 19; and *Legenden aus dem Künstlerleben*, pp. 52–53.

53. Corinth, *Legenden aus dem Künstlerleben*, pp. 65–66.

54. Corinth, *Selbstbiographie*, p. 104.

55. Schlittgen, *Erinnerungen*, p. 126.

56. Jean Crespelle, *Les maîtres de la belle époque* (Paris: Hachette, 1966), p. 89.

57. Corinth, *Gesammelte Schriften*, p. 15.

58. Thomas Corinth, *Lovis Corinth: Eine Dokumentation*, p. 32; for the context, see the column by Beurmann in the *Basler Nachrichten*, July 29, 1925, reprinted on pp. 31–32.

59. See Corinth, *Legenden aus dem Künstlerleben*, p. 68.

60. Corinth, *Selbstbiographie*, p. 108.

61. Corinth, "In der Akademie Julian," 21; and *Legenden aus dem Künstlerleben*, pp. 60–61.

62. See Georg Biermann, *Der Zeichner Lovis Corinth*, Arnolds Graphische Bücher, vol. 2, series 5 (Dresden, 1924), p. 10; on this drawing see also Thomas Deecke, "Die Zeichnungen von Lovis Corinth: Studien zur Stilentwicklung" (Ph.D. diss., Freie Universität, Berlin, 1973), pp. 35–36, no. 17, and p. 189, n. 68.

63. Horst Uhr, "The Drawings of Lovis Corinth" (Ph.D. diss., Columbia University, New York, 1975), pp. 75–77, plates 33–37.

64. For a recollection of Corinth's summer in Panker, see the column by E. Schaumburg from an unidentified newspaper of 1926, reprinted in Thomas Corinth, *Lovis Corinth: Eine Dokumentation*, pp. 33–34.

65. Ibid., p. 33.

66. Uhr, "The Drawings of Lovis Corinth," p. 79, plates 39, 40.

67. Corinth, *Selbstbiographie*, p. 105.

68. Corinth, *Das Erlernen der Malerei*, pp. 58–59.

69. Cf. Aristide Michel Perrot, *Manuel de dessinateur; ou, traité complet du dessin*, ed. A. Vergnaud, 3d rev. and enl. ed. (Paris, 1832), p. 105.

70. Corinth, *Das Erlernen der Malerei*, p. 88.

71. Ibid., pp. 88–89.

72. Walter Leistikow, "Über das Erlernen der Malerei," *Die Kunst für Alle* 23 (1908): 351.

73. Margarethe Moll, "Erinnerungen an Lovis Corinth," *Neue deutsche Hefte* 2 (1955): 197.

2 INDECISION AND CHANGE

1. Lovis Corinth, *Selbstbiographie* (Leipzig: Hirzel, 1926), p. 105.

2. Ibid., pp. 105–106.

3. Werner Doede, *Berlin: Kunst und Künstler seit 1870* (Recklinghausen: Bongers, 1961), p. 39.

4. Paul Ortwin Rave, *Kunst in Berlin* (Berlin: Staneck Verlag, [1965]), p. 162.

5. For the exhibition reviews by Friedrich Pecht, see *Die Kunst für Alle* 1, no. 18–2, no. 3 (1886).

6. Pecht, in *Die Kunst für Alle* 1 (1886): 268.

7. See Georg Voss, "Die Berliner Kunstausstellung," *Die Kunst für Alle* 2 (1887): 356–359 and 369–371.

8. See Cornelius Gurlitt, *Die deutsche Kunst seit 1800: Ihre Ziele und Taten,* 4th ed. (Berlin: Georg Bondi, 1924), pp. 419–420.

9. Laforgue's essay, originally intended for translation and publication in a German newspaper, was subsequently published under the title "L'Impressionisme" in Jules Laforgue, *Mélanges posthumes,* vol. 3 of *Oeuvres complètes,* 4th ed. (Paris: Mercure, 1902–1903), 133–144. See also Barbara Ehrlich White, *Impressionism in Perspective* (Englewood Cliffs, N. J.: Prentice Hall, c. 1978), pp. 33–34.

10. Corinth, *Selbstbiographie,* p. 106.

11. Gert von der Osten, *Lovis Corinth,* 2d rev. ed. (Munich: Bruckmann, 1959), p. 188. Von der Osten also lists an artist by the name of Rehländer. Herrmann Katsch mentions several additional members: Nicolaus Geiger, Johann Mühlenbruch, and one Kurt Herrmann Zaak. Two architects, one called Eichhorn, the other Höniger, also attended the *Abendakt.* See Herrmann Katsch, "Meine Erinnerungen an Karl Stauffer-Bern," *Die Kunst für Alle* 25 (1909): 11–18 and 59–68.

12. Käthe Kollwitz studied with Stauffer-Bern for one year, from 1885 to 1886. Recognizing her innate talent as a graphic artist, Stauffer-Bern encouraged her to develop her drafting, although she herself was at the time still thinking of becoming a painter. Stauffer-Bern introduced Kollwitz to the prints of Max Klinger, whose cycle *A Life* (1883) made a deep impression on the young woman. Klinger's work was to remain for her a lifelong source of inspiration. See Käthe Kollwitz, *Ich will wirken in dieser Zeit,* introd. Friedrich Ahlers-Hestermann (Berlin: Mann, 1952), p. 31.

13. See Max Lehrs, *Karl Stauffer-Bern, 1857–1891: Ein Verzeichnis seiner Radierungen und Stiche* (Dresden: Ernst Arnold, 1907); and Hans Wolfgang Singer, *Karl Stauffer-Bern: Die Radierungen und Stiche des Künstlers* (Berlin: Amsler und Ruthardt, 1919).

14. Quoted in Georg Jacob Wolf, *Karl Stauffer-Bern* (Munich: D. und R. Bischoff, 1907), p. 17.

15. Conrad von Mandach, *Stauffer-Bern: Handzeichnungen* (Landschlacht/Bodensee: Verlag Dr. Carl Hoenn, [1924]), pp. 8–10.

16. Heinrich Weizsäcker, "Karl Stauffer-Bern," *Die Kunst unserer Zeit* 3 (1892): 55.

17. Lovis Corinth, *Gesammelte Schriften* (Berlin: Fritz Gurlitt Verlag, 1920), p. 50.

18. Wolf, *Karl Stauffer-Bern,* p. 50.

19. See Herbert Eulenberg, *Lovis Corinth: Ein Maler unserer Zeit* (Munich: Delphin, 1917), p. 8; and Paul Eipper, *Ateliergespräche mit Liebermann und Corinth,* ed. Veronika Eipper (Munich: Piper, 1971), pp. 52–53.

20. The inscription "Paris 1885" on the drawing in Hamburg was added at a later date. The drawing is stylistically incompatible with Corinth's graphic output from the Paris years but entirely in keeping with the drawings he made at Der Nasse Lappen.

21. Corinth, *Gesammelte Schriften,* p. 15.

22. Lovis Corinth, *Das Erlernen der Malerei,* 3d ed. (Berlin, 1920; Hildesheim: Gerstenberg, 1979), p. 135.

23. For an excerpt from the review published in the *Berliner National Zeitung* in February 1888, see Thomas Corinth, ed., *Lovis Corinth: Eine Dokumentation* (Tübingen: Wasmuth, 1979), p. 36.

24. Charlotte Berend-Corinth, *Lovis* (Munich: Langen–Georg Müller Verlag, 1958), pp. 114–115.

25. Charlotte Berend-Corinth, *Die Gemälde von Lovis Corinth* (Munich: Bruckmann, 1958), p. 60.

26. Alfred Rohde, *Der junge Corinth* (Berlin: Rembrandt, 1941), p. 108.

27. Corinth, *Selbstbiographie*, p. 108.

28. Besides the painting in Munich, which remained in Trübner's possession until 1910, the *Christ in the Tomb* is known in two additional, closely related, versions (Kunsthalle, Hamburg; Staatsgalerie, Stuttgart). Corinth, who became closely acquainted with Trübner only in 1892, may have seen the painting in Munich in the early 1880s. Writing in 1913, he praised the picture as Trübner's best work and went so far as to compare it favorably with works by Holbein and Grünewald. See Corinth, *Gesammelte Schriften*, p. 36.

29. Corinth, *Selbstbiographie*, p. 108.

30. Thomas Corinth, *Lovis Corinth: Eine Dokumentation*, p. 78.

31. Peter Hahn, "Das literarische Figurenbild bei Lovis Corinth" (Ph.D. diss., Eberhard-Karls-Universität, Tübingen, 1970), p. 44.

32. See Rohde, *Der junge Corinth*, p. 120.

33. For references to the painting, see Berend-Corinth, *Die Gemälde von Lovis Corinth*, p. 64.

34. See Thomas Deecke, "Die Zeichnungen von Lovis Corinth: Studien zur Stilentwicklung" (Ph.D. diss., Freie Universität, Berlin, 1973), pp. 46–47.

35. Corinth, *Selbstbiographie*, p. 108.

36. August Endell, *Um die Schönheit: Eine Paraphrase über Münchner Kunstausstellungen 1896* (Munich: Verlag Emil Franke, 1896), pp. 66–67.

37. Lovis Corinth, *Legenden aus dem Künstlerleben*, 3d ed. (Berlin: Bruno Cassirer, 1918), p. 86.

38. Gurlitt, *Die deutsche Kunst seit 1800*, p. 407.

39. Kenworth Moffett, *Meier-Graefe as Art Critic*. Studien zur Kunst des neunzehnten Jahrhunderts 19 (Munich: Prestel, [1973]), p. 54.

40. Hans Rosenhagen, *Würdigungen* (Berlin: Hermann Nabel, 1902), p. 81.

41. Quoted in John Rewald, *Post-Impressionism from Van Gogh to Gauguin*, 2d ed. (New York: Museum of Modern Art, 1962), p. 149.

42. Hermann Bahr, *Die Überwindung des Naturalismus* (Dresden: E. Pierson, 1891), p. 152.

43. Gurlitt, *Die deutsche Kunst seit 1800*, p. 402.

44. The critical events leading up to the founding of the Munich Secession took place between February and November 1892. For a detailed account, see Hermann Uhde-Bernays, *Die Münchner Malerei im neunzehnten Jahrhundert*, vol. 2, *1850–1900* (Munich: Bruckmann, 1927), pp. 233–241. For additional observations, see Corinth, *Selbstbiographie*, pp. 108–109; Hermann Schlittgen, *Erinnerungen* (Hamburg-Begedorf: Stromverlag, 1947), pp. 198–199; and Siegfried Wichmann, *Secession: Europäische Kunst um die Jahrhundertwende* (Munich: Haus der Kunst, 1964), pp. 6–9.

45. Cf. Corinth, *Selbstbiographie*, pp. 110–111, and Schlittgen, *Erinnerungen*, p. 109.

46. For Eckmann's letter to Trübner, see Hans-Jürgen Imiela, *Max Slevogt* (Karlsruhe: Braun, 1968), p. 352, n. 19.

47. Corinth, *Selbstbiographie*, p. 109.

48. See the excerpt from a review of January 29, 1892, in Thomas Corinth, *Lovis Corinth: Eine Dokumentation*, pp. 38–39.

49. Corinth, *Gesammelte Schriften*, p. 33.

50. This humorous skit, which was never performed because of Corinth's break with the Munich Artists' Association, is published in Alfred Kuhn, *Lovis Corinth* (Berlin: Propyläen, 1925), pp. 209–212. For a well-illustrated, concise history of Allotria, see Eugen Roth, ed., *Ein halbes Jahrhundert Münchner Kulturgeschichte: Erlebt mit der Künstlergesellschaft Allotria* (Munich: Thiemig, 1959). For Corinth's own memories of this beloved institution, see *Legenden aus dem Künstlerleben*, pp. 131–156.

51. Berend-Corinth, *Die Gemälde von Lovis Corinth,* p. 65, no. 92.

52. On Arthur Langhammer, another member of Allotria, and his faithful dog Hipp, see Corinth, *Legenden aus dem Künstlerleben,* pp. 137–138.

53. Quoted from the exhibition catalogue *Katalog der Ausstellung des Nachlasses Walter Leistikows in Berlin W.* (Berlin: Salon Cassirer, 1908), p. 14.

54. See Kathryn Bloom Hisinger, ed., *Art Nouveau in Munich: Masters of Jugendstil* (Munich: Prestel, in association with the Philadelphia Museum of Art, 1988), pp. 49–55.

55. Friedrich Ahlers-Hestermann, *Stilwende: Aufbruch der Jugend um 1900* (Berlin: Mann, 1941), p. 27.

56. Corinth, *Legenden aus dem Künstlerleben,* pp. 73–74; see also Hisinger, *Art Nouveau in Munich,* pp. 158–159.

57. Corinth, *Gesammelte Schriften,* p. 20.

58. Ibid., p. 15.

59. Ibid., p. 16.

60. Hahn, "Das literarische Figurenbild bei Lovis Corinth," pp. 58–64.

61. Max Klinger, *Malerei und Zeichnung,* 6th ed. (Leipzig: Thieme, 1913), p. 65.

62. Hans Wolfgang Singer, ed., *Briefe von Max Klinger aus den Jahren 1874–1919* (Leipzig: Seemann, 1924), pp. 65–66.

63. Klinger, *Malerei und Zeichnung,* p. 44.

64. Ibid.

65. See the excerpt from the review in *Die Gegenwart,* reproduced in Thomas Corinth, *Lovis Corinth: Eine Dokumentation,* pp. 44–45.

66. Corinth's admiration for Heine and Gulbransson is documented by his articles "Thomas Theodor Heine und Münchens Kunstleben am Ende des vorigen Jahrhunderts," *Kunst und Künstler* 4 (1906): 143–156, and "Olaf Gulbransson," *Kunst und Künstler* 6 (1907): 55–64; reprinted in Corinth, *Legenden aus dem Künstlerleben,* pp. 83–98 and 99–109, respectively.

67. Corinth's other illustrations for *Jugend* include *A Secret* (*Jugend* 1:57), *Nude Girl by the Water* (*Jugend* 1:312), and *Faust: The Garden Scene* (*Jugend* 1:647). *Sleep, Baby, Sleep,* an illustration to Paul Cahr's short story of the same title, appeared in *Simplizissimus* 1, no. 21.

68. Joseph Ruederer, *Tragikomödien* (Berlin: Georg Bondi, 1897).

69. See p. 68.

70. Corinth, *Gesammelte Schriften,* p. 18.

71. See Hahn, "Das literarische Figurenbild bei Lovis Corinth," p. 71.

72. See Berend-Corinth, *Lovis,* p. 227.

73. See Corinth, *Das Erlernen der Malerei,* p. 163.

74. For an excerpt from the review, see Thomas Corinth, *Lovis Corinth: Eine Dokumentation,* p. 48.

75. For a reproduction of the caricature, see the exhibition catalogue *Lovis Corinth, 1858–1925: Gemälde und Druckgraphik* (Munich: Städtische Galerie im Lenbachhaus, 1975), p. 36.

76. See Thomas Corinth, *Lovis Corinth: Eine Dokumentation,* p. 45.

77. See Hahn, "Das literarische Figurenbild bei Lovis Corinth," pp. 122–124.

78. Friedrich Wolters, *Stefan George und die Blätter für die Kunst: Deutsche Geistesgeschichte seit 1890* (Berlin: Georg Bondi, 1930), p. 81.

79. Peg Weiss, *Kandinsky in Munich: The Formative Jugendstil Years* (Princeton, N. J.: Princeton University Press, 1979), p. 192, n. 17.

80. Julius Meier-Graefe, *Entwicklungsgeschichte der modernen Kunst,* 2d ed. (Stuttgart: J. Hoffmann, 1924), 2:710.

81. See Andreas Haus, "Gesellschaft, Geselligkeit, Künstlerfest: Franz von Lenbach und die Münchner Allotria," in the exhibition catalogue *Franz von Lenbach, 1836–1904*, ed. Rosel Gollek and Winfried Ranke (Munich: Städtische Galerie im Lenbachhaus, 1986), pp. 99–116.

82. Quoted from the anonymous article "Das Münchner Künstlerfest 1898," *Die Kunst für Alle* 13 (1898): 197–198.

83. Max Halbe, *Gesammelte Werke* (Munich: A. Langen, 1917), 1: 5:

Dir ist bestimmt zu wandern auf Erden.
Der andern ihr Glück soll deines nicht werden.
Sollst suchen und irren in unsteter Hast,
An reichster Tafel friedloser Gast.

Und wie du auch jagst von Westen nach Osten,
Den Jammer der Welt, du sollst ihn durchkosten,
Und wo du nur irrst in Nord oder Süd,
Dein Kräutlein, dein Kräutlein nirgendwo blüht.

Zu suchen bist du verdammt auf Erden.
Der andern ihr Glück soll deines nicht werden,
Der andern Ihr Frieden, dir leiht er nicht Ruh!
Ein flüchtiger Wandrer, ein Kämpfer bist du.

84. Max Halbe, *Jahrhundertwende: Geschichte meines Lebens, 1893–1914* (Danzig: A. W. Kafemann, 1935), p. 329.

85. Friedrich Nietzsche, *Gesammelte Werke* (Leipzig: Kröner, 1910), 6: 67.

86. Halbe, *Jahrhundertwende*, p. 113.

87. For a detailed account of Nietzsche's expanding reputation in Germany in the 1890s, see R. A. Nicholls, "Beginning of the Nietzsche Vogue in Germany," *Modern Philosophy* 56 (1958–1959): 24–37.

88. See Corinth's letter of July 18, 1898, to Dr. Carl Graeser, in Thomas Corinth, *Lovis Corinth: Eine Dokumentation*, p. 53.

89. See Wolfgang Schlenck, *100 Jahre Evangelische Kirche Bad Tölz, 1880–1980* (Bad Tölz: Evangelisch-Lutherisches Pfarramt, 1980), no pagination; and Peter-Klaus Schuster, *"München leuchtete": Karl Caspar und die Erneuerung christlicher Kunst in München um 1900* (Munich: Prestel, 1984), pp. 197–198.

90. See Corinth's letter of November 4, 1901, to Dr. Carl Graeser, in Thomas Corinth, *Lovis Corinth: Eine Dokumentation*, p. 67.

91. This relief is reproduced in Rohde, *Der junge Corinth*, p. 118, fig. 86; for a related discussion of similar themes by the young Max Beckmann, see Barbara C. Buenger, "Max Beckmann's Amazonenschlacht: Tackling 'die grosse Idee,'" *Pantheon* 42 (1984): 140–150.

92. Cf. Joseph Ruederer, *Wallfahrer- Maler- und Mördergeschichten*, 3d ed. (Munich: Süddeutsche Monatshefte, 1913), p. 88.

93. Halbe, *Jahrhundertwende*, p. 272.

94. In 1898 and 1900 Corinth painted individual portraits of two of the men included in the Munich group portrait (B.-C. 163, 204). In 1906 and 1919 he painted portraits of two other members of the lodge (B.C. 329, 779, 780). The Johannes Lodge originally possessed three of these portraits; it still owns the portrait of Conrad Müller (B.-C. 204), standing second from the left in the group portrait.

95. For the identification of the individuals represented, see Hans-Jürgen Imiela, "Die Porträts Lovis Corinths" (Ph.D. diss., Johannes-Gutenberg-Universität, Mainz, 1955), p. 201, n. 162.

96. See ibid., p. 46.

97. See Leo Michelson, "Corinths letzte Tage in Amsterdam," *Kunst und Künstler* 26 (1926): 14.

98. See Imiela, "Die Porträts Lovis Corinths," pp. 45–46, 202, n. 164, for specific examples of paintings by Dirck Jacobsz.

99. See Doede, *Berlin: Kunst und Künstler seit 1870*, p. 55; and Lovis Corinth, *Das Leben Walter Leistikows: Ein Stück Berliner Kulturgeschichte* (Berlin: Paul Cassirer, 1910), pp. 29–50.

100. *Das Leben Walter Leistikows*, pp. 51–66; and Peter Paret, *The Berlin Secession: Modernism and Its Enemies in Imperial Germany* (Cambridge: Harvard University Press, Belknap Press, 1980), pp. 59–91.

101. Liebermann's introduction is reprinted in Max Liebermann, *Gesammelte Schriften* (Berlin: Bruno Cassirer, 1922), pp. 255–256.

102. See Thomas Corinth, *Lovis Corinth: Eine Dokumentation*, pp. 57–58. For the portrait Corinth painted at this time of Max Liebermann, see Berend-Corinth, *Die Gemälde von Lovis Corinth*, B.-C. 180.

103. See the letter from Hans Rosenhagen to Charlotte Berend, in Berend-Corinth, *Die Gemälde von Lovis Corinth*, pp. 191–192.

104. See also Imiela, "Die Porträts Lovis Corinths," pp. 56–57.

105. Despite the date inscribed on the canvas, Charlotte Berend dates the picture 1899. See Berend-Corinth, *Die Gemälde von Lovis Corinth*, B.-C. 171.

106. See Hugo Daffner, *Salome: Ihre Gestalt in Geschichte und Kunst. Dichtung—bildende Kunst—Musik* (Munich: H. Schmidt, [c. 1912]); see also J. Adolf Schmoll gen. Eisenwerth, "Salome 1900," *Du* 8 (1981): 45–53; and in the same issue, 20–44, 54–59; for a more recent, feminist, account of the popularity of the Salome theme, see Bram Dijkstra, *Idols of Perversity: Fantasies of Feminine Evil in Fin-de-Siècle Culture* (New York: Oxford University Press, 1986), pp. 379–393.

107. Cf. Mario Praz, *The Romantic Agony*, 2d ed. (London: Oxford University Press, 1970), p. 315; Dijkstra, *Idols of Perversity*, pp. 395–396; Jules Laforgue, *Six Moral Tales*, ed. and trans. Frances Newman (New York: Horace Liveright, 1928).

108. In Berend-Corinth's catalogue this painting is incorrectly dated 1899. On the origin of the portrait, see the excerpt from the letter of January 29, 1959, from Bianca Israel to Thomas Corinth, in Thomas Corinth, *Lovis Corinth: Eine Dokumentation*, pp. 59–60.

109. Hans Rosenhagen, "Die zweite Ausstellung der Berliner Secession," *Die Kunst* 1 (1900): 462.

110. See the note on p. 307 of Alfred Lichtwark, *Briefe an Max Liebermann*, ed. Carl Schellenberg (Hamburg: J. Trautmann [im Auftrage der Lichtwarkstiftung], 1947).

111. Paul Fechter, *Menschen und Zeiten: Begegnungen aus fünf Jahrzehnten* (Gütersloh: C. Bertelsmann, [c. 1948]), p. 94.

112. See Corinth, *Selbstbiographie*, p. 119.

113. See the various letters mentioning the painting, in Thomas Corinth, *Lovis Corinth: Eine Dokumentation*, pp. 65–66.

114. The date on the canvas, somewhat illegible, is frequently read as 1900. The last numeral, however, can just as easily be read as a 1. Max Halbe, moreover, remembers the portrait as having been painted in 1901. See Halbe, *Jahrhundertwende*, p. 325.

115. As a result of subsequent renumbering, this house later had the number 48.

3 MATURITY

1. For a useful reference, see Donald E. Gordon, *Modern Art Exhibitions, 1900–1916,* Materialien zur Kunst des 19. Jahrhunderts, vol. 14, parts 1–2 (Munich: Prestel, 1974).

2. Quoted from Peter Paret, *The Berlin Secession* (Cambridge: Harvard University Press, Belknap Press, 1980), p. 65.

3. Quoted from Werner Doede, *Berlin: Kunst und Künstler seit 1870* (Recklinghausen: Bongers, 1961), p. 82.

4. See Lovis Corinth, *Das Leben Walter Leistikows: Ein Stück Berliner Kulturgeschichte* (Berlin: Paul Cassirer, 1910), p. 29.

5. Paret, *The Berlin Secession,* p. 81; see also Marion F. Deshmukh, "Art and Politics in Turn-of-the-Century Berlin: The Berlin Secession and Kaiser Wilhelm II," in *Turn of the Century: German Literature and Art, 1890–1915,* ed. Gerald Chapple and Hans H. Schulte, 463–475, McMaster Colloquium on German Literature 2 (Bonn: Bouvier, 1981).

6. Lovis Corinth, *Selbstbiographie* (Leipzig: Hirzel, 1926), p. 149.

7. For the memories of Wanda Schlepp, see Thomas Corinth, ed, *Lovis Corinth: Eine Dokumentation* (Tübingen: Wasmuth, 1979), pp. 107–108; for further brief references, see the letter of November 15, 1907, from August Macke to his wife and the letter of August 12, 1960, from Jakob Steinhardt to Thomas Corinth, excerpted in ibid., p. 116.

8. Corinth, *Selbstbiographie,* p. 120.

9. Ibid.

10. See Charlotte Berend-Corinth, *Mein Leben mit Lovis Corinth* (Munich: List, 1958), p. 86 (entry for March 15, 1926); and Charlotte Berend-Corinth, *Lovis Corinth: Bildnisse der Frau des Künstlers,* introd. Carl Georg Heise (Stuttgart: Reclam, 1958), pp. 18–19.

11. Berend-Corinth, *Mein Leben mit Lovis Corinth,* p. 18 (entry for September 26, 1925).

12. Ibid., pp. 117–120 (entry for April 30, 1927).

13. Both the drawing and the oil sketch were signed at a later date and incorrectly inscribed with the year 1903.

14. Berend-Corinth, *Lovis Corinth: Bildnisse der Frau des Künstlers,* p. 21.

15. See Lovis Corinth, *Das Erlernen der Malerei,* 3d ed. (Berlin, 1920; Hildesheim: Gerstenberg, 1979), pp. 10, 139.

16. Hans-Jürgen Imiela, "Die Porträts Lovis Corinths" (Ph.D. diss., Johannes-Gutenberg-Universität, Mainz, 1955), p. 82.

17. Charlotte Berend-Corinth, *Lovis* (Munich: Langen–Georg Müller Verlag, 1958), pp. 125–126.

18. Elvira Olschky, "Erinnerungen an Corinth," *Die Kunst* 27 (1926): 248.

19. Max Liebermann, *Die Phantasie in der Malerei: Schriften und Reden,* ed. and introd. Günter Busch (Frankfurt: S. Fischer, 1978), p. 49.

20. Gustav Pauli, "Lovis Corinth," *Kunst und Künstler* 16 (1918): 338.

21. Julius Meier-Graefe, *Entwicklungsgeschichte der modernen Kunst,* 3d ed. (Munich: Piper, 1920), 2: 361–362.

22. Corinth, *Selbstbiographie,* pp. 120–121.

23. Barbara C. Buenger, "Max Beckmann's Amazonenschlacht: Tackling 'die grosse Idee,'" *Pantheon* 42 (1984): 140–150. For a later influence of Corinth on Beckmann, see Siegfried Gohr, "Max Beckmanns zwei Frauen von 1940—eine Antwort auf Corinth," *Museen der Stadt Köln Bulletin* 4 (1982): 44–45.

24. See Corinth, *Das Erlernen der Malerei,* opposite p. 48.

25. Ibid., p. 170.

26. Berend-Corinth, *Mein Leben mit Lovis Corinth*, p. 94 (entry for May 18, 1926).

27. Corinth, *Selbstbiographie*, p. 165.

28. Charlotte Berend-Corinth, *Die Gemälde von Lovis Corinth* (Munich: Bruckmann, 1958), p. 88.

29. See Peter Hahn, "Das literarische Figurenbild bei Lovis Corinth" (Ph.D. diss., Eberhard-Karls-Universität, Tübingen, 1970), p. 91.

30. Ibid.

31. In a letter Liebermann wrote to Wilhelm Bode; quoted in Hermann Uhde-Bernays, ed., *Künstlerbriefe über Kunst: Bekenntnisse von Malern, Architekten, und Bildhauern aus fünf Jahrhunderten* (Dresden: W. Jess, [1926]), p. 649.

32. Cf. Peter Selz, "E. L. Kirchner's 'Chronik der Brücke,'" *College Art Journal* 10 (1950): 50.

33. Peter Selz, *Max Beckmann*, exhibition catalogue (New York: Museum of Modern Art, 1964), pp. 26–30.

34. See Horst Uhr, "The Drawings of Lovis Corinth" (Ph.D. diss., Columbia University, 1975), p. 177, plate 114; and Hahn, "Das literarische Figurenbild bei Lovis Corinth," p. 91.

35. Berend-Corinth, *Die Gemälde von Lovis Corinth*, p. 95.

36. Berend-Corinth, *Mein Leben mit Lovis Corinth*, p. 59 (entry for December 16, 1925).

37. Corinth, *Das Erlernen der Malerei*, p. 89.

38. Berend-Corinth, *Lovis*, p. 104. For other figure compositions in this context, see B.-C. 229, 231, 315, 323, 337, 348, 349, 351, 353, 387, 388, 390, 412, 415, 416, 418, 457, 459, 476.

39. Berend-Corinth, *Die Gemälde von Lovis Corinth*, p. 100.

40. Corinth, *Das Erlernen der Malerei*, pp. 88–89.

41. Ibid., p. 131.

42. For Corinth's comments on this painting, see his letters to Charlotte Berend in Thomas Corinth, *Lovis Corinth: Eine Dokumentation*, pp. 76–81.

43. Georg Biermann, *Lovis Corinth*, 2d ed. (Bielefeld: Velhagen und Klasing, 1922), pp. 88–89.

44. See Trudis Goldsmith-Reber, "Max Reinhardt als Wegbereiter der modernen Bühnenkunst: Seine Zusammenarbeit mit Malern und Architekten von 1905–1915," in Chapple and Schulte, *Turn of the Century: German Literature and Art, 1890–1915*, pp. 291–310.

45. Carl Niessen, *Max Reinhardt und seine Bühnenbilder* (Cologne: Wallraf-Richartz-Museum, 1958), p. 13.

46. See Oliver Martin Sayler, ed., *Max Reinhardt and His Theatre* (New York: Brentano's, [1924]), p. 134.

47. In 1911 Corinth also prepared two oil sketches for *Das Rheingold* (B.-C. 513, 514) as part of a projected new production of Wagner's *Ring* cycle at the Dresden Opera. See Thomas Corinth, *Lovis Corinth: Eine Dokumentation*, pp. 149, 151. As late as 1922 Victor Barnowsky commissioned Corinth to paint sixteen oil sketches (B.-C. 877–892) that were translated by professional scenery painters into sets for a performance of Goethe's *Faust* at the Lessingtheater, Berlin. For this production Corinth also prepared twenty color sketches for figurines of the major characters. See ibid., pp. 285, 287, 288.

48. Corinth, *Das Erlernen der Malerei*, p. 143.

49. Tilla Durieux, *Eine Tür steht offen: Erinnerungen* (Berlin-Grunewald: Herbig, [c. 1954]), pp. 26–27.

50. Franz Hadamowsky, ed., *Max Reinhardt: Ausgewählte Briefe, Reden, Schriften, und Szenen aus Regiebüchern* (Vienna: Prachner, 1963), p. 18.

51. Ibid., p. 91.

52. Durieux, *Eine Tür steht offen,* p. 39. For Corinth's role portraits, see also the chapter "Das Schauspieler-Rollenporträt," in Imiela, "Die Porträts Lovis Corinths," pp. 98–106.

53. Berend-Corinth, *Lovis,* p. 103.

54. Quoted from Hans Konrad Röthel, introduction to Berend-Corinth, *Die Gemälde von Lovis Corinth,* p. 42.

55. Gert von der Osten, *Lovis Corinth,* 2d rev. ed. (Munich: Bruckmann, 1959), p. 96.

56. Margarethe Moll, "Erinnerungen an Lovis Corinth," *Neue deutsche Hefte* 2 (1955): 196.

57. Corinth, *Selbstbiographie,* p. 89.

58. Ibid., p. 90.

59. Berend-Corinth, *Lovis,* p. 82.

60. See Paret, *The Berlin Secession,* p. 201.

61. Karl Scheffler, "Berliner Secession," *Kunst und Künstler* 10 (1912): 434. For the controversies surrounding the Secession, see Paret, *The Berlin Secession,* pp. 200–217.

62. Carl Vinnen, ed., *Ein Protest deutscher Künstler* (Jena: E. Diederichs, 1911).

63. Reprinted in Lovis Corinth, *Gesammelte Schriften* (Berlin: Fritz Gurlitt Verlag, 1920), pp. 59–62.

64. Subsequently reprinted as Alfred Walter Heymel, ed., *Deutsche und Französische Kunst* (Munich, 1911).

65. On Vinnen's *Protest deutscher Künstler* and the various responses, see Paret, *The Berlin Secession,* pp. 182–199.

66. See Corinth, *Das Erlernen der Malerei,* pp. 85–86.

67. See Emil Waldmann, "Edouard Manet in der Sammlung Pellerin," *Kunst und Künstler* 8 (1910): 387–398.

68. See Liebermann, *Die Phantasie in der Malerei: Schriften und Reden,* pp. 43–66.

69. Quoted in Hans-Jürgen Imiela, *Max Slevogt* (Karlsruhe: Braun, 1968), p. 122. On the problematic nature of "German Impressionism," see the chapter "Der sogenannte deutsche Impressionismus," pp. 107–125.

70. Alfred Lichtwark, *Das Bildnis in Hamburg* (Hamburg: Der Kunstverein zu Hamburg, 1899), 1: 7–9.

71. Alfred Hentzen, "Die Entstehung der Bildnisse des Historikers Eduard Meyer von Lovis Corinth in der Kunsthalle in Hamburg," *Jahrbuch der Hamburger Kunstsammlungen* 6 (1961): 117–142.

72. Ibid., 127–128.

73. Lichtwark suggested that the pages might be the text of an address the dean was about to give. See ibid., 135.

74. See ibid., 142.

4 CRISIS

1. See Gert von der Osten, *Lovis Corinth,* 2d rev. ed. (Munich: Bruckmann, 1959), p. 113.

2. Lovis Corinth, *Selbstbiographie* (Leipzig: Hirzel, 1926), p. 123.

3. See Alfred Kuhn, "Erinnerungen an Lovis Corinth," *Zeitschrift für bildende Kunst* 59 (1925): 196.

4. Charlotte Berend-Corinth, *Mein Leben mit Lovis Corinth* (Munich: List, 1958), p. 103 (entry for November 3, 1926), and *Lovis* (Munich: Langen–Georg Müller Verlag, 1958), pp. 132–133.

5. See also Thomas Corinth, ed., *Lovis Corinth: Eine Dokumentation* (Tübingen: Wasmuth, 1979), p. 156.

6. Berend-Corinth, *Lovis*, pp. 133–141.

7. See also Imiela, "Die Porträts Lovis Corinths" (Ph.D. diss., Johannes-Gutenberg-Universität, Mainz, 1955), p. 131.

8. Charlotte Berend-Corinth, *Lovis Corinth: Bildnisse der Frau des Künstlers* (Stuttgart: Reclam, 1958), pp. 17–18.

9. Berend-Corinth, *Lovis*, pp. 148–149.

10. Ibid., p. 140.

11. See Peter Selz, *German Expressionist Painting* (Berkeley: University of California Press, 1957), pp. 250–271. The Sonderbund exhibition, incidentally, also served as the model for the New York Armory Show in 1913.

12. Berend-Corinth, *Lovis*, p. 135.

13. Quoted in Thomas Corinth, *Lovis Corinth: Eine Dokumentation*, p. 166.

14. Charlotte Berend-Corinth, *Die Gemälde von Lovis Corinth* (Munich: Bruckmann, 1958), p. 95, no. 327.

15. Ibid., p. 121, no. 521.

16. Quoted in Rudolf Pfefferkorn, *Die Berliner Secession: Eine Epoche deutscher Kunstgeschichte* (Berlin: Haude und Spener, 1972), p. 52.

17. See Peter Paret, *The Berlin Secession* (Cambridge: Harvard University Press, Belknap Press, 1980), pp. 219–232.

18. Lovis Corinth, "Mein Lebenswerk," in the exhibition catalogue *Lovis Corinth: Ausstellung des Lebenswerks* (Berlin: Berliner Secession, 1913), p. 8.

19. See Thomas Corinth, *Lovis Corinth: Eine Dokumentation*, p. 166.

20. Lovis Corinth, *Gesammelte Schriften* (Berlin: Fritz Gurlitt Verlag, 1920), pp. 97–112.

21. Lovis Corinth, *Über deutsche Malerei: Ein Vortrag für die Freie Studentenschaft in Berlin* (Leipzig: Hirzel, [c. 1914]).

22. *Gesammelte Schriften*, pp. 87–91.

23. Corinth, *Selbstbiographie*, pp. 128–131.

24. See the exhibition catalogue *Lovis Corinth* (New York: Gallery of Modern Art, 1964), p. 25.

25. See also Imiela, "Die Porträts Lovis Corinths," p. 181.

26. Lovis Corinth, "Ein Brief des Künstlers an den Herausgeber," *Deutsche Kunst und Dekoration* 41 (1917): 31.

27. For other such repetitions of much earlier paintings, see *Bacchanale* (1914; Schw. 150), after B.-C. 131 from 1896; *In Hell* (1914; Schw. 189), after B.-C. 209 from 1901; and *Salome* (1916; Schw. 234), after B.-C. 171 from 1900.

28. See Max Klinger, *Malerei und Zeichnung*, 6th ed. (Leipzig: Thieme, 1913), pp. 23, 33; and Peter Hahn, "Das literarische Figurenbild bei Lovis Corinth" (Ph.D. diss., Eberhard-Karls-Universität, Tübingen, 1970), p. 117.

29. See Imiela, "Die Porträts Lovis Corinths," p. 143.

30. Karl Schwarz was later the director of the Jewish Museum in Berlin; in 1933 he emigrated to Israel, where he became the director of the museum in Tel Aviv.

31. Herbert Eulenberg, *Lovis Corinth: Ein Maler unserer Zeit* (Munich: Delphin, 1917).

32. See also Imiela, "Die Porträts Lovis Corinths," pp. 149–150.

33. Corinth, *Selbstbiographie*, p. 127.

34. Ibid., p. 125.

35. Ibid., pp. 127–129.

36. See Peter Gay, *Weimar Culture: The Outsider as Insider* (New York: Harper and Row, 1968), p. 73.

37. Richard Hamann and Jost Hermand, *Stilkunst um 1900,* Epochen deutscher Kultur von 1870 bis zur Gegenwart 4 (Frankfurt: Fischer Taschenbuch, 1977); see the chapter "Idealismus statt Materialismus," pp. 77–101.

38. See Marion F. Deshmukh, "German Impressionist Painters and World War I," *Art History* 4 (1981): 66–79.

39. Thomas Corinth, *Lovis Corinth: Eine Dokumentation,* p. 351; and letter dated February 9, 1989, from Wilhelmine Corinth Klopfer to the author.

40. Corinth, *Selbstbiographie,* p. 137.

41. Ibid., p. 139.

42. Ibid.

43. Ibid., p. 138.

44. Ibid., p. 140.

45. Ibid., p. 157.

5 SENEX

1. Thomas Corinth, ed., *Lovis Corinth: Eine Dokumentation* (Tübingen: Wasmuth, 1979), p. 282; see the letters of September 8 and 16.

2. Lovis Corinth, *Selbstbiographie* (Leipzig: Hirzel, 1926), p. 177.

3. See Gerhard Femmel, ed., *Corpus der Goethezeichnungen,* vol. 2 (Leipzig: Seemann, 1960), no. 9.

4. Ludwig Steub, *Das bayerische Hochland* (Munich: J. G. Cotta, 1860), p. 467; Friedrich Wilhelm Walther, *Topische Geographie von Bayern* (Munich: Verlag der Litterarisch-artistischen Anstalt, 1844), p. 77; references from Werner Timm, ed., *Lovis Corinth: Die Bilder vom Walchensee,* exhibition catalogue (Regensburg: Ostdeutsche Galerie; Bremen: Kunsthalle, 1986), pp. 9–13.

5. Timm, *Bilder vom Walchensee,* pp. 23–24.

6. Charlotte Berend-Corinth, *Lovis* (Munich: Langen–Georg Müller Verlag, 1958), p. 201.

7. For the watercolor, see Timm, *Bilder vom Walchensee,* no. 79.

8. Ibid., p. 12.

9. Berend-Corinth, *Lovis,* p. 201.

10. See Timm, *Bilder vom Walchensee,* no. 91; for the origin of the triptych, see Berend-Corinth, *Lovis,* p. 217. Charlotte Berend, too, contributed to the exterior decoration of the house by painting wildflowers on the window shutters.

11. Timm, *Bilder vom Walchensee,* p. 40; see also Charlotte Berend-Corinth, *Mein Leben mit Lovis Corinth* (Munich: List, 1958), pp. 99–200 (entry for July 26, 1926).

12. See also B.-C. 200, 596.

13. Cf. Timm, *Bilder vom Walchensee,* p. 63.

14. Ibid.

15. Corinth, *Selbstbiographie,* pp. 159, 161, 163, 171–173.

16. Bernard S. Myers, *The German Expressionists: A Generation in Revolt* (New York: Praeger, 1957), p. 22.

17. Karl Schwarz, "Lovis Corinth, Berlin," *Deutsche Kunst und Dekoration* 41 (1917): 3–17, "Corinth als Graphiker," *Die Kunst* 19 (1918): 362–372, and "Corinth als Zeichner und Graphiker," in the exhibition catalogue *Lovis Corinth zum 60. Geburtstag* (Berlin: Berlin Secession, 1918).

18. In 1920 Corinth also painted a portrait of Henny Porten in the role of Anne Boleyn; see B.-C. 789.

19. See *Lovis Corinths "Fridericus Rex": Der Preussenkönig in Mythos und Geschichte*, exhibition catalogue by Hans Gerhard Hannesen, (Berlin: Staatliche Museen Preussischer Kulturbesitz, Kupferstichkabinett, 1986).

20. Thomas Corinth, *Lovis Corinth: Eine Dokumentation*, p. 122; see the letter from Corinth to Charlotte Berend.

21. Ibid.; see the annotation to Corinth's letter by Thomas Corinth and p. 357, entry for March 17, 1924.

22. From a letter to the critic and collector P. D. Ettlinger, quoted in *The Memoirs of Leonid Pasternak*, trans. Jennifer Bradshaw, introd. Josephine Pasternak (London: Quartet, 1982), p. 119.

23. Ibid., p. 120.

24. For a reproduction of Pasternak's portrait of Corinth, painted in a mixture of gouache and pastel, see ibid., section of plates following p. 112.

25. Alfred Kuhn, "Erinnerungen an Lovis Corinth," *Zeitschrift für bildende Kunst* 59 (1925): 196.

26. Elvira Olschky, "Erinnerungen an Corinth," *Die Kunst* 27 (1926): 248.

27. Ibid.; see also Charlotte Berend-Corinth, *Die Gemälde von Lovis Corinth* (Munich: Bruckmann, 1958), p. 168; Grönvold died in Berlin on November 7, 1923.

28. Ibid., p. 173.

29. Lovis Corinth, *Das Erlernen der Malerei*, 3d ed. (Berlin, 1920; Hildesheim: Gerstenberg, 1979), p. 11.

30. Ibid., p. 82.

31. Ibid., pp. 194–195.

32. Georg Bussmann, *Lovis Corinth: Carmencita. Malerei an der Kante,* (Frankfurt: Fischer Taschenbuch, 1985), p. 57.

33. Berend-Corinth, *Mein Leben mit Lovis Corinth*, pp. 41–42 (entry for November 9, 1925).

34. Hans-Jürgen Imiela, "Die Porträts Lovis Corinths" (Ph.D. diss., Johannes-Gutenberg-Universität, Mainz, 1955), p. 136.

35. Corinth, *Das Erlernen der Malerei*, p. 137.

36. Corinth, *Selbstbiographie*, p. 178.

37. Ibid., p. 183.

38. Ibid.

39. Paul Fechter, *Menschen und Zeiten: Begegnungen aus fünf Jahrzehnten* (Gütersloh: C. Bertelsmann, [c. 1948]), p. 226.

40. Wilhelm Hausenstein, "Lovis Corinth," *Die Kunst und das schöne Heim* 56 (1958): 364.

41. Cf. Thomas Corinth, *Lovis Corinth: Eine Dokumentation*, p. 238.

42. Alfred Kuhn, *Lovis Corinth* (Berlin: Propyläen, 1925), p. 205.

43. Ibid.

44. See Thomas Corinth, *Lovis Corinth: Eine Dokumentation*, p. 239.

45. Rudolf Grossmann, "Besuch bei Corinth," *Kunst und Künstler* 23 (1925): 268–271.

46. Corinth, *Selbstbiographie*, pp. 168–171.

47. Berend-Corinth, *Mein Leben mit Lovis Corinth*, pp. 65–66 (entry for January 29, 1926).

48. Ibid., p. 66.

49. Berend-Corinth, *Lovis*, p. 259.

50. See also Leopold Reidemeister, "Lovis Corinths Walchenseepanorama," *Wallraf-Richartz-Jahrbuch* 15 (1953): 233–234.

51. Peter Hahn, "Das literarische Figurenbild bei Lovis Corinth" (Ph.D. diss., Eberhard-Karls-Universität, Tübingen, 1970), p. 153; Gert von der Osten, *Lovis Corinth*, 2d rev. ed. (Munich: Bruckmann, 1959), pp. 180–181.

52. Thomas Corinth, *Lovis Corinth: Eine Dokumentation*, p. 358.

53. Corinth, *Selbstbiographie*, pp. 184–185.

54. Ibid., p. 185.

55. Thomas Corinth, *Lovis Corinth: Eine Dokumentation*, p. 63; see Corinth's letter of October 1900 to Dr. Carl Graeser.

56. Corinth, *Selbstbiographie*, p. 186.

57. Ibid., p. 188.

58. Ibid.

59. Berend-Corinth, *Die Gemälde von Lovis Corinth*, p. 201, document no. 27.

60. Corinth, *Selbstbiographie*, p. 194.

61. Leo Michelson, "Mit Corinth in Holland: Die letzten Arbeiten des Meisters," *Kunstwanderer*, 1924–1925, nos. 1–2: 421.

BIBLIOGRAPHY

WRITINGS BY LOVIS CORINTH

"In der Akademie Julian." *Kunst und Künstler* 3 (1905): 18–24.

"Die Religionen und die Kunst." *Nord und Süd* 32 (1908–1909): 502–512.

"Das Handwerk in der Malerei." *Die deutsche Rundschau* 21 (1910): 1112–1114.

Das Leben Walter Leistikows: Ein Stück Berliner Kulturgeschichte. Berlin: Paul Cassirer, 1910.

"Der bildende Künstler." In *Lovis Corinth*. Seemanns Künstlermappe 42. Leipzig: Seemann, 1911.

"Die Invasion der französischen Kunst." *Süddeutsche Monatshefte* 8 (1911): 777–779.

Über deutsche Malerei: Ein Vortrag für die Freie Studentenschaft in Berlin. Leipzig: Hirzel, [c. 1914].

"Ein Brief des Künstlers an den Herausgeber." *Deutsche Kunst und Dekoration* 41 (1917–1918): 31.

Legenden aus dem Künstlerleben. 3d ed. Berlin: Bruno Cassirer, 1918.

Gesammelte Schriften. Berlin: Fritz Gurlitt Verlag, 1920.

Von Corinth und über Corinth. (With Wilhelm Hausenstein). Leipzig: Seemann, 1921.

Selbstbiographie. Leipzig: Hirzel, 1926.

Das Erlernen der Malerei. 3d ed. Berlin, 1920. Reprint. Hildesheim: Gerstenberg, 1979.

OEUVRE CATALOGUES

Berend-Corinth, Charlotte. *Die Gemälde von Lovis Corinth*. Introduction by Hans Konrad Röthel. Munich: Bruckmann, 1958.

Müller, Heinrich. *Die späte Graphik von Lovis Corinth*. Hamburg: Lichtwarkstiftung, 1960.

Schwarz, Karl. *Das graphische Werk von Lovis Corinth* (The graphic work of Lovis Corinth). 3d enl. ed. San Francisco: Alan Wofsy Fine Arts, 1985.

SELECTED LOVIS CORINTH EXHIBITION CATALOGUES

Lovis Corinth: Ausstellung des Lebenswerkes. Introductory remarks by Lovis Corinth and Max Liebermann. Berlin: Berlin Secession, January 19–February 23, 1913.

Ausstellung Lovis Corinth: Gemälde, Handzeichnungen, Graphik. Mannheim: Kunsthalle, July 1917.

Lovis Corinth. Berlin: Nationalgalerie, 1923.

Ausstellung Lovis Corinth. Zurich: Kunsthaus, May 10–June 29, 1924.

Lovis Corinth Ausstellung von Gemälden und Aquarellen zu seinem Gedächtnis. Introduction by Ludwig Justi. Berlin: Nationalgalerie, January–February 1926.

Lovis Corinth Gedächtnisausstellung: Handzeichnungen. Introduction by Paul Fechter, "Der Zeichner Corinth." Berlin: Berlin Secession, January–February 1926.

Lovis Corinth. Basel: Kunsthalle, March 14–April 13, 1936.

Lovis Corinth: Paintings from 1913–1925. New York: Westermann Gallery, April 19–May 15, 1939.

Lovis Corinth (1858–1925): Paintings, Drawings, Prints. Introduction by Edward Alden Jewell. New York: Galerie St. Etienne, April 16–May 10, 1947.

Lovis Corinth, 1858–1925: Gedächtnisausstellung zur 25. Wiederkehr seines Todestages. Hannover: Landesmuseum, July 16–September 3, 1950.

Lovis Corinth, 1858–1925: Retrospective Exhibition 1950–51. Introduction by Julius S. Held. Boston, Mass.: Institute of Contemporary Art; Colorado Springs, Colo.: Fine Arts Center; Columbus, Ohio: Gallery of Fine Arts; Detroit, Mich.: The Detroit Institute of Arts; Kansas City, Mo.: William Rockhill Nelson Gallery of Art; Milwaukee, Wis.: Milwaukee Art Center; Montreal: Museum of Fine Arts; Ottawa: The National Gallery of Canada; Portland, Oreg.: Portland Museum of Art; Toronto: Art Gallery of Toronto.

Ausstellung Lovis Corinth. Preface by Heinrich Becker. Bielefeld: Kunsthaus, January 7–February 5, 1951.

Prints by Lovis Corinth. From the Collection of Mr. and Mrs. Sigbert H. Marcy. Introduction by Ebria Feinblatt. Los Angeles: Los Angeles County Museum of Art, March 9–April 18, 1956.

Lovis Corinth, 1858–1925: Handzeichnungen, Radierungen, Lithographien aus der Sammlung von Wolfgang Gurlitt, München. Kaiserslautern: Pfälzische Landesgewerbeanstalt, September 17–October 13, 1957.

Ausstellung Lovis Corinth, 1858–1925: Aus Anlass seines 100. Geburtstages. Berlin: Nationalgalerie der ehemals Staatlichen Museen im Knobelsdorf-Flügel des Schlosses Charlottenburg, January 18–March 2, 1958.

Lovis Corinth: Zum 100. Geburtstag. Preface by Günter Busch. Bremen: Kunsthalle, March 16–April 20, 1958.

Lovis Corinth Gedächtnisausstellung zur Feier des hundertsten Geburtsjahres. Introduction by Hans Konrad Röthel. Wolfsburg: Stadthalle, May 4—June 15, 1958.

Lovis Corinth: Zur Feier seines hundertsten Geburtstages. Munich: Galerie Wolfgang Gurlitt, July 7–August 17, 1958.

Lovis Corinth, 1858–1925. Basel: Kunsthalle, September 13–October 12, 1958.

Lovis Corinth Gedächtnisausstellung: Zur Feier des 100. Geburtsjahres. Introduction by Gert von der Osten. Hannover: Kunstverein, October 26–November 30, 1958.

Lovis Corinth Graphik: Ausstellung zum 100. Geburtstag. Berlin: Staatliche Museen, Kupferstichkabinett, 1958.

Lovis Corinth: An Exhibition of Paintings. Introduction by Hans Konrad Röthel. London: Tate Gallery, January 9–February 15, 1959.

Lovis Corinth: Sammlung Dr. Fritz Rothmann, London. Kassel: Staatliche Kunstsammlungen, 1963–1964.

Lovis Corinth. Introductory essays by Hilton Kramer and Alfred Werner. New York: Gallery of Modern Art, September 22–November 1, 1964.

Lovis Corinth, 1858–1925. Kansas City: Charlotte Crosby Kemper Gallery, Kansas City Art Institute and School of Design, November 11–December 10, 1964.

Lovis Corinth, 1858–1925: Handzeichnungen und Aquarelle. Introduction by Hans-Friedrich Geist. Lübeck: Overbeck-Gesellschaft, June 20–August 15, 1965.

Lovis Corinth. Reutlingen: Hans Thoma Gesellschaft, October 9–November 6, 1966.

Lovis Corinth: Das Porträt. Karlsruhe: Badischer Kunstverein, June 4–September 3, 1967.

Lovis Corinth: Das graphische Spätwerk. Introduction by Rudolph Pfefferkorn. Montpellier: Maison de Heidelberg; Marseille: Goethe Institute; Wetzlar: Stadtmuseum; Berlin: Kunstamt Reinickendorf, 1969.

Lovis Corinth: Das graphische Spätwerk. Hamm: Städtisches Gustav-Lübcke-Museum, January 11–February 8, 1970.

Lovis Corinth. Berlin: Galerie Pels-Leusden, January 29–March 24, 1973.

Lovis Corinth, 1858–1925. Catalogue by J. W. von Moltke. Bielefeld: Kunsthalle, September 8–October 20, 1974.

Lovis Corinth, 1858–1925: Gemälde und Druckgraphik. Organized by Armin Zweite; with essays by Wolf-Dieter Dube, Peter Hahn, Hans-Jürgen Imiela, Eberhard Ruhmer, and Armin Zweite. Munich: Städtische Galerie im Lenbachhaus, September 12–November 16, 1975.

Lovis Corinth: Handzeichnungen und Aquarelle, 1875–1925. With an introduction by Günter Busch. Bremen: Kunsthalle, October 5–November 16, 1975.

Lovis Corinth: Gemälde, Aquarelle, Zeichnungen, und druckgraphische Zyklen. Organized by Horst Keller; with essays by Siegfried Gohr, Johann Jakob Hässlin, und Horst Keller. Cologne: Kunsthalle Köln, January 10–March 21, 1976.

Lovis Corinth: German Graphic Master, 1858–1925. Ithaca, N. Y.: Herbert F. Johnson Museum of Art, Cornell University, September 25–November 11, 1979.

Lovis Corinth, 1858–1925. Edited by Zdenek Felix; with essays by Gerhard Gerkens, Friedrich Gross, and Joachim Heusinger von Waldegg. Essen: Folkwang Museum, November 10, 1985–January 12, 1986; Munich: Kunsthalle der Hypo-Kulturstiftung, January 24–March 30, 1986. Cologne: DuMont, 1986.

Lovis Corinths "Fridericus Rex": Der Preussenkönig in Mythos und Geschichte. Organized and written by Hans Gerhard Hannesen. Berlin: Staatliche Museen Preussischer Kulturbesitz, Kupferstichkabinett, February 27–April 20, 1986; Bonn–Bad Godesberg: Wissenschaftszentrum, May 7–June 15, 1986; Cappenberg: Schloss Cappenberg, July 2–August 24, 1986.

Lovis Corinth: Die Bilder vom Walchensee. Vision und Realität. Edited by Werner Timm; with essays by Wilhelmine Corinth Klopfer and Hans-Jürgen Imiela. Regensburg: Ostdeutsche Galerie, April 27–June 15, 1986; Bremen: Kunsthalle, June 22–August 17, 1986.

WRITINGS ON LOVIS CORINTH

Berend-Corinth, Charlotte. "Vom Leben und Schaffen Corinths." *Das Kunstblatt* 15 (1931): 198–211, 288–297.

———. *Lovis.* Munich: Langen–Georg Müller Verlag, 1958.

———. *Lovis Corinth: Bildnisse der Frau des Künstlers.* Introduction by Carl Georg Heise. Stuttgart: Reclam, 1958.

———. *Mein Leben mit Lovis Corinth.* Munich: List, 1958.

Bertrand, Robert. *Louis Corinth.* Paris: Braun et Cie., [1940].

Biermann, Georg. *Lovis Corinth.* 2d ed. Bielefeld: Velhagen und Klasing, 1922.

———. "Lovis Corinth. Zu dem künstlerischen Werk der letzten Jahre." *Cicerone* 14 (1922): 552–556; *Jahrbuch der jungen Kunst* (1922): 69–74.

———. *Der Zeichner Lovis Corinth.* Arnolds Graphische Bücher 2, Folge 5. Dresden: 1924.

Breuer, Robert. "Lovis Corinth und Lesser Ury." *Die Weltbühne* 18 (1922): 192–194.

Bussmann, Georg. *Lovis Corinth: Carmencita. Malerei an der Kante.* Frankfurt: Fischer Taschenbuch, 1985.

Conradt, Walter. "Lovis Corinth als religiöser Maler." Ph.D. diss., Albertus Universität, Königsberg, 1921.

Corinth. Bastei Galerie der Grossen Maler. Introduction by Joachim Streubel. Bergisch Gladbach: Bastei, 1964.

Corinth, Thomas. "Lovis Corinths letzte Reise in die Ostpreussische Heimat." *Das Ostpreussenblatt,* Hamburg, April 5, 1958.

———. "Meine Eltern, zum 80. Geburtstag von Charlotte Berend-Corinth." *Das Ostpreussenblatt,* Hamburg, May 21, 1960.

———. "Lovis Corinth und Berlin." *Jahrbuch der Stiftung Preussischer Kulturbesitz* 3 (1964–1965): 337–355.

———. "Lovis Corinth, 1858–1925." In *Grosse Deutsche aus Ostpreussen,* 175–183. Munich: Gräfe und Unzer, 1970.

———. "Lovis Corinth als Buch-Illustrator." *Illustration 63* 7 (1970): 67–71.

———. "Lovis Corinths Beziehung zu Hermann Struck und die Spaltung der Berliner Secession." In the Almanac *Spuren unserer Zeit,* 3–21. Hannover: Verlag Refugium Walter Koch, 1972.

———. "Erinnerungen an Lovis Corinths letzte Jahre." *Weltkunst* 15 (1975): 1248–1249.

———. "Erinnerungen an meinen Vater." *Das Magazin* 23, no. 6 (1976).

———, ed. *Lovis Corinth: Eine Dokumentation.* Tübingen: Wasmuth, 1979.

Deecke, Thomas. "Lovis Corinths Zeichnungen nach Dürer." *Philobiblon* 11 (1967): 104–110.

———. "Die Zeichnungen von Lovis Corinth: Studien zur Stilentwicklung." Ph.D. diss., Freie Universität, Berlin, 1973.

Donat, Adolf. "Corinth in der National-Galerie." *Kunstwanderer,* July 1923, 448–450.

———. "Lovis Corinth und die deutsche Malerei." *Kunstwanderer,* August 1925, 419–421.

Eberlein, K. K. "Corinth als Zeichner." *Cicerone* 16 (1924): 612–617.

Eipper, Paul. "Corinth erzählt." *Querschnitt* 5 (1925): 761–765.

———. "Sommertage mit Lovis Corinth: Erinnerungen an den Meister." *Westermanns Monatshefte* 139 (1925–1926): 275–289.

———. *Ateliergespräche mit Liebermann und Corinth.* Edited by Veronika Eipper. Munich: Piper, 1971.

Elias, Julius. "Liebermann und Corinth." *Kunst und Künstler* 13 (1915): 408–420.

———. "Lovis Corinth." *Die Weltbühne* 21 (1925): 370–375.

Eulenberg, Herbert. *Lovis Corinth: Ein Maler unserer Zeit*. Munich: Delphin, 1917.

Fechter, Paul. "Der Landschafter Corinth." *Cicerone* 18 (1926): 621–631.

———. "Der Zeichner Corinth." In the exhibition catalogue, *50. Ausstellung der Berliner Secession*. Berlin, 1926.

———. *Menschen und Zeiten: Begegnungen aus fünf Jahrzehnten*. Gütersloh: C. Bertelsmann, [c. 1948].

Frick, Mechthild. *Lovis Corinth*. Reihe Welt der Kunst. 3d ed. Berlin: Henschelverlag, 1984.

Fussmann, Klaus. "The Colors of Dirt." *Art Forum*, May 1986, 106–109.

Glaser, Kurt. "Lovis Corinth." *Kunst und Künstler* 20 (1922): 229–236.

Grossmann, Rudolf. "Besuch bei Corinth." *Kunst und Künstler* 23 (1925): 268–271.

Gugg, Anton. "Farbe und Malweise bei Lovis Corinth." Ph.D. diss., Universität Salzburg, 1977.

Hahn, Peter. "Das literarische Figurenbild bei Lovis Corinth." Ph.D. diss., Eberhard-Karls-Universität, Tübingen, 1970.

Halbe, Anneliese. "Sommertage in meinen Kinderjahren." *Westdeutsches Jahrbuch* (1963): 57.

Harms, Ernest. "Lovis Corinth, 1858–1925." *Art News* 57 (1958): 30–32, 51–53.

Hausenstein, Wilhelm. "Corinth." *Der neue Merkur*, September 1925, no pagination.

———. "Lovis Corinth." *Die Kunst und das schöne Heim* 56 (1958): 361–378.

Hausenstein, Wilhelm, with Lovis Corinth. *Von Corinth und über Corinth*. Leipzig: Seemann, 1921.

Hecker-Corinth, Mine [Wilhelmine Corinth Klopfer]. "Mein Vater Lovis." *Die Erzählung* 1 (1947): 5–8.

Henning, Edward B. "A Late Self-Portrait by Lovis Corinth." *Cleveland Museum Bulletin* 67 (1980): 279–284.

Hentzen, Alfred. "Die Entstehung der Bildnisse des Historikers Eduard Meyer von Lovis Corinth in der Kunsthalle in Hamburg." *Jahrbuch der Hamburger Kunstsammlungen* 6 (1961): 117–142.

Imiela, Hans-Jürgen. "Die Porträts Lovis Corinths." Ph.D. diss., Johannes-Gutenberg-Universität, Mainz, 1955.

————. "Max Liebermann, Lovis Corinth, und Max Slevogt." In *Beiträge zur Theorie der Künste im 19. Jahrhundert*, no. 2, 257–270. Studien zur Philosophy und Literatur des neunzehnten Jahrhunderts, Bd. 12. Edited by Helmut Koopmann and J. Adolf Schmoll gen. Eisenwerth. Frankfurt: Klostermann, [c. 1971/1972].

————. *Printed Graphics: Max Liebermann (1847–1935), Max Slevogt (1868–1932), Lovis Corinth (1858–1925)*. Stuttgart: Institut für Auslandsbeziehungen, 1979.

————. "Lovis Corinth: Neubau in Monte Carlo, 1914." In *Festschrift für Carl-Wilhelm Clasen zum 60. Geburtstag*, 117–124. Rheinbach-Merzbach: CMZ-Verlag, 1983.

Justi, Ludwig. "Corinths Ecce Homo." *Museum der Gegenwart: Zeitschrift der deutschen Museen für Neuere Kunst* 1 (1930–1931).

————. *Von Corinth bis Klee: Ein Gang durch die Nationalgalerie*. Deutsche Malkunst im 20. Jahrhundert 2. Berlin: Julius Bard, [1931].

Kuhn, Alfred. "Corinth als Graphiker." *Kunst und Künstler* 22 (1924): 199–208 and 244–251.

————. "Corinth als Illustrator." *Monatshefte für Bücherfreunde und Graphiksammler* 1 (1925): 87–99.

————. "Erinnerungen an Lovis Corinth." *Zeitschrift für bildende Kunst* 59 (1925): 195–197.

————. *Lovis Corinth*. Berlin: Propyläen, 1925.

Kurth, W. "Das graphische Werk von Lovis Corinth." *Kunstchronik und Kunstmarkt* N.F. 28 (1917): 353–355.

Laporte, Paul M. "Lovis Corinth and German Expressionism." *Magazine of Art* 42 (1949): 301–305.

Leistikow, Walter. "Über das Erlernen der Malerei." *Die Kunst für Alle* 23 (1908): 351–354.

Lovis Corinth. Introduction by Rudolph Klein. Berlin: Otto Beckmann Verlag, [1908].

Lovis Corinth, 1858–1925. Introduction by Helga Weissgärber. Leipzig: Seemann, 1956.

Lovis Corinth: Walchensee. Introduction by Horst Keller. Munich: Piper, 1976.

Meier-Graefe, Julius. "Corinths Landschaften." *Zeitschrift für bildende Kunst* N.F. 32 (1921): 153–158.

Metken, Günter. "Lovis Corinth, Selbstbildnis vor der Staffelei." *Saarheimat* 8 (1964): 385–386.

Michelson, Leo. "Mit Corinth in Holland: Die letzten Arbeiten des Meisters." *Kunstwanderer*, 1924–1925, nos. 1–2: 420–421.

———. "Corinths letzte Tage in Amsterdam." *Kunst und Künstler* 26 (1926): 10–17.

Moll, Margarethe. "Erinnerungen an Lovis Corinth." *Neue deutsche Hefte* 2 (1955): 194–198.

Müller-Mehlis, Reinhard. "Vier Porträts der Familie Mainzer von Lovis Corinth." *Die Kunst und das schöne Heim* 84 (1972): 94–96.

Netzer, Remigius. *Lovis Corinth, 1858–1925: Graphik.* Munich: Piper, [1958].

Olschky, Elvira. "Erinnerungen an Corinth." *Die Kunst* 27 (1926): 242–250.

Osten, Gert von der. *Zehn Bilder von Lovis Corinth.* Oberlenningen: Scheufelen, 1958.

———. *Lovis Corinth.* 2d rev. ed., Munich: Bruckmann, 1959.

———. "Kleine Gemäldestudien." *Niederdeutsche Beiträge zur Kunstgeschichte* 1 (1961): 273–296.

———. *Lovis Corinth.* Berlin-Darmstadt-Vienna: Deutsche Buchgemeinschaft, 1963.

Pauli, Gustav. "Lovis Corinth." *Kunst und Künstler* 11 (1913): 244–245.

———. "Lovis Corinth." *Kunst und Künstler* 16 (1918): 334–345.

Reidemeister, Leopold. "Lovis Corinths Walchenseepanorama." *Wallraf-Richartz-Jahrbuch* 15 (1953): 233–234.

Reinhold, C. F. "Lovis Corinth." *Aufbau* 4 (1948): 618–621.

Reiser, K. A. "Lovis Corinth als Graphiker." In the exhibition catalogue *Lovis Corinth.* Reutlingen: Hans Thoma Gesellschaft, 1966.

Roh, Franz. "Der Malprozess beim späten Corinth." *Die Kunst und das schöne Heim* 50 (1953): 336–340.

Rohde, Alfred. *Der junge Corinth.* Berlin: Rembrandt, 1941.

Sacherlotzky, Rotraud. "Two Self-Portraits by Lovis Corinth." *Cleveland Museum Bulletin* 70 (1983): 418–431.

Scheffler, Karl. "Lovis Corinth." *Kunst und Künstler* 6 (1908): 234–246.

———. "Corinths Zeichnungen." *Kunst und Künstler* 15 (1917): 367–368.

———. "Corinth." *Kunst und Künstler* 21 (1923): 339–348.

———. "Corinth." *Kunst und Künstler* 24 (1926): 217–222.

Schmeer, W. "Die moderne Galerie des Saarland Museums 5: Lovis Corinth 'Walchensee, Blick auf den Wetterstein,' 1921." *Saarheimat* 13 (1969): 150–151.

Schnackenburg, Bernhard. "Ein frühes Skizzenbuch von Lovis Corinth." *Niederdeutsche Beiträge zur Kunstgeschichte* 16 (1977): 159–170.

Schneider, Bruno. *Lovis Corinth.* Berlin: Safari-Verlag, [1959].

Schnell, Robert Wolfgang. "Eroberung der Wirklichkeit: Zum 100. Geburtstag von Lovis Corinth." *Bildende Kunst* 6 (1958): 387–392.

Schwarz, Karl. "Lovis Corinth, Berlin." *Deutsche Kunst und Dekoration* 41 (1917): 3–17.

———. "Corinth als Graphiker." *Die Kunst* 19 (1918): 362–372.

———. "Corinth als Zeichner und Graphiker." In the exhibition catalogue *Lovis Corinth zum 60. Geburtstag.* Berlin: Berlin Secession, 1918.

Singer, Hans W., ed. *Zeichnungen von Lovis Corinth.* Meister der Zeichnung, no. 8. Leipzig: A. Schumann's Verlag, 1921.

Stabernack, J. "Die Goetheillustrationen von Slevogt, Liebermann, und Corinth." Ph.D. diss., Freie Universität, Berlin, 1960.

Steiner, Paula. *Lovis Corinth, dem Ostpreussen.* Königsberg: Gräfe und Unzer, [c. 1925].

Stuhlfaut, Georg. *Die religiöse Kunst im Werk von Lovis Corinth.* Lahr i. Baden: Verlag für Volkskunst und Volksbildung, 1926.

Uhr, Horst. "The Drawings of Lovis Corinth." Ph.D. diss., Columbia University, New York, 1975.

———. "The Late Drawings of Lovis Corinth: The Genesis of His Expressionism." *Arts Magazine* 51 (1976): 106–111.

———. "*Pink Clouds, Walchensee:* The 'Apotheosis' of a Mountain Landscape." *Bulletin of the Detroit Institute of Arts* 55 (1977): 209–215.

———. "Lovis Corinth's Formation in the Academic Tradition: Evidence of the Kiel Sketchbook and Related Student Drawings." *Arts Magazine* 53 (1978): 86–95.

Wankmüller, Rike. "Zu einigen Spätwerken von Lovis Corinth." *Das Kunstwerk* 15 (1961): 62.

Weissgärber, Helga. "Beiträge zur Bildinhaltskunde der neueren deutschen Malerei am Beispiel der Gemälde von Lovis Corinth." Ph.D. diss., Karl-Marx-Universität, Leipzig, 1955.

———. *Lovis Corinth.* Leipzig: Seemann, [1956].

Werner, Alfred. "Lovis Corinth: Irrealist Realist." *American Artist* 38 (1974): 32–37.

Werner, Bruno. "Zum Altersstil Corinths." *Die Kunst für Alle* 41 (1926): 233–241.

———. "Selbstbildnisse und Altersstil: Zur zehnten Wiederkehr des Todestages von Lovis Corinth." *Deutsche Rundschau* 244 (1935): 41–48.

———. "Lovis Corinth." In *Die grossen Deutschen.* Edited by Willy Andreas and Wilhelm von Scholz, 4: 416–433. Berlin: Propyläen, 1936.

Wingler, Hans M. *Wie sie einander sahen: Moderne Maler im Urteil ihrer Gefährten.* Munich: Langen–Georg Müller Verlag, [1957].

Wirth, Irmgard. *Berliner Maler: Menzel, Liebermann, Slevogt, Corinth.* 2d ed., Berlin: Arno Spitz, 1986.

OTHER SELECTED SOURCES

Ahlers-Hestermann, Friedrich. *Stilwende: Aufbruch der Jugend um 1900.* Berlin: Mann, 1941.

Bahr, Hermann. *Die Überwindung des Naturalismus.* Dresden: E. Pierson, 1891.

Baltzer, Ulrich. "Aus den Anfängen der Königsberger Kunstakademie." In *Königsberger Beiträge,* 10–18. Königsberg: Gräfe und Unzer, 1929.

Becker, Wolfgang. *Paris und die deutsche Malerei, 1750–1840.* Studien zur Kunstgeschichte des neunzehnten Jahrhunderts 10. Munich: Prestel, [1971].

Beenken, Hermann. *Das neunzehnte Jahrhundert in der deutschen Kunst: Aufgaben und Gehalte. Versuch einer Rechenschaft.* Munich: Bruckmann, [c. 1944].

Berg, Leo. *Der Übermensch in der modernen Literatur: Ein Kapitel zur Geistesgeschichte des 19. Jahrhunderts.* Munich-Leipzig: A. Langen, 1897.

Beringer, Joseph August. *Trübner.* Klassiker der Kunst 26. Stuttgart-Berlin: Deutsche Verlags-Anstalt, 1917.

Berlin. Salon Cassirer. *Katalog der Ausstellung des Nachlasses Walter Leistikows in Berlin W.,* 1908.

Bie, Oscar. "Walter Leistikow." *Kunst und Künstler* 2 (1904): 260–268.

Boime, Albert. *The Academy and French Painting in the Nineteenth Century.* London: Phaidon, 1971.

Brahm, Otto. *Karl Stauffer-Bern: Sein Leben, seine Briefe, seine Gedichte.* 6th ed. Leipzig: G. J. Göschen, 1907.

Buenger, Barbara C. "Max Beckmann's Amazonenschlacht: Tackling 'die grosse Idee.'" *Pantheon* 42 (1984): 140–150.

Buyck, Jean F. "Antwerp, *Als Ik Kan,* and the Problem of Provincialism." In the exhibition catalogue *Belgian Art, 1800–1914,* 71–80. Brooklyn, N. Y.: Brooklyn Museum, 1980.

Colin, Paul. *La peinture belge depuis 1830.* Brussels: Editions des Cahiers de Belge, 1930.

Crespelle, Jean. *Les maîtres de la belle époque.* Paris: Hachette, 1966.

Daffner, Hugo. *Salome: Ihre Gestalt in Geschichte und Kunst. Dichtung—bildende Kunst—Musik.* Munich: H. Schmidt, [c. 1912].

Dayot, Armand. *Salon de 1884.* Paris: Baschet, 1884.

Deshmukh, Marion F. "Art and Politics in Turn-of-the-Century Berlin: The Berlin Secession and Kaiser Wilhelm II." In *Turn of the Century: German Literature and Art, 1890–1915,* edited by Gerald Chapple and Hans H. Schulte, 463–475. McMaster Colloquium on German Literature 2. Bonn: Bouvier, 1981.

———. "German Impressionist Painters and World War I." *Art History* 4 (1981): 66–79.

Dijkstra, Bram. *Idols of Perversity: Fantasies of Feminine Evil in Fin-de-Siècle Culture*. New York: Oxford University Press, 1986.

Doede, Werner. *Berlin: Kunst und Künstler seit 1870*. Recklinghausen: Bongers, 1961.

Durieux, Tilla. *Eine Tür steht offen: Erinnerungen*. Berlin-Grunewald: Herbig, [c. 1954].

———. *Meine ersten neunzig Jahre*. Munich-Berlin: Herbig, 1971.

Elias, Julius. "Schwarz-Weiss." *Kunst und Künstler* 6 (1908): 183–194.

Endell, August. *Um die Schönheit: Eine Paraphrase über Münchner Kunstausstellungen 1896*. Munich: Verlag Emil Franke, 1896.

Faust, Wolfgang Max, and Gerd de Vries. *Hunger nach Bildern: Deutsche Malerei der Gegenwart*. Cologne: DuMont, 1982.

Fehrer, Catherine. "New Light on the Académie Julian and Its Founder (Rodolphe Julian)." *Gazette des Beaux-Arts* 56 (1984): 207–216.

Femmel, Gerhard, ed. *Corpus der Goethezeichnungen*, vol. 2. Leipzig: Seemann, 1960.

Flügel, Rolf, ed. *Lebendiges München (1158–1959)*. Munich: Bruckmann, 1950.

Gause, Fritz. *Die Geschichte der Stadt Königsberg in Preussen*. 2 vols. Cologne-Graz: Böhlau, 1965.

Gay, Peter. *Weimar Culture: The Outsider as Insider*. New York: Harper and Row, 1968.

Glaser, Kurt. "Die Geschichte der Berliner Sezession." *Kunst und Künstler* 26 (1927): 14–20 and 66–70.

Gohr, Siegfried. "Max Beckmanns zwei Frauen von 1940—eine Antwort auf Corinth." *Museen der Stadt Köln Bulletin* 4 (1982): 44–45.

Gordon, Donald E. *Modern Art Exhibitions, 1900–1916*. Materialien zur Kunst des 19. Jahrhunderts, vol. 14, parts 1–2. Munich: Prestel, 1974.

———. *Expressionism: Art and Idea*. New Haven: Yale University Press, 1987.

Gurlitt, Cornelius. *Die Kunst unserer Zeit auf der Internationalen Kunstausstellung zu Berlin 1891*. Munich, [1892].

———. *Die deutsche Kunst seit 1800: Ihre Ziele und Taten*. 4th ed. Berlin: Georg Bondi, 1924.

Hadamowsky, Franz, ed. *Max Reinhardt: Ausgewählte Briefe, Reden, Schriften, und Szenen aus Regiebüchern*. Vienna: Prachner, 1963.

Haftmann, Werner. *Painting in the Twentieth Century*. New York: Praeger, 1965.

Halbe, Max. *Gesammelte Werke*, vol. 1. Munich: A. Langen, 1917.

———. *Jahrhundertwende: Geschichte meines Lebens, 1893–1914*. Danzig: A. W. Kafemann, 1935.

Hamann, Richard, and Jost Hermand. *Gründerzeit: Deutsche Kunst und Kultur von der Gründerzeit bis zum Expressionismus*, vol. I. Berlin: Akademie, 1965.

————. *Naturalismus.* Epochen deutscher Kultur von 1870 bis zur Gegenwart 2. Frankfurt: Fischer Taschenbuch, 1977.

————. *Stilkunst um 1900.* Epochen deutscher Kultur von 1870 bis zur Gegenwart 4. Frankfurt: Fischer Taschenbuch, 1977.

Hamilton, George Heard. *Painting and Sculpture in Europe, 1880–1940.* The Pelican History of Art. Baltimore: Penguin Books, 1967.

Hancke, Erich. *Max Liebermann: Sein Leben und seine Werke.* 2d ed. Berlin: Bruno Cassirer, 1923.

Hartrick, Archibald Standish. *A Painter's Pilgrimage through Fifty Years.* Cambridge: Cambridge University Press, 1939.

Haus, Andreas. "Gesellschaft, Geselligkeit, Künstlerfest: Franz von Lenbach und die Münchner Allotria." In the exhibition catalogue *Franz von Lenbach, 1836–1904,* edited by Rosel Gollek and Winfried Ranke, pp. 99–116. Munich: Städtische Galerie im Lenbachhaus, December 14, 1986–May 3, 1987.

Hermand, Jost, ed. *Jugendstil.* Wege der Forschung 110. Darmstadt: Wissenschaftliche Buchgesellschaft, 1971.

Herrmann, Paul. *Diktatur der modernen Kunst, Anhang: Was die Künstler sagen.* Berlin-Charlottenburg, 1920.

Heusinger von Waldegg, Joachim. *Grotesker Jugendstil: Carl Strathmann, 1866–1939.* Exhibition catalogue. Bonn: Rheinisches Landesmuseum, March 25–May 2, 1975.

Hevesi, Lajos [Ludwig]. *Altkunst-Neukunst: Wien, 1894–1908.* Vienna: C. Konegen, 1909.

Heymel, Alfred Walter, ed. *Deutsche und Französische Kunst.* Munich, 1911.

Hisinger, Kathryn Bloom, ed. *Art Nouveau in Munich: Masters of Jugendstil.* Munich: Prestel (in association with the Philadelphia Museum of Art), 1988.

Hofmann, Werner. *Das irdische Paradies: Kunst im neunzehnten Jahrhundert.* Munich: Prestel, 1960.

Imiela, Hans-Jürgen. *Max Slevogt.* Karlsruhe: Braun, 1968.

Joachimides, Christos M., Norman Rosenthal, and Wieland Schmied, eds. *Deutsche Kunst im 20. Jahrhundert: Malerei und Plastik, 1905–1985.* Munich: Prestel, 1986.

Karlinger, Hans. *München und die deutsche Kunst des 19. Jahrhunderts.* Bayerische Heimatbücher 6. Munich: Knorr und Hirth, 1933.

Katsch, Herrmann. "Meine Erinnerungen an Karl Stauffer-Bern." *Die Kunst für Alle* 25 (1909): 11–18 and 59–68.

Klinger, Max. *Malerei und Zeichnung.* 6th ed. Leipzig: Thieme, 1913.

Kollwitz, Käthe. *Ich will wirken in dieser Zeit.* Introduction by Friedrich Ahlers-Hestermann. Berlin: Mann, 1952.

Königsberg, Stadt-Museum. *Die Gemälde des Königsberger Stadt-Museums.* Preface by Alfred Rohde. Kunstsammlungen Stadt Königsberg, 1884.

Kramer, Hilton. *The Age of the Avant-Garde: An Art Chronicle of 1956–1972.* New York: Farrar, Straus and Giroux, [1973].

Laforgue, Jules. *Oeuvres complètes.* 4th ed. Paris: Mercure, 1902–1903.

———. *Six Moral Tales.* Edited and translated by Frances Newman. New York: Horace Liveright, 1928.

Langer, Alfred. *Wilhelm Leibl.* Leipzig: Seemann, 1961.

Lees, Frederic. "The Work of Jean-Jacques Henner." *The International Studio* 9 (1899–1900): 77–82.

Lehrs, Max. *Karl Stauffer-Bern, 1857–1891: Ein Verzeichnis seiner Radierungen und Stiche.* Includes the manuscript of Stauffer-Bern's treatise "Tractat der Radierung." Dresden: Verlag Ernst Arnold, 1907.

Lichtwark, Alfred. *Das Bildnis in Hamburg.* 2 vols. Hamburg: Der Kunstverein zu Hamburg, 1899.

———. *Briefe an Max Liebermann.* Edited by Carl Schellenberg. Hamburg: J. Trautmann (im Auftrage der Lichtwarkstiftung), 1947.

Liebermann, Max. *Gesammelte Schriften.* Berlin: Bruno Cassirer, 1922.

———. *Die Phantasie in der Malerei: Schriften und Reden.* Edited by Günter Busch. Frankfurt: Fischer Verlag, 1978.

Ludwig, Horst. *Münchner Malerei im 19. Jahrhundert.* Munich: Hirmer, 1978.

Mandach, Conrad von. *Stauffer-Bern: Handzeichnungen.* Landschlacht/Bodensee: Verlag Dr. Carl Hoenn, [1924].

———. *Karl Stauffer-Bern.* Bern: Alfred Scherz, 1928.

Markowitz, Irene. *Die Düsseldorfer Malerschule.* Düsseldorf: Kunstmuseum, 1967.

Max Klinger: Wege zum Gesamtkunstwerk. With contributions by Manfred Boetzkes, Dieter Gleisberg, Ekkehart Mai, Hans-Georg Pfeiffer, Ulrike Planner-Steiner, and Hellmuth Christian Wolff. Mainz: Zabern: 1984.

Meier-Graefe, Julius. *Entwicklungsgeschichte der modernen Kunst.* 3 vols. Stuttgart: J. Hoffmann, 1904; 3d ed. Munich: Piper [c. 1915–1927].

Meissner, Franz Hermann. *Max Klinger: Radierungen, Zeichnungen, Bilder, und Skulpturen.* Munich: Franz Hanfstaengl, 1914.

Milner, John. *The Studios of Paris: The Capital of Art in the Late Nineteenth Century.* New Haven: Yale University Press, 1988.

Moffett, Kenworth. *Meier-Gräfe as Art Critic.* Studien zur Kunst des neunzehnten Jahrhunderts 19. Munich: Prestel, [1973].

Muenier, Pierre-Alexis. *La vie et l'art de Jean-Jacques Henner.* [Paris]: Flammarion, [c. 1927].

Die Münchner Malerschule, 1850–1914. With contributions by Christoph Heilmann, Horst Ludwig, Eberhard Ruhmer, and Siegfried Wichmann. Exhibition catalogue. Munich: Bayerische Staatsgemäldesammlungen und Haus der Kunst München e.V., July 28–October 7, 1979.

Munich, Haus der Kunst. *München, 1869–1958: Aufbruch zur modernen Kunst.* Exhibition catalogue. 1958.

Muther, Richard. *Die belgische Malerei im neunzehnten Jahrhundert.* Berlin: Fischer, 1904.

Myers, Bernard S. *The German Expressionists: A Generation in Revolt.* New York: Praeger, 1957.

Nicholls, R. A. "Beginning of the Nietzsche Vogue in Germany." *Modern Philology* 56 (1958–1959): 24–37.

Niessen, Carl. *Max Reinhardt und seine Bühnenbilder.* Cologne: Wallraf-Richartz-Museum, 1958.

Nietzsche, Friedrich. *Gesammelte Werke.* Vol. 6. Leipzig: A. Kröner, 1910.

Osborn, Max. "Walter Leistikow." *Deutsche Kunst und Dekoration* 5 (1899–1900): 113–136.

———. "Otto Eckmanns kunstgewerbliche Tätigkeit." *Deutsche Kunst und Dekoration* 6 (1900): 313–332.

Ostini, Fritz von. *Böcklin.* Bielefeld und Leipzig: Velhagen und Klasing, 1893.

Paret, Peter. *The Berlin Secession: Modernism and Its Enemies in Imperial Germany.* Cambridge: Harvard University Press, Belknap Press, 1980.

Pasternak, Leonid. *The Memoirs of Leonid Pasternak.* Translated by Jennifer Bradshaw; introduction by Josephine Pasternak. London: Quartet, 1982.

Pastor, Willy. *Max Klinger.* 2d ed. Berlin: Amsler und Ruthardt, 1919.

Pauli, Gustav, ed. *Max Liebermann: Des Meisters Gemälde.* Klassiker der Kunst 19. Stuttgart-Berlin: Deutsche Verlags-Anstalt, 1911.

Pecht, Friedrich. "Die Berliner Kunstausstellung." *Die Kunst für Alle* 1, no. 18–2, no. 3 (1886).

Perrot, Aristide Michel. *Manuel de dessinateur; ou, traité complet du dessin.* Edited by A. Vergnaud. 3d rev. and enl. ed. Paris, 1832.

Pevsner, Nikolaus. *Academies of Art: Past and Present.* Cambridge: Cambridge University Press, 1940.

Pfefferkorn, Rudolf. *Die Berliner Secession: Eine Epoche deutscher Kunstgeschichte.* Berlin: Haude und Spener, 1972.

Praz, Mario. *The Romantic Agony.* 2d ed., London: Oxford University Press, 1970.

Rave, Paul Ortwin. *Kunst in Berlin.* Berlin: Staneck Verlag, [1965].

Relling, Dr. [Jaro Springer]. "Der Fall Munch." *Die Kunst für Alle* 8 (1893): 102.

Rewald, John. *Post-Impressionism from Van Gogh to Gauguin.* 2d ed. New York: Museum of Modern Art, 1962.

———. *The History of Impressionism.* 4th rev. ed. New York: Museum of Modern Art, 1973.

Rischbieter, Henning, comp. *Art and the Stage in the 20th Century: Painters and Sculptors Work for the Theater.* Documented by Wolfgang Storch; translated by Michel Bullock. Greenwich, Conn.: New York Graphic Society, [c. 1968].

Rosenberg, Adolph. *Die Münchner Malerschule in ihrer Entwicklung seit 1871.* Leipzig: Seemann, 1887.

Rosenberg, Alfred. *Der Mythus des 20. Jahrhunderts: Eine Wertung der seelisch-geistigen Gestaltenkämpfe unserer Zeit.* Munich: Hoheneichen-Verlag, 1936.

Rosenhagen, Hans. "Die zweite Ausstellung der Berliner Secession." *Die Kunst* 1 (1900): 459–480.

———. *Würdigungen.* Berlin: Hermann Nabel, 1902.

———. "Walter Leistikow—Berlin." *Deutsche Kunst und Dekoration* 16 (1905): 499–509.

———. *Uhde: Des Meisters Gemälde.* Stuttgart-Leipzig: Deutsche Verlags-Anstalt, 1908.

Roth, Eugen, ed. *Ein halbes Jahrhundert Münchner Kulturgeschichte: Erlebt mit der Künstlergesellschaft Allotria.* Munich: Thiemig, 1959.

Rothenstein, William. *Men and Memories: Recollections of William Rothenstein, 1872–1900.* 3 vols. New York: Coward-McCann, 1931–[1939].

Rothes, Walter. "Carl Strathmann." *Die Kunst für Alle* 29 (1914): 505–516.

Ruederer, Joseph. *Tragikomödien.* Berlin: Georg Bondi, 1897.

———. *Wallfahrer- Maler- und Mördergeschichten.* 3d ed. Munich: Süddeutsche Monatshefte, 1913.

Ruhmer, Eberhard. *Der Leibl-Kreis und die Reine Malerei.* Rosenheim: Rosenheimer Verlagshaus, 1984.

Sayler, Oliver Martin, ed. *Max Reinhardt and His Theatre.* New York: Brentano's, [1924].

Scheffler, Karl. "Erklärung." *Kunst und Künstler* 9 (1911): 210–211.

———. "Berliner Secession." *Kunst und Künstler* 10 (1912): 434.

Scheidig, Walther. *Die Geschichte der Weimarer Malerschule.* Weimar: Böhlaus, 1971.

Schlenck, Wolfgang. *100 Jahre Evangelische Kirche Bad Tölz, 1800–1980.* Bad Tölz: Evangelisch-Lutherisches Pfarramt, 1980.

Schlittgen, Hermann. *Erinnerungen.* Hamburg-Begedorf: Stromverlag, 1947.

Schmalenbach, Fritz. "Jugendstil: Ein Beitrag zu Theorie und Geschichte der Flächenkunst. Ph.D. diss., Westfälische Wilhelms-Universität, Münster, 1934.

Schmoll gen. Eisenwerth, J. Adolf. "Salome 1900." *Du* 8 (1981): 45–53.

Schultzmann, Monty. *Die Malerin Charlotte Berend-Corinth*. Munich: Bruckmann, [1966].

Schuster, Peter-Klaus. *"München leuchtete": Karl Caspar und die Erneuerung christlicher Kunst in München um 1900*. Munich: Prestel, 1984.

Selber [Leistikow, Walter]. "Die Affäre Munch." *Die Freie Bühne* 3 (1892): 1296–1300.

Seling, Helmut, ed. *Jugendstil: Der Weg ins 20. Jahrhundert*. Heidelberg: Keysersche Verlagsbuchhandlung, 1959.

Selz, Peter. "E. L. Kirchner's 'Chronik der Brücke.'" *College Art Journal* 10 (1950): 50–54.

———. *German Expressionist Painting*. Berkeley: University of California Press, 1957.

———. *Max Beckmann*. Exhibition catalogue. New York: Museum of Modern Art, 1964.

Singer, Hans Wolfgang. *Karl Stauffer-Bern: Die Radierungen und Stiche des Künstlers*. Berlin: Amsler und Ruthardt, 1919.

———, ed. *Briefe von Max Klinger aus den Jahren 1874–1919*. Leipzig: Seemann, 1924.

Steub, Ludwig. *Das bayerische Hochland*. Munich: J. G. Cotta, 1860.

Uhde-Bernays, Hermann, ed. *Künstlerbriefe über Kunst: Bekenntnisse von Malern, Architekten, und Bildhauern aus fünf Jahrhunderten*. Dresden: W. Jess, [1926].

———. *Die Münchner Malerei im neunzehnten Jahrhundert*. Vol. 2, *1850–1900*. Munich: Bruckmann, 1927.

Vinnen, Carl, ed. *Ein Protest deutscher Künstler*. Jena: E. Diederichs, 1911.

Vogt, Paul. *Expressionism*. New York: Harry N. Abrams, 1980.

Voss, Georg. "Die Berliner Kunstausstellung." *Die Kunst für Alle* 2 (1887): 356–359 and 369–371.

Waldmann, Emil. "Edouard Manet in der Sammlung Pellerin." *Kunst und Künstler* 8 (1910): 387–398.

Walther, Friedrich Wilhelm. *Topische Geographie von Bayern*. Munich: Verlag der Litterarisch-artistischen Anstalt, 1844.

Weisbach, Werner. "Walter Leistikow." *Zeitschrift für bildende Kunst* N.F. 13 (1902): 281–294.

Weiss, Peg. *Kandinsky in Munich: The Formative Jugendstil Years*. Princeton, N. J.: Princeton University Press, 1979.

Weizsäcker, Heinrich. "Karl Stauffer-Bern." *Die Kunst unserer Zeit* 3 (1892): 53–60.

White, Barbara Ehrlich. *Impressionism in Perspective*. Englewood Cliffs, N. J.: Prentice Hall, [c. 1978].

Wichmann, Siegfried. *Realismus und Impressionismus: Bemerkungen zur Freilicht-malerei des 19. und beginnenden 20. Jahrhunderts.* Stuttgart: Schuler Verlags-gesellschaft, 1964.

———. *Secession: Europäische Kunst um die Jahrhundertwende.* Munich: Haus der Kunst, 1964.

Wolf, Georg Jacob. *Karl Stauffer-Bern.* Munich: D. und R. Bischoff, 1907.

———. *Leibl und sein Kreis.* Munich: Bruckmann, 1923.

Wolters, Friedrich. *Stefan George und die Blätter für die Kunst: Deutsche Geistes-geschichte seit 1890.* Berlin: Georg Bondi, 1930.

Zimmermann, Ernst. "Prof. Otto Eckmann, Berlin. I. Die Jahre künstlerischer Entwicklung." *Deutsche Kunst und Dekoration* 6 (1900): 305–313.

Züricher, U. W., ed. *Familienbriefe und Gedichte von Karl Stauffer-Bern.* Leipzig: Insel, 1914.

Designer: Steve Renick
Compositor: G&S Typesetters, Inc.
Text: Palatino
Display: Palatino
Printer: Toppan Printing Company, Ltd.
Binder: Toppan Printing Company, Ltd.